Impressions of France: Monet, Renoir, Pissarro, and their Rivals

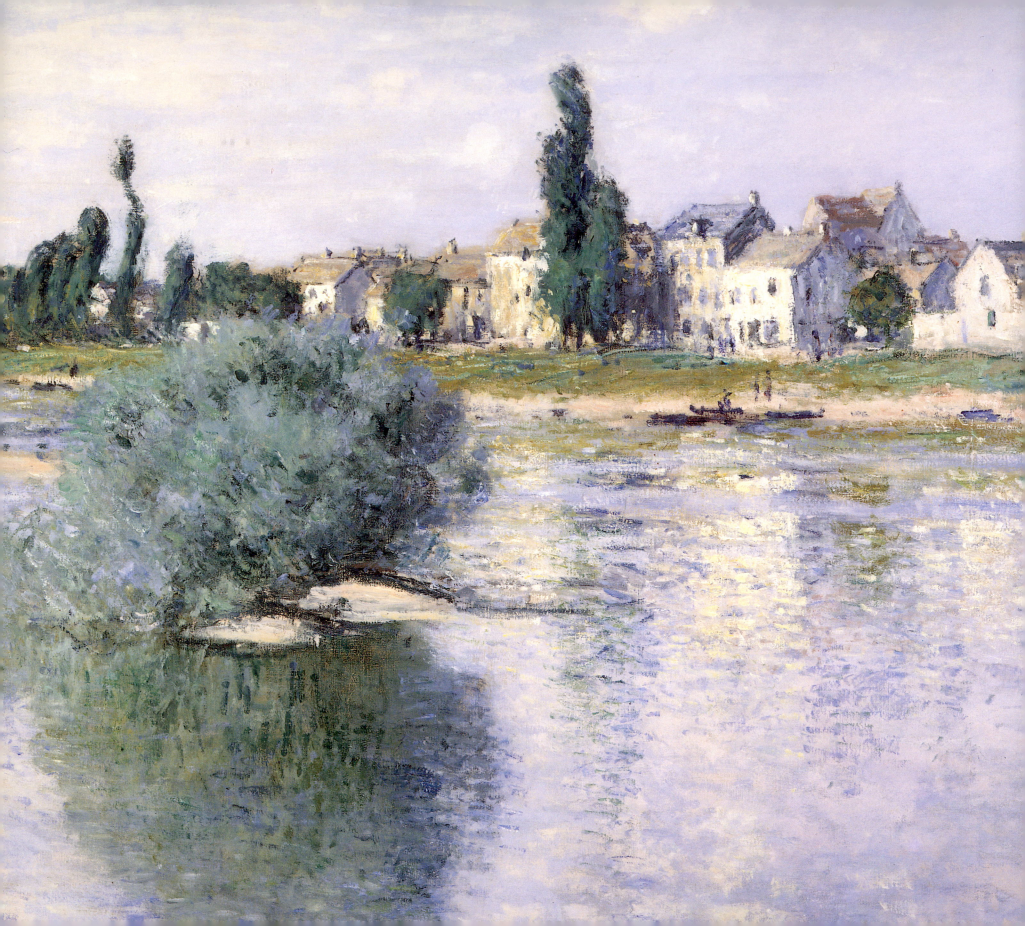

Impressions of France: Monet, Renoir, Pissarro, and their Rivals

John House

with contributions from
Ann Dumas
Jane Mayo Roos
James F. McMillan

Museum of Fine Arts, Boston

Published on the occasion of the exhibition *Impressions of France: Monet, Renoir, Pissarro, and their Rivals*, organized by the South Bank Centre, London, and the Museum of Fine Arts, Boston

Hayward Gallery, London
18 May–28 August 1995
Museum of Fine Arts, Boston
4 October 1995–14 January 1996

Exhibition
Curated by John House
Organized by Andrew Dempsey
and Julia Coates

Catalogue
Edited and co-ordinated
by Joanna Skipwith
Designed by Esterson Lackersteen
Printed by The White Dove Press
ISBN 1 85332 142 7
© The South Bank Centre 1995
© Texts, the authors 1995
ISBN 0-87846-452-2 (U.S. edition)

South Bank Centre publications may be obtained from Art Publications, South Bank Centre, Royal Festival Hall, London SE1 8XX.

Cover illustration: Alfred Sisley, *The Seine at Bougival*, c. 1872, cat. 68 (detail)
Back cover: Alexandre Ségé, *In the Land of Chartres*, Salon of 1884, cat. 46 (detail)
Frontispiece: Claude Monet, *Lavacourt*, Salon of 1880, cat. 36 (detail)

An exhibition organized by the South Bank Centre, London, and the Museum of Fine Arts, Boston. The Boston presentation of the exhibition was made possible by the generous support of Fleet Financial Group and Shawmut National Corporation. Additional support was provided by the National Endowment for the Arts, a Federal agency.

Lenders

Finland
Collection Antell Ateneum, Helsinki
France*
Agen, Musée des Beaux-Arts
Angers, Musée des Beaux-Arts
Arras, Musée des Beaux-Arts
Avignon, Musée Calvet
Beauvais, Musée Départemental
 de l'Oise
Bernay, Musée de Bernay
Besançon, Musée des Beaux-Arts et
 d'Archéologie
Béziers, Musée des Beaux-Arts
Blérancourt, Musée National de la
 Coopération Franco-Américaine
Bordeaux, Musée des Beaux-Arts
Brest, Musée de Brest
Caen, Musée des Beaux-Arts
Carcassonne, Musée des Beaux-Arts
Carpentras, Musée de Carpentras
Chartres, Musée des Beaux-Arts
Compiègne, Musée National du
 Château
Dijon, Musée des Beaux-Arts
Dunkerque, Musée des Beaux-Arts
Grenoble, Musée de Grenoble
Lyon, Musée des Beaux-Arts
Marseille, Musée des Beaux-Arts
Montauban, Musée Ingres
Montpellier, Musée Fabre
Morlaix, Musée des Jacobins
Moulins, Musée d'Art et
 d'Archéologie
Nantes, Musée des Beaux-Arts
Nice, Musée des Beaux-Arts
Orléans, Musée des Beaux-Arts
Paris, Musée d'Orsay
Paris, Musée de l'Orangerie
Paris, Ministère de la Culture et de
 la Francophonie, Fonds National
 d'Art Contemporain
Rouen, Musée des Beaux-Arts

Saint-Lô, Musée des Beaux-Arts
Toulon, Musée de Toulon
Troyes, Musée des Beaux-Arts
The Netherlands
The Hague, H. W. Mesdag Museum
Otterlo, Kröller-Müller Museum
Rotterdam, Museum Boymans-van
 Beuningen
Norway
Oslo, Nasjonalgalleriet
Switzerland
Zürich, Walter Feilchenfeldt
The United Kingdom
Birmingham Museums and Art
 Gallery
Edinburgh, National Gallery of
 Scotland
Glasgow Museums: Art Gallery &
 Museum, Kelvingrove
Ipswich Borough Council
 Museums and Galleries
Leeds Museums and Galleries
 (City Art Gallery)
London, Courtauld Institute
 Galleries
London, The Trustees of The
 National Gallery
London, Tate Gallery
Newcastle upon Tyne, Laing Art
 Gallery (Tyne and Wear Museums)
Southampton City Art Gallery
The United States of America
Baltimore, The Walters Art Gallery
Boston, Museum of Fine Arts
Brooklyn, The Brooklyn Museum
Buffalo, New York, Albright-
 Knox Art Gallery
Chicago, The Art Institute of
 Chicago
Chicago, Terra Foundation
 for the Arts
Columbus Museum of Art, Ohio

Dallas Museum of Art
Malibu, The J. Paul Getty Museum
New Haven, Yale University Art
 Gallery
New York, The Metropolitan
 Museum of Art
Northampton, Massachusetts,
 Smith College Museum of Art
Philadelphia Museum of Art
Portland Art Museum, Oregon
Santa Barbara Museum of Art
Springfield, Massachusetts,
 Museum of Fine Arts
Toledo, Ohio, The Toledo Museum
 of Art
Washington, Board of Trustees,
 National Gallery of Art
Washington, The Corcoran Gallery
 of Art
Williamstown, Massachusetts, Sterling
 and Francine Clark Art Institute

and private collectors who have
wished to remain anonymous.
*In some cases the loans are
'en dépôt de l'Etat'.

Foreword

This exhibition originated in an earlier collaboration between our two institutions – the great Renoir exhibition in 1985, which was also shared with the Réunion des Musées Nationaux in Paris. *Renoir* was curated, on the British side, by Dr John House of the Courtauld Institute of Art in London. Some time after that exhibition we began to talk with John House about another project. Almost immediately, he hit upon the idea of mounting an exhibition about landscape painting in France in the later nineteenth century, which would attempt, for the first time, to place Impressionism in its contemporary context.

We should like to acknowledge with gratitude the fact that John House is in effect the 'onlie begetter' of this exhibition. He has developed his project with considerable independence, whilst benefiting at all times from the advice and guidance of colleagues in the Department of European Paintings of the Museum of Fine Arts, Boston; especially Peter Sutton, the Mrs Russell W. Baker Curator until 1994, and subsequently Eric Zafran, Acting Curator until March of this year; and throughout with Robert Boardingham, Assistant Curator and the Department's specialist in this area. All have helped with the academic work on the exhibition and have given invaluable advice on the many aspects of its realization.

John House has been ably assisted in his research for the exhibition by the art historian Ann Dumas, who is also a contributor to this catalogue. We are grateful to her and to our other authors, Jane Mayo Roos and James F. McMillan, as well as to John House for his formidable essay and entries. We should also like to thank our editor, Joanna Skipwith, who became an essential member of the team in the later stages.

We are greatly indebted to Andrew Dempsey, Associate Curator at the Hayward Gallery, who has organized the exhibition in collaboration with Désirée Caldwell and Joshua Basseches, formerly of the Museum of Fine Arts, Boston; and to Julia Coates, Assistant Exhibition Organiser at the South Bank Centre, who has been at the heart of the complex administration involved in this major international enterprise.

As always we owe an enormous amount to our lenders. Responses to our loan requests have been magnificent. We offer our private collectors and fellow museum directors our most heartfelt thanks for agreeing to lend works that, in many cases, have pride of place on their walls. We hope that a lively interest in our project will provide some recompense for their sacrifice. John House is particularly indebted to those curators who generously spared time to show him their collections. Their help and enthusiasm contributed greatly to the formulation of the project and the selection of works.

We are especially grateful to the Réunion des Musées Nationaux and the Inspection Générale des Musées de France, and through them, to the many national and regional museums of France which have collaborated with our team of francophile scholars on both sides of the Atlantic.

Henry Meyric Hughes
Director of Exhibitions, Hayward Gallery
South Bank Centre

Malcolm Rogers
Ann and Graham Gund Director
Museum of Fine Arts, Boston

Sponsors' foreword

Fleet Financial Group and Shawmut National Corporation are pleased to sponsor the presentation of *Impressions of France: Monet, Renoir, Pissarro, and their Rivals* at the Museum of Fine Arts, Boston. Boston is the only United States venue for this exciting exhibition, organized by the Museum and the South Bank Centre, London.

The works gathered here provide an opportunity to see the differing interpretations of the French landscape by Impressionist painters and by painters from the Paris Salon. This is the first time the subject has been explored in any exhibition.

We are delighted to make this unique opportunity available to New Englanders and to those who visit from other regions and countries. We hope that many people will come, enjoy, and learn from it.

Our joint sponsorship of this exhibition is in part a celebration of the proposed merger of our two institutions and the planned relocation of Fleet's corporate headquarters to Boston. Both the merger and our sponsorship reflect our ongoing commitment to the people of New England.

We are also pleased to celebrate the 125th Anniversary of Boston's Museum of Fine Arts. We believe all New Englanders should take great pride in the Museum, one of the world's most outstanding cultural institutions.

In the spirit of celebration, we welcome viewers to share this wonderful exhibition.

Terrence Murray
Chairman
Fleet Financial Group

Joel B. Alvord
Chairman
Shawmut National Corporation

Introduction

John House

French Impressionism remains one of the most popular and immediately recognisable styles of painting. Yet it is usually viewed in isolation, and is seen as one of the succession of movements that constitute 'modern art'. Although historians have recently begun to place Impressionism in wider contexts and to examine the French art world of the later nineteenth century in broader terms, exhibitions have continued to emphasise Impressionism's independence.

Two major shows in the mid 1980s looked afresh at the movement, but both included only Impressionist paintings. *A Day in the Country*, shown in Los Angeles, Chicago and Paris, focused on the subject matter the artists depicted but did not explore what other, non-Impressionist, artists were making of the same themes at the same time. *The New Painting*, shown in Washington and San Francisco, looked at the Impressionist group exhibitions – the institutional framework for their activities – yet without examining the key institution against which the Impressionists were reacting: the Paris Salon. Recently *Origins of Impressionism*, seen in Paris and New York, began with a group of paintings from the Salon of 1859 but thereafter confined itself to paintings that showed affiliations with the work of the future Impressionists. And although *Monet to Matisse*, mounted in Edinburgh in 1994, explored key themes in landscape painting of the period, it did not address the contexts for which the paintings were originally intended.

Impressions of France places the Salon at centre stage. The huge Salon exhibitions were the central forum for the display of contemporary art in Paris, and the focus for discussions of the state of modern art. Traditionally landscape had been regarded as a minor type of painting, but it had become enormously popular in France by the 1860s, and its position in contemporary art was much debated: what subjects should landscape paintings depict, and how should they be treated?

The initial responses to the Impressionists' exhibitions were conditioned by these debates and by the contrasts between their work and the landscapes shown at the Salon. Yet these Salon landscapes have never been explored; most are by artists who find no place in the histories of the period, and many have not been on public display for years. A crucial part of French nineteenth-century landscape painting has been invisible.

Impressions of France traces the development of Salon landscapes and Impressionist landscapes from 1860 to 1890. The few pictures that the members of the Impressionist group produced for the Salon are included with the other Salon paintings, since they were designed to be seen on its densely hung walls.

During the thirty years covered by this exhibition there were dramatic developments in the French art world, as in the country's political and social life. State art policy changed throughout the period, and there were major shifts in the position of artists working outside the Salon. Up to the outbreak of the Franco-Prussian War and the fall of Emperor Napoleon III in 1870, during the so-called 'liberal' phase of the Second Empire, there was much technical experimentation in Salon landscape. The State bought a wide range of paintings for France's museums and public buildings, including some of the boldest Salon landscapes. But this experimentation involved primarily the ways in which the landscapes were presented and executed; their subject matter remained conventional, focusing on the distinctive sites of rural France.

In the later 1860s the Impressionists-to-be developed a small-scale, calculatedly informal type of landscape, often unpicturesque by contemporary standards and of an explicitly modern subject. The Impressionists developed and accentuated these characteristics in the 1870s. In addition, they exhibited many landscapes that were startlingly lightly worked and seemingly unfinished.

In contrast with the shock caused by the Impressionist landscapes of the mid 1870s, the Salon became more conservative. In the wake of France's defeat in the Franco-Prussian War and the events of the Paris Commune, the early years of the Third Republic witnessed an attempt by the State to reinstate a time-honoured notion of history painting. Reversing its policy of the 1860s, the State purchased very few landscapes in the mid 1870s, and those it did were markedly traditional, even neo-classical in style. However, the

position of landscape was transformed by the government changes of the late 1870s and the emergence of the 'opportunist' Republic. From 1879 onwards open-air painting was actively encouraged by the authorities, as were overtly contemporary subjects, and both were purchased by the State.

Simultaneously, in about 1880, several painters of the Impressionist group abandoned their unpicturesque contemporary subjects in favour of lavish views of dramatic and remote sites. Impressionist influence also began to be felt at the Salon; it remained controversial throughout the 1880s, but the cultural climate was clearly one of reconciliation – of amnesty for the artistic 'intransigents', as the Impressionists had been labelled, as well as for the former Communards. In 1888 the State bought its first Impressionist canvas: Sisley's *September Morning* (cat. 109). But on the whole the Impressionists rejected the possibilities offered by the Salon in favour of the pursuit of success through the dealer market.

The two sequences of paintings reveal how, during each phase of these thirty years, Impressionist works diverged from the dominant patterns of Salon landscape. The contrasts that emerge throw fresh light on the reasons why Impressionist painting was so controversial on first appearance, and suggest the changing implications of the 'independence' that the Impressionists claimed. The contrast is not merely between large paintings in the grand halls of the Salon and small paintings in the modest spaces in which the Impressionists exhibited. The two forums reflected a key issue in French painting of the period: the distinction between public and private.

The Salon was a vast public forum, and the pictures the State bought there were central to public culture; when displayed in museums across the country they played a significant role in defining French culture and the image of France itself. By contrast, the careers of the Impressionists marked the emergence of the 'private sector' in the art market. Alternative exhibition forums were found, and wealthy collectors were cultivated by dealers. By the 1890s it was the dealer market that helped Monet and Renoir to gain real success.

This exhibition presents paintings of French subjects but includes canvases shown at the Salon by non-French artists. In selecting the Salon paintings we decided to include only paintings that were displayed at the Salon, rather than different or smaller works by the same artists. As Salon landscape in these years had never been seriously explored, it seemed best, in the early stages of planning, to select paintings that most closely reflected the patterns of State support in these years. However, it soon became clear that some of these did not fulfil other important criteria: the paintings had to suggest the range of options open to landscapists at the Salon and the types of pictures the State was prepared to buy – but they also had to appeal to a 1995 audience. We therefore adopted a more personal and intuitive approach, selecting paintings that we found splendid and fascinating.

The State gave consistent support to some painters, whose works, to late-twentieth-century eyes, seem routine and repetitive, and they do not appear in this exhibition. Likewise it includes few of the forest interiors influenced by the 'Barbizon School' which, numerically at least, had a dominant place on the Salon walls. Other omissions are, inevitably, the result of the physical fragility of the paintings – notably the most spectacular of Courbet's and Daubigny's Salon landscapes.

In selecting the Impressionist paintings we have chosen canvases that demonstrate the widest range of different approaches to landscape. We have avoided the stereotype vision of Impressionism as an art devoted to sunny rivers and fields, and have instead sought to reveal the painters' explorations of unexpected sites and unexpected ways of viewing their subjects.

Comparison with the Salon reveals Impressionist landscape, particularly during the 1870s, to have been more challenging and more subversive than has previously been acknowledged. But the Salon paintings are not included merely as a foil to a reappraisal of Impressionism. They are presented as works of great conviction and authority in their own right, works that are central to the understanding of French art and French history in the later nineteenth century.

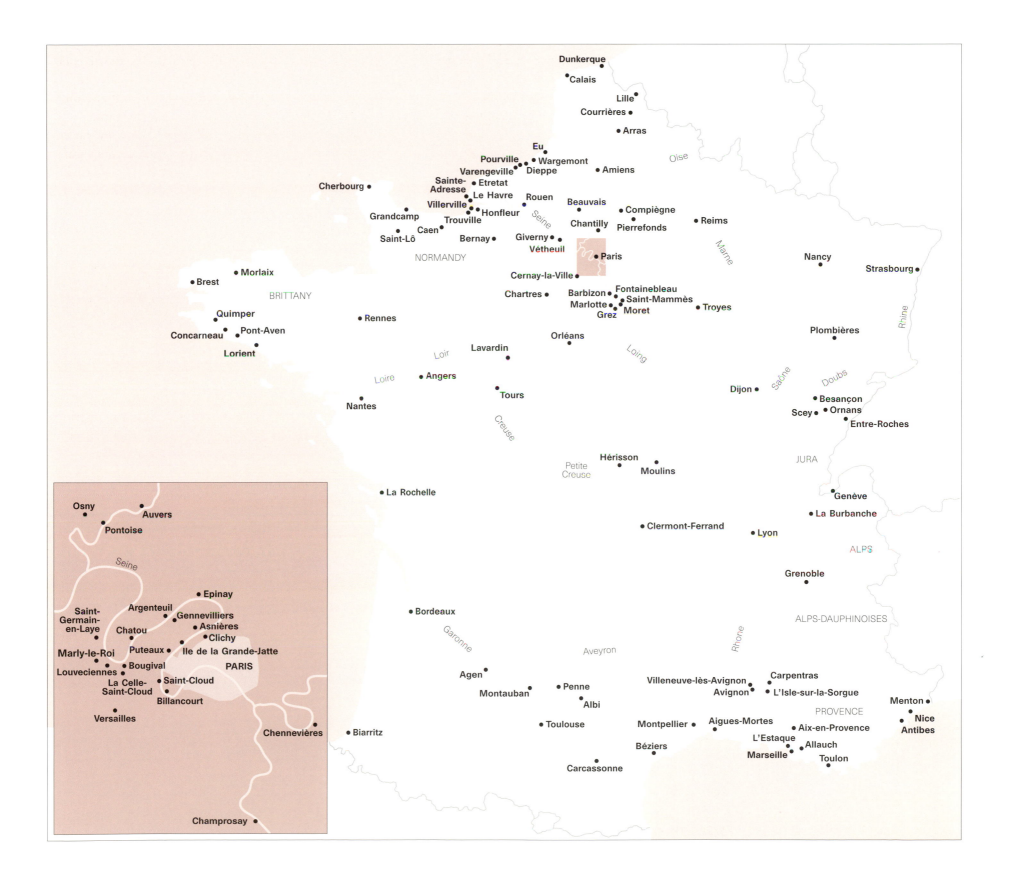

Dunkerque
Calais
Lille
Courrières
Arras
Eu
Pourville
Wargemont
Varengeville
Dieppe
Amiens
Sainte-
Adresse
Etretat
Cherbourg
Villerville
Le Havre
Rouen
Beauvais
Compiègne
Reims
Grandcamp
Honfleur
Seine
Chantilly
Pierrefonds
Trouville
Caen
Giverny
Saint-Lô
Bernay
Vétheuil
Paris
NORMANDY
Nancy
Strasbourg
Cernay-la-Ville
Morlaix
Chartres
Barbizon
Fontainebleau
Brest
Marlotte
Saint-Mammès
BRITTANY
Grez
Troyes
Moret
Rhine
Quimper
Rennes
Plombières
Concarneau
Pont-Aven
Loir
Lavardin
Orléans
Loing
Lorient
Loire
Angers
Saône
Doubs
Tours
Dijon
Besançon
Nantes
Scey
Ornans
Creuse
Entre-Roches
Hérisson
JURA
Petite
Creuse
Moulins
Osny
Auvers
La Rochelle
Genève
Pontoise
La Burbanche
Seine
Clermont-Ferrand
Lyon
ALPS
Epinay
Grenoble
Saint-
Germain-
en-Laye
Argenteuil
Gennevilliers
Asnières
Bordeaux
ALPS-DAUPHINOISES
Chatou
Clichy
Garonne
Puteaux
Ile de la Grande-Jatte
Aveyron
Rhône
Marly-le-Roi
PARIS
Bougival
Agen
Carpentras
Louveciennes
Saint-Cloud
Villeneuve-lès-Avignon
La Celle-
Saint-Cloud
Montauban
Penne
Avignon
L'Isle-sur-la-Sorgue
Billancourt
Albi
Menton
Versailles
Toulouse
Montpellier
Aigues-Mortes
PROVENCE
Nice
Chenneviéres
Biarritz
Béziers
Aix-en-Provence
Antibes
L'Estaque
Allauch
Carcassonne
Marseille
Toulon
Champrosay

Framing the landscape

John House

The French word *paysage*, like the word landscape, refers to two things: the visual representation of an outdoor scene and the scene itself. In writings about landscape painting in nineteenth-century France these two meanings were often deliberately merged. When discussing the landscapes exhibited at the Paris Salon, critics would write as if the paintings had transported them from the exhibition halls into the open air:

The critic feels a sense of joy and refreshment when, having examined the history paintings, the mythologies, the sentimental scenes and the portraits, he sees, in the middle of his voyage through the exhibition, these green meadows, these deep woods, these solitary valleys where the landscapists allow him to stroll and to breathe at leisure.[1]

The experience of landscape in France in the later nineteenth century was rooted in these ambiguities: paintings viewed as if they were actual scenes, and the countryside viewed as if it were a picture. Yet many commentators were worried by this, arguing that the higher aims of fine art could not be fulfilled by paintings that they saw as mere portraits of particular places.

The 'Landscape'

What is a landscape painting? The standard nineteenth-century answer was that it was a view of the countryside without figures in it, or one where they played a subordinate role.[2] However, the place of figures in the landscape was more than a question of classification. In 1864 the critic Léon Lagrange explained why he preferred landscapes without figures: '... reduced to its very own elements, nature still speaks to anyone who wishes to listen to it in a language full of elevation. The absence of man seems to lend nature's voice yet more resonance.'[3] In 1861 Maxime du Camp was still more explicit about why he wanted to cleanse the landscape of its human occupants:

The painters of landscapes and marines do not generally realise how much they harm their pictures by loading them with useless little people. What one loves in the forests, in the meadows, by the edge of the sea, is the absolute solitude which allows one to be in direct communion with nature; if a peasant or a sailor appears, the spell is broken, and one is grasped again by the humanity that one had wanted to escape; what is true in reality is also true in fiction; a landscape only has grandeur if it is uninhabited ...[4]

This is 'nature' stripped of signs of human life and labour, presented as a spectacle for solitary contemplation.

Du Camp's comments show that the notion of landscape itself, like that of landscape painting, is not simply a question of subject matter, but involves a particular way of seeing – one that views the outdoor scene as a landscape. The 'landscape' itself, as W. J. T. Mitchell has recently insisted, is 'already a representation in its own right'.[5] Du Camp's wish to banish the figure was an attempt to defuse the threat of other, potentially potent, ways of seeing the countryside. The distinction appears most starkly in a passage by the American writer Ralph Waldo Emerson (1836):

The charming landscape which I saw this morning, is indubitably made up of some twenty or thirty farms. Miller owns this field, Locke that, and Manning the woodland beyond. But none of them owns the landscape. There is a property in the horizon which no man has but he whose eye can integrate all the parts, that is, the poet. This is the best part of these men's farms, yet to this their warranty-deeds give no title ... you cannot freely admire a noble landscape, if laborers are digging in the field hard by.[6]

Of the landscapes in the present exhibition that were first shown at the Salon, only Millet's (cat. 12) attempts to bridge this division between 'landscape' and the owned, worked countryside; Monet wittily played on the contrast between the two in *The Beach at Sainte-Adresse* (fig. 1), where the fishermen in the foreground turn their backs on the 'landscape' that we and the bourgeois couple on the beach (the man with his telescope) are looking at.

Through the elimination or subordination of the figure, the landscape sought to distance itself from contemporary social issues. Yet, amid the dramatic social and political transformations of the period, the position of landscape painting was inevitably scrutinised within wider contexts. A central issue was the contrast between the image of the rural landscape and the modern city. Art critics repeatedly speculated on the reasons for the popularity of landscape. Whatever their

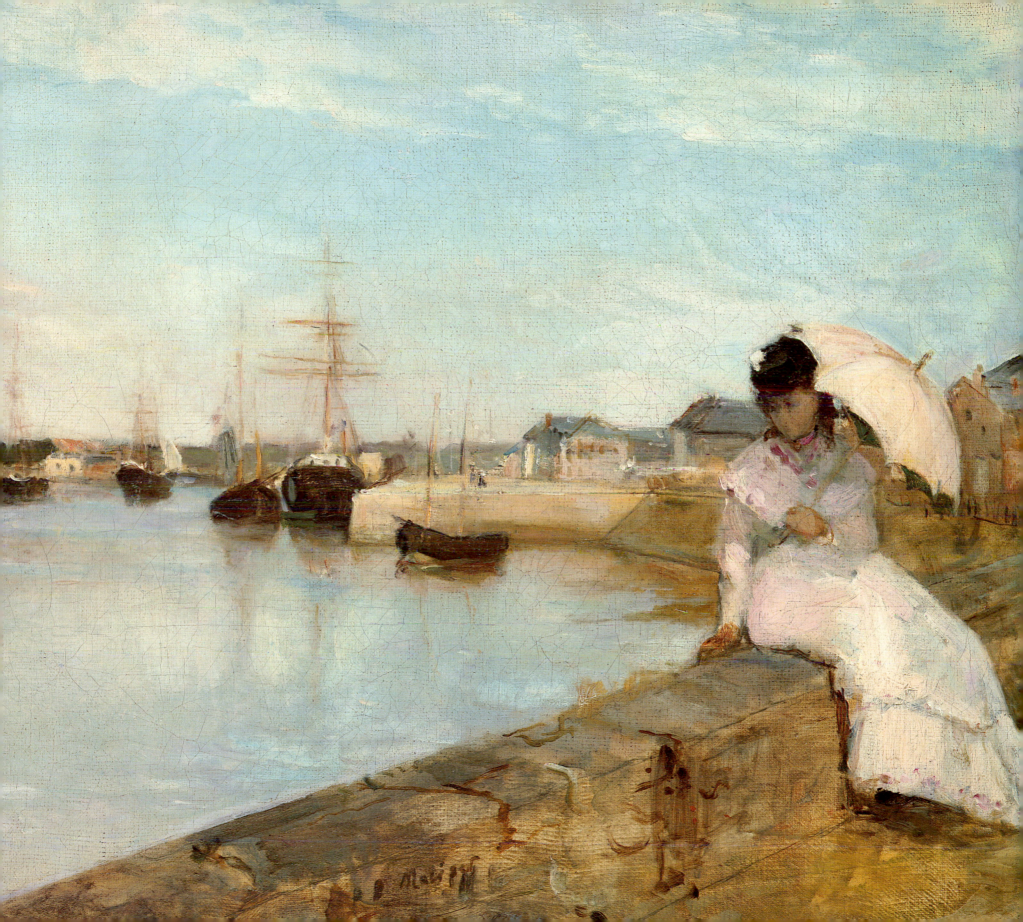

1. Mantz 1863, pp. 36–7.
2. For instance Houssaye 1882, p. 861.
3. Lagrange 1864, pp. 6, 9.
4. Du Camp 1861, pp. 145–6.
5. Mitchell 1994, pp. 14–15.
6. R. W. Emerson, 'Nature', in *The Collected Works of Ralph Waldo Emerson, Volume I: Nature, Addresses and Lectures*, Cambridge, Mass., 1971, pp. 9, 39, quoted in Mitchell 1994, pp. 13–15.
7. For a key discussion of these issues, in the context of English literature, see Williams 1975.
8. The local lines were a central part of the Freycinet Plan, launched in 1878. Français's *Valley of the Eaugronne* (cat. 54) was a response to this process. On the Freycinet Plan, see Weber 1977, pp. 209–11.
9. Nodier 1820, pp. 1–5; on the *Voyages pittoresques* in relation to the development of the imagery of France in the nineteenth century, see especially Grad and Riggs 1982.
10. Nodier 1820, pp. 7–8.
11. Hugo 1835, dedication to subscribers and p. 1. Abel Hugo was the brother of Victor.
12. Green 1990, pp. 80ff.
13. See Buzard 1993, pp. 3–10.
14. See Herbert 1994, pp. 2–4; Culler 1988, pp. 156–9.
15. De Beauvoir 1841, p. 219; Hippolyte Taine presented a very similar account of the various types of tourists in *Voyage aux Pyrénées*, Paris, 1858 (1897 edition, pp. 281–90).

analysis of contemporary art and society, one theme recurred: the love of landscape was seen in opposition to the experience of modern urban life – as a refuge from its mental and physical pressures.[7]

By the later nineteenth century landscape was essentially an urban art form. It was exhibited and sold in cities, primarily in Paris. In contrast to eighteenth-century England, few of the viewers and buyers of landscape in nineteenth-century Paris belonged to the rural landowning classes, and few would have had first-hand experience of the changing conditions in the countryside. Their idea of landscape stood in contrast to their own experiences of life in the city. Countryside and 'landscape' were commodities that could be consumed in many forms: through antiquarian and geographical treatises; through popular magazines and novels; through topographical prints and exhibition paintings; and through actual travel and tourism.

Viewing the Landscape

There were two stages in the development of interest in the French countryside in the nineteenth century. From the 1820s onwards, the country's picturesque sites and monuments began to be visited and studied, and guidebooks began to popularise their beauties. Later in the century the horizons opened further as travel was transformed by the development of the railway. The *grandes lignes* from Paris to the main French cities were mostly completed by the mid 1850s; a web of local lines that linked even remote regions to the national network were built from the 1880s on.[8]

The study of provincial France was pioneered by the volumes of *Voyages pittoresques et romantiques dans l'ancienne France* from 1820 onwards. In the first volume, on Normandy, Charles Nodier insisted on the national significance of France's monuments, not only as objects of beauty, but also as salutary reminders of the imprint of French history. His was not a work of antiquarianism but rather 'a voyage of impressions, if one may describe it like this'.[9] Nodier recognised that the 'superb countryside' might appeal to the landscapist, but the Normandy volume focused on historical monuments because it was the monuments that were

then at risk from destruction; the countryside would remain for future generations to enjoy and paint.[10] By the end of the century Nodier's priorities had been reversed. For the most part the monuments were safe, but the countryside was now at risk from modernisation and agricultural decline.

In contrast to the lavish volumes of the *Voyages pittoresques*, Abel Hugo's *France pittoresque* of 1835 surveyed the whole country in one dense tome. The purpose of the book was blatantly nationalistic, insisting that France was as worthy of study as foreign countries such as Italy that had, until then, been favoured by travellers and painters: 'France contains all the riches of nature, combined with the treasures of intelligence and industry ... France, by its position, by its nature and by the character of its inhabitants, is the land of civilisation.'[11] The book's many illustrations include both monuments and natural sites.

Books such as these mark the beginnings of a type of travel not confined to the pre-Revolutionary elite of the Grand Tour, but in principle accessible to a wider range of the middle classes. Nicholas Green has noted a shift during these same years to a new style of writing about travel: away from a primary concern with literary and philosophical associations, and towards a 'nature tourism' that focused on the sensory experience of the sites themselves.[12] This new conception of travel, Green argues, was inseparable from changing perceptions of Paris: fears of the city's infected old quarters and anxieties about its burgeoning boulevard consumer culture. However, historical monuments remained a central focus in travel writing and for travel itself throughout the century, and accounts of any site might expound on its historical associations (see cat. 79).

The nineteenth century saw the emergence of a key distinction in the history of modern travel: between the tourist and the traveller. Travellers see themselves as solitary, independent, free-ranging and fascinated by the unknown, while tourists stick in groups and follow prescribed paths, seeking only what can be accommodated within familiar frameworks. We all like to think of ourselves as travellers, while

Fig. 1
Claude Monet
The Beach at Sainte-Adresse, 1867
75.8 × 102.5 (29⅞ × 40⅜)
The Art Institute of Chicago

Fig. 2
Eugène Le Poittevin
Sea Bathing at Etretat, 1866, exhibited at
the Salon of 1866, 66.5 × 152 (26⅛ × 59⅞)
Musée des Beaux-Arts, Troyes

dismissing our fellow travellers as mere tourists.

However, self-styled travellers are also outsiders, engaging with the 'Other'; they may better be labelled 'anti-tourists', since the uniqueness and authenticity they claim for their own experiences are the direct opposite of what they reject in 'tourism'.[13] Likewise, the claim to independence does not necessarily entail travelling independently. Even when travelling in groups, they may seek to separate themselves from the shared experience; and the tourist may momentarily assume the position of traveller. The advertising for package tours today makes much of the possibility of the unique, 'authentic' experience that may be found just off the beaten track.[14]

The same distinctions were central to landscape painting. The landscape painter presented himself as the ultimate 'anti-tourist', travelling alone in search of sites and understanding them in a way that no one else could; yet the painter encountered the landscape as an outsider, and the painted landscapes were viewed and judged in the city.

In the nineteenth century the term 'tourist' was not necessarily used pejoratively: in 1838 Stendhal entitled his volume of travels around France *Mémoires d'un touriste*. But, even before the age of rail, 'tourist' was used to designate the visitor who focused on the superficial attractions of a place. The stereotypes were already in place in 1841, in Roger de Beauvoir's essay on the tourist in the series *Les Français peints par eux-mêmes*: tourists travel only to confirm their preconceptions, while the writer sets himself apart, since he alone is able to see beyond the tourists around him to appreciate the *paysage*.[15] This process was accelerated by the railway, which created a new class of traveller whose experiences literally followed a rigid, immovable track; contemporary guidebooks likewise followed the paths of the railway.

The same years witnessed the rapid development of the holiday resort and of travel not for exploration but for rest and recreation. Even before the railway reached the Channel Coast, resorts such as Etretat and Trouville were becoming popular, but the arrival of the train gave easy access to fashionable Parisians; it was this beach life that formed the subject of Eugène Le Poittevin's

16. On Trouville and Boudin, see Hamilton 1992; for a description of Trouville and its tourist potential just before the arrival of the railways, see Chapus 1862, pp. 272–89.

17. Green 1990, pp. 84–9 and note 71 on p. 196.

18. The urban fantasy of the *maison de campagne* was parodied by Frédéric Soulié in 1841 in *Les Français peints par eux-mêmes*, contrasting the dream of a rural idyll of cheap, healthy, natural living with the likely inconveniences and frustrations that such a house would bring (Soulié 1841, pp. 25–32).

19. For example the periodicals *L'Illustration* (1843+), *Le Monde illustré* (1857+) and *Le Tour du monde* (1860+).

20. Michelet 1861; Michelet 1868.

21. For valuable discussions of these issues, see Mitchell 1994, pp. 16–18; and Urry 1990, pp. 7–14, 41–7. See also R. Barthes, 'The *Blue Guide*', in Barthes 1972.

22. In this discussion I use the male personal pronoun; ambitious landscape painting in oils was overwhelmingly a male-dominated profession in these years. However, see Elodie La Villette (cat. 50) and Berthe Morisot (cats. 61, 66, 80).

23. Thoré 1870, I, p. 293, reviewing the London International Exhibition of 1862.

24. Guérin 1945, p. 23.

25. Sensier 1870, p. 376.

26. On Sensier and Millet, see Parsons and McWilliam 1983.

Sea Bathing at Etretat (fig. 2) and Eugène Boudin's most celebrated paintings.[16]

The train also brought the day tripper, even lowlier than the tourist in esteem. The stereotype of the day tripper was the worker, artisan or petit bourgeois, either exploring the pleasures and entertainments of the city's fringes, or pursuing a naïve and uninformed notion of 'nature' and the countryside.

Apart from tourism, there were other reasons why city dwellers might travel to the French countryside. Many Parisians had migrated from the provinces or were the children of migrants, retaining a sense of their *pays* and ties with their relatives there. The wealthier might own substantial country properties and farms that were worked by tenants. These groups all differed from the tourist in one way: they had a stake in a particular place.

The same is true of the city dwellers who owned or rented a *maison de campagne*. By the 1840s, as Nicholas Green has argued, this was used primarily as a rural refuge, though it also needed to be within easy reach of Paris.[17] This combination of retreat with access shows again how inseparable the experience of countryside and landscape was from the city and the concerns of urban living.[18] In this respect the position of the landscapist who regularly painted a single area was very similar to that of the owner of a *maison de campagne*; although he had a stake in the place, his vision of it, and the paintings he produced there, were geared not towards the local community but to the interests of the Parisian public.

The new modes of travel were accompanied by changes in the ways in which travel and remote places were promoted in Paris. The mass of illustrated material that became available from the 1840s onwards, in guidebooks and magazines, offered a vast range of information to the prospective traveller and the armchair tourist.[19] Many other types of publication also discussed the countryside and the French provinces. Ideas of 'nature' were central to contemporary religious, philosophical and scientific discussions. Today we tend to see these as specialised types of writing, but in mid-nineteenth-century France there were no such boundaries. Semi-specialist essays on geology and metaphysics might appear in periodicals and popular series of books designed for a general educated audience; and celebrated authors such as Jules Michelet published successful books on themes like the sea and the mountain, which offered a hybrid synthesis of philosophy, geology, natural history and sociology.[20]

There has been much discussion of how to characterise the engagement of tourists and travellers with the sites they visit. The physical access to unfamiliar places and the tourist 'gaze' have often been described in terms of the predator or of penetration, implying some sense of invasion and violation. However, this model is not always applicable. The package tourist generally encounters the 'Other' pre-packaged: the tourist industry itself may irreversibly alter the cultural patterns of the places it colonises, but the tourist is protected from the disorientation of the truly 'Other'. Even the solo traveller in France is invited to follow certain tracks – no longer the train tracks of the nineteenth-century Joanne guides, but the recommended sites and itineraries of the green Michelin guides, with their carefully indicated starred viewpoints.

Travellers engage with what they see in different ways. Someone seeking to buy a *maison de campagne* will view places differently from a group following a Michelin itinerary.[21] Among these ways of seeing is the one that views a place as 'landscape'. Although the process of finding a prospect, of seeking out a viewpoint for a landscape, may be an intrusion, the landscape 'gaze' itself claims not to be invasive, since it depends on a process of distancing and framing. In a broader sense, the 'landscape' view of nature is not about the site itself, but about the image that is made of it, whether a memory, a photograph, a verbal description or a painting.

The Painter in the Landscape

Landscape painting was viewed in terms of both art and nature. It was judged in relation to its subject – for the significance of the subject itself and for its apparent truthfulness – but it also had to justify itself as fine art. The history of nineteenth-century landscape painting is the history of successive attempts to reconcile these

Fig. 3

Fig. 4

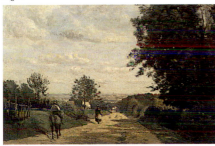

Fig. 3
Jean-Baptiste-Camille Corot
Souvenir of Italy, 1873, exhibited at
the Salon of 1873
172.7 × 144.4 (68 × 56⅞)
Glasgow Museums: Art Gallery & Museum,
Kelvingrove

Fig. 4
Jean-Baptiste-Camille Corot
The Sèvres Road, c. 1860
34 × 49 (13⅜ × 19¼)
Musée d'Orsay, Paris

apparently conflicting requirements.

The landscape painter was expected to have special insight into 'nature', particularly after the invention of photography, which superseded the purely reproductive function of landscape painting. But there was much disagreement about what the landscapist's involvement in his subject should be.[22] Was the artist's vision justified by some generalised notion of 'truth to nature' that had little to do with the particular site, or was truth more specific, more local? And if so, how might the landscapist claim special insight into that place?

Jean-Baptiste-Camille Corot was consistently praised in the years after 1860 as a painter who understood the 'truths of nature'. Yet his paintings ranged from artificial pastorals such as *Souvenir of Italy* (fig. 3), through more informal images of particular places – sometimes but not always entitled *souvenir* (fig. 19) – to small studies, often executed in front of the subject (fig. 4). But whatever site he treated, whether an Italian lake or a corner of northern France, his art tended to be discussed in terms of mood, reverie and poetry (see cat. 25).

In general, though, landscapists were expected to engage more directly with their subjects. In 1862 Théophile Thoré spelt out his requirements for a true landscapist:

The true artist is an indissoluble fusion of nature and humanity, a visionary and a thinker at the same time ... [such artists] see what they need to see, experience a corresponding impression of it, and then translate it without any other concern. I have lived with them in the woods, often with Rousseau for example, and the man interested me as much as the painter: his heart was always involved, and his eye, too; his hand followed. When the whole man is absorbed like this in his work, when he lives in it and makes it live within him, it is not surprising that his work has expressive virtues.[23]

In part, Théodore Rousseau's vision is here justified by his personality: by the unity of heart, eye and hand. In part, the justification is external: Rousseau lives where he paints, in the Forest of Fontainebleau (see fig. 5), and Thoré has witnessed his immersion in it.

Such testimonies recurred throughout the period, and played a significant part in the attempts of painters

to distinguish themselves from photographers. In 1872, writing from New Orleans to a friend, Edgar Degas explained why he was painting so little there: 'One can't just arrive in Louisiana and make art as easily as one can in Paris; that would be just like *Le Monde illustré*. It's only a long stay that can reveal to you the habits of a race, that is to say its charm. The instantaneous is photography, nothing more.'[24]

Yet even an extended period of familiarisation might not be considered enough. For Alfred Sensier, writing in 1870, the painter's birthplace was all-important:

A continual source of trouble, doubt and despair for our contemporary artists is the imbalance that has led them to be born in Paris, in Lyon or in Marseille, and has made them children of an unreasonable and pernicious atmosphere, and has led them to a love of nature through their loathing for cities. Their childhood impressions have not been frank, simple and 'animal', and they always feel themselves embarrassed by the thorns of the rustic soil ... Throughout his life Rousseau expiated the misfortune of being born in the Place des Victoires; nothing has been able to free him from the doubts of his vision, his timidity as a painter and the profusion of his invention.[25]

Sensier's was an extreme position, and a form of special pleading on behalf of Jean-François Millet.[26] Yet the links between a painter's birthplace and the paintings he produced were more complex than Sensier's account implies. Although Millet exhibited one landscape of his birthplace on the Normandy coast at the Salon (cat. 12), his reputation as a 'peasant painter' was founded on his paintings of the Barbizon region near the Fontainebleau Forest where he lived and worked (see fig. 31). Moreover, Sensier's arguments obscure the fact that Millet's paintings, and the accounts he propagated of his origins, were designed for a Parisian audience; his images of rural life found their meanings in urban culture.

The issue of the relationship between the landscapist and the peasant population recurred for Camille Pissarro in 1892. The anarchist theorist Kropotkin had argued in *La Conquête du pain* that only someone who had lived as a peasant could paint peasants truthfully and without sentimentality. Pissarro responded: 'Certainly one must be involved in one's subject in

27. Letter from Pissarro to Octave Mirbeau, 21 April 1892, in Bailly-Herzberg, III, 1988, p. 217.
28. See House 1986, pp. 137, 140–1.
29. On his working practices, see House 1986, pp. 135–56.
30. De Maupassant 1886; de Maupassant described watching Corot, Courbet (see fig. 21) and, most recently, Monet, painting at Etretat on the Normandy coast.
31. Henriet 1876, pp. 19, 23, 25ff, 48–9 (all reprinted from his 1867 essay).
32. Henriet 1876, pp. 105–7, from the section added in 1876.
33. For a useful anecdotal history of artists' colonies, see Jacobs 1985.
34. Letter from Monet to Bazille, December 1868, in Wildenstein 1974, pp. 425–6.
35. Green 1990, pp. 167–81; on Rousseau's reaction, see pp. 118–19, 179 and note 81 on p. 211.
36. Lenoir 1872, pp. 111–13.

order to render it well, but is it necessary to be a peasant? Let us, rather, be artists, and we will be able to experience everything, even a *paysage* without being *paysan*.'[27]

Another way by which artists might promote the authenticity of their knowledge was circulating stories of their heroics in immersing themselves in their subjects. Monet, in particular, used these tactics. In the winter of 1866–7 he ensured that a reporter saw him painting deep in a snowdrift near Honfleur; in the 1880s accounts reported him braving waves, gales and rain in order to paint the French coasts.[28] This image was confirmed by his paintings of extreme weather effects (see cats. 78, 94, 112), and by his sedulously propagated (and unjustified) reputation as a painter who only worked out of doors.[29]

Images emerged of the distinctive lifestyle of the landscapist, its principal feature being solitary contemplation. In 1886 Guy de Maupassant presented the landscapist out of doors from morning to evening, living by his eyes alone, seeking out the nuances of colour that the studio education of the Ecole denied him.[30] Frédéric Henriet, a close associate of Charles-François Daubigny, described the escape to the country of 'the landscapist who desires silence and solitude'. The artist reconnoitres for sites, seeking 'to penetrate the intimate meaning, the unique accent, the essential character of this nature ... whose secret he searches out', and stops to paint where instinct leads him. The painter is set apart both from the local peasants and farmers and from the bourgeois tourists: we see how little those who work the land understand the landscapist's art, and a mocking aside introduces the ladies of the village who encourage him to paint the most obvious picturesque sites in the area – 'a real little Switzerland'.[31]

Yet Henriet's book shows that, as for the tourist, Paris was the necessary repoussoir for the landscapist's retreat from the city:

[In the country] how far away Paris is! And what does the echo of the boulevard ... mean to him now that he has cut the mooring that tied him to real life in order to sail off into the true ideal! ... in these periods of work and contemplation ... I do not want to know about the controversies that divide men ...[32]

There is no sense here that the countryside might have its own 'real life'!

Daubigny's more down-to-earth vision of the landscapist's life made the links to Paris still more explicit. In his sequence of etchings entitled *Voyage en bateau* of 1862, a visual narrative of his travels in his studio boat along the rivers Seine and Oise, we see him painting in communion with nature (figs. 6, 7). He and his son fish in the river, eat and sleep in the local inns, but socialise with friends who have come down from Paris by train, not with the local children whom they watch from a safe distance. This is an image of urban bohemianism transported to the countryside.

The interdependence of city and country in the life of the landscapist emerges most vividly in the growing popularity of artists' colonies from the mid century onwards. Barbizon and other villages around the Fontainebleau Forest were the earliest and most celebrated of these (see cats. 13, 21); but in the later part of the century groups of painters congregated in the summer in many other villages: Grez-sur-Loing, on a river to the south of the Fontainebleau Forest (cats. 40, 42); Cernay-la-Ville, beyond Versailles to the south-west of Paris (cat. 27); and Pont-Aven in Brittany, made famous by Paul Gauguin, but a popular centre for American artists twenty years before he went there (cats. 37, 108).[33]

In such colonies painters could live cheaply and informally, and find a ready stock of subjects. The pattern of communal living – of transporting an artistic coterie from Paris for the summer – is closer to the 'tourist' model than to the 'traveller'. As the many reminiscences of life in these colonies reveal, the artists formed self-contained communities, preoccupied by artistic affiliations and rivalries, and above all by the effect that they would produce in Paris, through their paintings and the stories of their bohemian lifestyle.

The rival claims of solitude and communal discussion posed a real problem for the young landscapist seeking to establish his artistic identity. In December 1868 Monet wrote to Bazille from Etretat on the Normandy coast: 'In Paris one is too preoccupied by what one sees and what one hears, however strong one is; what I am doing

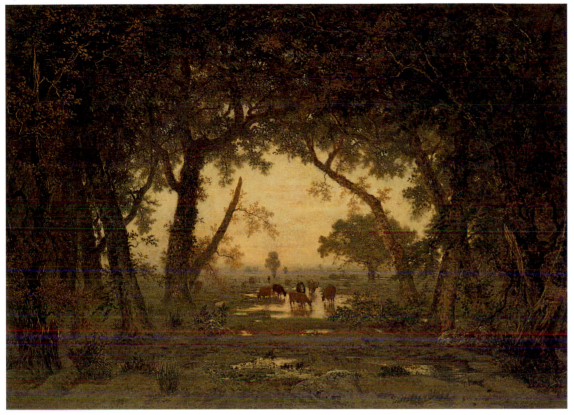

Fig. 5
Théodore Rousseau
The Forest of Fontainebleau, Morning, c. 1850,
exhibited at the Salon of 1850–1
97 × 132 (38⅛ × 52)
Wallace Collection, London

here has, I think, the merit of not resembling anyone, because it is simply the expression of what I myself have experienced.'[34] Yet, as Monet well knew, it was in Paris that this artistic identity would make its mark.

The artist occupied a special place between the tourist and those who worked the land. Like the tourist, the artist was an outsider who saw the countryside as landscape; but he also had 'inside knowledge', and his view of the landscape might be very different from that of the tourist. This emerges vividly in relation to Rousseau's vision of the Fontainebleau Forest (see fig. 5). While Rousseau was living there, Charles-François Denecourt was opening the forest out to visitors, publishing guidebooks and creating walks that offered the visitor an easy path and interesting viewpoints. In a sense, this allowed the forest to be seen as 'landscape'; but Rousseau and other painters opposed these developments, seeking to preserve its pristine wildness and to exclude the tourist hordes.[35]

As with the traveller and the tourist, the presence of the painter prospecting for sites in the countryside might be invasive, showing scant regard for property or local customs – as when the Orientalist painter Alexandre Lenoir hid behind a bush in Egypt to watch and sketch Muslim women bathing, and was stoned for his efforts.[36] But the landscapist's engagement with his subject was characterised in quite different terms in the nineteenth century. It was viewed as a solitary dialogue between painter and 'nature', and the painter might even be presented as a passive receptor and translator of nature's voice. Of course the terms in which this 'nature' and its 'voice' were understood were a far cry from the lived countryside and its social networks; the landscapist's identity and the 'nature' that spoke to him were an integral part of urban culture.

The Landscapist's Choices

When beginning a picture the landscapist had two important choices to make: his subject, and the way that subject should be presented on the canvas. The choice of subject may seem primary, but in practice it was the way in which it was structured that defined his position as an artist.

19

37. See Gombrich 1960.
38. For an important critique of Gombrich's position, see Mitchell 1986, pp. 75–94.
39. See Boime 1971, pp. 142–8.
40. About 1868, pp. 738–9; a very comparable account appears in de Montaiglon, July 1875, p. 20.
41. Lafenestre, 'Le Salon de 1872', in Lafenestre 1881, I, p. 292.

The neo-classical landscape of the early nineteenth century, looking back to the Italianate landscapes of Claude Lorrain and Poussin, offered the principal model against which landscape paintings were judged. The landscapes of the 'School of 1830', of artists such as Rousseau, Paul Huet (see cat. 17) and Jules Dupré, provided an alternative paradigm and alternative artistic models: the landscapes of seventeenth-century Holland. Corot's early Salon paintings reveal how readily each of these models could be assimilated and then discarded: a neo-classical Italian scene exhibited in 1827 was followed in 1833 by an emphatically Dutch view of the Forest of Fontainebleau.

Both models persisted throughout the century. The artifice of neo-classical landscape enjoyed a brief revival in the mid 1870s when the French State again bought the paintings of Paul Flandrin (cat. 28), but echoes of the neo-classical clarity of form and orderly spatial recession recur in works as dissimilar as Corot's late *souvenirs* (fig. 3) and the landscapes of Harpignies (cats. 26, 29). Likewise the more informal Dutch mode, fundamental to the forest scenes of Rousseau (fig. 5) and the river views of Daubigny (cat. 11, fig. 12), is echoed in the work of painters such as Léon Pelouse (cat. 27) and Antoine Guillemet (cat. 31).

E. H. Gombrich has viewed the key developments in western art in terms of schema and correction. While recognising the artifice of every pictorial representation, he has described the development of naturalistic modes of representation as a succession of moments when artists looked afresh at the world around them and used the evidence of their eyes to correct the formulae or schemata that they had inherited.[37]

At first sight the history of French nineteenth-century landscape fits this pattern well. The Dutch mode was initially regarded as a 'natural' corrective to the artifice of neo-classicism, but by the 1860s it was widely seen as belonging to a particular moment in history and taste; the emergence of Impressionism in the late 1860s and 1870s is generally viewed as a further, decisive step towards a 'natural' vision in art.

Any notion of naturalism, however, depends on cultural assumptions. There has never been a consensus about what constitutes naturalistic representation, even during the past two hundred years when something like our present-day notions of 'nature' have been current.[38] This emerges clearly in the contrast between our own culture's assumption that the Impressionist landscape is a particularly 'natural' form of painting, and the responses of Impressionism's first viewers, most of whom saw it as a travesty of their idea of 'nature' in art.

The issues of 'realism' and the 'natural' in painting were a central preoccupation in the 1860s and 1870s. The original critical responses to paintings, such as those quoted in the catalogue entries, reveal that many types of image could be regarded as natural or truthful in the later nineteenth century. Rather than seeing Impressionism as some sort of breakthrough, we find a range of competing conventions in landscape painting of the period, all vying with each other to be considered 'natural'.

Many different facets of a painting might make it appear 'natural': the composition, the choice of subject, the way in which the elements in the scene were rendered, and the facture adopted. In compositional terms, the idea of the 'natural' was best invoked by making the picture look as if it had not been 'composed' at all. Yet the structure of the painting depended on the artist's choice of viewpoint and on the way in which he framed the scene; he might also modify the forms before him (see cats. 31, 38, 100).

Seeking to rid themselves of both neo-classical and Dutch conventions, many landscapists adopted deliberately simplified structures, even in landscapes exhibited at the Salon. A perspective might run straight into the picture (see cats. 18, 35, 37). A scene might be viewed frontally, whether it was a slab of rocks (cat. 4) or an open meadow (cats. 38, 40); it might appear to continue uninterrupted beyond the frame of the picture (cats. 24, 43); or it might be viewed from an unexpected angle (cats. 13, 56).

The question of subject matter was central for the landscapist. The Prix de Rome for landscape painting, awarded at the Ecole des Beaux-Arts between 1817 and 1863, was explicitly for historic landscape – that is, for scenes including a historical or mythological scene

Fig. 6

Fig. 6

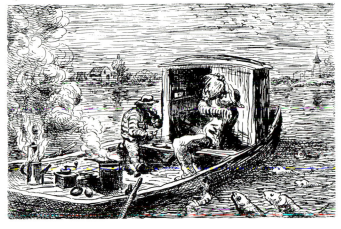

Fig. 6
Charles-François Daubigny
Gulping it down (Luncheon on the boat)
from *Voyage en bateau*, 1862
Lithograph, 10.6 × 16 (4⅛ × 6⅛)
Private Collection, London

Fig. 7
Charles-François Daubigny
Departure from *Voyage en bateau*, 1862
Lithograph, 10.2 × 15.8 (4 × 6 ¼)
Private Collection, London

Fig. 8
Paul-Albert Girard
The Procession of Silenus,
winner of the Prix de Rome for
Paysage historique in 1861
113 × 147 (44½ × 57⅞)
Ecole Nationale Supérieure des Beaux-Arts, Paris

Fig. 7

Fig. 8

(see fig. 8).[39] Though painters such as Français continued on occasion to treat such themes in their landscapes (see fig. 42, p. 124 and entries for cats. 1, 30), these requirements were widely seen as irrelevant to the types of landscape that developed after 1830.

However, the choice of subject remained crucial. The key question was the status of the *motif*. This was not simply a neutral designation of a picture's theme. A true motif was expected to be visually striking and to carry historical or poetic associations, and it needed to be presented in an ordered pictorial form. Views of historic sites or dramatic natural scenes most obviously fulfilled these prescriptions.

For conservative critics, the history of French nineteenth-century landscape was the story of the decline of the motif. In 1868 Edmond About contrasted past with current methods. Traditionally the artist had composed his subject from a repertory of elements:

Forests, rocks, shorelines, valleys, flocks, palaces, ruins, cottages, costumes, types, these were the materials from which one composed a landscape ... When by chance one encountered a combination of beautiful things well grouped in nature, one said: 'That's a picturesque site', that is to say a site worthy of being painted, comparable to those that true artists represent.

For contemporary artists, by contrast, 'the slightest fragment of nature is material for a picture, provided one knows how to paint and how to render an impression.'[40] For Georges Lafenestre, those who focused on mere impressions were 'tourists of the brush' when compared with the few artists who still 'raise themselves up to the poetic conception of the expressive landscape, to the pondered composition of their personal creation, where elements borrowed from living nature are grouped together and enhance and strengthen each other, so as to throw the individual sentiment of the artist into relief.'[41]

The supporters of new developments saw these changes as positive gains in two ways: concentration on fleeting effects of atmosphere revealed the artist's sensitivity to nature itself; and this sensibility best expressed the emotion of the scene. The tensions between old and new notions of landscape emerge particularly clearly in Courbet's dealings with his

42. See the fascinating discussion in Wagner 1981.
43. See Shiff 1984, Part One, pp. 3–54.
44. Gautier 1861, p. 119.
45. Lagrange 1865, pp. 152–3; Blanc 1866, p. 40.
46. Claretie, 'L'Art français en 1872', in Claretie 1874, p. 173; see also pp. 231, 287.
47. Guillemot 1898, p. 1.
48. See p. 28 and House 1986, pp. 158–64.
49. Cherbuliez 1876, pp. 515–18; on the use of the politically radical term 'intransigent' to describe the 'Impressionists', see Eisenman in San Francisco 1986.
50. Bigot 1877, p. 1046.
51. Guillemin 1876, pp. 104–5.
52. Baudelaire 1964, pp. 7–11.
53. For example Merlet 1862, pp. 263–4.
54. They were strongly advocated by Jules Ferry, the new Minister of Public Instruction and Fine Arts, at the Salon prizegiving in 1879; his speech is reprinted in the 1880 Salon catalogue, pp. VI ff.
55. See pp. 47–50.

patrons during the 1860s: collectors generally wanted paintings with recognisable features such as figures, boats or deer (see cat. 16), but Courbet sought to market his landscapes primarily as demonstrations of his mastery of the '*effet*'.[42] However, the landscapes he showed at the Salon usually had more distinctive motifs (see also fig. 21).

The distinction between the emotional impact of the scene and the subjective response of the artist was consistently blurred in the writing of the period, in particular in the use of the terms *effet*, *sensation* and *impression*. It was the artist's subjective engagement with nature's fleeting effects that was expressed by the picture and transmitted to the viewer.[43]

In the present context, *impression* is the most significant term. It referred initially to the impression made on the viewer by the experience of nature's most transitory effects, and then, by extension, to paintings that recorded such impressions. In 1861 Théophile Gautier criticised Daubigny, 'who has such a faithful and truthful feeling for nature', for 'contenting himself with an *impression* and neglecting the details'.[44] For Lagrange in 1865 Daubigny was the leader of the 'school of the *impression*', and in the following year Charles Blanc criticised certain followers of Corot for being satisfied with 'rendering the *impression*', commenting: 'this is the big word in a certain camp'.[45] In 1872 Jules Claretie lamented that landscapists were too readily satisfied 'with an *impression*, with an *effet* for their pictures'.[46]

To hostile critics all works by the new landscapists were mere *impressions*. Yet the artists themselves distinguished between their *impressions* and their more highly finished paintings. When Monet was asked why he had given the title *Impression, Sunrise* to his celebrated picture at the 1874 group exhibition (fig. 9), he replied, '[because] it really couldn't pass as a view of Le Havre'.[47] At the same exhibition he showed another, larger and more finished picture of Le Havre, titled *Le Havre: Fishing Boats leaving the Port*, which presumably could pass as a 'view'.[48]

After the naming of the group as 'Impressionists' in 1874, the term was usually used to refer to their work. However, in 1876 Victor Cherbuliez contrasted the

Fig. 9

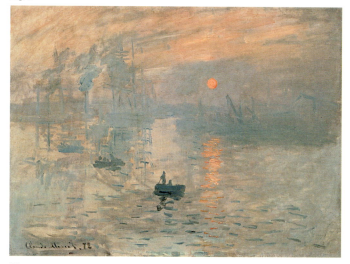

Fig. 9
Claude Monet
Impression, Sunrise, 1872, exhibited in the first Impressionist group exhibition of 1874
48 × 63 (18⅞ × 24⅞), Musée Marmottan, Paris

Fig. 10
The Viaducts and the Landscape
Engraving from A. Guillemin,
Les Chemins de fer, 1876, p. 105

'formless, confused sketches' of these 'intransigents' with 'the reasonable and reasoned Impressionism' of paintings by Harpignies and Pelouse at the Salon (see cats. 27, 29).[49]

Notionally at least, the painting of *effets* and *impressions* was unconcerned with the actual site depicted. Yet discussion continued about the subject matter for landscape painting, in particular about the acceptability of overtly contemporary scenes. Henriet insisted that the true landscapist favoured unspoilt sites and time-worn buildings, despite the incursions of 'civilisation': 'Every conquest of industry, every material improvement involves some sacrifice of the poetry of memories or of picturesque beauties.' For Charles Bigot, reviewing the third Impressionist group exhibition in 1877, their choice of subjects represented a wholesale misunderstanding not only of the art of landscape, but of 'nature' itself:

In the final analysis, it is not true nature that they have looked at and have tried to render, but rather the nature that one encounters on outings in the great city or its surroundings, where the harsh notes of the houses, with their white, red or yellow walls and their green shutters, clash with the vegetation of the trees and form violent contrasts with it. How much better have ... our modern landscapists, the Rousseaus, the Corots and the Daubignys, understood how to express not only the poetry but also the truth of nature! How much better have they represented the countryside, with its waters, its woods, its fields and its meadows, with its distant and calm horizons![50]

The most positive endorsement of the potential of contemporary subjects came not from an artist or a critic, but in Amédée Guillemin's volume on *Le Chemin de fer* in the popular *Bibliothèque des Merveilles*:

... the railways are not, as people keep repeating, the enemy of art and of the picturesque in landscape. These beautiful viaducts, with their long rows of white arches, masked in turn by rocks and clumps of greenery, have a decorative effect that is very simple and very satisfying.

The accompanying illustration, titled *The Viaducts and the Landscape* (fig. 10), juxtaposes the train on its viaduct with an archetypal ramshackle cottage.[51]

The problem was not simply the inclusion of the visible signs of modernisation. The idea of 'modernity'

also involved a particular way of seeing the world. It was thus that Charles Baudelaire understood it in his essay on Constantin Guys, published in 1863: his *modernité* was based on the image of the man in the urban crowd, the *flâneur*, scrutinising the figures around him but retaining his distance and anonymity. Baudelaire described this engagement with the world as *curiosité* – a type of indiscriminate looking that was fascinated by all sorts of visual stimuli but was unconcerned with the relative significance of the objects within a scene.[52] For contemporary moralists such vision posed a real threat to social values and hierarchies.[53]

The Impressionists' landscapes of the 1870s explored this seemingly indiscriminate vision. In Sisley's *Boats on the Seine* (cat. 87), for instance, all the elements are equally trivial and none treated with special attention. Even where Sisley did choose a celebrated subject in *The Watering Place at Marly in Winter* (cat. 79), he treated this remnant of one of Louis XIV's palaces as if it were no more important than the other elements in this mundane scene.

After the government changes of 1877–9 the new Republican authorities actively sponsored the painting of significant contemporary subjects.[54] In the 1880s the State purchased a number of pictures of such themes, among them Boggs's *The Place de la Bastille in 1882* (cat. 39), a contemporary subject presented as a motif in the conventional sense. The Impressionists' paintings of Paris and its surroundings of the mid 1870s had been executed during the years when State policy was promoting a return to traditional academic values.[55] But when the State began to encourage explicitly contemporary subjects, the members of the Impressionist group turned away from them (see cats. 93, 94, 95). This shift coincided with their attempts to market their work through art dealers such as Paul Durand-Ruel; their pursuit of the bourgeois collector market probably led them towards more conventionally picturesque themes.

The question of painting technique was inseparable from the changing attitudes towards subject matter in landscape. Throughout these years the manual dexterity of French painters was much admired, but this was accompanied by fears that mere skill was replacing more

56. Gautier 1857, p. 34.

57. See Thoré's 1868 comments on Manet's brushwork: 'His present vice is a sort of pantheism that places no higher value on a head than on a slipper ...' (Thoré 1870, II, pp. 531–2).

58. Chevalier 1877, p. 331.

59. On the Salon and the Triennale in these years, see Mainardi 1993.

60. See pp. 40–42, and Wrigley 1993, pp. 285ff.

61. For example du Camp 1864, pp. 685–6; Gautier 1866; Couture 1869, pp. 136, 139, 223, 225ff.

62. Sensier 1869, p. 404; Sensier 1870, pp. 373–4; Castagnary 1892, I, pp. 203ff (on Salon of 1864), 235f (on Salon of 1866).

63. See Sherman 1989, especially chapter 1.

64. In 1866 there were 42 landscapes among 129 State purchases, from a total of 1,998 paintings at the Salon; in 1870, 48 landscapes among 126 purchases from 2,991; in 1872, 34 landscapes among 122 purchases from 1,536; in 1877, 3 landscapes (including Busson, cat. 32) among 37 purchases from 2,192; in 1878, 21 landscapes among 59 purchases from 2,330; in 1880, 20 landscapes among 108 purchases from 3,957. The figures for 1872 also include drawings. From 1864 to 1886 State purchases were photographed and published in folio volumes by Michelez; on State purchases in the 1850s, see Angrand 1968; on the 1870s and 1880s, see Vaisse 1980, pp. 396–444.

65. As noted by Sherman 1989, p. 35.

66. These rooms in the Louvre have recently been reopened to the public.

67. This was the only canvas Daubigny executed of a sequence that he proposed as a follow-up to Joseph Vernet's Ports of France (see figs. 35, 47); see Philadelphia 1978, pp. 284–5.

serious, humanistic values. Landscape painting was a focus for these anxieties, because of the virtuoso sketch-like technique it often displayed, combined with the declining concern for the motif. Courbet's rejection of conventional drawing and his use of the palette knife were much debated; for Gautier, he was a master of 'peinture matérielle' but lacked any higher values: 'He will serve you up a fine morsel, just as a cook brings you a finely-cooked steak ...'.[56] Brushwork that treated every element in the scene as if it were equally significant was the visual equivalent of the unselective curiosité that so disconcerted the moralists (see cats. 80, 87).[57]

The concentration on colour at the expense of modelling and drawing gave rise to related concerns. In academic theory the rendering of form relied on the intellect, whereas colour belonged to the realm of the senses. A rich coloured palette was acceptable if subordinated to clearly defined forms, as in Flandrin's neo-classical landscapes (see cat. 28); but paintings dominated by colour alone were seen as inadequate and superficial, or, worse, as subverting the supremacy of mind over matter. Such concerns lay behind the opposition to the luminous tonality and intense colour of Impressionist landscape. However, for critics who supported a type of painting based on sensory experiences, the Impressionist palette marked the triumph of a spontaneous, 'natural' form of painting over academic artifice.

Artistic theory of all types demanded a unity between the theme of the picture and its treatment. For most of their earliest critics in the 1870s, the Impressionists' landscapes lacked such unity: their subjects were trivial and fragmentary, their technique incomplete. However, one critic, Frédéric Chevalier, recognised in 1877 that even these discordant elements might be understood as a coherent world view; together, their subjects and technique could stand for the idea of modernity:

The characteristics that distinguish the Impressionists – the brutal handling of paint, their down-to-earth subjects, the appearance of spontaneity that they seek above all else, the deliberate incoherence, the bold colouring, the contempt for form, the childish naïveté that they mix heedlessly with exquisite

refinements – this disconcerting mixture of contradictory qualities and defects is not without analogy to the chaos of opposing forces that trouble our era.[58]

Viewing the Painted Landscape

The Salon, held annually from 1863 onwards, was the unequivocal focus of the Parisian art world. Its control was transferred from the State to the artists themselves in 1881, but it remained the single forum for displaying French art until 1890. In that year the Salon split in two, with the creation of the Société Nationale des Beaux-Arts (the Salon du Champ de Mars).

The position of the Salon was very problematic. It was widely felt that it served two irreconcilable interests: as a showcase for the best of contemporary French art, and as a shop window for artists to sell their wares. In principle it was felt that fine art and commerce belonged to two different worlds, but in practice this was unrealistic. The Paris Expositions Universelles that took place roughly every decade presented a considered retrospective of recent work, but a more frequent forum was needed to show the best current work. Plans were repeatedly mooted for the conversion of the Salon into a permanent exhibition focused solely on selling, and the institution of a more select temporary exhibition. The Exposition Nationale Triennale was launched in 1883 but it collapsed after one exhibition because of lack of public interest, and the Salon continued to serve both functions throughout the period.[59]

The position of landscape at the Salon, and in French art as a whole, was hotly debated. In the traditional hierarchy of the genres of painting it occupied a lowly place, below historical and religious painting.[60] The Prix de Rome for paysage historique gave it a certain recognition, but at the same time implied that serious landscape painting should have a subject beyond the scene itself. From 1848 onwards 'pure' landscape was widely accepted at the Salon, but theorists and moralists repeatedly asked why it had become so popular.

Landscape was seen as the art of democracy and freedom, but this aroused mixed feelings. For the supporters of old hierarchies it represented decline and degeneration, and the loss of the heroic ideals of the past.[61] For others it represented liberation from the

Fig. 11

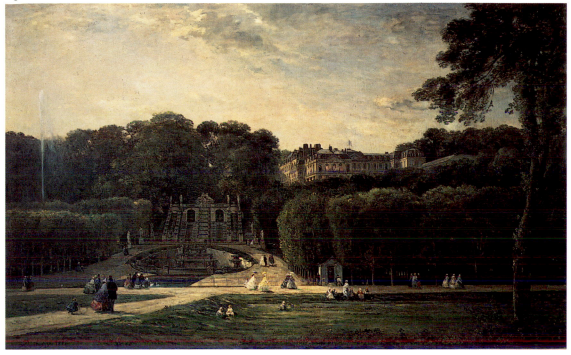

Fig. 12

Fig. 11
Charles-François Daubigny
The Park of Saint-Cloud, 1865,
exhibited at the Salon of 1865
124 × 201 (48⅞ × 79⅛)
Musée de Châlons-sur-Marne

Fig. 12
Charles-François Daubigny
River Landscape, 1860
28.7 × 59.1 (11¼ × 23¼)
Courtauld Institute Galleries, London
(Princes Gate Collection)

Academy and a renewal of both art and society. But even here opinions might vary: Alfred Sensier praised landscape as a mark of health, in contrast to the effects of urbanisation and industrialisation, while Jules Castagnary welcomed it, though only as one stage in the progression towards an art that would depict modern urban man, and thereby fulfil the Republican dream.[62]

The State played a complex and often ambiguous role as patron of art. The great majority of the Salon landscapes illustrated in this catalogue were bought by the State, and their placing in provincial museums had a political as well as a cultural purpose.[63] Their purchase was central to the policy of Napoleon III in the 1860s, and again of the Third Republic from the late 1870s onwards, of fostering a sense of national identity throughout France, but from 1875–7 there was a sudden and marked decline in the number of landscapes purchased, coinciding with President MacMahon's 'moral order' régime.[64] Regional differences were encouraged, provided they were subordinated to an overriding notion of nationhood. Many landscapes bought by the State were sent to museums in the provinces represented in the pictures (see cats. 4, 5, 30);[65] but others were sent to regions of France far from their natural subjects (cats. 7, 27). Major centres did own paintings of the local province, but they also displayed images of other and very different regions of France.

Under Napoleon III pictures were commissioned from some of the most controversial landscapists, notably Daubigny. In 1860–1, he painted decorative canvases for the Ministry of State in the Louvre Palace;[66] and in 1862–5 he executed another major State commission, *The Park of Saint-Cloud* (fig. 11),[67] a motif of a very conventional type, but with the fashionable figures in the foreground adding a note of modernity.

Many of the landscapes bought by the State in the 1860s and the 1880s did not represent motifs in the traditional sense; they were experimental in both composition and technique (see cats. 4, 38, 44). Yet in one sense they did reflect a traditional approach to public painting: they were very large, on a scale to attract attention on the crowded walls of the Palais de l'Industrie, where the Salon was held.

25

68. Letter from Duret to Pissarro, 15 February 1874, in Pissarro and Venturi 1939, I, pp. 33–4; translation in Rewald 1973, p. 310.

69. Sensier 1872, pp. 204, 256–7, 273; Thoré 1870, I, pp. 48–9; Jean-Aubry 1922, pp. 53–4, 66. On artists' sales, see Vaisse 1980, pp. 300–1; there has been little research into the practice of artists sending their own work to auction sales and mounting whole sales of their work.

70. Burty, April 1875, p. III.

71. On the auction, see Rewald 1973, pp. 351–4, and Bodelsen 1968. Burty's preface (Burty, March 1875), the nearest thing to a manifesto for the Impressionist group, is reprinted in Riout 1989, pp. 47–9.

72. On the exhibitions of the *cercles*, see Ward 1991, pp. 605–8; Garb 1994, pp. 32–41.

73. Champier 1880, pp. 173–4, quoted by Ward 1991, p. 607.

74. Houssaye 1880, pp. 193–4.

75. An exception was the Goupil gallery; for an engraving of its display space in 1860, see Ward 1991, p. 616. On the development of the art dealer as a profession from the 1820s onwards, see Whiteley 1983; Green 1987; Green 1990, pp. 25–8.

76. Gautier 1858, p. 10.

77. Henriet 1854, pp. 113–14, 133–5; see also Gautier 1858, pp. 12–13.

78. Henriet 1854, p. 115.

This highlights a paradox in the position of landscape at the Salon. The developments in landscape all seemed to lead towards smaller pictures. Modest subjects suited smaller formats; the rapid technique needed to catch transitory effects also demanded portable canvases; and private collectors, often with modest-sized apartments, sought domestic-sized pictures. The large landscapes exhibited at the Salon, however informal their subjects, were only suitable for display in public buildings.

Small landscapes were exhibited at the Salon occasionally, and might attract critical notice if the painter was well known (see cat. 1). Sisley's views of semi-industrial Parisian scenes (see fig. 13), that the Salon jury accepted in 1870 were, however, ignored. A comparably informal small landscape by Johan Barthold Jongkind (fig. 14) was rejected in 1863 and shown instead in that year's Salon des Refusés. The Salon was, on the whole, a most unsuitable site for bringing pictures like these before prospective buyers.

The Impressionist group exhibitions of 1874–86 have generally been regarded as alternatives to the Salon, and as responses to the rejection of paintings by the Salon jury. However, there were other important outlets in these years: dealers' shops, exhibitions organised by *cercles* or other private bodies, and, probably most significant, auction sales.

The situation facing a little-known landscapist was summed up by the critic Théodore Duret, seeking to dissuade Camille Pissarro from joining the planned group exhibition in 1874:

You have still one step to take: that is to succeed in becoming known to the public and accepted by all the dealers and art lovers. For this purpose there are only the auctions at the Hôtel Drouot and the big exhibition at the Palais de l'Industrie [the Salon] ... Your name is known to artists, critics, and to a special public. But you must make one more step and become widely known. You won't get there by exhibitions put on by private societies. The public doesn't go to such exhibitions, only the same nucleus of artists and patrons who already know you. The Hoschedé sale [at which Pissarro's work had recently fetched good prices] did you more good and advanced you further than all the private exhibitions imaginable. It brought

you before a mixed and numerous public ... Among the 40,000 people who, I suppose, visit the Salon [figures of attendances at the Salon in the mid 1870s show annual totals of about 500,000], you'll be seen by fifty dealers, patrons, critics who would never otherwise look you up and discover you ...[68]

Duret's letter indicates that, after the Salon, display at the Hôtel Drouot (the Paris auction rooms) was the next most important means of bringing works of art before the public. The landscapists Eugène Ciceri, Charles Hoguet, Narcisse Diaz and Théodore Rousseau had pioneered the practice of artists organising auctions of their own works in about 1850, and the practice spread in the 1860s.[69] In 1875 Amand Gautier, a painter of genre scenes and still lifes, mounted an auction of his own work. In the preface to the sale catalogue Philippe Burty explained Gautier's reasons:

Unfortunately, no discreet, convenient location yet exists in Paris where one can, without pretension but also without reticence, display a few hundred studies or drawings – or even paintings – each of which is completed and explained by the others. The Hôtel Drouot alone has the advantage of attracting the mass public every day and thoroughly provoking the critics as a result ...[70]

Just a week before the Gautier sale another auction had taken place at the Hôtel Drouot, with another preface by Burty: the auction of paintings by Monet, Morisot, Renoir and Sisley that has played such a prominent part in histories of Impressionism.[71] Far from being an unusual experiment, these sales were more frequent than group exhibitions such as the one the artists had organised the previous year.

The *cercles*, the French equivalent of gentlemen's clubs, provided a forum very different from the auction house. Several of them organised regular exhibitions; in their relatively modest rooms smaller paintings could be displayed more sympathetically than at the Salon.[72] For Victor Champier they offered the ideal, elite alternative to the Salon:

Amateurs, disheartened by the exhaustion of the Salon ... prefer these intimate exhibitions that seem improvised ... Artists freely send to them the piece they have to hand: a successful sketch, a

Fig. 13

Fig. 14

Fig. 13
Alfred Sisley
View of the Canal Saint-Martin, 1870,
exhibited at the Salon of 1870
50 × 65 (19⅝ × 25⅝)
Musée d'Orsay, Paris

Fig. 14
Johan-Barthold Jongkind
Ruins of the Château of Rosemont, 1861,
exhibited at the Salon des Refusés of 1863
34 × 56.5 (13⅛ × 22¼)
Musée d'Orsay, Paris

curious *pochade*, an indication of landscape, as well as a painting pushed to perfection.[73]

Others, though, felt that the *cercles* offered only second-choice works by the artists who showed at the Salon:

At the Salon, they show the paintings which create their reputation, their most resolved and lasting works; at the *cercles*, portraits painted on commission or out of obligation, paintings quickly executed, successful sketches … Also, newcomers never exhibit in them.[74]

Small, semi-private spaces also offered opportunities for exhibitions in these years, among them the offices of the fashionable periodical *La Vie moderne*, run by the publisher Georges Charpentier, which mounted small one-artist shows of Manet, Monet and Sisley in 1880–1.

There were also the commercial galleries. In the 1860s it was unusual for art dealers to have a substantial gallery space.[75] They generally operated out of small shops; their primary display space was their shop window, in which they placed a limited and changing selection of their stock. It was the window displays that led Gautier in 1858 to describe Rue Laffitte, the principal art dealers' street, as 'a sort of permanent Salon'.[76]

In 1854 Henriet welcomed the dealers' windows as legitimate contexts for the commercialism that worried the critics in the Salon, but he felt that the demands of dealers and collectors encouraged the taste for *petite peinture*, in contrast to the loftier ambitions that brought a painter real success.[77] However, he also pinpointed a particular type of painting that made a visit to Rue Laffitte worthwhile: whereas Corot submitted his Italianate scenes to the Salon (see fig. 3), 'it is only in Rue Laffitte that one can savour the intimate, domestic side of his talent, and learn to love the good, naïve Corot of Ville d'Avray, Bougival and Bas-Meudon' (fig. 4).[78]

This comment highlights the emergence of distinctive 'dealer landscapes' – smaller and less formal than Salon paintings. They were the stock-in-trade of landscapists such as Boudin and Jongkind (see fig. 14) through the 1860s, and also formed the bulk of the production of painters like Daubigny (fig. 12), alongside the large pictures he showed at the Salon.

Such pictures played a key part in the production of the future Impressionists early in their careers

79. In 1873–5 Durand-Ruel published a series of 300 etched reproductions of the paintings – mainly landscapes – in his stock, including three paintings by Monet, five by Pissarro and three by Sisley; plus many by Corot, Millet and Rousseau among others (Durand-Ruel 1873–5).

80. See Ward 1991, p. 613–17.

81. On the group exhibitions, see Rewald 1973 and San Francisco 1986.

82. On the 1867 project, see Bazille's letters to his parents, April/May 1867, letters 91 and 93 in Bazille 1992, pp. 137, 140.

83. On these terms, see House 1986, pp. 157–66.

84. Duranty 1876, reprinted in San Francisco 1986, p. 483 and Riout 1989, p. 130.

85. Reprinted in the 1880 Salon catalogue, p. VII.

86. See Green 1990, pp. 6–7, 139–40.

(see cats. 60, 63), and it was this type of painting that Monet, Pissarro and Sisley sold to the dealer Paul Durand-Ruel in the early 1870s, when he was trying to launch their careers outside the Salon (see Monet, cat. 65; Sisley, cat. 68).[79] Although small and intended for a domestic setting, they are far more elaborately finished than the rapid sketches that contributed most to Impressionism's reputation (see fig. 9).

Only in the 1880s did dealers, led by Georges Petit, begin to mount more ambitious exhibitions. Petit's Expositions Internationales, in which Monet, Renoir, Pissarro and Sisley were included in the mid 1880s, offered a new model of display in lavish surroundings;[80] it was Petit's retrospective of Monet and Rodin in 1889 that established Monet's success. Durand-Ruel had tried to boost the reputation of the Impressionist landscapists in 1883, with one-artist shows of Boudin, Monet, Renoir, Pissarro and Sisley (the first attempt anywhere to use a sequence of monographic shows as a marketing strategy). However, it was not until 1891 that Durand-Ruel began the long series of single-artist exhibitions that sealed the Impressionists' success. It is in the proliferation of alternative exhibiting groups and dealer exhibitions after 1890 that we find the real roots of the present-day structures of the art world, where dealers are the primary agents in establishing an artist's reputation.

The eight Impressionist group exhibitions of 1874–86 were presented as a single numbered sequence, but they did not reflect a single coherent strategy.[81] The initial abortive project for an exhibition in 1867 was directly triggered by the many rejections from that year's Salon.[82] The 1874 exhibition was discussed by most critics as an alternative to the Salon, but it was largely composed of smaller paintings. In part these were 'dealer landscapes' of the sort that they had recently been selling to Durand-Ruel; the dealer's financial problems in 1874 must have been one of the catalysts that led them to mount their long-planned show. However, in this first show and the next two, in 1876 and 1877, several of the artists also included some of their most sketchy and improvisatory works, among them Monet's *Impression, Sunrise* (fig. 9), shown in 1874. In the titles they gave their exhibition paintings they made clear distinctions between these two types of picture, subtitling the sketch-like paintings *impression*, *esquisse* (sketch) or *étude* (study).[83]

In showing both sketches and 'dealer landscapes' the painters brought together types of painting that normally belonged in different settings and addressed different publics. The primary audience for the 'dealer landscape' was the stroller down the Rue Laffitte, while the sketches were aimed towards a more elite and intimate viewership like that of the *cercles*. The appeal to a select, insider audience was central to the propaganda surrounding the group's exhibitions. In 1876 their associate Duranty wrote of their work:

The public wants finish above all. The artist, charmed by the delicacy or the boldness of a colour effect, of a gesture, of a group, is much less concerned about finish and correctness, which are the only qualities appreciated by the inartistic ... It matters little that the public does not understand. It matters that artists should understand, and in front of them one can exhibit sketches, preparations, underpaintings where the thought, the intention and the draughtsmanship of the artist are often expressed with more rapidity, more concentration ...[84]

Both sketches and 'dealer landscapes' were accommodated in the first three group shows. Thereafter, the conflicting interests of the artists pulled the group apart. First Renoir and then Monet withdrew, as their ambitions encouraged them to separate their reputation from the group's notoriety, and both submitted to the Salon again. Monet's one submission, in 1880 (cat. 36), followed the change in government and Jules Ferry's appeal, in his ministerial speech at the Salon prizegiving in 1879, to plein-airist landscapists to return to the Salon.[85]

When Durand-Ruel was able to resume buying their work early in 1881, Monet and Renoir realised that their future was not amongst the monumental public paintings of the Salon, but rather in the commercial space of the dealer.

At one extreme of the audience for art in Paris was the *grand public*, the half million who visited the annual Salon; at the other the elite who attended the *cercles* or

Fig. 15

Fig. 15
Honoré Daumier
'What a bastardised and corrupt society we live in!
… all these people just look at the canvases of
monstrous scenes and no one stops to look at
paintings of beautiful and pure nature! …', 1865
Lithograph, 22.6 × 22 (8⅞ × 8⅝)
Private Collection

the Impressionist group shows. Notions of the 'public' and of 'popular' taste raise problems, for they are constructions made from an elite standpoint. Only a tiny proportion of nineteenth-century art viewers recorded their opinions. We have some informal comments, in letters and diaries, mostly written by one elite, the artists themselves. Otherwise, we have the printed accounts of art critics; and, whatever the critic's standpoint, he too represented an informed 'insider' voice. In these writings the 'public' puts in an appearance, but always set in contrast to the more enlightened views of the writer. Cast in this role, the 'public' might have many contradictory views attributed to it; for defenders of academic ideals, public taste favoured slapdash virtuosity, while supporters of the *impression* and the *effet* opposed their own taste to the idea of a public that favoured anecdote and literal representation.

In nineteenth-century France there was no simple correlation between taste and social class. The notion of 'bourgeois' taste was as much of a negative stereotype as that of the 'public' (see cat. 36); yet most art lovers and most artists, whatever their aesthetic position, were broadly members of the bourgeoisie. Any attempt to define taste in terms of birth or profession is contradicted by the evidence: the five key patrons of the Impressionists in the mid-to-late 1870s were a retired customs official (Victor Chocquet); an operatic baritone (Jean-Baptiste Faure); a pastrycook and restaurateur (Eugène Mürer); a homeopathic doctor (Georges de Bellio); and the spendthrift proprietor of a company that made fabrics for women's clothing (Ernest Hoschedé).

Taste needs to be discussed in terms of cultural constituencies or interest groups.[86] Personal preferences clearly played a part; but these gained their meanings and significance only in relation to the community who shared these interests, and by contrast with other communities with different tastes. Such groups might associate themselves with a particular institutional position (for instance the aesthetic of the Ecole des Beaux-Arts); or they might locate their own taste in relation to personal friendships, whether with critics, collectors or artists.

The distinction between public and elite taste parallels the contrast between tourist and traveller. The tourist represents the 'public' view of a place, while travellers define themselves by their distinctive responses or their specialised interests.

The landscapist was at the meeting point between art and travel. As a traveller, he was the ultimate anti-tourist, representing independent exploration and individual response; yet the sites he chose were defined and understood by reference to shared frameworks of knowledge about the French landscape. As a painter, he represented a personal sensitivity to his subjects and a privileged skill in transforming his experiences into 'art'. And yet the forms his paintings took – the subjects he chose and the schemata and techniques he adopted – inevitably located him within the framework of aesthetic debate. His uniqueness was defined in opposition to the public, but it was within that public that his art found its audience and its market.

The public face of landscape

Anne Dumas

When we think of the landscapes painted in France in the later nineteenth century, the images that come to mind are fields of poppies by Monet or peaceful village scenes by Pissarro. Our view of the landscape painting of this period, and perhaps even of the French countryside itself, has become fused with Impressionism. But at the time it was not the Impressionists' portrayal of nature that corresponded with the public view of landscape painting, but rather that of the numerous landscape painters who exhibited every year at the official Salon. Some of them – for example Corot, Daubigny and Millet – are familiar names, but many others, such as Ségé, Français or Chintreuil, have been long forgotten. Yet, in their day, these artists attracted a vast public and much critical attention. It was their landscapes that established the terms by which all landscape painting was judged, and it was their vision of France that encapsulated contemporary attitudes to nature and to art.

Although the repertory of Impressionist subjects is well known, that of the Salon painters is much less so. For many people a typical Salon landscape suggests a vaguely Arcadian scene or the background to some historical composition. But in fact an examination of Salon landscapes reveals an unexpectedly wide and varied range of subjects, sometimes overlapping with the subjects of Impressionism but more often revealing very different concerns.

Throughout the period covered by this exhibition the annual Salon was the main forum for artists to display and sell their work. Once accepted by the Salon, the most prestigious and sought-after outcome was to have a work purchased by the State; there was also the possibility of selling to a private collector from the urban middle-class public. Landscapes were especially popular with this new class of art-buying city dweller, and the rapidly growing number of landscapes exhibited at the Salon was directly related to extensive urban development, in particular that of Paris, which accelerated during the Second Empire with Haussmann's rebuilding of the capital. The idea of nature as a refuge from the negative aspects of life in the city had begun to emerge in the previous generation. From the 1820s onwards, the new Parisian bourgeoisie had been eager consumers of a whole range of nature commodities: dioramas of spectacular natural scenery; topographical prints that advances in printing techniques were making increasingly available; articles on the countryside in journals and books; numerous reviews of landscape painting in the Salon; and now the paintings themselves, which could bring a piece of the countryside into their newly-built apartments.[1] 'A landscape painting is a window in our wall', insisted the critic Léon Lagrange in 1864:

It reveals the countryside we yearn for, and which we go a long way to find. Through it nature communicates with us and offers that balm which we gain from the peace of the fields. A view of sky, a few trees, a stream, rocks, a bit of sea, what sweet repose they offer for the eyes, what endless charm for the mind, what powerful and wholesome nourishment to sustain and refresh us.[2]

Of equal importance to this urban construction of nature was the notion that the rise in landscape painting expressed a developing sense of national consciousness. Castagnary echoed a view held by many critics when he claimed that it was through landscape painting that art was becoming indigenous and expressing the essential character of France. Seen collectively, he felt, the different views of France presented at the Salon formed an image of the fatherland (la patrie).[3] Not surprisingly, for a country with a long agrarian history, self-definition was rooted in the land.[4] And, as Nicholas Green has pointed out, in the period after 1815, when national awareness was particularly acute, the sense of the land played an important role: 'the move was towards an ideological construction of the nation centred on the land, the regions. At a time when France had little sense of social or even geographical unity, here was a nascent rhetoric of nationalism which was to find political and cultural expression only in the very different conjuncture of the early Third Republic.'[5]

This new sense of nationhood stimulated an enthusiastic rediscovery of France and a desire to document all aspects of its landscape and heritage. In the eighteenth century, the age of the Grand Tour, travel had centred on Italy and the classical world, but now France was deemed worthy of attention.

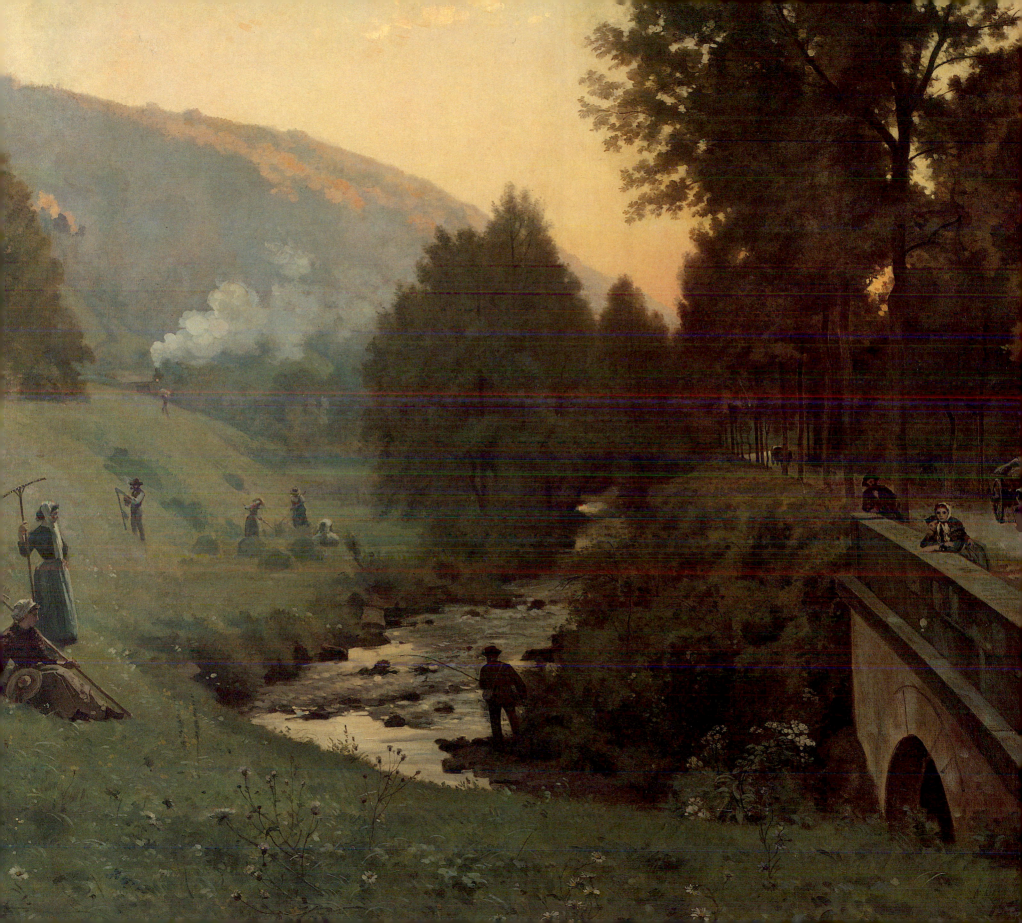

1. See Green 1990, pp. 95–110.
2. Lagrange 1864, p. 6.
3. Castagnary 1866, in Castagnary 1892, I, pp. 235–6.
4. See Gravier 1942, pp. 6–8.
5. Green 1990, p. 102.
6. Bigot 1883, p. 462.
7. C. Nodier, J. Taylor and A. de Cailleux, *Voyages pittoresques et romantiques dans l'ancienne France*, Paris, 1820–78.
8. Herbert 1988, p. 196.
9. '... moving tableaux of every aspect of nature: mountains follow on after each other like the waves of a stormy sea; forests undulate beneath the blue sky; the river runs like a silver thread through green fields; endless vistas suddenly open up across woods and gorges; all at once, the sea with its infinite sound and white sails springs into view only to disappear immediately behind the towering gloomy cliffs ...', Gastineau, 1860, p. 371.
10. Claretie 1865, p. 46.
11. Badin 1864, p. 167.
12. See Nordman 1986, p. 541. After the death of Adolphe Joanne's son in 1912 they became the *Guides Bleus*.
13. Mayer 1981, pp. 189–96. The recording of the past occurred in different ways. François Guizot founded the Société de l'Histoire de la France and encouraged the publication of medieval charters, documents and archives (see Snyder 1964, p. 118). In 1840 Viollet-le-Duc restored Vézelay, the first of a number of medieval monuments he worked on including Notre Dame in Paris and the town of Carcassonne; a Commission des Monuments Historiques was founded, Prosper Mérimée being one of its earliest inspectors; the Musée des Monuments Français was established in 1880 to house plaster replicas of ancient monuments in France that were threatened with ruin.
14. Only later, in the 1890s, did some of the Impressionists turn to historic monuments, Monet's Rouen cathedral series, 1892–4, being an obvious example.
15. Nodier 1820, pp. 1–2
16. On Pierrefonds, see Joanne 1881, pp. 315–18. For Napoleon III and nationalism, see Snyder 1964, p. 118.

'The French landscapists no longer looked to Italy, but to their own country, and they found it beautiful and worthy of inspiring artists', asserted Bigot.[6]

The most significant contributions to this endeavour were the folio volumes devoted to some of the French provinces. Entitled *Voyages pittoresques et romantiques dans l'ancienne France*, they were launched in 1820 and most volumes appeared during the next two decades.[7] Under the direction of that remarkable nineteenth-century polymath, Baron Taylor, teams of writers and illustrators journeyed to the remote corners of the provinces, excavating folklore and mythology, and recording the most picturesque views and historic (mostly Gothic) monuments.

Although the opportunity to travel in this first phase of the discovery of France, i.e. before 1850, was only possible for a minority (the *Voyages pittoresques*, for instance, were sold to an elite group of subscribers) this changed dramatically with the advent of the railways. The first passenger line, from Paris to Saint-Germain, opened in 1837, followed by lines to Rouen in 1843 and Le Havre in 1847. From then on the rail network expanded rapidly, linking the major provincial towns to Paris.[8] For the first time it was possible for large numbers of people to explore the French countryside, not just around Paris but much further afield. The excitement this generated is evident in the numerous manuals for railway travellers, in the illustrated magazine articles accompanying the inauguration of each new branch of the rail network, and in the caricatures that appeared in the 1850s and 1860s.

Not only did the railways change the landscape itself, they offered new ways of seeing the landscape (see fig. 16). The breathless prose in an entertaining article by Bernard Gastineau, entitled 'The Train Journey: Fantasy', mimics the rhythm of the train as the author describes the passenger's astonishment at the rapid succession of landscapes that pass before the train window like some spectacular diorama.[9] For Jules Claretie, also writing in the 1860s, the train was an artist who revealed the landscape in broad panoramas:

Fig. 16

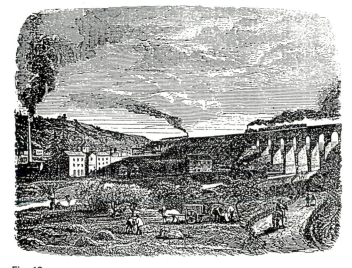

Fig. 16
The Malaunay Viaduct
Engraving from E. Chapus, *De Paris au Havre*, *Guides-Joanne*, 1862, p. 161

Fig. 17

Fig. 18

Fig. 17
The Limbourg brothers
September from *Les Très Riches Heures du Duc de Berry*, *c.* 1416, illuminated manuscript, 21.8 × 13.4 (8⅝ × 5¼)
Musée Condé, Chantilly
Fig. 18
The Château of Pierrefonds
Engraving from C. Nodier, J. Taylor and
A. de Cailleux, *Voyages pittoresques dans l'ancienne France: Picardie*, 1845, plate 202

In a few hours [the train] shows you all of France, and unrolls before your eyes its infinite panorama, a vast succession of charming tableaux and novel surprises. Being an artist versed in the ways of the masters, it only shows you the great outlines of a landscape. Don't ask it for details, but the living whole. Then, having charmed you with its painterly skills, it suddenly stops and quite simply lets you get off where you wanted to go.[10]

The new tourists were aided in their appreciation of France's landscapes and sites by the boom in travel literature and guidebooks that accompanied the opening of the railways. Even by 1864 the guides were so pervasive that the world-weary author of the 'Journey of a Parisian in search of Nature' could complain:

If I want to find some really interesting countryside, woods without lovers, mountains without the English, landscapes without landscapists, I must find an area not recommended by any of the guides, some wild, unexplored scenery, if there is still such a thing.[11]

Pre-eminent were the famous Joanne guides. The main series, the *Itinéraire général de la France*, which was started in 1861, eventually ran into several editions and more than 200 volumes covering every area of France.[12] The Joanne guides presented a view of France that was entirely dominated by the train. They were read by the rail traveller, who surveyed the countryside, guidebook in hand, as it passed by the train window. They stopped where the train stopped, and the length of the itineraries was devised according to the train timetables. Packed with factual information, briskly conveyed, the guides were often accompanied by topographical engravings (see fig. 16). Although the scenic aspects of each region were amply described, the most detailed descriptions were reserved for France's historical monuments.

The documenting of ancient monuments, and their subsequent exposure, was fundamental to the growing sense of nationhood. In a period of dynamic social change and political upheaval, a period that had witnessed revolutions in 1830 and 1848, crushing defeat in the Franco-Prussian War in 1870 and for the Paris Commune the following year, the monuments of pre-Revolutionary France became emblems of an age of order and political stability that were cherished by conservatives.[13]

Historic monuments were an obvious choice of landscape subject to endorse a sense of unbroken cultural identity. Although historical subjects are rare in Impressionist imagery (see, however, cat. 59), a glance at the titles to be found in the Salon's exhibition catalogues reveals the frequent appearance of *ruines*, *église* and *château*.[14] In their portrayals of historic monuments Salon painters were preserving the tradition of Romantic imagery pioneered in the illustrations of the *Voyages pittoresques*. Ruins, with their associations of fragility and decay, were particularly potent emblems of history, replete with memories of a collective past, as Charles Nodier explained in his introduction to the first volume of the *Voyages pittoresques*, *Ancienne Normandie*, in 1820:

At the sight of [ruins], all the memories of days gone by awaken: whole centuries with their customs, their beliefs, their revolutions, the glory of great kings and great captains, all seem to appear in these solitary places.[15]

Typical examples of this interest in historic monuments are the paintings of the famous château at Pierrefonds, before and after restoration, by Paul Huet and Emmanuel Lansyer (see cats. 17, 20). Pierrefonds was a well-known site close to the royal forest and palace at Compiègne; it was rich in historical associations and recent imperial ones, and the *Voyages pittoresques* volume on Picardy devoted several pages and no fewer than six plates to it (see fig. 18). After a destructive fire in the early seventeenth century, the great medieval fortress had remained an imposing ruin until 1857 when Viollet-le-Duc began to restore it at the instigation of Napoleon III, whose enthusiasm for work of this kind was allied to his nationalist interests.[16]

In *The Ruins of the Château of Pierrefonds*, 1868 (cat. 17) Huet, the last great exponent of the Romantic landscape tradition, summons all the rhetoric of Romanticism in his freely brushed rendering of the ruined building, silhouetted against the stormy sky. In marked contrast to this emotive view Lansyer uses sharp-edged documentary realism to depict the château after restoration (cat. 20). Contemporary guidebooks

17. Zeldin 1977, p. 10.
18. *Ibid.*
19. 'It is enough to have glanced quickly at the galleries of the Exposition Universelle to know that we are absolutely the masters and true initiators in [landscape] painting. Which school, today, could show us landscapists like Théodore Rousseau, Millet and so many others ?' Mantz 1867, p. 538.
20. Blanc 1866, p. 38.
21. A survey of *souvenir* and *vue* in Salon titles in five sample years shows: 1861: 15/44; 1870: 32/87; 1876: 7/11; 1882: 10/26; 1889: 9/17.
22. Delaborde 1889, p. 652.
23. A. M. 1861, p. 136.
24. Houssaye 1883, p. 620.
25. Mantz 1869, p. 508.
26. Joanne 1882, p. 214.

commented on the rather brash appearance of the restored castle, but dominating the landscape in its pristine splendour Lansyer's Pierrefonds seems to function as an icon of medieval France and brings to mind images of feudal castles from a Book of Hours (see fig. 17).

The quest for national identity went even further back into French history. In the nineteenth century, as the bourgeoisie began to trace their descent back to Gallo-Roman times, the ancient Gauls came to symbolise democratic freedom.[17] Augustin Thierry's standard work, *L'Histoire des Gauls*, first published in 1828, had gone through several editions by 1881.[18] Napoleon III took an interest in ancient Gaul, and several excavations of Gallic sites were undertaken during the Second Empire. Gallic themes appeared in painting: the subtitle of Courbet's *The Oak at Flagey* was 'known as the oak of Vercingétorix, Caesar's Camp near Alesia, Franche-Comté'. In Penguilly l'Haridon's remarkable exercise in pictorial archaeology, *Roman City built at the Foot of the Alpes-Dauphinoises sometime after the Conquest of the Gauls*, 1870, the reference is explicit (see cat. 23).

Although paintings of monuments were the most obvious illustration of history, a sense of a national past could also be seen as grounded in the landscape itself. The Barbizon painters working in and around the Forest of Fontainebleau from the 1830s onwards had presented a vision of nature, untainted by human habitation, which could evoke a sense of a primeval past (see fig. 5). Their forest views and empty heaths established models for the image of primitive nature that persisted throughout the century (see cats. 27, 41), and views of Fontainebleau's ancient woodland remained a significant category each year at the Salon. The chief proponents of the Barbizon group – Rousseau, Dupré and Daubigny – were revered by conservative critics and upheld as an example to landscapists.[19] Their deaths in the 1860s and 1870s were mourned as a national loss.

The neo-classical style of landscape painting, derived from Claude and Poussin, provided an alternative model, especially for the Arcadian landscape, which though a dying tradition in the later nineteenth century

continued to be represented at the Salon (see cat. 28). It was Corot who was the leading exponent of this tradition (fig. 19), and his landscapes, which are less portrayals of particular places than nostalgic evocations of a lost, idealised past – 'sublime and evocative souvenirs' as Charles Blanc described them – were considered masterpieces of poetic landscape and inspired many followers (cat. 25).[20]

One of the most enduring notions of landscape valued by critics and Salon audiences was that which enshrined an image of the archetypal French landscape, not as an Arcadian reverie, but rooted in the specifics of place. It is significant that in the Salon titles during the period covered by this exhibition, *vue*, denoting a real place, far outnumbers *souvenir*, suggesting the distancing of imagination or memory.[21] In addition, to emphasise the particularity of the scene depicted, titles often designate not only the name of the village or town, but also the *département*. Busson's *The Village at Lavardin (Loir-et-Cher)*, 1877 (cat. 32) set, as its title makes clear, in the heartland of France, conforms completely to an ideal of a domesticated, harmonious France. Several years later a critic reviewing the 1889 Salon admired Busson for his 'calm and tranquillity' and for painting 'the pleasant and gentle sites of central France.[22]

Another aspect of '*la belle France*' that recurs in Salon landscapes is found in the tranquil river views typified by the paintings of the Oise that Daubigny made from his studio boat (see cat. 11). Pissarro, who was influenced by Daubigny at the beginning of his career in the 1860s, painted similar subjects (cat. 8). Français, too, was clearly working in a Daubigny mode in his *On the Riverbank, near Paris* (cat. 1), which was seen in 1861 as an embodiment of a certain idea of France, leading one critic to pun on Français's 'nationalistic' name: '... it is the most indisputable illustration of our national painting. I do not wish to make a bad pun, but Monsieur Français is certainly a French artist par excellence.'[23] The site of Français's idyllic scene, not specifically acknowledged in the title – perhaps to preserve a more generalised archetypal sense of a river landscape – is in fact Bougival, easily accessible from Paris by train.

Fig. 19

Fig. 20

Fig. 19
Jean-Baptiste-Camille Corot
Souvenir of Mortefontaine, 1864, exhibited
at the Salon of 1864, 65 x 89 (25½ × 35)
Musée du Louvre, Paris

Fig. 20
Antoine Chintreuil
Space, 1869, exhibited at the Salon of 1869
102 × 202 (40⅛ × 79½)
Musée d'Orsay, Paris

A decade later, Bougival, together with other nearby villages along the Seine – Louveciennes and Marly-le-Roi – would be colonised by the Impressionists. Although, more often than not, the Impressionists emphasise the contemporary and social aspects of these places (see cats. 64, 68), they could also create timeless and archetypal images of this river landscape (fig. 33, p. 66).

Beside these benign images of France, vast panoramas that evoke the immensity of nature appeared in increasing numbers at the Salon. In 1883 Houssaye noted that artists 'were searching above all for effects of distance, aerial perspective and limpid atmosphere. They included the least number of elements possible within the picture and painted emptiness to create an impression of infinity.'[24] Chintreuil was particularly admired for this kind of subject, and his panoramic canvas, *Space*, 1869 (fig. 20), was praised by the critic Mantz for depicting the magnitude of nature, rather than merely 'photographing' it.[25] Binet's *Edge of the Wood, near Eu (Seine-Inférieure)* of 1883 (cat. 43) ignores the 'picturesque character' that Joanne ascribes to the Eu forest in Normandy.[26] His vast tract of unmodulated terrain breaks with the accepted view of the picturesque, and indeed of composition.

In their search for remote landscapes to paint, the Salon painters travelled widely in France. In this respect they diverged from the Impressionists, who, in the 1870s, were not drawn to remote terrain on a grand scale but to a domesticated nature, integrated with man. Not until the 1880s did some Impressionists begin to seek out a wilder nature: Monet, for example, in his paintings of the Creuse valley and Normandy coast (see cats. 100, 113). In their willingness to travel to far-flung parts of France in search of motifs and to engage with rugged nature, the Salon landscapists conform to an older tradition of the traveller-artist – the illustrators of the *Voyages pittoresques*, or Rousseau and Corot travelling to the French provinces before the age of rail.

The connection between rail travel, tourist guides and Impressionism is evident, since the sites the Impressionists painted – in and around Paris, along the Seine or along the Channel coast – were precisely the

27. See Herbert 1988, chapters 6 and 7.
28. *Paysagistes Lyonnais*, 1800–1900, Musée des Beaux-Arts, Lyon, June–September, 1984, p. 53.
29. *Les Tendances nouvelles*, no. 60, 1913 (?) Musée d'Orsay Documentation.
30. See Joanne 1866, p. 168.
31. Duranty, 14 July 1877, p. 52.
32. Cherbuliez 1876, p. 517.
33. Houssaye 1882, p. 862.
34. Ménard 1870, p. 56.
35. Duvergier de Hauranne 1873, p. 865.
36. Hamel 1889, p. 451.
37. Zeldin 1980, pp. 43–84.
38. Cited in Delouche 1977, p. 184.
39. See Sherman 1989, p. 29 for haphazard distribution of paintings to regional museums under the Second Empire and p. 35 for more systematic allocation of paintings with subjects appropriate to the places they were being sent to in the 1880s.

places recently colonised by tourism.[27] On the other hand, the impact of railways and tourism on the Salon painters is more complex and harder to assess. Trains or other signs of man's appropriation of nature, which regularly appear in Impressionist paintings, are rarely found in Salon landscapes. The train in Français's *Valley of the Eaugronne* (cat. 54) is an amusing exception. Salon artists plainly travelled by train to reach the sites they painted, sites that the Salon audiences would have visited by train, and which featured in the guidebooks. A contemporary railway map, for instance, reveals that Penne, the site of Nazon's remote-looking *The Banks of the Aveyron* (cat. 3) was on the rail route from Figeac to Montauban. And Appian's equally remote-looking *Grey Day in the Marsh of La Burbanche (Ain)* (cat. 14) was painted while he was staying at the Hôtel du Chemin de Fer in Roussillon, Ain, in the marshy countryside to the east of Lyon.[28] Moreover, the sites they painted, especially the more obviously scenic views and historic monuments, coincided with guidebook descriptions and tourist expectations. But, on the whole, the illusion they continued to preserve in their paintings was of nature far from civilisation. Clear examples of this are the many paintings of the Forest of Fontainebleau that present an image of a remote and timeless landscape even though the forest had become overrun with tourists.

Views of the Channel coast that appeared in large numbers at the Salon similarly ignored the invasion of tourism, concentrating instead on the elemental forces of nature. Unlike the Impressionists, who often stressed the contemporary social aspects of the newly developed seaside resorts, Courbet's archetypal image of the Normandy coast, *The Cliff at Etretat after the Storm*, shown at the Salon of 1870 (fig. 21), gives no hint of the resort's popularity. La Villette, who specialised in dramatic views of the Normandy and Brittany shores, wrote in awe of the sea: 'How does one speak of the sea, of its immensity, of its depth, of its rich colour, its movement, its brutal force which carries everything away, and of the brilliant sunlight on its restless waves, a dazzling, indescribable light?'[29] Her view of Dieppe (cat. 50) ignores the casinos and bathing establishments

described at length in all the guidebooks, but concentrates on the elemental grandeur of majestic cliffs and virtually empty beach.[30] Boudin excludes any reference to place in the interests of stressing the elemental effects of weather in *A Squall* (cat. 49), which, apart from the incidental distraction of the boats, recalls Courbet's and Whistler's reductive depictions of sea and sky on the Normandy coast in 1865.

In these views of solitary nature the weather, seasons and times of day, frequently combined with the word *effet* in the title of a painting, were often employed to evoke a particular mood or feeling (see cats. 11, 21). Autumn was by far the most popular season, evening the preferred time of day; and a melancholy, reflective mood pervades many of the Salon landscapes (cats. 3, 47). Duranty, the leading spokesman for the Impressionists, who preferred the luminous conditions of summer and snow (cats. 76, 78), condemned these 'old-fashioned' landscapes for their sunsets and dark lugubrious scenes.[31] However, for Cherbuliez, reviewing the Salon in 1876, the landscapes really capable of capturing *impressions* were not painted by the Impressionists but by the 'great masters' who 'command their brush to tell us what they felt in such and such a place, season, month of the year or time of day; they explain not so much what they have seen as what they have felt'.[32] By 1882 Houssaye was bored with the endless round of seasons and times of day: 'When the landscapist has expressed spring's freshness, summer's ardour, autumn's calm, winter's sadness or, if you prefer, morning's opal mists, midday's dazzling sun, evening's warm dusk or night's cold shadows, he will have said all there is to say. He has only a few tunes to play.'[33]

Increasingly, effects of weather and light were perceived as supplanting traditional forms of subject. Critics noted that the elements of drama formerly found in narrative history-painting could now be expressed through the abstract qualities of light and weather. For Lagrange, Chintreuil was 'this new Wagner, who can create drama from colour and landscape effects alone; from now on the "Crossing of the Red Sea" will be replaced by the "Passage from Dawn to Day"'. For Ménard his paintings were not subjects but 'effects

Fig. 21

Fig. 21
Gustave Courbet
The Cliff at Etretat after the Storm, 1870,
exhibited at the Salon of 1870
133 × 162 (52⅜ × 63¾)
Musée d'Orsay, Paris

of atmosphere'[34]; while Duvergier de Hauranne dismissed him as the painter of 'meteorological landscape'.[35] Like their Romantic predecessors, the Salon painters used extremes of weather to introduce drama into their subjects (see cats. 5, 15).

The prevalence of views of Normandy was part of a trend to exhibit paintings of the different regions of France. By 1889 this trend had become so pervasive at the Salon that Maurice Hamel complained that collectively these regional views 'are only good for an illustrated album of France, a coloured supplement to the Joanne guide'.[36] Although the interest in regional scenes was stimulated by the tourism that such guidebooks supported, the growth of regional awareness touches on deeper issues connected to nationalism and the growth of regional consciousness in opposition to centralisation from Paris.[37]

Brittany, Normandy and Provence were the regions that featured most prominently in Salon paintings during this period. Of these, Brittany and Provence were characterised by remoteness from Paris, a distinctive and rugged terrain, long histories of independence and a separate language and literature. With increasing economic unity in the second half of the century imposed by a centralised administration and aided by the growing communications network of roads and particularly railways, strong regional resistance movements sprung up, especially in Brittany and Provence. The fear that the ease of railway communication would erode the individual character of the regions was deeply felt. Henri Charpentier, the author of *La Bretagne Contemporaine*, an edition of lithographs produced in Nantes in 1865, sent out the following invitation to the inauguration ceremony for the extension of the *Chemin de Fer de l'Ouest* as far as Quimper:

You are invited to attend the funeral cortège of the customs, languages and traditions of old Armorica, deceased today in the nineteen hundredth year of her life – the ceremony will take place tomorrow, 7 September 1863, at the station. Shed a tear for her! On behalf of the children.[38]

Regionalism could also determine the acquisition policy of museums.[39] When the Besançon museum's

40. AN F²¹ 2207.

41. [Jules] Castagnary, 'Fragments d'un livre sur Courbet', Part 2, *Gazette des beaux-arts*, December 1911, p. 495.

42. Cited in André Fermigier, *Courbet*, Geneva, 1961, p. 16.

43. See Wagner 1981, pp. 410–31, for discussion of Courbet's attitude to the commercial market.

44. Lagrange 1864, p. 16.

45. See Dole 1993, pp. 8, 16.

46. See Delouche 1977, pp. 181–3; Zeldin 1980, pp. 54–8.

47. Duret 1912, p. 99.

48. De Laincel 1865, p. 103.

49. Mantz 1872, p. 45.

50. Proust 1882, p. 534.

request for a work by Courbet was turned down by the State, it was given a work by Pointelin, another local artist (see cat. 38).[40]

The Franche-Comté was put on the map at the Paris Salon by the three regional subjects that Courbet had submitted in 1851: *The Burial at Ornans*, *The Stonebreakers* and *The Peasants of Flagey*, inspiring Castagnary's remark: 'One might have said that these were a fragment of the Franche-Comté detached from that robust province and transported to Paris.'[41] The spectacular scenery of the Franche-Comté, with its mountains, waterfalls and pine forests, had appealed to the Romantic sensibility and had inspired one of the best volumes of the *Voyages pittoresques*, published in 1825. Courbet identified strongly with his native region: 'to paint a country (*un pays*) you have to know it. I know my country, and I paint ... go and see it, you will recognise all my pictures' he explained.[42] Trading on the beauty of the area and his identity as a rough-hewn man from the region, Courbet produced views of well-known scenic spots to fulfil the demands of his clientele.[43] One such view, *The Source of the Loue*, 1864 (fig. 22), had been featured as a picturesque site in the *Voyages pittoresques* volume (see fig. 23).

The physicality of Courbet's response to the subject, which critics remarked on, was emulated by another artist from the region, Bavoux, whose rendering of the craggy rocks along the River Doubs caused one critic to note: 'Nature has planted itself on the canvas' (cat. 4).[44] The Franche-Comté's scenic beauty-spots in fact inspired a whole group of regional painters, many of whom were Courbet's imitators. However, an entirely different view of the region is found in Pointelin's reductive paintings of barren Jura hillsides (cat. 38), which owe their almost symbolist resonance to the fact that Pointelin always painted from memory.[45]

Brittany was valued for its remote location and wild scenery, for its long history of independence under the *ancien régime*, and for resisting centralisation and modernisation more than other provinces.[46] Much of its appeal lay, too, in its Celtic origins which offered a compelling alternative to ancient Gaul. Views of the weather-beaten Breton coast, particularly in the western-

Fig. 22

Fig. 23

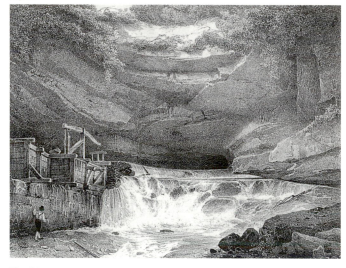

Fig. 22
Gustave Courbet
The Source of the Loue, 1864
100.3 × 132 (39½ × 52)
Albright-Knox Art Gallery, Buffalo, New York
George B. and Jenny R. Matthews Fund, 1959
Fig. 23
The Source of the Loue
Engraving from C. Nodier, J. Taylor and A. de Cailleux, *Voyages pittoresques dans l'ancienne France: Franche-Comté*, 1828, plate 118

most part, Finistère, were widely represented at the Salon. Less common than coastal views, but still substantially represented, were scenes of the Breton interior: Ségé's windswept trees in *The Oaks of Kertrégonnec (Finistère)* (cat. 22), for example, or the broad, open country behind the port of Concarneau by the American painter, Picknell (cat. 37).

Provence, like Brittany, had a strong regional character and a distinctive landscape. It was admired for its brilliant light and, because of its position in the Mediterranean, its associations with the classical world. A strong separatist movement, led by the poet Frédéric Mistral, was committed to preserving the local language, Langue d'Oc, and the long tradition of regional poetry. An important school of Provençal painting had been established at Marseille under Loubon in the 1850s and both Aiguier (cat. 9) and Guigou (cats. 2, 19) had emerged from this context. For the critic Théodore Duret, Guigou was steeped in the landscape of Provence; unlike the northern painters who came to the south but exaggerated the bright colours, he had a profound understanding of the character of the place. 'He had painted his land like a man who has entered right into it, who had made it the object of constant observation, who seized its soul.'[47]

In the 1860s Provence developed as a tourist area and became a popular winter residence for affluent northerners. It also attracted artists, and in 1865 Louis de Laincel, a critic from the south, noted the large numbers of Provençal landscapes at the Salon that year, but regretted that painters always chose the best-known motifs.[48] Cézanne worked in his native province from the 1860s onwards (see cats. 88, 102, 103), Renoir settled in the south in the 1880s (cat. 105), Monet painted at Antibes in 1888 (cat. 112) and Harpignies spent his winters there during the 1880s.

Throughout the period under discussion critics consistently saw landscape painting in opposition to the city. However, from the early 1870s a counterview that valued modern urban subjects began to emerge in critical debate. In 1872 Paul Mantz praised those artists who were capable of discovering poetry in such banal subjects as Paris and its surroundings.[49] A decade later Antonin Proust went so far as to state that artists had a duty to record for posterity the subjects of their own time, however ugly these might be.[50]

The result of this shift in attitude is seen in a steady increase in views of Paris throughout the period. Many of the urban views that appeared in the Salon followed a topographical tradition that favoured the city's well-known landmarks. In *The Place de la Bastille in 1882* (cat. 39) Boggs used a wide perspective and dramatic weather to highlight the historical symbolism of the famous Republican monument: the July Column. But as well as such obviously conventional Parisian views, paintings of the unpicturesque *terrain vague* on the industrial outskirts of the city – an area that avant-garde artists such as Seurat and Signac were simultaneously exploring – became acceptable at the Salon. Billotte's view of the dreary landscape at the city's edge, *Winter Fog at the Porte de Courcelles* (cat. 56), is one such example.

The acceptance of contemporary urban subjects at the Salon in the 1880s signified an important break with the attitudes that had prevailed for most of the previous two decades. In the 1860s and 1870s the paintings accepted by the Salon had, in different ways, reinforced links with tradition and excluded references to modernity. The loss of faith in the value of tradition, combined with the Salon's declining authority after its break with the State in 1880, meant that the assumptions on which it had been based ceased to have meaning.

Herbivores versus herbiphobes: landscape painting and the State

Jane Mayo Roos

In the later nineteenth century landscape painting could be read from two opposing points of view. For its supporters, the landscape image represented the most salutary aspects of modern life: in its avoidance of grandiose themes it promised the end of an elitist structuring of the world, and in its embrace of everyday experience it augured the advent of a new social equality. For its detractors, landscape painting signified the erosion of the great traditions of the past: in rejecting figural representation it announced the decline of humanist values, and in focusing on natural elements it assumed the threatening aspect of a world turned upside down. From one point of view, landscape painting provided a necessary corrective to the authoritarian mores of the times; from the opposite extreme, the genre was disdained as an unruly, weed-like growth that had invaded the precincts of high art.

Throughout the period covered by this exhibition an aesthetic hierarchy continued to affect the reception of pictorial art. Inherited from an earlier age, this hierarchy attached the greatest significance to history painting, which was followed in descending order by portraiture, genre, landscape and still life. History painting and portraits were the most highly regarded because of the importance they gave to the human figure. Genre painting fell lower in the hierarchy because, although it depicted the actions of human beings, the protagonists were generally anonymous and the narrative setting familiar and prosaic. Landscape and still life came last because in these types of painting the figures tended to be small in scale or absent entirely.[1]

By the later nineteenth century the landscape subject took many different forms, as the works in this catalogue demonstrate. The 'pure' landscapes of Harpignies and Ségé (cats. 29, 22), the agrarian views of Binet and Donoho (cats. 43, 40) and the poetic images of Chintreuil and Corot (cats. 15, 25) give some idea of landscape painting's range. Gathering popularity through the century was a contemporary variant of the landscape subject, one that focused on the French city or suburb and depicted present-day figures and nineteenth-century architecture. Stylistic differences also distinguished landscape paintings from one another; the delicate brushwork, muted palette and soft lighting of Corot's *Near Arras* (cat. 25), for example, form a marked contrast to the broad strokes, earth colours and particularised light and shade of Pissarro's *Chennevières, on the Banks of the Marne* (cat. 10).

However, the differences between one landscape painting and another tended to assume less importance than the discursive implications of the genre as a whole. Listen to Charles Blanc, as he explained the difficulties that landscape painting posed, in his review of the Salon of 1866. At the time Blanc was one of the most influential writers on the visual arts; he was a passionate defender of traditional painting and an ardent supporter of heroic, figural works.[2] Though his criticism is often devalued today because he supported the 'wrong' side in the modernist-traditionalist conflict, he was an articulate analyst of the complexities of contemporary art. Landscape painting clearly troubled him:

Without getting into a quarrel with critics who are in love with equality in art, we will gently remind them that there is a gradation in the kingdoms of nature, and that if the purpose of art is to express life – this is precisely their way of defining it – the human figure is the most exalted image that an artist can propose for a model, because it sums up all prior creation. Filling the immense space that separates intelligence from vegetation, it manifests the highest degree of life, which is to say thought ... it is impossible to equate, to give equal merit to, landscape and the human figure.[3]

Blanc was not the only writer to find landscape deficient in this respect. Charles Baudelaire, the critic who might seem Blanc's antithesis in his attitudes towards modernist works, had similar reservations about the landscape subject. Baudelaire could never bring himself to accept a form of art that lacked a dominant human presence, nor could he appreciate the humble character of a natural view: 'you see, my dear friend,' he wrote in 1859, 'I can never regard the choice of subject as a matter of indifference.' Landscape painting was, for Baudelaire, the work of artists who were 'far too herbivorous' in their tastes and whose penchant for this 'foolish cult of nature' was symptomatic of a general decline in the visual arts.[4]

With figural and historical works setting the

Jean-Baptiste-Camille Corot
Near Arras
detail of cat. 25

1. The hierarchy pervaded contemporary criticism as well, and many *salonniers* used this conceptual framework to structure their reviews of the exhibition.

2. Blanc founded the *Gazette des beaux-arts* in 1859; his *Histoire des peintres de toutes les écoles* appeared in fascicles between 1848 and 1876; and his popular *Grammaire des arts du dessin* was published in 1867.

3. Blanc 1866, pp. 503–4.

4. Baudelaire 1859, in Baudelaire 1961, pp. 1077–84.

5. *Ibid.* pp. 1081, 1084.

6. See Galassi 1990, Herbert 1962 and Chu 1990. Galassi and Chu both estimated that all through the early part of the century between twenty-five and thirty per cent of the works at the Salon were landscapes (Galassi, p. 241, Chu, p. 116). See also Rosenthal 1914, Dorbec 1925, Herbert 1970, Los Angeles 1984, Green 1990, and the essays by K. S. Champa and F. S. Wissman in Champa 1991.

7. Zola, 'Mon Salon' [1868], 1991, p. 213.

8. Castagnary, 'Philosophie du Salon de 1857', 1892, I, p. 17.

9. Du Camp, 'Salon de 1864', 1867, p. 73.

10. Chesneau 1868, pp. 261–2.

11. See also Fromentin's monograph of 1875, reprinted in 1984, p. 718; on Fromentin's critical writings, see Schapiro 1994, pp. 103–34.

12. Du Camp, *op. cit.*, p. 74.

13. Castagnary, 'Salon de 1863', 1892, I, p. 140.

14. Castagnary 1866.

15. About 1867.

16. Because the title of the ministry of fine arts changed repeatedly, I have used the uncapitalised, generic designation 'ministry of fine arts' in this essay. In discussing the various groups that controlled the production of art in the period, I have purposely used masculine designations because the administrators, academicians and Salon jurists were exclusively male.

17. On the art policies of the Second Empire, see Boime in Weisberg (ed.) 1982, pp. 31–123 and Mainardi 1987. On the role of ministers during the Second Empire, see Plessis 1979, pp. 37–48.

18. On Vaillant's ministry, see Chennevières 1883–9, I, pp. 3–4.

standard, landscape paintings left a lot to be desired. They lacked the nobility associated with depictions of the human figure, and they had none of the erudition of subjects drawn from a historical text; they did not require the type of training provided by the Ecole des Beaux-Arts, and they challenged the communal values on which the Ecole's conventions were based. In the estimation of critics like Baudelaire, landscape painters lacked imagination and, through sheer laziness, produced pedestrian sketches that merely copied the natural world (see fig. 24).[5]

Yet landscape painting had become increasingly popular with the public and with a growing number of artists.[6] By the 1850s railway transport had greatly facilitated travel, and rampant urbanisation had encouraged a taste for the joys of country life. Writers of the period frequently alluded to the idea that nature and the natural view offered a peaceful retreat from the stresses of modern life. As Emile Zola observed in 1868: 'times have changed very much ... We walk in the fields, our nervous systems a wreck; we are impressed by the smallest breath of air, interesting ourselves in the bluish ripples of a lake, in the rose tint of a corner of the sky.'[7] For Castagnary the quiet of the countryside offered solace from the hubbub of everyday life: 'bruised by the tumult of the world, poets and dreamers take refuge in the peace of the fields, in the contemplation of a nature that is calm and serene.'[8] For Maxime du Camp landscape painting and the love of nature were responses to 'the painful realities and poignant sorrows' of the times.[9] And for Ernest Chesneau 'the grandeur' of landscape painting derived from the artist's ability to depict the countryside 'as a place of asylum, apart from the devouring activity, the continuous fever of the city'.[10]

Imbedded in landscape painting were significant ideological issues that catapulted the controversy out of the realm of aesthetic discourse. Blanc's opposition to the genre, related earlier, hints at the deep-seated values that inflected the landscape view. In alluding to 'equality in art', he connected landscape painting with democratic ideas, and his criticism slips from aesthetics to ideology. His reference to 'a gradation in the kingdoms of nature' implies that man stands at the apex of creation,

according to the Christian view; only the misguided critic, seduced by 'equality', could imagine that the depiction of vegetation could ever equal the depiction of the human form.[11]

Many writers interpreted landscape painting according to the same criteria and, regardless of their attitudes towards it, expressed their arguments in similar terms. In 1864 du Camp addressed the 'invasion' of landscape painting that had recently taken place. He viewed the phenomenon as a positive development, which had produced 'the only truly fertile school' in modern France. He connected the origins of the genre with the reawakening of 'bucolic desires' that preceded the revolution of 1789, and identified socialism as an important factor in landscape's popularity. By promoting 'a vague and consoling pantheism' socialism had 'taught artists that God is everywhere, in trees as in men, in animals as in plants.'[12] Castagnary also interpreted landscape as a phenomenon with political and social roots. For him, the naturalist 'revolution', of which landscape painting was the first manifestation, sprang from the philosophy and politics of the age, which took 'the equality of individuals' as its first principle and worked towards the levelling of 'false hierarchies'.[13] In Castagnary's eyes, landscape painting had nationalistic connotations as well: it enabled artists 'to take possession of France, its soil, air and countryside'. With landscape, France had developed an indigenous form of art, capable of reflecting the country's 'essential character'. Grounding itself 'in contemporary society', the naturalist landscape was 'in perfect harmony with our literature, our philosophy, our politics and even our ethics'.[14] Edmond About expressed the matter more concisely when he wrote that 'the theory of landscape and politics is the same. It can be summed up in one single word, the proudest and sweetest in our language: freedom.'[15]

The Second Empire

Landscape painting's association with modernity and democracy influenced State policy. During the 1860s, in the last years of the Second Empire, three groups of men exerted the greatest influence on artistic practice

Fig. 24

Fig. 24
Honoré Daumier
Landscapists at Work, 1862
32 × 44 (12⅝ x 17⅜)
The Metropolitan Museum of Art, New York
Harris Brisbane Dick Fund, 1928

in France: the ministry of fine arts, the Academy of Fine Arts and the jury for the spring Salon.[16] Each group had a different set of vested interests and each a different kind of power. As landscape painting grew in popularity with the public, the art world became increasingly divided over its acceptance as a form of art. The Academy was overwhelmingly herbiphobic, while the imperial administration vacillated in its policies as it struggled to extend its power. As the decade progressed landscape painters secured greater prominence on the Salon jury, but their ascendancy came to an abrupt halt when the empire fell in 1870.

In the 1860s the ministry of fine arts was a tightly structured bureaucracy, which answered directly to Napoleon III. Though words like 'the state', 'the government' and 'the administration' conjure up the image of an enormous political machine, with countless contributory parts – anonymous, faceless and interchangeable – in reality a small group of individuals had the power to determine the country's policies. Heading the ministry, and appointed by Napoleon III, was the Maréchal Vaillant, who became the Minister of the Imperial House and of the Fine Arts in 1863. Like all ministers in the Second Empire, Vaillant functioned as an instrument of imperial power, rather than an independent, autonomous executor.[17] Though he signed the major documents issued by the ministry, he was essentially a politician and a spokesman for Napoleon III.[18]

Directly beneath Vaillant, and actually formulating much of the administration's policy, was Alfred-Emilien de Nieuwerkerke, the Superintendent of Fine Arts (fig. 25). An appointee of Napoleon III, and the elegant consort of the Princesse Mathilde, Nieuwerkerke directed the fine-art services during most of the Second Empire. As an administrator he was autocratic and mercurial, and his first priority was to bring the fine arts under government control. The *Souvenirs* of Philippe de Chennevières, who worked with Nieuwerkerke in the 1850s and 1860s, lovingly recall the weekly receptions that were an important part of Nieuwerkerke's social calendar:

19. Chennevières 1883–9, II, p. 90.
20. Quoted in Bouret 1973, pp. 19–20.
21. Speech given by Nieuwerkerke at the awards ceremony following the Salon of 1863, reprinted in the catalogue for the Salon of 1864, pp. xii–xv. On Nieuwerkerke's administration, see Green 1987, pp. 71–84 and Mainardi 1987. In *Early Impressionism and the French State*, to be published by Cambridge University Press, I examine administrative policy (1866–74) at length.
22. The Academy was the fourth division of the Institut de France; the standard history of the Academy is Delaborde 1891.
23. The rules specified that the applicants must be French bachelors under the age of thirty at the time that year's competition began; see Grunchec 1984, pp. 25–8.
24. See Grunchec 1984; Boime 1986; and Beulé 1863, pp. 916–38.
25. See the differing theories about the early phase of the Prix de Rome in historical landscape in Boime 1986, especially pp. 134–47; and Galassi 1990, especially pp. 237–8. The classic explication of the historical landscape is Valenciennes [1800].
26. Writing about the competition in 1861, Paul Mantz criticised Girard's *The Procession of Silenus* (fig. 8) and the paintings of other highly ranked competitors on just this count: 'The sky, the water, the trees, the colour and the light – everything is false, everything is chimerical in these so-called landscapes, whose only analogue is the wallpaper that can still be found in the dining-rooms of certain provincial inns'. Mantz 1861, p. 466.
27. In semiotic terms, naturalistic landscape elements functioned as iconic signs, which implied the existence of real-world referents, whereas the figural and architectural elements that were an important part of the historical landscape remained generated from the realm of the symbolic. See Peirce 1985.
28. Zola, 'Mon Salon' [1868], 1991, p. 212.
29. Throughout the essay I have referred to the Salon jury for the painting section only; there were also juries for sculpture, architecture and prints. The number of artists who made up the painting jury varied throughout the period, from nine in 1864 to eighteen in 1866 and 1870. In the 1870s the number remained constant, at fifteen.
30. The estimate on attendance is based on figures from the Archives du Louvre for the Salon of 1866, according to which 297,218 people had visited the exhibition (Dossier X, Salon of 1866). At the awards ceremony following the Salon of 1876 Minister Waddington set the number of Salon visitors that year at 518,892 (catalogue for the Salon of 1877, p. v). In a speech given by Nieuwerkerke in 1863, he estimated that between 30,000 and 40,000 people attended on Sundays, when admission to the exhibition was free (reprinted in the catalogue for the Salon of 1864, p. xii).

One has no idea how much people coveted invitations to those famous Fridays at the Louvre: how much the artists seemed delighted to rub elbows as equals with the greatest names of the chic faubourgs, and how much, in their turn, people of the world – foreign diplomats as well as men of the court and the old legitimists who had remained faithful to the superintendent – seemed enchanted to mix with the world of the arts and to have the chance to chat with painters and sculptors whom they had only known by reputation.[19]

As a man who loved power and social position, Nieuwerkerke had little tolerance for paintings that depicted the modest beauties of the natural world. Faced with landscapes of the Barbizon school, he is supposed to have said: 'It is the painting of democrats, of men who never change their linen, and who want to force themselves on the fashionable world. This art displeases and disgusts me.'[20] Though the comment may well be apocryphal – it has the exaggeration and punch of a caricature – his documented statements on the arts demonstrate a similar negativity. In a speech after the Salon of 1863 he noted with regret the increasing number of landscape painters, 'our prodigal sons', and went on to reassure the audience that landscape painting posed no threat because the administration would 'always be partial to *le grand art*'.[21] However, Nieuwerkerke was also a pragmatist, and in his attempt to exert government control he sometimes introduced policies that benefited the artists whose works he disliked.

In the early 1860s the Academy was the one institution whose power rivalled Nieuwerkerke's own. A division of the French Institute, the Academy comprised an elite corps of fifty men: fourteen painters, eight sculptors, eight architects, four engravers, six musicians, and ten 'free' academicians (the latter consisting primarily of museum administrators and writers on the arts).[22] The Academy was a self-contained society that elected its own members, all of whom served for life. It directed the Ecole des Beaux-Arts, the state training school for the visual arts, and served as the jury for the Salon, the government's exhibition of contemporary art. It also supervised the competitions for the Prix de Rome – given annually in historical painting,

sculpture and architecture – which sent young male artists to study at the Villa Medici.[23] In 1816 the Academy had introduced a Prix de Rome in *paysage historique* (historical landscape), but the competition was limited to once every four years.[24]

The purpose of the award seems to have been to absorb landscape into the realm of heroic art by promoting an ennobled, classicising variant of it.[25] However, as landscape became an increasingly popular genre, naturalism began to invade the *paysage historique*. In a sense the format of the Prix de Rome contained the seeds of its own destruction: in one phase candidates were required to produce a tree 'portrait', and were thus encouraged towards naturalism, but in another they were required to depict an imagined and imaginary *paysage historique*. By the 1860s the conflict between historical and landscape elements had become impossible to resolve. On the one hand, idealised and imaginative foliage, which formed the appropriate *mise-en-scène* for mythological or biblical figures, looked old-fashioned and out-of-date.[26] On the other, naturalistic foliage was inconsistent with an invented narrative, the specificity of the vegetation being at odds with the idealisation of the figures.[27] The historical landscape thus asked the viewer to accept an irreconcilable set of visual codes, and by 1868 Zola could write that 'the classical landscape is dead, killed by life and killed by truth.'[28] With its own variant of landscape painting virtually impossible to maintain, the Academy grew yet more intolerant of the genre as a whole.

The third group of men with the power to influence the fate of landscape painting were the dozen or so artists who served as the jury for the Salon.[29] Throughout most of the nineteenth century the Salon maintained a position as the pre-eminent venue for the exhibition of contemporary art. Held in the newly constructed Palais de l'Industrie, it included an average of 4,000 works and opened in May to extensive coverage in the press. Part market-place and part entertainment, the Salon drew 300,000 to 500,000 visitors during the six weeks it remained open, many attending on Sundays when admission to the exhibition was free (figs. 26, 27, 28).[30]

31. Letter from Renoir to Durand-Ruel, March 1881, in Venturi 1939, I, p. 115.

32. In their sociological study of French cultural institutions in the second half of the nineteenth century, White and White estimated that among 'serious professional painters in the Paris orbit' about one-quarter received Salon medals, less than one-fifth were elected to the Legion of Honour, and about one in a hundred were elected to the Academy of Fine Arts (1965, p. 20). Statistics gathered by the government in 1858 indicated that there were 948 living artists who had received medals or been decorated with the Legion of Honour (report by Frédéric Buon in the office of fine arts, November 1858, AN F21 487). Making up this total were 692 painters, 155 sculptors and engravers of medallions, and 101 printmakers. According to a later report by Buon, in 1869 there were 1,426 recognised artists, 478 of whom were members of the Legion of Honour (428 French and 50 foreigners, 20 October 1869, AN F21 531).

33. As late as 1879 landscape painters protested against this aspect of the Salon. A letter to the government, published in *La Chronique des arts* (15 February 1879, pp. 49–50) objected to the regulations for the Salon, stating that first-class medals were 'generally given to large works or to history painting' and that there were 'very few examples of first-class medals given by the jury to painters of genre, of landscape or of still life'.

Fig. 25

Fig. 26

Fig. 25
Portrait of Count de Nieuwerkerke, 1856,
by Jean-Auguste-Dominique Ingres
Graphite and chalk on paper, 33 × 24.3 (13 × 9½)
The Harvard University Art Museums. Bequest of
Grenville L. Winthrop

Fig. 26
The Palais de l'Industrie and the Champs-Elysées,
by Maxime Lalanne
Engraving from *Paris-Guide*, 1867

Exhibiting at the Salon was an economic necessity for artists in the nineteenth century. Paris had a growing number of art galleries in the 1860s – those of Louis Martinet and Paul Durand-Ruel among them – but the size of the Salon's public, combined with the reviews it generated in the press, meant that there was little competition from other venues. In the increasingly democratic society of the period, knowledge of the visual arts carried social cachet, but the newly-monied middle class tended to approach the buying of art with an edgy insecurity that clung to the judgements of the Salon's jury. As Renoir described the situation in 1881: 'in Paris there are scarcely fifteen people capable of liking a painter who doesn't show at the Salon. There are 80,000 who won't buy so much as a nose from a painter who is not hung at the Salon.'[31] Thus exhibiting at the Salon was far more important than showing one's work in the galleries of a private dealer.

In addition to the hierarchy in subject matter, there was also a hierarchy among the Salon's exhibitors. First-, second-, and sometimes third-class medals were given, which enhanced an artist's reputation and raised the value of the works. Furthermore, with the winning of Salon medals an artist became eligible for the Legion of Honour and could rise through the ranks from Chevalier, to Officer, to Commander. The result was a pyramid of power: at the top stood the academic elite, below were the members of the Legion of Honour, and below them the artists who had achieved Salon awards. Standing outside the hierarchy, and often manoeuvring to get in, were the thousands of artists who lacked official credentials.[32]

In the 1860s the situation of the landscape painter at the Salon was an ambiguous and precarious one. Like women artists, landscape painters found that their works were accepted for exhibition and were sometimes purchased by the State or recognised with an award. However, landscapists and women alike were pointedly excluded when it came to the highest levels of distinction: the first-class medals, the Legion of Honour and the Academy.[33] This neglect restricted their reputation with the public, lowered the value of their works and denied them full participation in the Salon process.

The jury for the Salon reviewed all works submitted

34. On the Salon of 1863, best known for the Salon des Refusés installed that year, see Rewald 1973, chapter III; Wildenstein 1965, pp. 125–52; and Boime 1969, pp. 411–26.

35. The *règlement* for the Salon of 1863 is in AN F[21] 529; the decree of 13 November 1863 was published in *Le Moniteur universel* (the newspaper of record) and reprinted in the *Gazette des beaux-arts*, December 1863, pp. 563–72, preceded by a report signed by Nieuwerkerke.

36. In addition to establishing an elected jury, Nieuwerkerke made the Salon annual once again (it had been biennial since 1853). This in itself was a liberal measure. A biennial exhibition encouraged conservativism: if an artist's works were turned down, it would be at least four years before their work was seen again at the Salon.

37. The documents for the Salons of the 1860s are found in AN F[21], 528 through 532, and in the Archives du Louvre, Dossier X. The *règlement*, the official statement of the rules, was reprinted at the beginning of each Salon catalogue; from 1864 onwards the results of the jury election were also reprinted in the Salon catalogue.

38. In 1866 Gérôme headed the list with 181 votes; Daubigny came in fifteenth place with 105, while Théodore Rousseau received 49 votes.

and, unless an artist was exempt, had the power to determine whether a painting was shown. From 1857 to 1863 the jury was composed exclusively of members of the Academy, the six musicians excepted. For the Salon of 1863 only eight academicians consented to participate on the painting jury, out of a possible fourteen members of this section of the Academy.[34] The number of rejections that year – estimates range from sixty to seventy per cent – unleashed deep resentment against the Academy and threw the art world into a state of civil war: the Academy and its supporters versus the thousands of non-affiliated artists.

Nieuwerkerke responded by attempting to realign the balance of power by means of a drastic curtailment of the Academy's responsibilities. In August 1863 he decreed that the Academy would no longer serve as the jury for the Salon, and in November he cut more deeply still: he removed the Ecole des Beaux-Arts from its jurisdiction, rescinded its right to judge the Prix de Rome and abolished the competition for historical landscape.[35] Instead, he centralised power in the hands of the State, placing the Salon, the Ecole and the Prix de Rome under the control of his administration.

Having loosened the Academy's hold, Nieuwerkerke relaxed the regulations for the Salon's jury in ways that significantly affected the landscape painter's situation. In 1864 he decreed that the jury would be chosen by election, though he limited the franchise to artists who had received public recognition for their works: members of the Academy or the Legion of Honour and artists who had won medals at the Salon.[36] And yet, even with this restricted electorate, it was now possible – for the first time in ten years – for a landscape painter to serve on the Salon's jury. Français, Corot and Fromentin were elected in 1864.[37] It was the thin edge of the wedge.

In the following years Nieuwerkerke further reformed the regulations. In 1866 he doubled the jury's size. This measure favoured 'fringe' candidates and Daubigny was elected in addition to Français, Corot, and Fromentin; Théodore Rousseau, whose works had been routinely excluded from the Salon between 1836 and 1847, gained enough votes to serve as an alternate.[38] With the loosening of the administration's policies,

Fig. 27

Fig. 28

Fig. 27
The Grand Salon Carré (the Salon d'honneur) at the Salon of 1863
Engraving, Cabinet des Estampes, Bibliothèque Nationale, Paris

Fig. 28
Varnishing Day at the Salon, 1866
Engraving, Cabinet des Estampes, Bibliothèque Nationale, Paris

39. The petitions are found in the Archives du Louvre, Dossier X, Salon de 1867.

40. The number of painters who participated in the process jumped from about 223 in 1864 to about 839 in 1868. These figures were taken from documents in the Archives Nationales (F²¹ 529 and F²¹ 531).

41. On the basis of records in the Archives Nationales, it can be deduced that in 1866 the jury accepted seventy per cent of the works; in 1867, when the Salon coincided with the Exposition Universelle in Paris, the jury accepted fifty-six per cent; and in 1868 they admitted eighty-three per cent (AN F²¹ 531).

42. Castagnary, 'Salon de 1868', 1892, I, p. 254. Castagnary's figures seem to have been a little off the mark; according to the Salon catalogues, the Salon of 1868 contained 1,468 more works than the Salon of the previous year.

43. The eighteen candidates were Bonvin, Chaplin, Chintreuil, Corot, Courbet, Daubigny, Daumier, Dumaresq, Frère, Amand Gautier, Hédouin, La Rochenoire, Leleux, Manet, Millet, Ribot, Vollon and Ziem. On the campaign of these artists in 1870, see Crapo 1990. Documents relating to the group and to the Salon of 1870 are found in Papiers de Courbet (Boîte 2) and SNR Manet (Boîte 5), Cabinet des Estampes, Bibliothèque Nationale; and in AN F²¹ 532.

44. See Fidell-Beaufort and Bailly-Herzberg 1975, p. 65.

45. On the early Third Republic, see Bury 1973; Cobban 1965; Edwards 1971; Halévy 1937; Joughin 1955; and Mayeur 1973.

46. On the renewed significance of academic painting in the 1870s, see Mainardi 1993.

artists pressed the State for further reforms; in 1867 they signed petitions and forced Nieuwerkerke to meet and discuss their demands. The artists who were active in these efforts included Monet, Renoir, Pissarro, Sisley, Guillemet, Laurens and Daubigny.[39] In 1868 Nieuwerkerke acceded to their demands and broadened the electorate further: he enfranchised all artists who had previously exhibited at the Salon. This policy came close to universal suffrage, and the number of painters who voted quadrupled. Daubigny soared to first place in the elections, surpassing all Academy members.[40]

The reforms of 1868 resulted in the most liberal exhibition since the Second Republic. The jury accepted a higher percentage of submissions – eighty-three per cent as opposed to fifty-six per cent in 1867 – and put 4,200 works on view.[41] In his remarks on the Salon Castagnary described Nieuwerkerke's displeasure at the fact that the jury had accepted so many works. The culprit, in Nieuwerkerke's eyes, was Daubigny:

M. de Nieuwerkerke blames Daubigny for everything. If the Salon this year is the way it is, a Salon of newcomers; if its doors have been opened to almost all of those who sent works; if it contains 1,378 more works than the Salon last year; if, in this overflow of free painting, the painting of the State makes a poor showing, it is Daubigny's fault.[42]

In the last years of the empire the country lost confidence in the government of Napoleon III and demanded that his cabinet be held accountable. The politically liberal Maurice Richard replaced Vaillant as the minister of fine arts, and Nieuwerkerke was forced to relinquish his control of the Salon. Artists began to realise that they could band together effectively and, through the power of numbers, secure even greater representation on the Salon's jury. In 1870 Corot, Daubigny and Jules La Rochenoire – along with Courbet and Manet – were instrumental in promoting a slate of candidates, largely made up of landscape and genre painters.[43] In the run-up to the election they printed ballots, issued a manifesto and persuaded newspapers to publicise their campaign. When the voting was over Daubigny and Corot headed the roster of jurors, which included Millet, Fromentin and Ziem. Elected as alternates were Vollon, Courbet and Chintreuil.

The jury for the Salon of 1870 was an explosive mixture of academicians at one extreme – Gérôme, Robert-Fleury, Cabanel, Pils, Cabat and Meissonier – and landscape painters at the other. Monet's work caused the most serious conflict, and when the majority voted to reject his work Daubigny resigned in frustration, followed by Corot.[44] And yet, though the Academy could still ostracise painters whose works they disliked, the Salon of 1870 was a remarkable demonstration of the ability of landscape and genre painters to act together and promote their own interests. In the seven years since 1863 the makers of 'a lesser sort of work' had managed to invade the Salon's jury, enlarge the exhibition and challenge the Academy's power. However, soon after the exhibition had closed the country found itself at war with the Prussians, and by the time the next Salon was held a very different atmosphere prevailed and the State had no interest in continuing the movement towards reform.

The Third Republic

The Third Republic was formed in the shadow of the Franco-Prussian War. On 1 September 1870 Napoleon III was captured at Sedan, and three days later a provisional government was declared. Through the autumn and winter of 1870–1 the Prussians held Paris under siege, and in January the war came to an end; Prussia was declared victorious and the French forces retired in defeat. With the Prussian conflict barely over, the city of Paris erupted in civil war: from March until May the politically radical Commune fought government troops with a brutal intensity unprecedented in the country's history. In the Commune's final week an estimated 20,000–25,000 people were killed.[45]

In terms of state policy the 1870s were dark years for landscape painters. As France struggled to recover from the catastrophes of 1870–1, its government found some consolation in a sense of continuity with the artistic traditions of the past. Heroic, historical works best suited the post-war mood and assumed an intensely nationalistic significance.[46] Landscape painting's connotations of individualism were far too disturbing for the government, which sought to promote an image

Fig. 29

Fig. 29
Caricature of Charles Blanc
Pastel by Felix Nadar from *Le Panthéon Nadar*
Cabinet des Estampes,
Bibliothèque Nationale, Paris

47. The principal documents for Blanc's administration are in AN F[21] 492–5B; and for the Salons of the 1870s in F[21] 524 and 533–8.
48. On Blanc, see Mantz 1882; Fiaux 1882; Massarani 1885; Chennevières 1883–9, I, pp. 86–98; Song 1984; Zimmermann 1989, pp. 199–209; and Mainardi 1993.
49. Himself an academician, Blanc shared the Academy's conservatism, and during his tenure the Academy regained control of the Prix de Rome and the curriculum at the Villa Medici. The decree concerning the Academy was dated 13 November 1863 – a pointed reference to Nieuwerkerke's infamous decree of 13 November 1863 (*Journal officiel*, 9 December 1871, p. 1855). See Mainardi 1993, especially pp. 37–42.
50. Blanc, 'Rapport au Ministre de l'Instruction Publique et des Beaux-Arts', 1871, pp. 5070–1, reprinted in the Salon catalogue of 1872, p. cxxv. By 'decorative art' Blanc meant works produced for public projects

of community and accord. Moreover, many of the century's best-known landscapists had died: Constant Troyon in 1865, Théodore Rousseau in 1867, Huet in 1869, Corot and Millet in 1875, Diaz and Fromentin in 1876 and Daubigny in 1878. Courbet, ostracised from the Salon of 1872, fled to Switzerland in 1873 and died in exile in 1877.

During these years the Third Republic was dominated by monarchist politicians and was extremely unstable in its executive structure. Cabinets rose and fell, ministers waltzed in and out of office and few in government expected the Republic to survive. In the administration of fine arts, the head of the fine-arts office was often the only thread of continuity from one cabinet to the next, and he enjoyed wide latitude in the implementation of his policies.

Under the government of 4 September 1870 Charles Blanc was appointed to head the administration of fine arts, as 'Director of Fine Arts' (see fig. 29).[47] Though considered a populariser, in the sense that he made the fine arts accessible to a broad public, the goal of his administrative policy, as of his writing, was to educate the public to appreciate 'great art', rather than reforming the arts or making them more democratic.[48]

Landscape painting found little sympathy in Blanc's policies, as was to be expected from the man who had written that it was 'impossible to equate, to give equal merit to, landscape and the human figure'.[49] In December 1871 he announced the position of the new government regarding the problems of the Salon. In a much-anticipated report he declared that it was the State's duty to promote heroic art, which he defined as 'monumental architecture, decorative painting, grand sculpture and classical engraving'. He stressed that the Salon played a crucial role in conveying and promoting the State's policies, and he defined its purpose as being to put on public view 'not familiar, anecdotal, intimate art, which addresses itself to the individual, but decorative art, which interests everyone'.[50] To this end he reinstated the restrictions on voting for the jury, limiting the electors to artists who had won a Salon medal, and exhorted the jury to be 'severe': to accept fewer works for exhibition and prevent the Salon from resembling 'a bazaar'.

51. Blanc, catalogue for the Salon of 1872, p. cxxvii.
52. Petition addressed 'A Monsieur le Président de la République', with covering note dated 23 February 1872, AN F21 534 (which contains other letters of protest as well); Blanc's response F21 535.
53. See, for example, the lavish catalogue of artists' works produced by the Galerie Durand-Ruel in 1873, which included a preface by Armand Silvestre.
54. See Green, March 1987, pp. 59–78, and House 1986, pp. 10–13.
55. Alexis 1873.
56. The designation was actually formulated by MacMahon in his inaugural address; see Mayeur 1973, p. 27. MacMahon had been the commander-in-chief of the armies of Napoleon III and had led the suppression of the Commune in 1871.
57. On Chennevières and his administration, see especially Champier, 14 February 1878, p. 247; Duval 1899, pp. 65–75; Lafenestre 1899, pp. 397–412; and Roujon 1912, pp. 6–39. After he was forced to resign Chennevières thoroughly documented the years of his administration in his *Souvenirs*, though much of what he wrote slants history in his own favour. On his administration, see Roos 1989, pp. 53–62, and Mainardi 1993. Many of the documents relating to Chennevières's administration are reproduced in his *Souvenirs*. His files in the Archives Nationales are, however, noticeably thin, the most important dossier being F21 4758.
58. Chennevières, 'Rapport à Monsieur le Ministre de l'Instruction Publique, des Cultes et des Beaux-Arts', 28 February 1874, AN F21 4403; and 'Décoration de l'Eglise Patronale de Ste Geneviève', undated description of the project, AN F21 4403.

Blanc stated outright that, while the government would support the exhibition of 'great art', it was the artists' responsibility to organise individual or group shows that would serve their commercial interests:

As to an exhibition designed to attract buyers, this belongs to the artists' private or collective initiative. If it suits them let them form themselves into a society, as the English painters have done, and devote themselves to the care of their affairs, and the Government will do all in its power to help them, in order to avoid breaking too brusquely a habit formed a long time ago.[51]

The implication of Blanc's report was clear: that the liberalism of the 1860s was over and that the State would run the Salon as a small, prestigious exhibition, which would contain only the most noble, most elevated art. Landscape and genre painters were put on notice, warned that they would receive little or no support from the current administration.

The announcement of the new policies, particularly shocking because it came from a nominally Republican administration, had immediate repercussions. First, there were vehement protests against the administration's focus on heroic, monumental art. One set of petitions – sent directly to the President of the Republic – reminded the administration that, in addition to decorative artists, France possessed 'a brilliant legion of genre painters and landscapists, numerous and growing each day', whose careers would be greatly harmed by the new regulations. A second petition requested that the rejected works be put on view. Among the signatories were Daubigny, Corot, Renoir, Pissarro and Cézanne.[52] Blanc waited until the Salon was about to close before he responded to the petitions, and wrote back denying the requests.

Secondly, recognising that they were being disinherited by the State, landscape and genre painters increasingly sought alternative means of support. They looked to dealers like Durand-Ruel to exhibit and publicise their works.[53] In the unstable post-war economy artists courted individual buyers as well, men like Ernest Hoschedé and Jean-Baptiste Faure.[54] Thirdly, the artists took Blanc's prescription seriously and began to organise exhibitions of their own. Having lived through the late 1860s, and seen the power of group effort, they now formed professional societies, which would create exhibitions outside the State's aegis. As the critic Paul Alexis wrote, in *L'Avenir national* in 1873: 'This powerful idea, the association ... begins to transfuse new blood into the veins of an old world. Contemporary artists, to be truly worthy of the name, can no longer enclose themselves in an Ivory Tower.'[55]

It was an important moment in the shift from State to private patronage, and the impact of the State's refusal to support landscape and genre painting should not be underestimated. Blanc had publicised his aesthetic views throughout the 1860s; he was profoundly committed to traditional figural works and there was no reason to think that he would suddenly change his mind.

In May 1873 France turned further to the political right and elected the Maréchal MacMahon as President. Under the rubric of 'the government of moral order', MacMahon's presidency gave greater political importance to the military, the Catholic Church and the traditional social hierarchy.[56] Though Blanc's artistic policy was conservative, his association with the Republic established in 1870 tainted him with a liberalism that ill-suited the new government. At the end of the year he was replaced by the Marquis de Chennevières, who had managed the Salon throughout the 1860s and who was perfectly suited to MacMahon's government (see fig. 30) An aristocrat and ultra-clerical, Chennevières despised democracy and the erosion of elitism it entailed. He was a man of the *ancien régime* and the policies he introduced were rooted in the beliefs and values of that earlier age.[57]

Barely installed in office, Chennevières initiated an expensive programme of historical painting for the Eglise Sainte-Geneviève, the building that the revolution had appropriated and designated as 'the Pantheon'. Characteristic of 'the government of moral order', Chennevières's project fused themes of patriotism, kingship and religion, in commemorating 'the marvellous history of the Christian origins of France'.[58] He then set about establishing the regulations for the Salon. In formulating policy for the exhibition of 1874 he returned to the voting system of the mid 1860s and restricted the right to vote on the jury to that ascending hierarchy of medal-winners, the Legion of Honour

59. *Règlement* for the Salon of 1874, AN F²¹ 535. Chennevières added a further elite category in permitting winners of the Grand Prix de Rome to vote for the jury.

60. Chennevières 1883–9, IV, p. 91.

61. See especially Fillonneau 1875, in which he blamed Chennevières for implementing projects that always seemed to end in a 'DISASTER!'.

62. *La Chronique des arts*, 17 January 1874, pp. 19–21. The juxtaposition can hardly have been coincidental and probably came about through the intervention of Philippe Burty who wrote for *La Chronique* and who would help the 'Impressionists' publicise their exhibition through the following months.

63. On the exhibition of 1874, see Rewald 1973, chapter IX; Paris 1974; Tucker 1986, pp. 93–117; and Ward 1991, pp. 599–622.

64. On the Prix du Salon, see AN F²¹ 535; the anger that the award generated can be seen clearly in the accounts of Chesneau 1874 and Fillonneau 1874.

65. According to the new regulation, award-winning artists would elect forty-five painters, from among whom a jury of fifteen would be chosen by the drawing of lots.

66. See Roos 1988, pp. 372–407.

67. Minutes of the Conseil Supérieur des Beaux-Arts, 18 December 1878, AN F²¹ 558. The Council's version of the rules was published in *La Chronique des arts*, 4 January 1879, pp. 1–4.

68. See especially Halévy 1930 and 1937.

69. *Règlement* for 1879, signed 28 February 1879, reprinted in the catalogue for the Salon of 1879, pp. xcix–cvi. Documents for the Salons of 1880–1 are found in the AN F²¹ 535 and 538.

70. Duranty 1879, pp. 126–8.

71. Duret (ed.) 1899, p. 436; see Stevens (ed.) 1992, p. 267. Duranty noted in *La Chronique des arts* that 'most of the impressionists, this year, wanted to take their chances at the Salon' (Duranty 1879, p. 127).

72. *Règlement* for the Salon of 1880, reprinted in the catalogue for the Salon of 1880, pp. cvix–cxvi.

and academicians.[59]

He, too, encouraged artists to assume the burden of exhibiting their own works, though his solution was different from that of Blanc. Early in 1874 Chennevières proposed the formation of an artists' society to manage the Salon. His was not to be a democratic organisation, but a 'national Academy' – the wording is significant – composed of the country's award-winning artists and based on the Academy of the seventeenth century. As he later explained:

Democracy has always horrified me and I see in it only principles that are corrosive and destructive for every society, civil or political. I intended to establish an aristocratic corporation, based on the elite and on recognised merit, on the election of the best by the best, and consequently maintaining a high level for those elected. Never did it enter my mind, since I had, I repeat, great plans for the future of my association, to hand over ... the guardianship of that future to the ever more degrading approval of a crowd.[60]

Such an organisation would have institutionalised the hierarchy that gave figural painters the edge, to the disadvantage of the landscape artist. Through 1874 and early 1875 Chennevières aggressively pursued the establishment of his academy, but artists resisted the project as they began to recognise its elitist nature. His proposed academy died in 1875 when artists refused, point blank, to cooperate, and Chennevières lost much of his credibility as an administrator.[61]

One description of his academy was published in *La Chronique des arts* on 17 January 1874, where it was directly preceded by the announcement of a 'Société Anonyme Coopérative', the group that organised the first 'Impressionist' exhibition of 1874.[62] It is impossible to avoid the conclusion that Chennevières's arrival at the ministry, and the announcement of his academy, provided the final stimulus that led these artists to organise their cooperative. Though the exhibition is generally hailed as an important landmark in the history of modernism, this interpretation takes a narrow view. Relatively few artists in that exhibition actually fit the designation 'modernist', and what unites them as a group is that they were, overwhelmingly, landscape and genre painters.[63]

In many respects Chennevières's administrative strategy was to ignore protest and promote his *idées fixes*. In 1874 he proposed a 'Prix du Salon', which would enable a young Salon painter to study in Rome for three years. The new fellowship angered nearly everyone: landscape and genre painters because the prize favoured heroic figural works, and the Academy and its supporters because the award rivalled the long-standing Prix de Rome.[64] To Chennevières's dismay, the Salon jury refused to grant the award. In 1875 he introduced a lottery system for electing jury members – anything to avoid democracy – and here again his policies met deep resistance.[65] Many of the randomly chosen jurors refused to serve and it was widely rumoured that Chennevières was about to resign.

Chennevières was finally forced out of office in 1878 because of his arrogant mismanagement of the Exposition Universelle.[66] He was replaced by Eugène Guillaume, the Director of the Ecole des Beaux-Arts and a member of the Academy since 1862. Although Guillaume served for only nine months, and was a key member of the institutional elite, it was under his administration that the inequities of hierarchy were finally addressed. The question of the Salon was turned over to the ministry's Superior Council on the Fine Arts, and in December 1878 it approved a revision of the Salon's rules.[67] An important part of the new *règlement* required that five of the fifteen positions on the painting jury be occupied by artists who specialised in 'landscape, animals, flowers, still life etc.' Thus the makers of what had traditionally been considered the lesser forms of art were ensured sizeable representation on the Salon's jury. In addition, the right to vote was extended to any artist who had exhibited at three previous Salons. This innovation ensured that a much larger pool of artists would choose the men who determined the Salon.

In the elections of January 1879 the country turned decisively to the political left; both houses of parliament were dominated by Republicans and MacMahon was forced out of office. In early February 1879 Jules Grévy was elected President, Jules Ferry was chosen as minister of fine arts, and Edmond Turquet was appointed to replace Guillaume as Director of Fine Arts. MacMahon's

73. As Zola remarked, the grouping together of these works served to demonstrate 'their mediocrity, at once lamentable and almost comic' ('Le Naturalisme au Salon' [1880], 1991, p. 410).

74. See *La Chronique des arts*, 3 April 1880, p. 110; 1 May 1880, p. 142; 22 May 1880, p. 165 and 29 May 1880, pp. 174–5; and AN F²¹ 535. On Turquet's appearance before the Chamber of Deputies, see *Journal officiel*, 19 May 1880, pp. 5389–96; an excerpt from his speech was published in *La Chronique des arts*, 22 May 1880, p. 165. See Chennevières's account of the affair (1883–9, IV, pp. 101–8), which is biased but nonetheless useful as a gauge of response.

75. Chennevières 1883–9, IV, p. 98.

76. The second painting submitted was *The Ice-Floes* (fig. 44, p. 136).

77. Documentation reprinted in the catalogue for the Salon of 1881, pp. lxxxi–cvii.

78. *Le Gaulois*, 22 December 1880.

79. On the formation of the new groups, see Mainardi 1993, especially pp. 85–6, and chapters 5 and 6.

80. Champier 1880, p. xxix and pp. 173–80.

Research for this essay was supported in part by a grant from the PSC-CUNY Research Award Program of The City University of New York. The project has benefited greatly from the generosity of Elizabeth Childs, Jill House, John House, Jean Kashmer, Arthur Mayo, Tracey Myers, Lucy Oakley, Mark Roskill, Dan Ruby, Joanna Skipwith, Richard Shiff and Deborah Yamin. For Katherine Roos.

Fig. 30

Fig. 30
Portrait of Philippe de Chennevières
Photograph by Félix Nadar, Cabinet des Estampes, Bibliothèque Nationale, Paris

'Republic of the Dukes' was finally replaced by a 'Republic of Republicans'.[68]

Having served on the Superior Council in 1878, Turquet had been part of the group that approved the regulations for the Salon of 1879. Now at the head of the administration he made very few changes to the rules.[69] With republicans in power and with reform in the air, a number of Impressionists returned to the Salon, as Duranty noted in *La Chronique des arts*.[70] The motivation was made explicit in a letter from Sisley to Théodore Duret: 'It is true that our exhibitions have served to make us known and in this have been very useful to us, but we must not, I believe, isolate ourselves too long. We are still far from the moment when we can do without the prestige attached to official exhibitions. I am, therefore, determined to send to the Salon. If I am accepted – there is a chance this year – I think I'll be able to do some business.'[71] Renoir and Cézanne joined him, but only Renoir's works made it past the jury.

For the Salon of 1880 Turquet retained the same regulations, though he added several refinements. He stipulated that in awarding the first-class medals for painting one must be given to a genre painting and one to a 'painting of landscape, animals, flowers or still life'.[72] In addition, he required that minutes be kept of all the jury's deliberations and he abolished the Salon's alphabetic installation, which had been the practice since 1861. Instead he designated special rooms for artists who had received Salon medals. It was a canny attempt to highlight the failings of hierarchy, and it infuriated the artists concerned.[73]

The jury's meetings in the spring of 1880 were the most fractious and acrimonious in years. In early April the landscape painter Français resigned when Bouguereau and Baudry were elected as President and Vice-President. Several weeks later, Bouguereau, Vollon and Van Marke resigned when Turquet admitted two paintings after the deadline for submission had passed. Tensions escalated when Turquet publicly accused the jury of reactionary politics. Baudry resigned, the entire painting jury submitted an official letter of protest, and Turquet was called before the Chamber of Deputies to defend his new policies.[74]

When the Salon opened it proved to be the largest exhibition ever, what Chennevières called 'a *tohu-bohu* without name'.[75] The jury accepted 7,300 works, resulting in a catalogue that was 800 pages long. The increased attention given to landscape painting, reflected in both the composition of the jury and the awarding of first-class medals, encouraged the participation of Monet for the first time since 1870. He submitted two landscape paintings, of which the jury accepted only his view of *Lavacourt* (cat. 36).[76] He did not win a first-class medal, and never again submitted to the Salon.

At the end of 1880 the State relinquished its control of the Salon. In a decree signed by Turquet the administration authorised the creation of the Société des Artistes Français, which would assume the responsibility for choosing and installing the Salon.[77] As he implied to a journalist from *Le Gaulois*, now that the country had a Republican form of government it was time to establish a 'Republic in the arts'.[78]

After the State had removed itself from the Salon, the importance of the exhibition gradually declined. In the years after 1881 dealer exhibitions became more ambitious and more influential, and other 'Salons' came into existence: the Salon des Indépendants in 1884 and the Salon de la Société Nationale des Beaux-Arts in 1890.[79] Artists' organisations assumed greater prominence as well, and by the early 1880s there were numerous independent exhibitions in addition to the one formed by the Impressionists. Among the more prominent were the Cercle de l'Union Artistique, the Cercle des Arts Libéraux, the Société Internationale de l'Art and the Société des Aquarellistes.[80] The crumbling hierarchy collapsed further, and in the years to come the controversy over landscape painting would gradually subside.

La France Profonde, modernity, and national identity

James F. McMillan

'France's name is diversity.'[1] So wrote the historian Lucien Febvre, and few would disagree. Likewise Fernand Braudel celebrated 'the dazzling triumph of the plural, of the heterogeneous, of the never-quite-what-you-find-elsewhere'. Other countries exhibited diversity, but, according to Braudel, 'not perhaps with quite the same exuberance or obstinacy'. Every region, every town, every village, every *pays* in France was different, moulded by a subtle interaction between its past and its land. The key to understanding France was as much geography as history:

Landscapes and panoramas are not simply realities of the present but also, in large measure, survivals from the past. Long-lost horizons are redrawn and recreated for us through what we see: the earth is, like our own skin, fated to carry the scars of ancient wounds.[2]

La France Profonde

Braudel's remarks seem particularly pertinent to an exhibition that captures the French landscape in all its rich diversity and frequently evokes the spirit of *la France profonde*, a timeless world rooted in the soil and unscathed by modern life. This 'true France', the pictures seem to say, was the world of sleepy villages and useful rural toil rather than the bright lights of Paris or the grim industrial towns of the north and east. By the second half of the nineteenth century few of the genuinely wild spaces remained, but those that did were undoubtedly an inspiration to the artistic imagination: mysterious forests; coastlines dominated by craggy cliffs and pounded by violent seas; the stony, sun-drenched hills of the Midi; the mountains and maquis of the south-east; the moors and marshes of the west.[3] Most of the French countryside, however, had been tamed by man, and was victim to the relentless advance of urban civilisation. In Brittany, for example, the area of moorland was reduced by fifty per cent to 500,000 hectares between 1840 and 1880, while in the Landes 300,000 hectares were drained by 2,500 kilometres of ditches in preparation for pine forests.[4]

Though hardly a *pays sauvage*, France was still a predominantly rural society in the period 1860–90. French urban growth was not spectacular by comparison with that of Britain or other European countries. Most of the urban community still lived in cities with a population of less than 10,000, usually market towns with strong links to the surrounding countryside rather than great centres of modern industry. In 1866 only eleven per cent of the population lived in cities with more than 50,000 inhabitants.[5] The politicians of the early Third Republic, dependent on peasant votes, liked to represent their country symbolically as the peasant girl Marianne and to encourage the view that the regime rested on the solid foundations of a peasant base and peasant values. Artists, likewise, often fashioned images designed to reassure their bourgeois clientele that the charms of the French countryside provided continuing evidence of social stability in times of political turmoil.[6] In pictures such as Millet's *Angelus* (fig. 31) and Ségé's *In the Land of Chartres* (cat. 46) the image of the rural idyll was reinforced by a reference to religious tradition, in the form of touching peasant piety or the splendour of Chartres cathedral.

Such impressions of France, however seductive, can be very misleading. For one thing, the countryside was no Arcadia. Wracked by problems of peasant debt, hunger for land and depopulation, rural France was beset with conflicts and tensions peculiar to itself. Sharp socio-economic distinctions separated wealthy tenant farmers from archetypal peasants, as well as from poor sharecroppers and rural day labourers. Moreover, while continuity was perhaps the principal feature of rural life in the period before 1880, changes did occur, increasingly so in the final decades of the nineteenth century. The decline of rural industries and the exodus of rural labourers led to a decline in specialisation and self-sufficiency, and the countryside became increasingly dependent upon the urban world for goods and services. Paradoxically, it was what economic historians call the process of 'dedifferentiation' that made France more of a 'peasant' society than ever before.[7] Thus the village of Marlhes, situated in the Stéphanois basin, was transformed by the crisis in the ribbon-making industry in Saint-Etienne, brought about by exposure to foreign competition. Textile work, once done by the women of the village in their homes, was relocated to small factories that employed men and some single women. Farm work, now geared to providing food supplies for the Saint-Etienne market, no longer provided employment for the poorest labourers,

1. Quoted in Braudel 1988, p.38.
2. *Ibid.*, pp. 31, 38–9.
3. Frémont 1992.
4. McPhee 1992, p. 223.
5. Merriman 1982; Agulhon 1983, pp. 18–125.
6. Thomson 1994, pp. 16–17.
7. McPhee 1992, p. 234.
8. Lehning 1980.
9. Boutry 1992, p. 66.
10. Langlois 1984.
11. See Gibson 1989 and Cholvy 1985.
12. Quoted in Cholvy 1991, p. 128.
13. *Ibid.*
14. See McMillan in *Religion and Society in France since 1789*, 1991.
15. See Desan 1990.
16. Guillaumin 1904.
17. See Devlin 1987.
18. McManners 1972.
19. See Weber 1991, chapter 8.
20. Silver 1980, pp. 277–94.
21. Corvol 1992, p. 673.
22. Weber 1976.

who were obliged to leave the area to seek jobs in urban industries.[8]

Nor was religion necessarily a stabilising influence. It is certainly true that, after the upheavals of the Revolutionary period, the nineteenth century witnessed a remarkable religious revival. Statistics suggest that Tridentine Catholicism reached its apogee in France in about 1870. Thus, as against 29,000 parishes in 1814, there were 32,000 in 1848 and 35,000 by 1875. The numbers of secular clergy expanded from 40,600 in 1830 to 56,400 by 1870. Put another way, there was one priest for every 913 inhabitants of France in 1810 and one for every 639 in 1870.[9] There was also a massive increase in the membership of religious orders, notably of female religious orders, whose numbers doubled to 135,000 between 1850 and 1878.[10] The nineteenth century, often seen as an age of dechristianisation, can be more accurately understood as a period of rechristianisation as far as much of the French countryside was concerned.[11]

Yet, even if one allows that historians and sociologists have tended to exaggerate the degree to which secularisation took place in the nineteenth century, especially in the cities and among workers, leaders of the French Church had much to worry about. Already in 1842 the Bishop of Chartres had observed that 'religion has been almost entirely abandoned by the men';[12] Chartres cathedral, so evocatively depicted by Ségé, was situated in one of the most dechristianised dioceses in France. Other parts of the Centre, the Limousin and the Charentes, were in a similar situation (in some parishes in the late 1850s no parishioners could be found making their Easter duties).[13] The reality was that the map of religious practice in France showed enormous regional variations. The high levels of Mass attendance and participation in the Easter services to be found in, say, Brittany or the Massif Central were not replicated in places like Chartres or Orléans.

Moreover, there was a marked contrast between the religious behaviour of men and that of women. Whether in the 'practising' or in the 'dechristianised' areas, significantly larger numbers of women attended church.[14] (Quite why this should have been the case

is still a matter of historical investigation, but it would be rash to attribute it to any innate female propensity for religious activity. Wider political and cultural factors were at work at least as far back as the period of the French Revolution when rural women were to the fore in seeking to defend their religion against the secularising policies of the Jacobins and their emissaries).[15] Young people of both sexes were also much less assiduous about church attendance than the elderly. In his semi-autobiographical novel Emile Guillaumin, a native of a village in the Allier, recalled:

According to the custom of my youth I went to Mass ... one Sunday in two approximately ... But I was far from taking literally all the stories of the priests – their theories of heaven and hell, confession and days of fasting and abstinence, I took those for fairy tales ... I therefore rarely thought about death, and still less about 'eternal salvation', and after my marriage, I had completely abandoned going to confession.[16]

What Guillaumin valued in religion was the cult of beneficent local saints and rituals that could be related to the rhythms of the seasons and the caprice of the elements.[17]

The cloud hanging over Chartres cathedral in Ségé's marvellous picture may therefore have been intended to symbolise the difficulties in which the Church found itself. In 1884, the year in which the picture was exhibited at the Salon, the Republicans passed a law reintroducing divorce as part of their drive to secularise the State and to 'privatise' religion – if not to root out religion altogether, then to ensure that it survived only at the level of individual piety rather than as the social, public and state-supported phenomenon that churchmen claimed it was entitled to remain. One of a series of *lois laïques* enacted between 1879 and 1889, the divorce law followed hard on the heels of legislation that introduced free, compulsory and secular elementary schooling and state secondary schools for girls. It was a prelude to the eventual separation of Church and State, which was to come about in 1905.[18] By 1870 anticlericalism had become an integral part of Republicanism, and the triumph of the Republic inevitably spelled attacks on the Church. *La France profonde* could not be cocooned from the vicissitudes of national politics.

Fig. 31

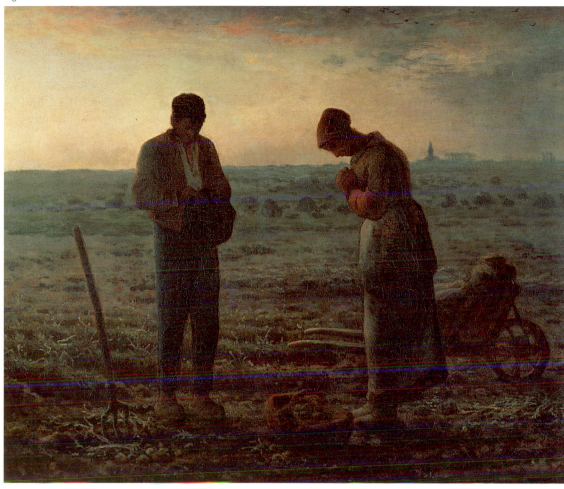

Fig. 31
Jean-François Millet
The Angelus, 1855–7
55.5 × 66 (21 ⅞ × 26)
Musée d'Orsay, Paris

Historians disagree about the degree of political awareness among peasants before 1870, but their apparent quiescence under the Second Empire should not be interpreted as docile submission to authoritarian rule after the great Red Scares of 1848 and 1851.[19] If peasants supported Napoleon III, it was because they recognised that the Empire had brought them unparalleled prosperity through its extension of the communications network and its programme of land reclamation. Additionally, they knew that the Empire was a bulwark against the Legitimist proposal to restore the monarchy, which, they feared, might augur the resurrection of feudalism. In the 1860s to identify with the Empire was to contest the concentration of power in the hands of local notables and their clerical allies.[20] It is no coincidence that in this period and under the 'moral order' regime of the 1870s the disturbing figure of the woodcutter hacking away deep in the forest was reproduced as an image of subversion and revolt.[21] On the other hand, once the Second Empire had fallen, most of the rural population had little difficulty in transferring their loyalties to a Republic that stood both for the preservation of the gains of 1789 and for the maintenance of order (all too apparent from its bloody suppression of the Paris Commune in 1871). By 1880, despite pockets of discontent in parts of southern and central France that would soon be ripe for cultivation by Marxist socialists preaching the doctrine of class struggle, the rural population as a whole was won over to the new Republican regime and increasingly integrated into the national political culture through the spread of elementary schooling, the extension of the road and rail network, and, not least, compulsory military service.[22] Peasants became not only Republicans but Frenchmen, and in this sense pictorial representations of the rural world as a bastion of stability in a world confronted by the challenge of socialism in the cities were not totally wide of the mark.

Modernity
Modernity, however, could not be kept out of the landscape; it intruded in the shape of railway lines, telegraph wires, iron bridges or the factory chimneys

23. Merriman 1982.
24. Tucker 1982.
25. See McMillan, *Napoleon III*, London, 1991, p. 136.
26. Gaillard 1977.
27. Thomson 1994, pp. 45ff.
28. Renan 1882.
29. See Michelet 1869, III and IV.
30. Michelet 1981, pp. 226–7.
31. L. Gambetta, speech at Annecy, 1 October 1872, quoted in Ford 1993, p. 16.

such as those depicted against the setting sun at Ivry by Guillaumin in 1873 (Musée d'Orsay, Paris). The total urban population increased by forty-four per cent between 1851 and 1881, nowhere more strikingly than in Paris, which grew from just over 1 million inhabitants to 2.3 million. Lyon, Marseille and other centres of industry such as Le Havre, Lille, Roubaix and Saint-Etienne showed a similar pattern of growth.[23] A new space emerged that was neither town nor country: the suburb. In the 1840s Argenteuil was still a country village by the Seine, some nine kilometres from Paris, but by the 1870s, when Monet lived there, it had become an industrial suburb, readily accessible by train to the throngs of visitors who came from Paris for a Sunday stroll by the river.[24]

France, indeed, was never as 'backward' as Anglo-Saxon economic historians used to suggest. Crude comparative figures for the production of coal, iron and cotton are not in themselves particularly significant, especially since France was subject to enormous variations depending on sector and region. Considered on a per capita basis, economic growth was not out of line with that in Britain. The Second Empire, in particular, was a time of remarkable economic expansion. Industry grew by two per cent a year. Construction boomed. The railway network was developed from 3,246 kilometres of track in 1851 to some 16,465 kilometres in 1869. The voracious needs of the iron and steel industry stimulated the coal production of the Nord. Banking was revolutionised and the Paris Bourse became a major player in the international money market. In the late 1860s Napoleon III began work on a novel whose central character (Monsieur Benoît, a grocer) had emigrated from France to the USA in 1847, and when he returned in 1868 was astonished by all the changes that had taken place in his absence.[25] It was no great loss to literature that the novel was never completed but the fact remains that a modern and dynamic economy developed in France during the Second Empire. The Emperor's political opponents contemptuously dismissed the *fête impériale* as an orgy of speculation and a cesspit of sleaze, but there were many signs that the regime had generated solid prosperity for the middle classes.

One dramatic sign of prosperity was the physical transformation of the capital, undertaken by Baron Haussmann, Napoleon III's Prefect of the Seine. The broad boulevards, handsome apartment buildings and beautiful parks that still adorn the city to this day form a lasting monument, as do the five new bridges over the Seine, the new railway stations and the new theatres (none more impressive than Garnier's Opéra), and the reading room of the Bibliothèque Nationale, though the elegant market stalls of the Halles Centrales are, alas, no more. Haussmann himself, of course, was the perpetrator of many acts of vandalism. His rebuilding programme destroyed much of the medieval city and obliged poorer families to abandon their city-centre neighbourhoods to seek cheaper lodgings in the new suburbs on the periphery. In the centre, however, (though not in the new working-class ghettoes) the quality of life was improved by the building of new drainage, sewage and water-supply systems.[26] Modernisation of the city continued under the Third Republic and was epitomised by the construction of the Eiffel Tower as the showpiece of the Exposition Universalle of 1889. Immediately recognised as a symbol of the city itself and an enormous tourist attraction, the tower was consciously designed by its engineer as an awesome demonstration of the power of modern technology, though for some artists, like the anarchist Pissarro, it was more appropriately identifiable as a demonstration of the power of capitalism and of the bourgeoisie. In his series of drawings entitled *Social Depravities* he depicted the city as corrupt and oppressive, in strong contrast to the bright and peaceful countryside peopled by contented peasants.[27] The rural idyll was by no means the exclusive property of conservatives.

National Identity

As the example of Pissarro shows, the French landscape is not necessarily innocent subject matter: it might be a means of expressing a particular vision of national identity, and politics could affect its representation. In a famous lecture delivered at the Sorbonne in 1882 Ernest Renan tackled the question 'What Is a Nation?' and affirmed:

Fig. 32
Monument to the Republic, 1883,
by Léopold Morice
Place de la République, Paris

Man is a slave neither of his race nor of his language, nor of his religion, nor of the course of rivers, nor of the direction of mountain chains. A great aggregate of men, healthy in spirit and warm of heart, creates the kind of moral conscience which we call a nation.[28]

For Renan the idea of the nation was essentially political: it derived from an act of will and involved freely given consent. It united shared memories with a desire to live together, and amounted, in Renan's phrase, to 'a daily plebiscite'.

This was essentially a Republican vision of the nation, predicated on the belief that France was 'invented' in 1789. The France of the monarchy and the *ancien régime* belonged to pre-history. Modern France emerged with the idea of popular sovereignty and, for the Jacobins and their nineteenth-century heirs, the Republic was the institution that could embody this idea. If German nationalists thought of the nation as a people bound together by a common culture, French Republicans considered it a contractual arrangement between citizens and the State. The polity mattered more than race, language or ethnicity. From the time of the Federalist crisis of 1793 Jacobin Republicans stressed the need for centralisation and regarded regionalist movements as threats both to the triumph of revolutionary principles and to national cohesion. Provincial particularism in its extreme manifestation meant the Vendée and counter-revolution and even a threat to the integrity of the national territory itself.[29] Michelet, who did more than any other individual to popularise the Republican version of French history, rejoiced at the gradual development of a common mentality that effaced local loyalties. In his celebrated 'Tableau de la France', the first chapter of the third volume of his *Histoire de France*, he observed:

the influence of soil, climate and race has ceded to social and political action. The fatality of local spots has been overcome. Man has escaped from the tyranny of material circumstances ... Society, liberty have overcome nature, history has effaced geography. In this marvellous transformation, the mind has triumphed over matter, the general over the particular, and the idea over the real.

The provinces were nothing without the centre and unity could be realised only by centralisation and 'the annihilation of all local spirit, of all provincialism'.[30]

The founding fathers of the Third Republic, who revered Michelet as a mentor, were fired by the same Republican mystique. France, declared Gambetta, was not the 'meeting of associated provinces ... It is not the Touraine united with Provence, nor Picardy joined to Languedoc, nor Burgundy attached to Brittany ... No! This whole, this unity, it is the French Republic.'[31] Hence the vast programme of republicanisation undertaken after 1879, when the Republicans finally considered themselves to be masters in their own house and in a position to strike against their clerical and reactionary enemies through legislation designed to secularise the State. This would be achieved primarily by the introduction of free and compulsory elementary education, administered by state-trained schoolteachers who would rear future generations in the Republican ideal. By and large, the enterprise was carried out successfully.

Yet the Republican vision of the nation was always contested. Under the Second Empire (and even earlier in the case of Brittany) regionalist movements began to be formed, some of which claimed to be apolitical while others made no secret of their support for the administrative decentralisation and local democracy first championed by the Federalists in 1793. The apolitical included the Comité Flamand de France, founded in 1853 to resuscitate the Flemish language and Flemish identity, and the Annales Franc-Comtois, started at Besançon by the Abbé (later Bishop) Louis Besson, both of which made much of the attachment of their respective regions (formerly part of the Habsburg Empire) to Catholicism. The connection with Catholicism was even stronger in Brittany, where nobles and clerics were among the most active champions of regional culture. Indeed, in 1853 Napoleon III suppressed the Association Bretonne, founded in 1843, because he believed it to be a front for Legitimists who wanted to restore the Bourbons. Probably the most celebrated of the societies that sought the preservation or

32. This paragraph and the following one draw on Gildea 1994, chapter 4, especially pp. 74ff.
33. *Ibid*, p. 180. On the Félibrige see also Martel 1992, pp. 567–611.
34. Sternhell 1978.
35. Irvine 1989.
36. Sternhell 1972.
37. Birnbaum 1993, p. 11.
38. McMillan 1993.
39. Quoted in Birnbaum 1993, pp. 33–4.
40. *Ibid*., chapter 4.
41. Braudel 1988, part 3.

reconstruction of a regional identity was the Félibrige, formed in 1854 by the Provençal poet Frédéric Mistral with the objective of reviving the *langue d'oc*, the language of Occitanie, and challenging the cultural supremacy of the French Academy. Mistral was nostalgic for the lost golden age of the troubadours and critical of contemporary France as a civilisation based on materialism and philistinism. Though claiming to be apolitical, he rejected the Third Republic's Jacobinism, maintaining that his movement was 'Girondin, federalist, religious, liberal and respectful of traditions'.[32]

The overtly federalist type of regionalist association was part of the liberal opposition to the Second Empire in the 1860s and included Legitimists, Orléanists and Republicans. One of the first acts of Emile Ollivier on becoming chief minister of the 'Liberal' Empire on 2 January 1870 was to set up a commission on administrative decentralisation. The Republicans, once in power, had no difficulty with the idea of restoring an element of local democracy: hence the law of March 1882, which gave municipal councils (with the exception of Paris) the right to elect their own mayors. The leaders of the Republican regime, however, discovered that centralisation was a powerful weapon and refused to tamper further with the apparatus of the State. In practice the most active campaigners for decentralisation under the Third Republic were men of the Right, among them the youthful Charles Maurras, who, with some other members, was expelled from the society of Félibres in 1892 for launching a manifesto that stated:

We are fed up with keeping quiet about our federalist intentions. We can no longer confine ourselves to demanding the rights and duties of freedom for our language and writers; that freedom will not achieve political autonomy, but will flow from it ... We demand liberty for our communes ... We want to release from their departmental cages the souls of provinces whose names are still used by everyone: Gascons, Auvergnats, Limousins, Béarnais, Dauphinois, Roussillonnais, Provençaux, and Languedociens.[33]

The name of Maurras is a reminder that by the 1890s there were Frenchmen who had developed a vision of the nation that was in marked opposition to that favoured by the advocates of the Republic. Between the Boulangist crisis of the late 1880s and the Dreyfus Affair of the late 1890s, a new, populist and revolutionary Right made a noisy appearance on the stage of French politics as advocates of an 'integral' nationalism that was anti-democratic, xenophobic and, above all, anti-Semitic.[34] In its first manifestations the new nationalism was not entirely without Republican connections. Its motivation, the desire for revenge against Germany for the loss of the provinces of Alsace and Lorraine after the disastrous war of 1870, was shared by the Ligue des Patriotes, a body founded in 1882 with a largely Republican membership that included the historian Henri Martin and the future President of the Republic Félix Faure. Under the influence of Paul Déroulède, however, the Ligue became a vehement critic of the existing Republican regime, which in Déroulède's view was too weak to provide the leadership required to renew the struggle with Germany. It was for this reason that the Ligue gave its backing to General Boulanger, the man who had seemed capable of squaring up to Bismarck in the mid 1880s, but who soon alarmed his original Republican backers by consorting with royalists and Bonapartists in what looked suspiciously like an attempt to establish a personalist and authoritarian regime.[35]

One fervent Boulangist was the writer Maurice Barrès (1862–1923), a native of Lorraine who became deputy for Nancy on the Boulangist ticket in the elections of 1889.[36] An advocate of 'nationalism, protectionism and socialism', he remained a Republican of sorts and a supporter of social reform, but his idea of the Republic was increasingly authoritarian. He was also an enthusiast for decentralisation and regionalism, believing with Mistral, whom he admired, that every region had its own special character to which its inhabitants had to be able to relate if they were to live together in harmony. From the mid 1890s, however, his ideas were to evolve much further towards the concept of an 'organic' nationalism that consciously rejected the legacy of the French Revolution and stressed instead the individual's ability to identify with the forces that shaped him, above all the soil, ties of blood and his ancestors. This cult of '*la terre et les morts*', developed in Barrès's novel *Les Déracinés* (1897), made him arguably the most influential writer of his generation, with an extraordinary hold over the

imagination of French youth.

Barrès also became increasingly anti-Semitic, though the leading light of anti-Semitism was Edouard Drumont (1844–1917), author of *La France juive* (1886) and founder of the newspaper *La Libre parole* (1892), which was to play a notable role in orchestrating the campaign against Dreyfus. Both Barrès and Maurras hailed Drumont as the prophet who had revealed that France was in danger of being overrun by Jews (he claimed that there were more than a million, whereas the real figure was closer to 100,000) while the Republic was at the mercy of Jewish financiers and ruled by an unscrupulous alliance of unpatriotic Jews, Protestants, Freemasons and 'foreigners'. Drumont's own star was to wane at the turn of the century, but Barrès, and even more Maurras, ensured that these views became the basis of a new, essentially racist, nationalist doctrine for the twentieth century. Jules Soury, Director of the Ecole des Hautes Etudes and an apologist for the new nationalism, was firmly of the view that in 1902 there were two Frances made up of irreconcilable enemies: Freemasons, Jews and Protestants on the one side, traditional Catholic France on the other. 'I am for war ...' he declared:

for war against that which we hate, the denial of national traditions, the abasement and the betrayal of the motherland by the Huguenots and the Freemasons, still more by the Jews who at least are not French; for war, for the defence of all that we love, the Land of our Dead, the Catholic Church, the Army of France.[37]

The reference to Catholicism was an essential one for integral nationalists, whether or not they were practising Catholics, like Drumont, or agnostics, like Maurras. In return many Catholics found themselves drawn to integral nationalism, grateful for the recognition that, in the face of the Republican anticlerical drive to secularise the State and society, there were still people ready to defend the traditional Catholic idea that religion was not simply a matter for the individual conscience but a social phenomenon to be practised in public. Their idea of the nation was based, however, on the conception of France as a Catholic country, the eldest daughter of the Church and dedicated to the cult of Joan of Arc rather than the impious Marianne.[38] France could only be France if it

remained attached to Catholic principles. As Ferdinand Brunetière put it:

just as Protestantism is England and Orthodoxy is Russia, so France is Catholicism ... everything which we allow to happen in the world against Catholicism, we do to the detriment of our own influence in the world, contrary to our history and at the expense of the qualities which are those of the French soul.[39]

The nation with which Renan and other Republicans identified was not that beloved of Catholic nationalists. On the contrary, in such circles the former seminarian Renan, whose *Vie de Jésus* had stripped Christ of his divine status and represented him as a mere man, was himself an object of particular loathing, a traitor and a new Judas who had insulted not just Christ but Catholic France.[40]

In the context of this exhibition it seems apposite to conclude that as a counterpoise to pictorial images of serenity and rural tranquillity one needs to recall the degree to which nineteenth-century France was ideologically and politically split. Braudel may well be correct in suggesting that the much-vaunted geographical diversity of France itself gave rise to serious divisions, if only because of the indifference of the various regions to what went on elsewhere.[41] In a country that had already known civil strife at the time of the One Hundred Years' War and during the reigns of Henri IV, Richelieu and Louis XIV, the French Revolution and the Napoleonic period created new and lasting rifts that it is no exaggeration to call *les guerres franco-françaises*. In the period 1860–90 the most chilling example of this phenomenon was that of the Paris Commune of 1871. It is true that during this period, and over the nineteenth century as a whole, the sense of belonging to a national community made impressive headway; that was a real achievement on the part of the Republic and Republicans. It would, however, be a mistake to reduce the whole of French history to that particular story. To narrate the French nation it is necessary to make more than passing reference to its propensity for civil war. As representations of national identity, the paintings in this exhibition are as notable for what they omit as for what they include.

	1860	1861	1862	1863	1864	1865	1866
History	● January: Paris city limits extended. ● Free trade treaty with Britain. ● March: Nice and Savoie annexed to France. ● November: Napoleon III announces initial plans for liberalisation.	● October: France, Britain and Spain launch expedition to Mexico; Spanish and British quickly withdraw.	● May: French defeat at Puebla in Mexico.	● May: Elections return pro-Imperial majority but Republican majorities in main cities. ● June: French take Mexico City. ● Publication of Ernest Renan, *Vie de Jésus*.	● April: Archduke Maximilian of Austria sets sail to become Emperor of Mexico. ● May: Maximilian reaches Mexico. ● December: Pope Pius IX publishes *Quanta Cura* and Syllabus of Errors.	● Napoleon III publishes first volume of *Histoire de Jules César* (second volume, 1866).	● July: Prussian defeat of Austria at Battle of Sadowa changes balance of power in Europe.
Public Sector Salon	● Comte de Nieuwerkerke continues as Superintendent of Fine Arts. ● No Salon.	● May onwards: Apart from pictures in central hall, the Salon is hung in alphabetical order of names of artists. ● Courbet gains second-class medal at the Salon, Manet gains an honourable mention. ● May: Garnier commissioned as architect of Paris Opéra. ● July: Unveiling of Delacroix's murals in church of Saint-Sulpice, Paris.	● No Salon.	● Salon becomes annual. ● May onwards: State-organised Salon des Refusés shows paintings excluded from Salon by jury, including works by Chintreuil, Harpignies, Jongkind, Lansyer, Manet, Pissarro, Whistler and perhaps Cézanne. ● August: Death of Delacroix. ● August: Salon jury removed from control of Academy; artists restricted to submitting two works a year to Salon. ● November: Ecole des Beaux-Arts reformed; Prix de Rome competition for *paysage historique* abolished.	● Reform of Salon jury leads to election of some landscapists. ● May onwards: Second Salon des Refusés attracts less attention.	● December: Reopening of Musée du Luxembourg, museum for display of modern French art.	
Private Sector Impressionist	● February–March: Major loan exhibition, Tableaux de l'Ecole Moderne, mounted by Louis Martinet. ● Spring: The art dealer Goupil opens new gallery with permanent display of modern paintings.	● March: First Paris performances of Wagner's *Tannhäuser* lead to scandal and cancellation. ● May: Théodore Rousseau organises exhibition and auction sale of his work at Hôtel Drouot. ● Louis Martinet founds Société Nationale des Beaux-Arts in order to 'make art independent'. ● Cézanne and Pissarro meet at Académie Suisse. ● December–February 1862: Courbet teaches at his studio in rue Notre-Dame-des-Champs.	● Publication of Daubigny's etchings *Voyage en bateau*. ● Monet, Renoir, Sisley and Bazille meet while studying in the studio of Charles Gleyre.	● Cézanne meets Guillaumin and Guillemet at Académie Suisse. ● March: Martinet mounts exhibition of modern painting including works by Corot, Courbet, Diaz, Rousseau and fourteen by Manet. ● November–December: Publication of Baudelaire's 'Le Peintre de la vie moderne'.	● February: Sale of contents of Delacroix's studio. ● August–December: Delacroix retrospective exhibition, organised by Martinet.	● February: End of Martinet's Société Nationale des Beaux-Arts.	● The dealers Durand-Ruel and Brame buy many unfinished paintings and studies from Théodore Rousseau.

1867	1868	1869	1870	1871	1872	1873	1874
● January: Plans for political liberalisation announced. ● February: French military withdrawal from Mexico. ● April–November: Exposition Universelle in Paris. ● 19 June: Execution of Emperor Maximilian in Mexico. ● Collapse of Crédit Mobilier, bank run by the Pereire brothers.	● May–June: Some relaxation of laws on press and public meetings.	● May: Opening of Folies-Bergère, the first music hall in Paris. ● November: Inauguration of Suez Canal. ● Construction of Bon Marché, the first purpose-built department store in Paris, run by Aristide Boucicault (see cat. 16).	● January: 'Liberal Empire' created with Léon Ollivier as chief minister. ● Dismissal of Baron Haussmann as Prefect of Paris. ● July: *Pater aeternus*, declaration of Papal infallibility. ● 19 July: Outbreak of Franco-Prussian War. ● August: Fall of Ollivier. ● 30 August–2 September: French defeat at Sédan. ● September: Fall of Napoleon III; Third Republic proclaimed, with General Trochu as President. ● September 1870–January 1871: Siege of Paris.	● 28 January: Armistice and capitulation of Paris. ● February: Adolphe Thiers becomes Premier after fall of Trochu; seat of government moved to Versailles. ● March: Commune takes control of Paris. ● 20 May: Treaty of Frankfurt gives Alsace and Lorraine to the Prussians and agrees to huge financial indemnity. ● 21–28 May: Versailles government overthrows Commune and massacres Communards in Bloody Week. ● August: Thiers becomes President.		● January: *Loi Roussel* passed against public drunkenness. ● May: Marshal MacMahon replaces Thiers as President, institutes 'Moral Order' regime. ● July: Law passed authorising the building of a basilica to the Sacred Heart (the Sacré Coeur) on hill of Montmartre to expiate for France's recent disasters. ● Repression of cafés and Republican press; commemoration of 14 July banned. ● Autumn: Failure of plan to reintroduce monarchy.	● January: State assumes right to appoint mayors in all communes.
● January: Death of Ingres. ● April onwards: Ingres retrospective exhibition at Ecole des Beaux-Arts. ● Eight Medals of Honour awarded at Exposition Universelle, the majority to genre painters; Théodore Rousseau the only landscapist among recipients. ● December: Death of Théodore Rousseau. ● Publication of Charles Blanc's *Grammaire des arts du dessin*.	● Further liberalisation of Salon jury.	● January: Death of Paul Huet. ● July: Unveiling of Carpeaux's *La Danse* on façade of Paris Opéra. ● August: Carpeaux's *La Danse* vandalised.	● January: Maurice Richard appointed minister of fine arts; Nieuwerkerke loses control of the Salon. ● April: Letter from Degas in *Paris-Journal* criticises installation of works at the Salon. ● June: Courbet refuses the Légion d'Honneur. ● November: Charles Blanc appointed Director of Fine Arts.	● April: Courbet assumes responsibility for fine arts under the Commune. ● 16 May: Destruction of Vendôme Column. ● June: Courbet arrested. ● September: Courbet jailed.	● Courbet excluded from Salon on political grounds.	● May onwards: State-organised Salon des Refusés, including works by Guillaumin and Renoir. ● July: Courbet goes into exile in Switzerland. ● December: Marquis de Chennevières appointed Director of Fine Arts.	● January: Chennevières launches project for mural decoration of church of Sainte-Geneviève (the Panthéon) in Paris. ● State buys twenty-nine landscapes at Salon. ● August–October: Baudry's decorations for the Paris Opéra exhibited at Ecole des Beaux-Arts before their installation.
● January: Zola publishes pamphlet on Manet. ● May onwards: Courbet and Manet hold one-artist exhibitions. ● April–May: First plan for group exhibition fails owing to lack of funds. ● June: Studies by Théodore Rousseau (the paintings owned by Durand-Ruel and Brame) exhibited at Cercle des Arts.	● May–June: Zola's Salon reviews focus on young artists, including the future Impressionists.	● May: In his Salon review Duranty describes young painters, including future Impressionists, as the 'Ecole des Batignolles'.	● Autumn: Daubigny, Monet and Pissarro take refuge from Franco-Prussian War in London. ● November: Bazille killed in action. ● December: Durand-Ruel opens London gallery, and meets Monet and Pissarro.		● Durand-Ruel buys extensively from Manet, Monet, Pissarro and Sisley.	● January: Durand-Ruel begins to publish etchings of his stock; continues to buy from Monet, Pissarro and Sisley. ● May: Paul Alexis writes article supporting independently organised exhibitions; Monet replies describing plans to form exhibiting society. ● December: Founding charter of Société Anonyme des Artistes Peintres, Sculpteurs, Graveurs, etc.	● Early: Financial difficulties force Durand-Ruel to stop buying. ● April–May: First group exhibition of Société Anonyme, leads to group being named 'Impressionists'; exhibition includes Boudin, Cézanne, Degas, Guillaumin, Monet, Morisot, Pissarro, Renoir and Sisley.

1875	1876	1877	1878	1879	1880	1881	1882
● January: Wallon Amendment affirms the Republic, by majority of one vote. ● June: Foundation stone of Sacré Coeur laid (completed 1919).	● January–March: Elections return right-wing majority in Senate, Republican majority in Chamber of Deputies.	● May: MacMahon seeks to extend presidential authority and power of the Right; nominates right-wing government under Duc de Broglie. ● Further repression of cafés and other sites of potential political opposition. ● October: Elections; Republicans retain majority in Chamber of Deputies.	● March: Freycinet launches plan for massive expenditure on railways, roads and canals. ● May onwards: Exposition Universelle in Paris. ● 30 June: *Fête nationale*.	● January: Elections return firm Republican majority in Senate; MacMahon resigns as President, replaced by Jules Grévy. ● June: Parliament returns from Versailles to Paris. ● Law votes implementation of Freycinet plan for transportation network.	● March: Decree against unauthorised religious orders, including Jesuits. ● July: Amnesty for former Communards and relaxation of laws controlling cafés. ● July: First revived celebration of 14 July. ● Proposal to build Statue of Liberty in front of the still incomplete Sacré Coeur. ● December: Law on secondary education for girls.	● June: Free primary education instituted and public meetings legalised. ● July: Relaxation of press censorship. ● November: Gambetta takes office as Premier.	● January: Fall of Gambetta government. ● February: Collapse of Union Générale bank. ● March: Municipal councils given right to elect their own mayors (but not in Paris). ● March: Compulsory primary education instituted, with religious instruction excluded. ● Parliament votes to rescind law of 1873 authorising building of Sacré Coeur, but decision not implemented.
● January: Inauguration of completed Paris Opéra. ● January: Death of Millet. ● February: Death of Corot. ● State buys twelve landscapes at Salon.	● State buys only six landscapes at Salon.	● State buys only three landscapes at Salon. ● December: Death of Courbet.	● February: Death of Daubigny. ● May: Eugène Guillaume appointed Director of Fine Arts. ● State buys twenty-one landscapes at Salon, and others at Exposition Universelle. ● Renoir returns to Salon. ● Medals of Honour at Exposition Universelle mostly awarded to history painters; Français the only landscapist among fifteen recipients. ● December: Revision of Salon rules: five out of fifteen jurors to be landscapists, animal or still-life painters.	● February: Edouard Turquet appointed Director of Fine Arts; proposal launched for Monument to the Republic in Paris. ● July: At Salon prizegiving Jules Ferry announces major change in State art policy, in favour of open-air painting and modern-life subjects; State buys twenty-one landscapes at Salon.	● Monet submits again, for last time, to Salon. ● May: Turquet abolishes alphabetical ordering of works at Salon, in favour of 'sympathetic groupings'.	● January: Salon passes from State control to Société des Artistes Français. ● November: Antonin Proust appointed minister of fine arts in short-lived Gambetta government.	● February: Paul Mantz appointed Director of Fine Arts. ● May: Courbet retrospective exhibition at Ecole des Beaux-Arts. ● November: Albert Kaempfen assumes responsibility for fine arts.
● March: Monet, Morisot, Renoir and Sisley mount auction sale of their work.	● April: Second group exhibition includes Caillebotte, Degas, Monet, Morisot, Pissarro, Renoir and Sisley. ● Duranty publishes *La nouvelle peinture*.	● April: Third group exhibition includes Caillebotte, Cézanne, Degas, Guillaumin, Monet, Morisot, Pissarro, Renoir and Sisley. ● May: Second auction sale of works by Caillebotte, Pissarro, Renoir and Sisley. ● Spring: Georges Rivière edits short-lived periodical *L'Impressionniste*.	● April–June: Durand-Ruel mounts exhibition of paintings and drawings by Daumier. ● June: Impressionist pictures fetch very low prices at the sale of Ernest Hoschedé's collection. ● Summer: Durand-Ruel mounts Exposition Rétrospective de Peinture Moderne, primarily of painters omitted from Exposition Universelle, including Courbet, Diaz, Millet and Rousseau. ● Théodore Duret publishes *Les Peintres impressionnistes*.	● April–May: Fourth group exhibition includes Caillebotte, Degas, Gauguin, Monet and Pissarro.	● April: Manet exhibits at offices of magazine *La Vie moderne*. ● April: Fifth group exhibition includes Caillebotte, Gauguin, Guillaumin, Morisot and Pissarro. ● June: Monet exhibits at offices of *La Vie moderne*. ● Durand-Ruel buys again from Sisley and Pissarro.	● Durand-Ruel buys again from Monet and Renoir. ● April: Sixth group exhibition includes Degas, Gauguin, Guillaumin, Morisot and Pissarro. ● Sisley exhibits at offices of *La Vie moderne*.	● March: Seventh group exhibition, organised by Durand-Ruel, includes Caillebotte, Gauguin, Guillaumin, Monet, Morisot, Pissarro, Renoir and Sisley. ● Spring: First Exposition Internationale organised by dealer Georges Petit.

1883	1884	1885	1886	1887	1888	1889	1890
	● March: Trade unions legalised. ● July: Divorce legalised.	● March: Fall of Jules Ferry splits Republicans. ● Church of Sainte-Geneviève deconsecrated and formally renamed the Panthéon, before Victor Hugo is buried there.	● January: General Georges Boulanger appointed Minister of War, becomes focus of political nationalism. ● January–March: Miners' strike at Decazeville (Aveyron). ● October: Law passed on laicisation of stateschool teachers.	● May: Boulanger leaves government. ● December: Sadi Carnot elected President after resignation of Grévy.	● Boulanger retires from army; becomes eligible for election. ● Boulanger elected Deputy for Nord.	● January: Boulanger elected Deputy in Paris. ● April: Threat of impeachment for endangering Republic leads Boulanger to flee to Brussels. ● May onwards: Exposition Universelle in Paris. ● August: Boulanger condemned for contempt of court.	
● April: Death of Manet. ● 14 July: Inauguration of Monument to the Republic by Léopold Morice on Place de la République, Paris (fig. 32). ● September–October: Exposition Triennale.	● January: Manet retrospective exhibition at Ecole des Beaux-Arts. ● December: Death of Bastien-Lepage.	● March–April: Exhibitions of Delacroix and Bastien-Lepage at Ecole des Beaux-Arts.		● May–June: Millet exhibition at Ecole des Beaux-Arts. ● September: Jules Castagnary appointed Director of Fine Arts.	● February: State buys its first painting by a member of the Impressionist group, from Sisley (cat. 109). ● June: Gustave Larroumet appointed Director of Fine Arts.	● Antonin Proust is Commissaire Spécial des Beaux-Arts for Exposition Universelle. ● Eight landscapists and painters of peasant life among thirty artists awarded Medals of Honour at the Exposition Universelle: Pascal Dagnan-Bouveret, Jules Dupré, Léon Lhermitte, Camille Bernier, Josef Israels, Max Liebermann, Henry Moore and Erik Werenskiold.	● January: Société Nationale des Beaux-Arts splits from Société des Artistes Français. ● February: Subscription organised by Monet and Sargent buys Manet's *Olympia*. It is offered as a gift to the State. ● May: Opening of Salon of Société des Artistes Français and Société Nationale's rival Salon du Champ de Mars; of former Impressionist group, Sisley alone shows with Société Nationale. ● July: Français becomes first landscapist to be elected to the Academy.
● January–May: Series of one-artist shows, of Boudin, Renoir, Monet, Pissarro and Sisley, mounted by Durand-Ruel. ● Publication of Huysmans's *L'Art moderne*.	● May–July: Exhibition of jury-free Salon des Indépendants. ● December: First exhibition of jury-free Société des Indépendants (mounts annual exhibitions from 1886 onwards).	● May–June: Monet included in Georges Petit's Exposition Internationale. ● Publication of Duret's *Critique d'avant-garde*.	● May–June: Eighth and final group exhibition includes Degas, Gauguin, Guillaumin, Morisot, Pissarro, Seurat and Signac. ● June–July: Monet and Renoir included in Georges Petit's Exposition Internationale. ● Durand-Ruel mounts Impressionist exhibition in New York.	● May–June: Monet, Renoir, Pissarro and Sisley included in Georges Petit's Exposition Internationale. ● The dealers Boussod & Valadon (formerly Goupil) begin to buy from Monet. ● Publication of Zola's *La Terre*.	● May–June: Durand-Ruel mounts exhibition of Boudin, John Lewis Brown, Caillebotte, Lépine, Morisot, Pissarro, Renoir, Sisley and Whistler. ● June–July: Monet exhibition at dealers Boussod & Valadon, organised by branch manager Theo van Gogh.	● June–July: Major Monet/Rodin retrospective exhibition at Georges Petit's gallery. ● Summer: Gauguin and associates mount exhibition of Peintres Impressionnistes et Synthétistes at Café Volpini.	● July: Death of Vincent van Gogh. ● Monet begins work on his series of *Grain Stacks*.

63

The catalogue

The paintings are presented in two chronological sequences, first the Salon landscapes in order of exhibition at the Salon, and second the Impressionist paintings in order of their execution. A list of artists and paintings included in the exhibition can be found on p. 297.

Paintings are exhibited in both London and Boston unless otherwise stated.

The titles used are the paintings' original titles, where known. For the Salon paintings the titles are those given in the official Salon catalogue, with some homogenisation of punctuation.

All paintings are oil on canvas. Dimensions are given in centimetres and inches, height before width.

References to documentary sources are given in abbreviated form in brackets within the text; full references can be found in the bibliography on p. 299.

The entries have been written by John House with the help of documents and press criticism gathered by Ann Dumas.

1

On the Riverbank, near Paris 1861
Au bord de l'eau, environs de Paris
Salon of 1861, no. 1169
80 × 120 (31½ × 47¼)
Musée des Beaux-Arts, Nantes

Riverbank scenes were very common at the Salon (see Daubigny, cat. 11), but this painting is unusual among Salon landscapes of the 1860s for two reasons: because of its comparatively small scale, and because of the presence of the fashionably dressed figures.

The title does not indicate the precise site, but many viewers would have recognised it as the stretch of the Seine between Chatou and Bougival, about ten miles west of the city, which later became one of the Impressionists' favourite sites (see fig. 33 and cats. 68, 98). Although the landscape in *On the Riverbank, near Paris* shows no signs of modernisation, the area was already well known for the many figures from Parisian artistic circles who lived nearby, and for its riverside entertainments (see Herbert 1988, pp. 210ff); Chatou was readily accessible by train, and the celebrated bathing place of La Grenouillère was on this reach of the river.

The foreground figures, the woman with a book on her knee and the man fishing, evoke the theme of bourgeois recreation. The theme of fishing – a standard metaphor for sexual intrigue at the time – lends a hint of potential immorality. The smaller

figures beyond suggest a more complex social scenario: a woman watching over her cows by the shack on the left; a man fishing from a boat; other figures by the river, one on horseback; and a larger boat, perhaps a ferry, at back right. Here we see the continuing peasant and agricultural life of the area, set alongside the foreground intruders.

The picture conveys with great finesse the complex effect of light reflected in the water and playing across the scene. For Louis Auvray in 1861 this 'ravishingly delicate and fresh study' revealed Français as a 'true naturalist' (Auvray 1861, p. 50). Gautier celebrated Français's success in making 'masterpieces of grace, elegance and spirit' without travelling further from Paris than Bougival: '*On the Riverbank, near Paris* is pure Français, with no concern for style, abandoning himself naïvely to his own nature.' He described the landscape and the figures, suggesting how central the proximity of Paris was to the meanings the picture conveyed: 'The pleasure is for the two of them to be alone in this pretty, unpretentious landscape ... on a fine summer day, with the possibility, after dining

under the arbour of the fisherman Contesenne, of returning to eat ices at Tortoni's.' (Gautier 1861, pp. 161, 164–5.)

Français's exhibits in the following two Salons polarised opinion among the critics: he showed two ambitious classicising landscapes, *Orpheus* (Musée d'Orsay, Paris) in 1863 and *The Sacred Wood* (Musée des Beaux-Arts, Lille) in 1864 (see also fig. 42, p. 124). For some this marked an admirable move towards a more serious form of art, but for others it was a betrayal of his understanding of nature and his true Frenchness (see Hébert 1864, p. 294).

Unlike most of the Salon landscapes included in the present exhibition, *On the Riverbank, near Paris* was not purchased by the French State. It was offered as a prize in a lottery in Nantes in 1861, and entered the local museum because it was unclaimed.

Fig. 33
Alfred Sisley
The Seine at Bougival, 1873
46 × 65.5 (18⅛ × 25¾)
Musée d'Orsay, Paris

2

The Hills of Allauch, near Marseille
1862
*Les Collines d'Allauch, environs
de Marseille*
Salon of 1863, no. 854
108 × 199 (42½ × 78⅜)
Musée des Beaux-Arts, Marseille

The Hills of Allauch, near Marseille marked Guigou's first appearance at the Paris Salon. He had previously exhibited in Marseille, the artistic centre of his native region, Provence, and had gained a reputation as a follower of the leading local landscapist, Emile Loubon. Loubon and other painters based in Marseille, such as Prosper Grésy and Marius Engalière, had created a distinctive Provençal style of landscape painting, which used a bold impasto and a luminous high-key palette to convey the southern light; Guigou's early works marked him out as the boldest of the younger artists working in this manner.

The Hills of Allauch, near Marseille is a view of the hills just to the east of Marseille; its grandiose panorama echoes Loubon's celebrated *Marseille seen from Les Aygalades on a Market Day* (fig. 34), shown at the 1853 Salon. In Guigou's painting, however, there is no indication of the nearby city; the Provençal landscape is presented as a remote and spectacular region, with a few small houses punctuating the plain and a few peasants in their distinctive local costume. This is an image of rustic Provence, in marked contrast to Flandrin's vision of the region as a classical Arcadia (see cat. 28).

The viewer is placed on or a little above the path that leads into the picture; we are able to associate with the peasants who walk away from us down the path, but our gaze also commands the grand view beyond, to which it is led by the framing device of the shadows at the bottom corners of the picture.

The whole scene is unified by the luminosity of tone and the rhythms of the forms and brushwork. The rippling sequence of hills is picked up in the clouds and in the broken rocks in the foreground; this energetic movement is complemented by the lively drawing of the stems in the bushes and the vigorously textured brushwork in their foliage.

For Marius Chaumelin, who had written about Guigou's earlier exhibits in Marseille, his 1863 Salon paintings marked a welcome calming of his earlier 'disorderly verve': *The Hills of Allauch, near Marseille* 'gives an exact idea of the Marseille countryside. Although treated with a rare vigour, it does not show the exaggerated impasto that one meets too often in the works of this artist.' (Chaumelin, quoted in Bonnici 1989, pp. 109–10.) The Paris-based Alexandre Pothey considered Guigou the epitome of the Provençal spirit: 'M. Guigou is a beginner who reaches us full of southern verve,

of youth and ardour. He is a lover of nature; he has a devil in him and his talent is very original. His painting is vigorous, warm in tone and full of brilliance and life; he attacks it boldly, perhaps too boldly.' (Pothey, quoted in Bonnici 1989, p. 109.)

In many ways this vision of the hills around Marseille is comparable to Cézanne's later views of the same region, such as *The Chaîne de l'Etoile with the Pilon du Roi* (cat. 88), in the way in which the space is presented, and in the sense of light and atmosphere. However, Cézanne consistently presented the foregrounds of his scenes as successions of planes, one beyond the other, denying the viewer the imagined access to the space that *The Hills of Allauch, near Marseille* offers.

The museum in Marseille bought the picture from Guigou's family in 1881, after the artist's death.

Fig. 34
Emile Loubon
*Marseille seen from the Aygalades
on Market Day*, 1853
140 × 240 (55⅛ × 94½)
Musée des Beaux-Arts, Marseille

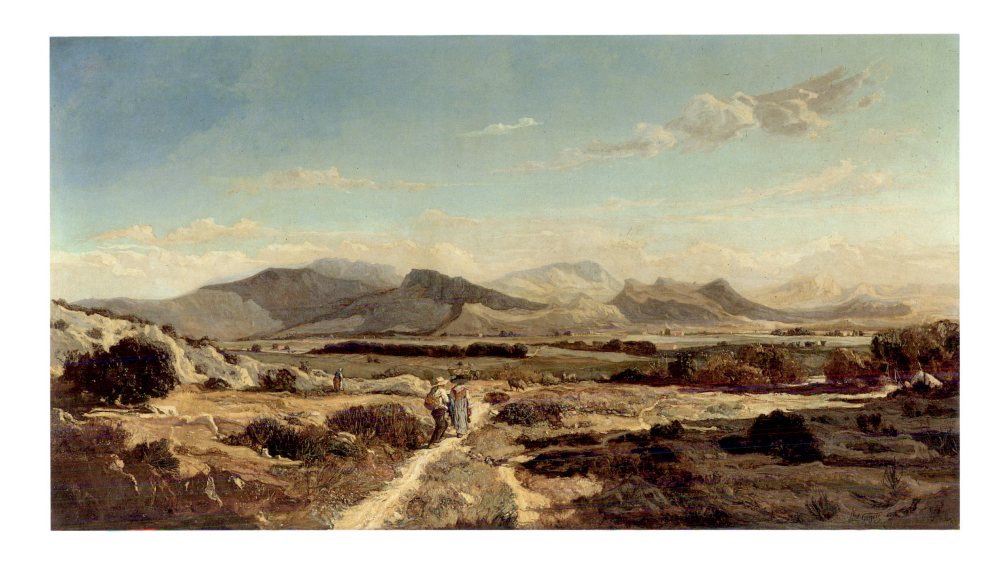

3

**The Banks of the Aveyron,
Autumn Evening 1863**

Bords de l'Aveyron, soir d'automne
Salon of 1863, no. 1392
81 × 141 (31 ⅞ × 55½)
Musée Ingres, Montauban

The castle on the hilltop is that of Penne, at the lower end of the gorges of the River Aveyron, north of Albi and east of Montauban. Penne was not a particularly well-known site, and the fact that it was not identified in the picture's original title suggests that the canvas was originally viewed as a typical image of this region of France, with its distinctive rock formation and its castle evoking a feudal past, untouched by modernity. Only the boats by the river hint at a continuing human presence.

The picture is a fascinating combination of tradition and experiment. The composition is clearly neo-classical in inspiration, with the winding river leading past the repoussoir of the trees on the left to the distant castle; and the site clearly belongs to the tradition of the *Voyages pittoresques* (see pp. 14, 32). But the extreme delicacy of the effects of light and atmosphere indicate Nazon's interest in the explorations of painters such as Daubigny, though the combination of sunset with the crescent moon gives the scene a resonance unlike Daubigny's seemingly informal observations of fleeting effects. Nor is the technique in any sense academic: the simplified and at times rather schematic rendering of the forms is quite unlike the artful complexity of neo-classical modelling (see cat. 28).

The critics in 1863 sought to define Nazon's position. For Claude Vignon (pseudonym of the female critic Noémie Cadiot), Nazon's individual and spiritual vision set him apart from the 'pure realists' (Vignon 1863, p. 387). Chesneau admired the atmospheric effect in *The Banks of the Aveyron, Autumn Evening*, but criticised the 'negligence' of its technique (Chesneau 1864, pp. 211–12). Likewise, du Pays praised his 'accurate and delicate sense of light' but not his paint-handling: 'Viewed from close to, the technique seems too conventionalised; he uses flat areas of colour too often, and the foliage, grass and plants look as if they are fixed and congealed in glue.' (Du Pays 1863, p. 26.)

The painting was bought by the State at the 1863 Salon, and displayed in the Musée du Luxembourg in Paris; it was transferred to Montauban in 1922.

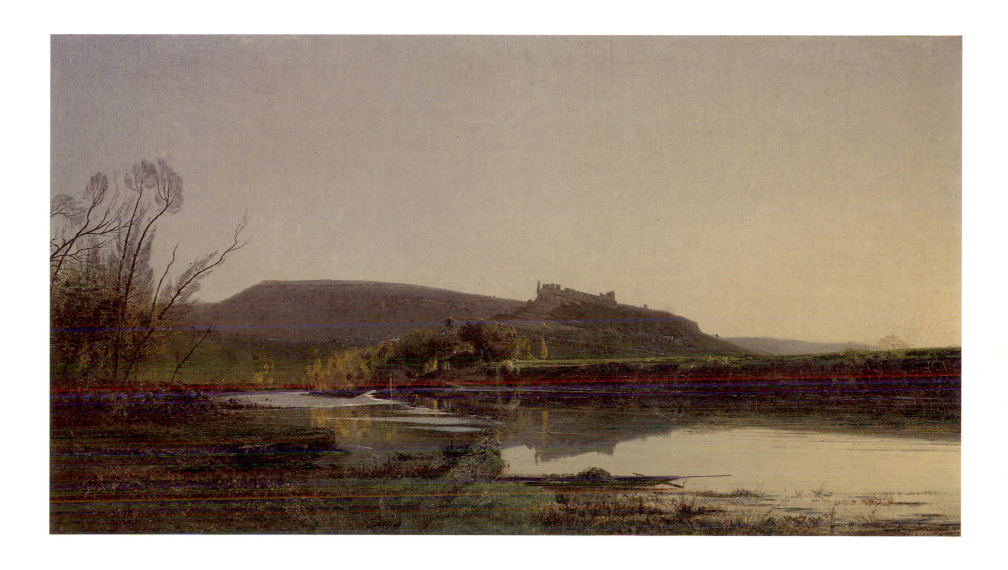

4

Entre-Roches on the Doubs 1864
Entre-Roches sur le Doubs
Salon of 1864, no. 104
124 × 200 (48⅞ × 78¾)
Musée des Beaux-Arts et
d'Archéologie, Besançon

Bavoux's *Entre-Roches on the Doubs* depicts a site on the spectacular upper reaches of the River Doubs, in the Jura mountains to the south-east of Besançon and Courbet's home town of Ornans. Although the title refers to a particular place, it was not readily accessible or well known, and the picture would have been seen as a generic image of the very distinctive *reculées* of the region, the deep river valleys that cut through the Jura plateau.

This is one of the most unexpected of all the landscapes purchased by the State during the Second Empire. The bold frontal composition and the breadth of its execution were an open rejection of current landscape conventions. The two slabs of rock do not constitute a motif in the accepted sense, and the composition has no clear focus apart from the play of sunlight on rock. Marks of human life are absent; only the birds give some sense of scale.

In technical terms the painting is obviously indebted to Courbet, notably in the breadth and confidence of the palette-knife strokes that suggest the forms without recourse to conventional modelling. Courbet's contemporary paintings of the source of the Loue (fig. 22) are an obvious comparison. Yet Bavoux's canvas is larger and more dramatic than any of Courbet's pure

landscapes; the play of sunlight makes an immediate impact, while the effect of the scene is heightened by the strong colour contrasts, between the blues of sky and distance and the rich orange accents on the cliff faces.

In 1864 Hébert was delighted by Bavoux's 'savage, rural rocks': 'What vigorous tones! What warmth! What truthfulness! This sterile, austere site, vividly lit, makes more of an impression than so many pretty, affected works ... It is broadly painted, and one could only wish that the light was more discreetly and soberly distributed.' (Hébert 1864, p. 294.) For Léon Lagrange, Bavoux had gone beyond the limits of art. 'Another eccentric: M. Bavoux. Here, it's no longer a matter of painting. It is nature that has placed itself on the canvas. There is no longer any question of beauty, or of style, or of poetic charm, or even of the impression; it is the thing itself: rocks that are rocks, grass that is grass, water that is ... a real mirror. Impossible to push illusion any further ... With an incomparable boldness of touch, M. Bavoux gives us the powerful sense of reality that we demand of a stereoscopic photograph.' (Lagrange 1864, p. 17.) The 'roughness' of the picture reminded du Pays so much of Courbet that he noted with surprise that Bavoux had been a pupil of the

academic Picot (du Pays 1864, p. 39). For Thoré, Bavoux had been 'perverted by his compatriot Courbet' (Thoré 1870, II, p. 83).

When the State offered to buy the painting, Bavoux accepted with great and tortuous humility: 'If recognition and courage are enough to make the encouragement that you deign to send me profitable to my feeble talent, I shall not fail.' (AN F²¹ 117.) However, it seems likely that the purchase was not merely a recognition of Bavoux's talents; his success stands in marked contrast to the State's much-discussed refusal to buy any of Courbet's work at this date, and it seems likely that the purchase was in part a coded sign to Courbet that he, too, might gain favour if he chose less provocative subjects (see House 1989, pp. 165–6). The next year, the Emperor bought one of Courbet's least controversial landscapes.

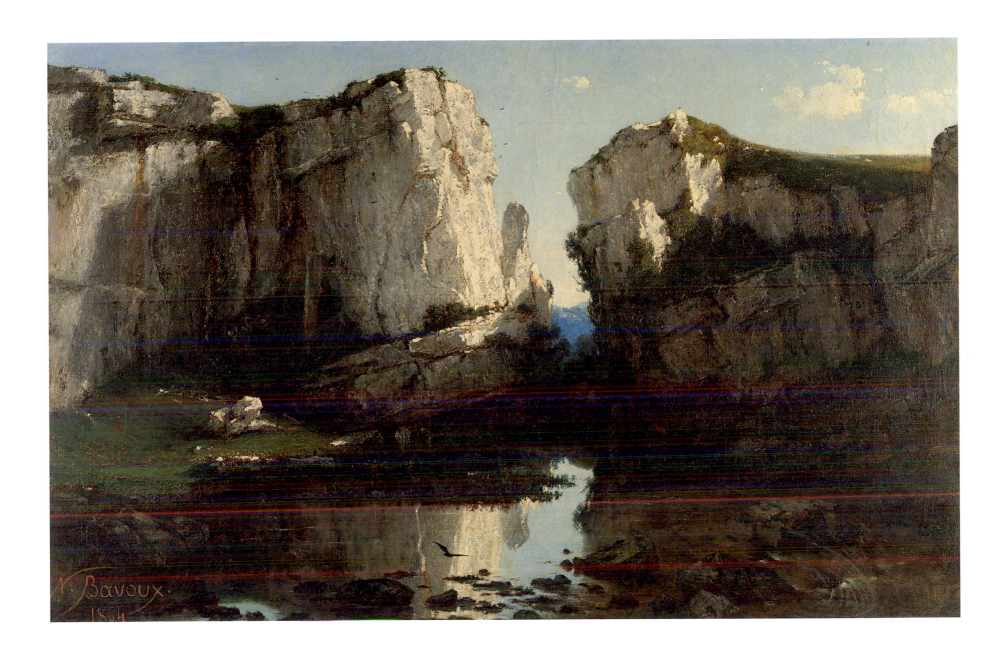

5

A Tempest 1864
Un Ouragan
Salon of 1864, no. 254
155.7 × 251 (61¼ × 98⅞)
Musée des Beaux-Arts, Arras
Exhibited in London only

A Tempest is a remarkable combination of the topographical and the elemental. The church spire in the background is recognisably that of Courrières, Breton's native village between Arras and Lille in north-eastern France, which would have been well known from his own work and especially from the peasant paintings of his more famous brother Jules. Yet the primary theme of the picture is evidently the forces of nature, as the title shows.

The effect is heightened by the extreme contrasts of scale, between the splintered foreground tree, with its branches blocking the road and closing off our entry to the scene, and the tiny forms of the windmills at back left and the figures in the field on the right. The interrelationship between man and nature is stressed by the placing of a cottage directly behind the principal tree trunk, which acts as a pivot to the whole scene.

In 1869 Gautier defined Breton's art: 'He has quickly made himself a reputation for the original way in which he understands nature, which he catches at its most remarkable moments, like a man who lives all the year round in close familiarity with the fields. Looking at M. Emile Breton's paintings, one can easily see that he is not an indoor landscapist, as so many are.' (Gautier 1880, p. 299.) This comment shows how effectively the Breton brothers cultivated their reputation as artists rooted in the country of their birth; to viewers today, the rhetorical basis of Emile Breton's images of the most extreme natural effects are very apparent.

A Tempest was bought by the State at the 1864 Salon and sent to the Arras museum, near the village of Courrières.

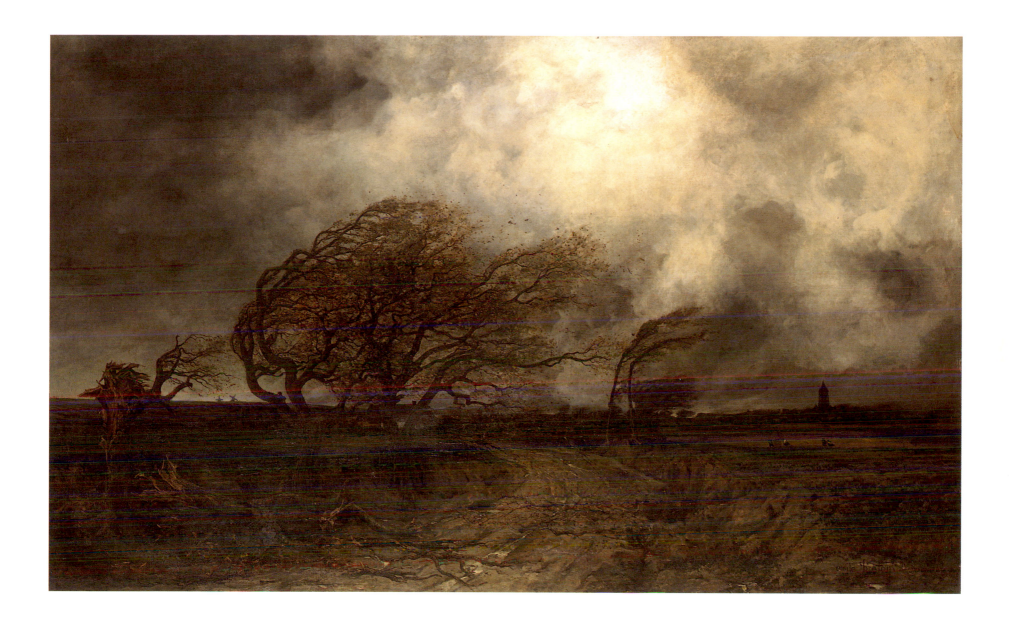

6

Villerville-sur-Mer 1864 and 1872
Villerville-sur-Mer
Salon of 1864, no. 503
100 × 200 (39⅜ × 78¾)
H. W. Mesdag Museum, The Hague

Villerville-sur-Mer is of exceptional interest in the history of French nineteenth-century landscape painting because it is the first large exhibition picture that was claimed to have been executed entirely out of doors. In his book on Daubigny, the artist's friend Henriet wrote: '*Villerville-sur-Mer* … was entirely executed on the spot. Daubigny had fixed his canvas to some posts firmly driven into the ground, and there it remained, continually exposed to the horns of cattle and the pranks of young rascals until it was completely finished. The painter had specifically chosen a turbulent grey sky with big clouds chased by an angry wind. He kept watch for the favourable moment and ran out to work on it as soon as the weather promised to correspond to the impression of the picture.' (Henriet 1875, p. 43.)

The grey weather allowed Daubigny to work for longer on the canvas without the light changing much. Whether or not it was executed entirely outside, Daubigny seems not to have repeated the experiment of painting so large a canvas in the open air. Though many of his smaller pictures were done on the spot, he usually worked up his Salon paintings in the studio from smaller studies.

Thomas Couture commented in 1869 that the ruse of painting out of doors in grey weather bypassed the point of landscape painting, which was to show the effects of sunlight (Couture 1869, p. 40). Monet's attempts to paint the monumental *Women in the Garden* (Musée d'Orsay, Paris) out of doors in clear sunlight in 1866 were intended to answer such criticisms, but even he was forced to finish the picture in the studio. Later the Impressionists, like Daubigny, worked outside only on their smaller canvases; Monet's Salon paintings of 1880 were executed in the studio (see cat. 36).

Although Villerville lay between the busy port of Honfleur and the rapidly developing beach resorts of Trouville and Deauville (linked to the railway network in 1863, the year before this picture was exhibited), Daubigny presented the place as a remote and unaltered rural site, as Guillemet would a decade later (see cat. 31); two local fisherwomen carry their catch up the rough hillside towards the village on the cliff-top.

Villerville-sur-mer was prominently hung in the central hall at the Salon of 1864 and was widely discussed by critics. Léon Lagrange voiced the academic reservations about Daubigny's art, describing him as the 'slave of the impression … afraid to put too much of himself in his pictures', but his final verdict was positive: 'The whole thing reveals perfect observation and great poetry … In *Villerville* I breathe a good salty air.' (Lagrange 1864, p. 11.) Thoré felt that the looseness and imprecision of Daubigny's brushwork was inappropriate for a subject taken directly from reality, but praised the unity of sky, water and land and the 'melancholy sentiment' that added to the character of the scene (Thoré 1870, II, p. 81). Castagnary had no reservations: 'No detail that might give it emphasis or life is overlooked, and they all combine and harmonise to give a dramatic and desolate impression; its effect is irresistible.' (Castagnary 1892, I, p. 193.)

The canvas in its present state is not as Daubigny left it in 1864; it is dated '1872' and was presumably reworked at this date. We do not know how it was altered, but Lagrange's review may offer a clue; he felt that the single female figure was placed too low and too far to the left (Lagrange 1864, p. 11), so the addition of a second figure may have been a response to his comments.

The painting was bought from the dealer Goupil by the Dutch landscape painter Hendrik Willem Mesdag after Daubigny's death, and was subsequently bequeathed to the Mesdag Museum in The Hague.

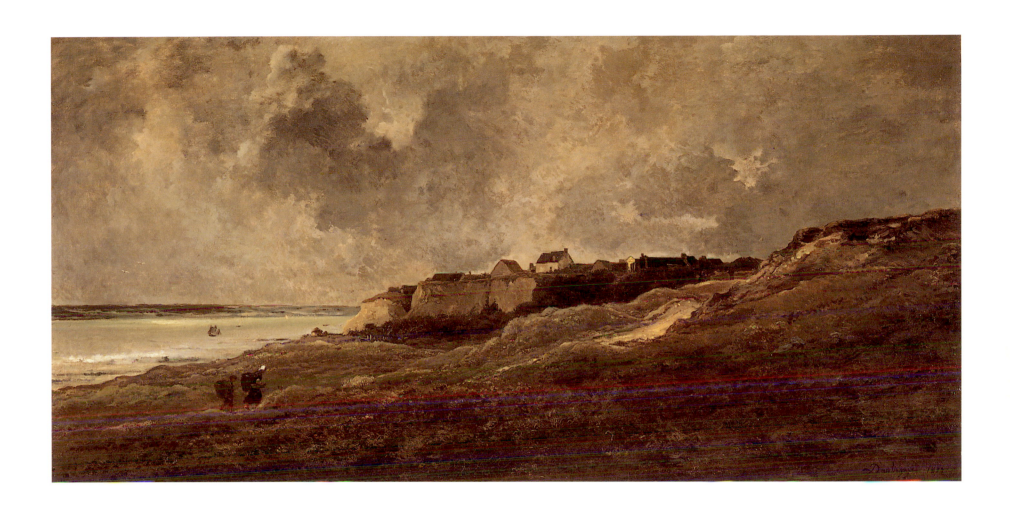

7

The Port of Brest 1864
Port de Brest
Salon of 1864, no. 1441
114 × 146 (44⅞ × 57½)
Musée de Brest

The Port of Brest was an ambitious attempt to revitalise the long tradition of topographical painting. By the 1860s scenes like this appeared more often as engravings in guides and travel books, but painters such as Noel and Adrien Dauzats continued to work in this vein on an ambitious scale. Noel's canvas would have evoked immediate memories of Joseph Vernet's series of monumental canvases depicting the ports of France in the 1750s and 1760s (see figs. 35 and 47, p. 166); Brest was one of the ports that Vernet had planned, but failed, to paint.

The idea of continuing Vernet's project was a live issue at the time. In 1862 Daubigny had proposed to the Government that he should paint a series of canvases of the imperial parks and castles as a follow-up to Vernet's ports, but in the end he produced only one canvas, *The Park of Saint-Cloud*, exhibited in 1865 (fig. 11; see p. 25 and Philadelphia 1978, pp. 284–5). Daubigny's proposal throws light on the explicitly nationalistic and imperialist tone of Noel's canvas, a celebration of France's naval power. Apparently it depicts the visit of two British frigates to Brest in the autumn of 1863, a demonstration of the *entente cordiale* recently established by the Franco-British alliance in the Crimean War and the trade treaty of 1860.

Noel's picture shows the continuity between past and present. On the right

is the château, built from the thirteenth century onwards, and the port is crowded with the traditionally rigged sailing ships. Spanning the river on the left, however, we can see the *pont tournant*, a feat of engineering constructed as recently as 1861; and the rowing boats carry many smartly dressed women, presumably visiting the British boats. A further contrast is set up between these fashionable figures and those working on the quay beyond them, unloading the nearest ship; one seemingly drunken figure is slumped against the lamppost, dangerously poised above the figures on the slipway.

Throughout, the picture is executed with a rather artful delicacy, giving it a busy, almost fussy surface; yet the figures are closely and at times wittily defined and the play of light is carefully observed. The space can be read with surprising clarity through the mass of boats that lead the eye back down the river to the building in the far distance.

Reviewing the picture in 1864, Louis Auvray praised the picture's remarkable 'truthfulness [*vérité*] of details and colour', but felt that the water lacked 'transparency' (Auvray 1864, p. 63). Edmond About's comments reveal the very different criteria that critics used in discussing a topographical image such as this, in contrast to the atmospheric landscapes that were so common at

the Salon (see cats. 5, 6). He praised the accumulation of different elements in it, but felt that it was perhaps 'a little overladen with details'. He had one substantial criticism, of the rather caricatural treatment of the figures: 'The foreground ... has a rather vulgar comic tone that distracts from the significance and seriousness of the background.' (About 1864, pp. 134–5.) Overall, though, he concluded: 'Everything is rendered with a striking truthfulness [*vérité*]: the movement and the multiple life that animates the great sea ports, the comings and goings of the embarkations, the physiognomy of a very particular public ... The constant hubbub of Brest has been so to speak caught in flight.'

During the Salon Noel wrote to the minister requesting that the State acquire the picture (AN F[21] 166). It was purchased and sent to the museum at La Rochelle, another port on the west coast of France (and one that Vernet had painted, see fig. 35); it was deposited in the museum in Brest only in 1992, as part of the rebuilding of its collections after their destruction during the Second World War.

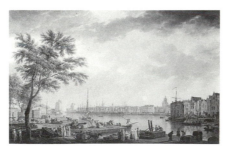

Fig. 35
Joseph Vernet
View of the Port of La Rochelle, 1762
165 × 263 (65 × 103½)
Musée du Louvre, Paris
(on deposit at Musée de la Marine, Paris)

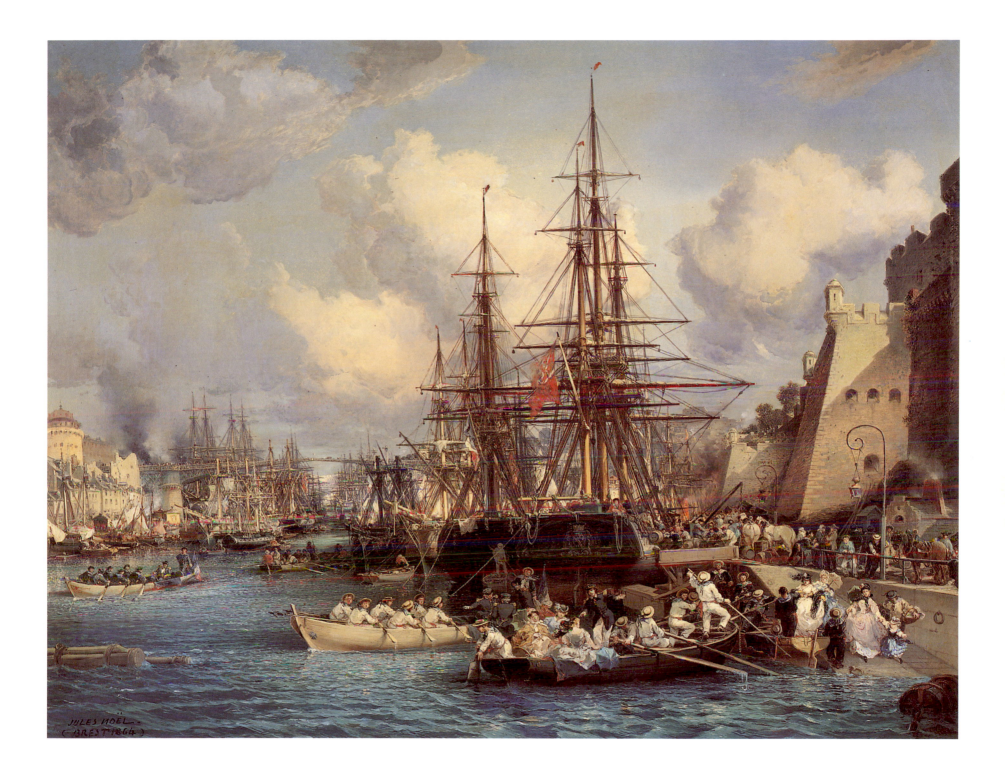

JULES NOËL
(BREST 1864)

8

The Banks of the Marne 1864
Bords de la Marne
? Salon of 1864, no. 1558
81.9 × 107.9 (32¼ × 42½)
Glasgow Museums: Art Gallery
& Museum, Kelvingrove

This painting (now titled *The Tow-Path* by the Glasgow Museums) is most probably the canvas that Pissarro exhibited at the 1864 Salon with the title *The Banks of the Marne*. The title defines it only as a scene on the Marne, a river that joins the Seine from the east just to the south-east of Paris (see also cat. 10); the painting is an archetypal river scene of the Ile de France region, of the type popularised by Daubigny (see cat. 11 and fig. 12). There are no distinctive topographical features; the little figure of a peasant woman on the path gives some sense of scale, but the sharpest focus is on the sunlit band that cuts across the path in the foreground.

The execution of the picture is reminiscent of Daubigny's more roughly finished exhibition pictures, with perhaps an echo of Corot in the softly brushed edges of the trees. Pissarro was one of the many young artists to have received informal instruction from Corot (see cat. 25). He later remembered Corot saying to him: 'We don't see the same way: you see green and I see grey and blond; but that is no reason for you not to study values.' (Quoted in Shikes and Harper 1980, p. 54.)

A small study for *The Banks of the Marne* survives (fig. 36), which shows that the large canvas was executed in the studio. In the study the figure is larger, which gives the whole scene a more intimate feeling, and there is also a small dark accent that suggests the presence of another figure further away down the path; in the final picture a second small figure seems to have been painted out at this point. Twentieth-century taste, which has so valued the apparent spontaneity of Impressionism, has put a high value on Pissarro's small outdoor studies such as fig. 36; however, during the mid 1860s he was clearly focusing his most ambitious efforts on Salon paintings such as *The Banks of the Marne*.

Fig. 36
Camille Pissarro
The Tow-path, 1864
24.4 × 32.4 (9⅝ × 12¾)
Fitzwilliam Museum, Cambridge

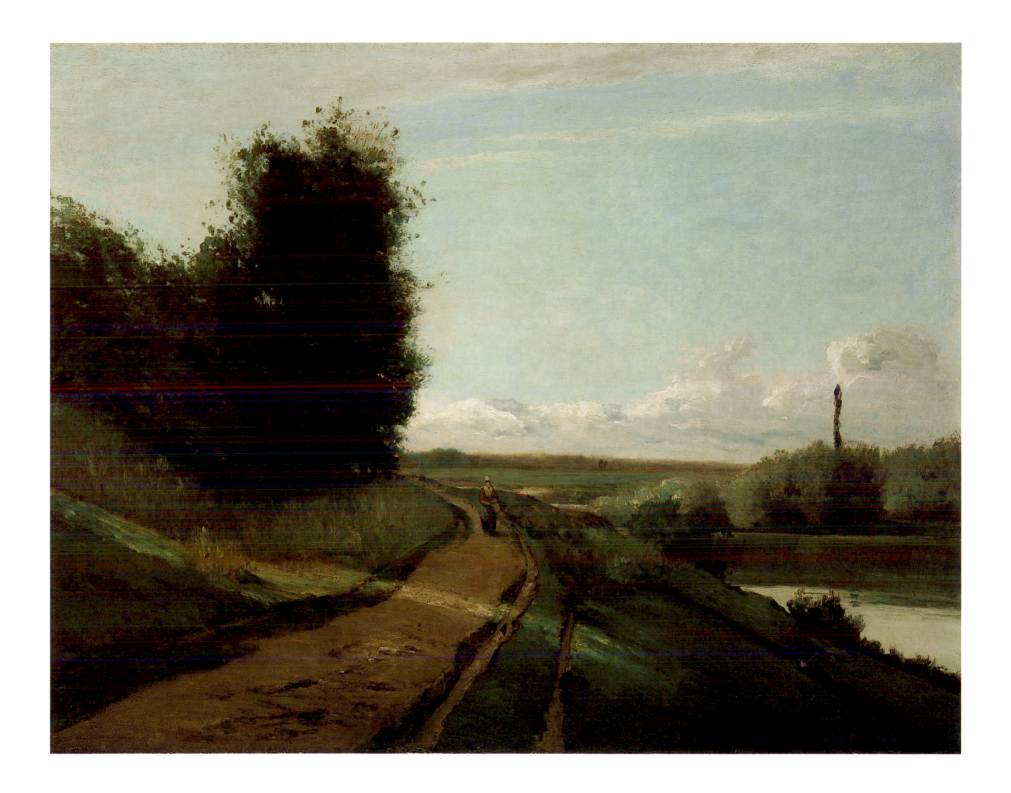

9

Tamaris, near Toulon 1865
Tamaris, environs de Toulon
Salon of 1865, no. 16
97 × 157 (38⅛ × 61⅞)
Musée de Toulon

Tamaris, near Toulon is a particularly spare image of France's Mediterranean coast, treated with a surprising economy of means. It is markedly different from the romanticised and theatrical vision of the same coastline in the contemporary works of painters such as Vincent Courdouan (fig. 37) and Raphael Ponson (see Thomson 1994, p. 67).

By the end of the nineteenth century Tamaris was becoming a busy resort, but in the 1860s it was still a tiny hamlet. The view in Aiguier's painting is not of Tamaris itself but looks south-westward towards Cap Sicié with the hamlet of Les Sablettes beneath it (see Toulon 1985, p. 164). *Tamaris, near Toulon* would have triggered a range of associations in its viewers. The picture's title would have reminded viewers of the proximity of France's leading naval port, from which the French navy had recently set sail for Mexico. And Tamaris itself had been the setting, and the title, of a recent novel by George Sand, published in 1862, in which the local scenery had been eloquently described (see Sand 1862, pp. 31–3, 164–5).

The three small boats by the near shore, one with a male figure dressed in red, and the silhouettes of a few houses by the water across the bay are subordinated to the effect of the contre-jour sunset. The distinctive blue-grey form of the cape is starkly silhouetted against the luminous yellow-gold of the setting sun. To the top of the picture the sky gradates towards blue, but it is treated with a delicate flecking of contrasting warm and cool hues that give the whole a remarkable shimmering effect; below, the composition is anchored by the rich blues of the sea, set against the warm hues where the evening light hits the near shore.

The Provençal critic Marius Chaumelin highly praised Aiguier's approach to landscape: '[He] has sought to give his marines and his landscapes that vague, indefinable impression that the mysterious harmonies of nature evoke in sensitive spirits. Instead of brutally copying what his eyes saw, he chose his lines, he sought the softest and most poetic effects of light; in a word, he composed his landscapes without altering the true appearance of the site and without falling into the exaggerations of the academic style.' (Chaumelin, quoted in de Laincel 1865, p. 91.) In an 1869 catalogue of the Toulon museum Charles-Antoine Bronzi criticised the systematic suppression of detail but praised the light effect: 'The firmness of the tonal relationships, especially, produces a powerful and penetrating harmony.' (Quoted in Toulon 1985, p. 164.)

The picture was bought by the city of Toulon in 1866, after Aiguier's death.

Fig. 37
Vincent Courdouan
At Cap-Brun, the Saint-Marguérite Cliff, 1867
Pastel, 24 × 40 (9½ × 15¾)
Musée de Toulon

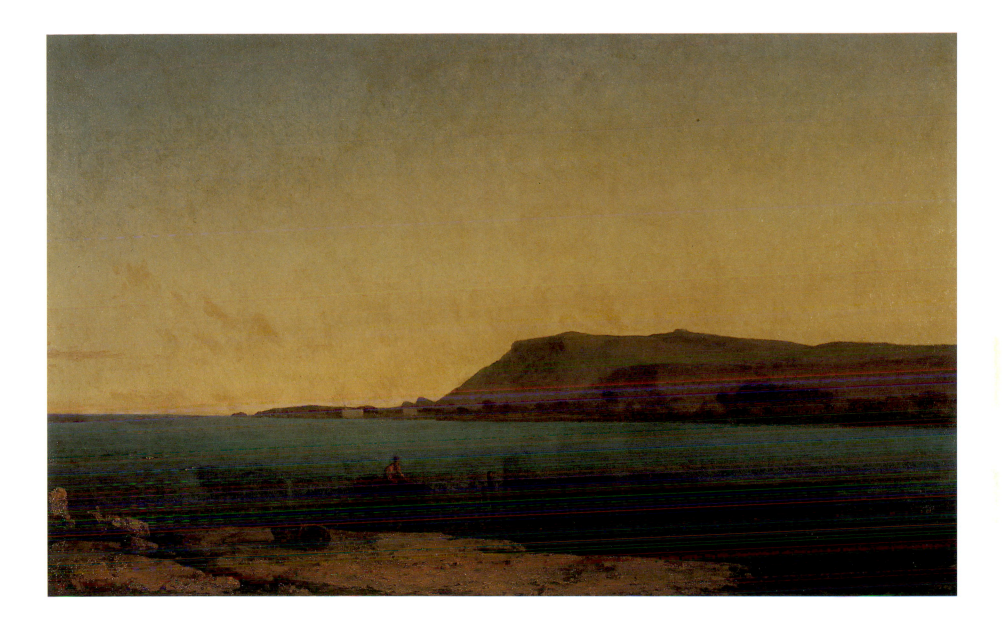

10

**Chennevières, on the Banks
of the Marne** *c.* 1864–5
Chennevières, au bord de la Marne
Salon of 1865, no. 1723
91.5 × 145.5 (36 × 57¼)
National Gallery of Scotland,
Edinburgh
Exhibited in London only

Like Pissarro's exhibit of the previous year, *The Banks of the Marne* (cat. 8), this painting is comparable to Daubigny's river scenes (see fig. 11). However, it marks a divergence from *The Banks of the Marne* and from the example of Daubigny in three ways: in the choice of a more explicitly contemporary subject; in the breadth of its technique; and in the use of the palette knife.

Chennevières, seen on the right, faces La Varenne-Saint-Hilaire across the River Marne just south-east of Paris. In the 1860s they were still rural villages, but the presence of the small factory by the river in the centre of Pissarro's painting hints at the industrial development in the region; likewise the wall alongside the river on the left suggests that the riverbank has been built up, and the little ferry boat seems to be carrying figures in bourgeois dress.

The palette-knife work in the picture is especially evident in the clouds and their reflections, and in the sunlit wall on the left; by contrast the buildings by the river and the foliage are primarily executed with the brush. The use of the knife at this date was explicitly associated with Courbet's technique (compare Bavoux, cat. 4), and was an overt rejection of academic methods. The tonality of the picture is still quite sombre; its firm, emphatic structure derives from the contrasts between the muted greens and browns and the sunlit accents on buildings and clouds. Pissarro had not yet begun to use the sky as a keynote to the picture, lending luminosity to the whole (contrast cat. 63, of 1870).

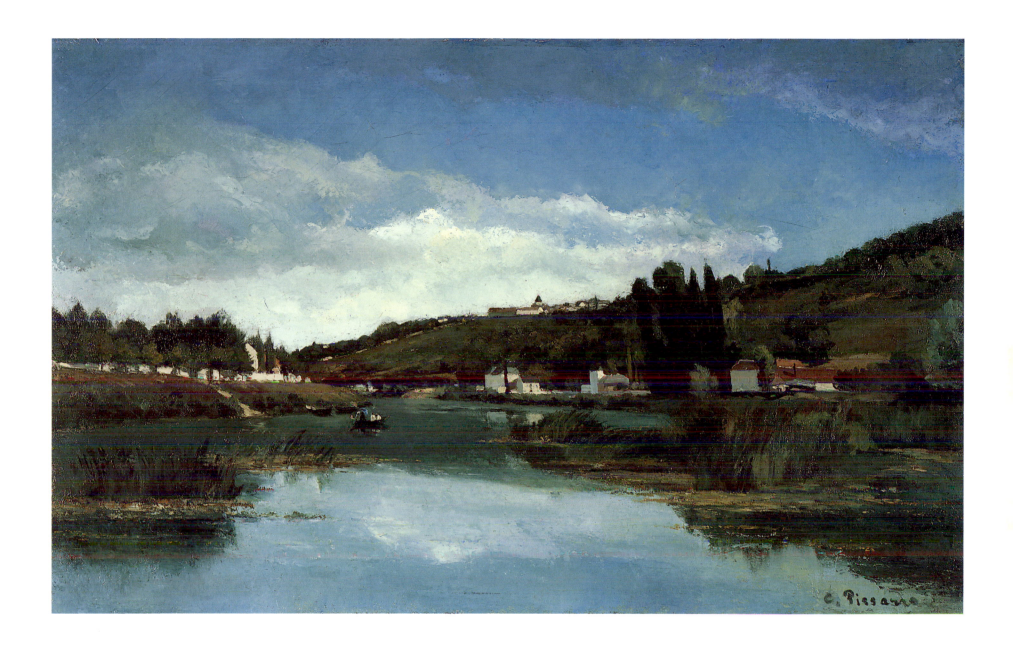

11

Morning Effect on the Oise 1866
Effet du matin sur l'Oise
Salon of 1866, no. 496
90.5 × 162.5 (35⅝ × 64)
Musée des Beaux-Arts, Rouen

Morning Effect on the Oise is an archetypal example of Daubigny's study of atmospheric effects across the riverside landscapes of the Seine and Oise valleys in the Ile de France. In marked contrast to his rougher, more sketchy canvases, which were much criticised at the Salon during the 1860s, paintings such as *Morning Effect on the Oise* present a softly brushed, almost delicate vision, close in some ways to Corot, but always showing a simple, everyday site, rather than an evocation of poetry or memory (see Corot, fig. 19). The use of the term *effet* in the title emphasises that the principal subject of the picture is the light effect, rather than a motif in the traditional sense (see pp. 21–2). The title is not specific and the site depicted is not at all distinctive. Daubigny's river scenes were a key influence on landscape painting for the rest of the century; even the young Impressionists adopted very similar formats for many of their river scenes in the 1870s (see fig. 33, p. 66).

Despite his doubts about the place of landscape in the hierarchy of the fine arts (see p. 40), Charles Blanc praised Daubigny's views of the banks of the Oise very highly in his review of the 1866 Salon: 'Who could have said that this familiar river, these simple clumps of trees, this nature without movement and without name, could have provided the material for a landscape of such engaging and penetrating beauty!' (Blanc, July 1866, p. 46.)

Seemingly artless, the effect of *Morning Effect on the Oise* is in fact carefully contrived. Although Daubigny sometimes took his viewpoints from open water, when working from his studio boat, here the viewer is placed on the bank. The eye is led gently into the distance by the gradation of the brushwork, from the broken flecks and dabs of paint in the foreground to the soft, slightly blurred forms in the distance; and a succession of slightly emphasised elements in the scene act as stepping stones that lead into the space, in a serpentine recession from front left to back right.

The painting was bought directly from Daubigny by the Rouen museum in 1866.

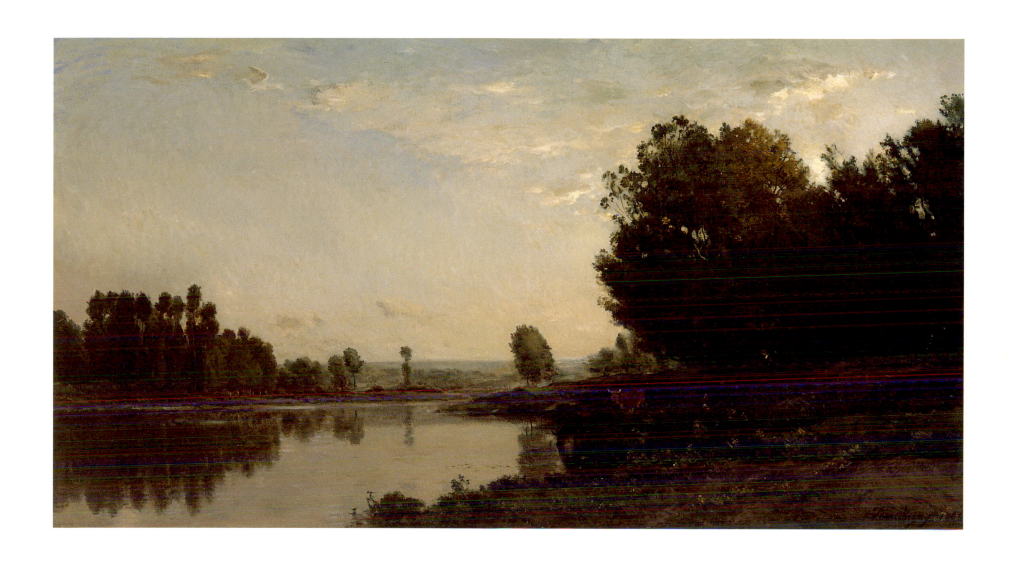

12

End of the Village of Greville
c. 1865–6
Un Bout du village de Greville
Salon of 1866, no. 1376
81.5 × 100.5 (32⅛ × 39⅝)
Museum of Fine Arts, Boston
Gift of Quincy Adams Shaw
through Quincy A. Shaw Jr and
Mrs Marian Shaw Haughton
Exhibited in Boston only

Millet was born in the hamlet of Gruchy, part of the commune of Greville, on the extreme north tip of the Cotentin peninsula in north-west Normandy, to the west of the port of Cherbourg. *End of the Village of Greville* shows the view over the Channel from the end of the little street that runs through Gruchy; the site survives largely unchanged.

This painting played an important role in Millet's development of his public image. Although his reputation had been gained principally for his peasant scenes from the area round Barbizon and the Fontainebleau Forest (see fig. 31), he made much of his background as the son of Normandy peasants. He had left Gruchy in the mid 1840s and visited it again only in 1853 and 1854 after his mother's death; it was on his last visit that he made the studies that led to *End of the Village of Greville*. He seems not to have gone to Gruchy again until a brief visit early in 1866, just before the picture was exhibited; on this visit he found that the elm that is the focus of the painting had been blown down (see Murphy 1984, p. 161). Thus the motif itself and its summer effect were based on memories and past studies.

He presented the picture as a distillation of his childhood. Before discovering the fate of the tree, he wrote of the painting in 1866 to Alfred Sensier, who acted as his agent and publicist: 'I'm working at my end of the village overlooking the sea; my old elm tree is, I think, beginning to look as if it is worn away by the wind. How I should like to be able to set it free in space as my memory sees it! Oh, you spaces that made me dream so much in my childhood, will I ever be able to give a hint of what you are like?' (Paris 1975, p. 238; see also p. 17.)

Two years later he elaborated on the meanings the picture had for him in letters to Théophile Silvestre: 'By the final house is an old elm that stands out against the infinite open space. For how long has this poor tree stood there battered by the north wind? I have heard the old folk of the village say that they have always known it as I saw it. It's neither very tall nor very thick, since it has constantly been worn away by the wind, but it is tough and gnarled.' He wanted to put the spectator in the position of the young child whom the mother holds up to look at the view: 'I wanted to be able to give the spectator some vague idea of what must enter the head of a child who has only ever received impressions of that sort, and of how the child must later feel himself out of his element in noisy, crowded surroundings.' (Murphy 1984, pp. 161, 242–3.)

As he presented it here, Millet himself could be associated both with the child who migrated to the city and with the tree that stood up to the winds; but these readings, proposed in letters to friendly critics, were an attempt to forge public meanings for the picture, rather than expressions of an inner, private symbolism. The effect of *End of the Village of Greville* resulted in part from the picture itself, but also from the image that Millet was building of himself as a peasant painter (see Parsons and McWilliam 1983).

The execution of the picture seems intended to heighten the sense of integration between the figures and their surroundings. In marked contrast to the deliberate roughness that Millet cultivated in some of his Barbizon scenes in the 1860s, the whole is executed with a refined and delicate touch, with rich variations of texture and colour. This can be seen as an attempt to evoke the innocent wonderment of the child's vision; but for critics such as Emile Zola, habituated to the vigour and simplicity of Millet's usual handling, it seemed soft and indecisive (Zola 1866, in Zola 1959, pp. 75–6; see also Castagnary 1892, I, p. 235).

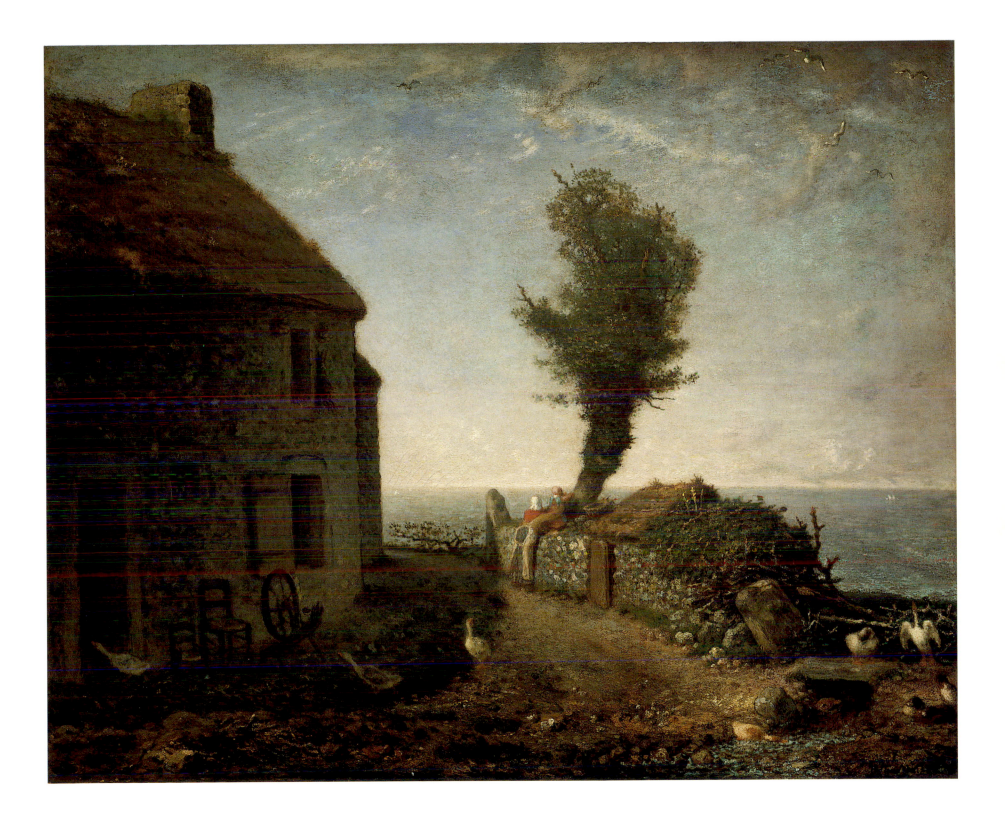

13

**A Road in Marlotte,
near Fontainebleau 1866**

*Une Rue à Marlotte, environs de
Fontainebleau*
? Salon of 1866, no. 1786
64.8 × 91.4 (25½ × 36)
Albright-Knox Art Gallery,
Buffalo, New York
General Purchase Funds, 1956

Marlotte, a small village on the
southern edges of the Forest of
Fontainebleau, was one of the principal
artists' colonies in the region, rivalling
the more famous Barbizon on the
opposite side of the forest. Renoir's
Cabaret of Mother Antony of 1866
(fig. 38) is eloquent testimony to the
artists' relaxed, bohemian lifestyle
there; Sisley is seen standing behind
the table, in front of the ebullient
caricatures that cover the wall.

*A Road in Marlotte, near
Fontainebleau* was almost certainly
one of Sisley's two Salon exhibits in
1866; the other, *Women going to the
Woods: Landscape* (Bridgestone
Museum of Art, Tokyo; see London
1992–3, pp. 90–3) is a more
straightforward view down the village
street. The titles of both pictures
indicate the proximity of the forest;

but both are a corrective to the
traditional view of it as a solitary
refuge (see fig. 5). Instead we see an
ordinary rural village and its humble
buildings in the dull light of an
overcast grey day; and in both the
peasant figures present the village
as a workplace.

*A Road in Marlotte, near
Fontainebleau* has a deliberately
awkward composition. The focal
points in it – the woodcutter with his
equipment and the highlights on walls
and buildings – are scattered across
the composition; the buildings on
the left form a particularly jumbled
and incoherent group. The road,
running in from the left, does not lead
the eye to any significant point; its
recession is blocked by walls and by
the figure of the woodcutter. This
seemingly casual accumulation

of mundane elements is a calculated
naïveté, which gives the scene
a heightened sense of actuality.

Likewise the sombre, earthy
tonality of the painting and the
technique – broad and quite rough –
enhance this sense of the humdrum
life of a rural village. The paint surface,
somewhat flattened by subsequent
restoration, would doubtless have
had a physical density and texture
that would have heightened this
effect still further.

Fig. 38
Pierre-Auguste Renoir
The Cabaret of Mother Antony, 1866
195 × 130 (76¾ × 51⅛)
Nationalmuseum, Stockholm

14

**Grey Day in the Marsh of
La Burbanche (Ain) 1868**
*Temps gris, marais de
la Burbanche (Ain)*
Salon of 1868, no. 45
72 × 134 (28⅜ × 52¾)
Musée des Beaux-Arts, Lyon

La Burbanche is a hamlet in the hills to the east of Lyon; it is a site of no special distinction and did not feature in the guidebooks of the period. The title of the picture emphasises the weather effect, but the indication of the precise location, together with the distinctiveness of the foreground rocks, establish it as a specific site, in contrast to more generic riverside landscapes like Daubigny's *Morning Effect on the Oise* (cat. 11). The herons, together with the absence of any sign of human activity, lend a sense of remoteness to the scene.

The picture is a remarkable display of painterly virtuosity. The overall effect is one of integrated tonal harmony; the subdued greens and browns of foliage and earth are subordinate to the all-enveloping grey of the atmosphere. Yet the various elements in the landscape are delineated with very varied types of

brushwork, often very delicate; some of the more graphic handling recalls Appian's much-admired work as an etcher.

For Raoul de Navery the picture proved that Appian was the complete landscapist: 'Everything holds together and everything has its value in the scene; nothing is sacrificed and nothing exaggerated; no artificial devices and no mannerisms; no interpretation of nature, but rather nature itself, caught in the act, and fixed with a broad and assured brush. The detail never harms the overall effect, and the effect helps to give value to the detail. *Grey Day in the Marsh of La Burbanche* is a jewel ... The foliage, the sky, the rocks, everything blends into a complete harmony.' (De Navery 1868, p. 10.) Castagnary, though, had reservations about the graphic quality of Appian's technique: 'Appian ... does not paint enough what he draws

so well.' (Castagnary 1892, I, p. 267.)

The treatment of atmospheric effects in this painting makes a fascinating contrast with the broader and more sketchy treatment of the *effet* in the work of painters such as Daubigny, which in turn contributed to the early development of Impressionist landscape. Appian's picture shows a quite different way of translating the fleeting effects of light and weather into paint.

The painting was bought by the State at the 1868 Salon.

15

The First Dawn, after a Stormy Night
c. **1867–8**
*Le Lever de l'aurore, après une
nuit d'orage*
Salon of 1868, no. 509
141 × 170 (55½ × 67)
Musée des Beaux-Arts, Troyes

Chintreuil did not choose distinctive natural sites for his major exhibition pictures, and their locations were not identified in the titles he gave them. Rather, he presented panoramic sweeps of countryside, often on a very large scale, and focused on unexpected and dramatic effects of light and weather that transformed a mundane scene into some sort of elemental drama. Describing his work in 1864, Léon Lagrange thought that his treatment of landscape had inherited the sense of drama traditionally associated with history painting: '... through the mists of this new Wagner, I see the landscape of the future ... The landscape of the future will give us, instead of the Passage of the Red Sea, the "passage from the dawn to the day".' (Lagrange 1864, p. 15.)

The First Dawn, after a Stormy Night plays unashamedly on extreme effects and contrasts, with the band of storm-clouds between the livid light of dawn and the serene upper sky, and the half-submerged boat in the disturbed, muddy water at the base; across the centre the scene is flanked by the silhouetted mass of the hillside and the broken textures of the wind-tossed trees.

The painting was noted by many critics in 1868, but not without reservations. Thoré had high praise for the energy of 'this battle of the elements, this victory of light over darkness', which inspired him to a lengthy meditation on the relationship between the sun and the earth (Thoré 1870, I, pp. 492–3). Marc de Montifaud (pseudonym for the female critic Marie-Amélie Chartroule de Montifaud) was also struck by its wider resonance: 'It is the male sadness of creation, in which the final rumbles of dull thunder are extinguished ... The flame-like flush of the dawn has a sinister gravity.' (De Montifaud 1868, p. 51.) The young Odilon Redon, in his one review of the Salon, had the highest praise for Chintreuil's ability to combine 'a sincere rendering of detail with the charm of the impression', but felt that he was working on rather too large a scale for the delicacy of his talent (Redon 1987, pp. 44–5). Paul Mantz used the picture to characterise Chintreuil's art: 'He loves exceptional subjects, he paints the caprices of nature – one might almost say its adventures. There is perhaps something a little forced in *The First Dawn, after a Stormy Night*.

The sky is still troubled by the tempests of the night before, a residual agitation is whipping up the waves on the lake, the ravaged trees are weeping, and the dawn, instead of emerging gently in its rose-violet veils, harshly fills the base of the sky with a red and almost bloody light.' (Mantz 1868, p. 382.) For Castagnary, though, it was simply 'heavy and rather sad' (Castagnary 1892, I, p. 267).

The painting was bought by the State at the 1868 Salon, and sent to the museum of Troyes.

17

The Ruins of the Château of Pierrefonds *c.* 1867–8
Les Ruines du château de Pierrefonds
Salon of 1868, no. 1279
107 × 160 (42⅛ × 63)
Musée National du Château,
Compiègne

Huet gained his reputation as one of the key landscapists of the 'School of 1830', who first popularised French monuments and scenery as subjects. Among the historical sites that Huet painted in the 1830s were the ruins of the Château of Pierrefonds, about fifty miles north-east of Paris. He did not make a major picture of the subject immediately, but returned to it, working from his studies, in the 1860s.

By the time he exhibited this painting, the castle had been transformed, reconstructed for Napoleon III to the designs of Eugène Viollet-le-Duc from 1858 onwards. Responses to the rebuilding were generally favourable, partly, doubtless, because of press censorship.

Huet's choice of such a subject after the castle ruins had been so dramatically renewed might seem a nostalgic return to a romantic vision of the medieval past, and, as such, an implied criticism of Napoleon's ambitions. It was, though, the second view of Pierrefonds that he had exhibited: in 1867 he had shown *The Château of Pierrefonds, Restored* (fig. 40), a canvas commissioned by the Emperor. *The Ruins of the Château of Pierrefonds*, though apparently not commissioned, was also bought by the Emperor (see Huet 1911, pp. 406–21; Philadelphia 1978, p. 317).

Huet saw the two canvases as pendants. In the view of the restored

castle the scene is bathed in soft sunlight, and the figures and cottages coexist in peaceful harmony beneath the castle walls. In this painting, by contrast, the castle is lit by a theatrical flash of sunlight through stormy clouds; the saplings and the figure of the peasant woman at bottom left are also highlighted, whereas the church and cottages are deep in the trees around the base of the castle hill. We see here two different ideas of elemental force: the storm, and the sense of erosion through time that has ruined the castle. Napoleon's restoration can be seen as having restored peace and harmony to the place, by reinstating a functioning feudal hierarchy at Pierrefonds.

In his private correspondence, though, Huet was equivocal about the restoration. He wrote to a friend: 'This restoration will be admirably done by Viollet-le-Duc. It has made good progress; this, alas, is the art of today! This trifle will cost a good fifteen million francs. It will be beautiful and will make the fortune of the area. The Emperor is making a Windsor out of it ...' (Huet 1911, p. 411).

The effect of the picture is heightened by the vivid and varied touch, which evokes both the textures of the different forms and the forces of wind and rain. It is unashamedly romantic. Huet's disregard for literal accuracy can be seen in a delightful

detail: the woman's scarf is being blown in the opposite direction to the trees.

Critics saw the picture as a welcome corrective to recent developments in landscape. Mantz contrasted it with the current taste for 'a more precise naturalism': 'M. Huet does not amuse himself by counting the branches of a tree, he expresses the tree in its general form and in its feeling ... A passionate, powerful artist, he has his place in the history of the modern school.' (Mantz 1868, p. 382.) Likewise Lafenestre contrasted his 'passionate landscapes' with 'the correct young people who are content to cut out patiently, from the rich mantle of old nature, their own little corner of a wood or a plain.' (Lafenestre 1881, I, p. 41.) Thoré concluded: 'His work is always poetic in feeling and magisterial in technique. He has never forgotten the inspiration of his youth, the landscapist Constable. His *Ruins of the Château of Pierrefonds*, exhibited in the central hall, looks very grand. It would be good in a museum, between a Troyon and a Jules Dupré, to teach young landscapists not to be too fussy about the treatment of grass and foliage.' (Thoré 1870, II, p. 495.)

Huet's two paintings of Pierrefonds were separated after the dispersal of Napoleon's private collections, and were only reunited in 1987 in the Château of Compiègne, a few miles from Pierrefonds.

Fig. 40
Paul Huet
The Château of Pierrefonds Restored, 1866,
exhibited at the Salon of 1867
109.5 × 146.5 (43⅛ × 57⅝)
Musée du Second Empire, Compiègne

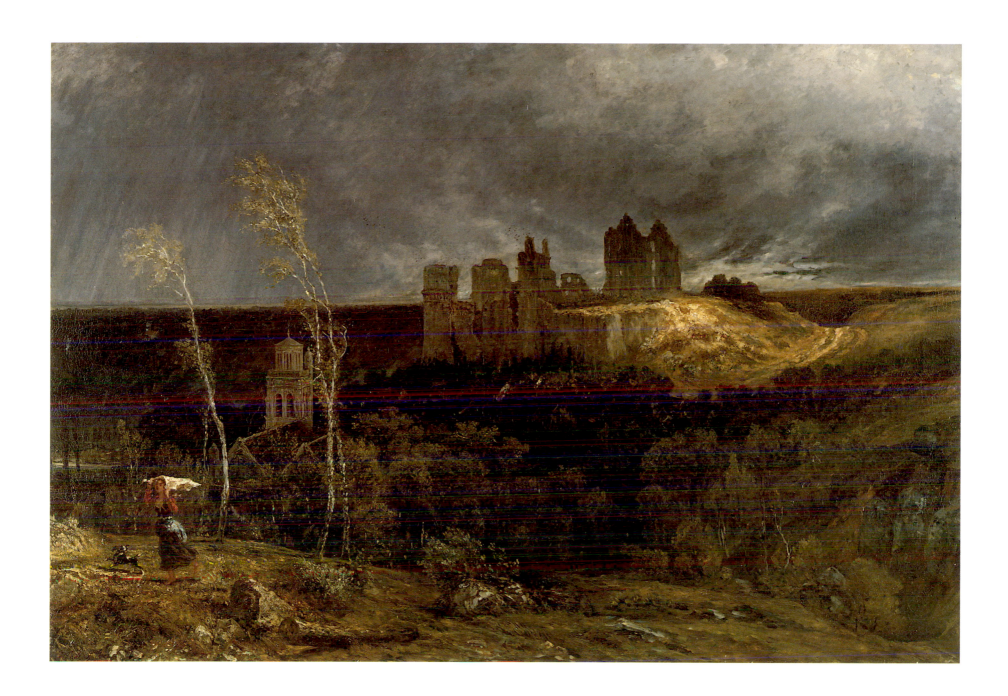

18

Avenue of Chestnut Trees, near La Celle-Saint-Cloud 1867
Avenue de châtaigniers, près la Celle-Saint-Cloud
Salon of 1868, no. 2312
95.5 × 122.2 (37⅝ × 48⅛)
Southampton City Art Gallery
Exhibited in London only

In contrast to Sisley's humdrum view of a village near the Forest of Fontainebleau (cat. 13), *Avenue of Chestnut Trees, near La Celle-Saint-Cloud* presents an archetypal image of a forest interior as a refuge; the rough track suggests human presence, but only the roe-deer disturbs the stillness.

La Celle-Saint-Cloud was a hamlet on the west side of the park of the Château of Saint-Cloud, one of Napoleon III's principal palaces, which would be destroyed in 1870 in the Franco-Prussian War (see fig. 11); the ride depicted in Sisley's painting was apparently imperial property. But how significant is the location? Various suggestions have been made: on the one hand, that its ownership made the canvas more acceptable at the Salon (see Los Angeles 1984, pp. 70–4); and on the other, that Sisley's painting treated the scene in ways that showed 'disrespect' for the subject (see London 1992–3, p. 94).

Sisley's treatment of the subject clearly allied him with newer conventions of landscape painting.

The brushwork is broad and assertive, responding flexibly to the various textures in the scene, and the greens of the foliage are full and delicately nuanced. Yet by 1868 such techniques were not innovatory or revolutionary. The State had commissioned a view of the Château of Saint-Cloud itself from Daubigny, key protagonist of this 'new' landscape (fig. 11); and Courbet's *sous-bois* with deer were winning high praise at the Salons – his *The Hunted Roe-Deer, on the Alert, Spring* (cat. 16) was on view at the same Salon.

Paintings of the same type as Sisley's were very common at the Salon; in the context of landscape painting in 1868 it seems unlikely that this painting would have been considered distinctive. It seems to have been ignored by critics at the time.

19

The Valley of Chinchon, at l'Isle-sur-Sorgues (Vaucluse) 1869

Le Vallon de Chinchon, à l'Isle-sur-Sorgues (Vaucluse)

Salon of 1869, no. 1132

66 × 101 (26 × 39¾)

Columbus Museum of Art, Ohio
Museum Purchase: Derby Fund

The history of nineteenth-century landscape painting has often been written in terms of artists gradually emancipating themselves from rules and formulae. Guigou's brief career followed the opposite path. His most experimental and unconventional works, in terms of both technique and composition, date from the late 1850s and early 1860s (see *The Hills of Allauch, near Marseille*, cat. 2). Thereafter he came to work more within the accepted frameworks of landscape composition, although by the later 1860s he was in contact with the circle of the Impressionists-to-be at the Café Guerbois.

The composition of *The Valley of the Chinchon* is almost neo-classical, with the near-left bush, the cliff on the right and the further rock-mass at centre left providing a sequence of orderly stepping-stones that lead the eye back to the vista of the far town and hills. The figures in the valley give a sense of scale, but the viewer is excluded from the space by the vigorously painted weeds and flowers in the foreground, which deny the imaginative access that orthodox neo-classical landscapes encouraged (contrast Flandrin's imaginary neo-classical idyll of Provence, cat. 28).

Likewise the technique of the picture retains something of the crispness of Guigou's earlier work. Olivier Merson commented on its 'harshness', but also saw merits in this failing: 'great frankness, boldness, and a sense of straight-forwardness that is certainly worth something' (Merson, quoted in Bonnici 1989, p. 111).

In 1870 Théodore Duret, close associate of the Impressionists-to-be and habitué of the Café Guerbois, summed up the development of Guigou's art: 'Paul Guigou made his début with landscapes which startled the public by their crude tones and the absence of conventional rules. Happily, since then he has shed some of his archaic roughness and some of the exaggerated crudity of his landscapes; he has retained the sincerity of tones and the accentuated colour, but has fused them into a harmonious ensemble.' (Duret 1885, pp. 6–7, quoted in Bonnici 1989, p. 111.)

L'Isle-sur-la-Sorgue (to give the site its correct name) is a town to the east of Avignon, a short distance downstream from the celebrated Fontaine-de-Vaucluse, source of the River Sorgues and site of the ruins of a castle traditionally associated with the poet Petrarch. The Château de Saumane, former residence of the Marquis de Sade, was even closer to Guigou's site, a little valley just north-east of the town. However, Guigou has treated the site simply as a Provençal valley. A small oil study for the picture survives, very similar to the final canvas (Bonnici 1989, no. 256 *bis*); we cannot tell, though, whether the study was painted out of doors or as a compositional sketch for the finished picture.

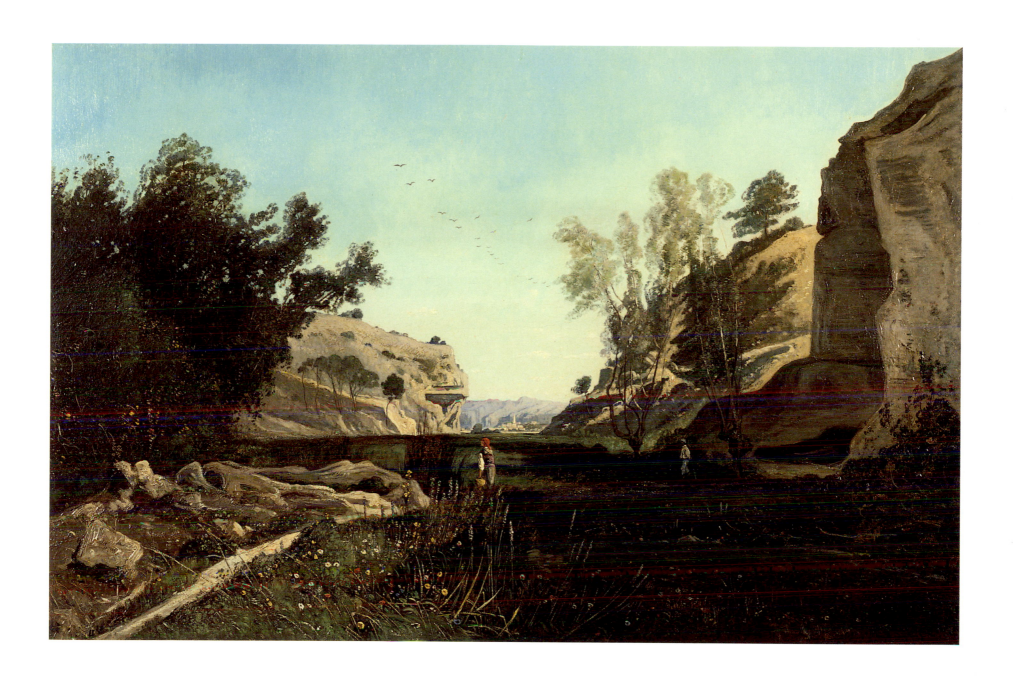

20

The Château of Pierrefonds 1868
Le Château de Pierrefonds
Salon of 1869, no. 1363
130 × 195 (51⅛ × 76¾)
Musée Départemental de l'Oise,
Beauvais

Like Huet's *The Château of Pierrefonds, Restored* (fig. 40, p. 98; see cat. 17), Lansyer's canvas shows the château after its dramatic transformation into Napoleon III's ideal feudal castle. Here, the clean forms of the château are bathed in afternoon sunshine, whereas the rough track and peasant figures in the foreground are in shadow. A shaft of sunlight cuts across to the cottages and the little turret on the right but, in contrast with Huet's picture of the restored castle, the two domains are clearly distinct; an improvised fence fringes the hill, to remind us of the boundary.

The contrast between the imperial and the mundane is reiterated in the execution of the picture. The foreground is clearly reminiscent of Courbet's manner, with broad sweeps of the palette knife (see cat. 16), whereas the château is defined with the crispness of the architectural draughtsman. The contrast in technique is also a reflection of Lansyer's most unusual training as an artist – first as a draughtsman under Eugène Viollet-le-Duc, architect of the restoration of Pierrefonds, and then, briefly, as a painter in the very

unorthodox and informal studio that Courbet ran in 1861 (see Lansyer's autobiography, in Loches 1993).

The inconsistencies in the picture were noted by Paul de Saint-Victor in 1869: 'M. Lansyer's *The Château of Pierrefonds* is broad and solid in execution, but is rather more like a view than a picture.' (De Saint-Victor 1869, p.165.) It was presumably both the central position of the castle, reminiscent of topographical prints, and its precise drawing that made the critic hesitate over the painting's status.

Lansyer's painting was bought by the State at the 1869 Salon and entered the Musée du Luxembourg in 1872; although officially transferred to the Louvre in 1896, after Lansyer's death, it was sent straight to the museum of Villefranche-sur-Saône, where it remained until its recent transfer to Beauvais.

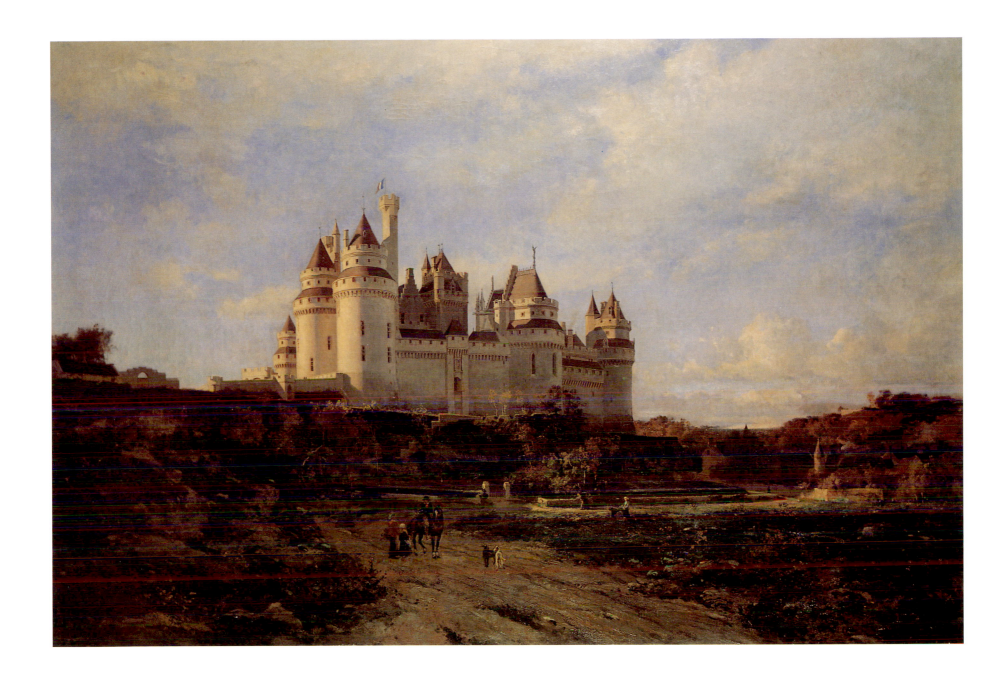

21

**The Chemin des Sables,
Storm Effect** *c.* **1868–9**
Le Chemin des Sables, effet d'orage
Salon of 1869, no. 1392
95 × 145 (37⅜ × 57)
Musée Fabre, Montpellier

The Forest of Fontainebleau was by far the most popular theme for landscapists throughout the later nineteenth century. Paintings tended to focus on the forest interior, presenting images of solitary refuge (see fig. 5). Laurens's picture presents a very different vision of the area of the forest, focusing instead on its remarkable rock formations and sandy tracks – more reminiscent of the scenes from the Middle East and North Africa in which Laurens specialised. These barren, rocky zones of the forest were rarely painted, though Denecourt's promenades in the forest had opened them out to visitors (see p. 19).

The painting is dominated by contrasts: light against dark, sunlight against storm, open against closed spaces. We gain a sense of scale and space from the figure of the traveller and the dog which races to join him. The man's windswept cloak and the rain on the horizon evoke the storm, whereas the boldly defined forms of the rocks give the scene a taut, coherent structure, almost neo-classical in its balance and its zigzag recession.

The brushwork is not demonstrative and the paint is not thickly loaded; the touch is variegated with delicacy and great economy to suggest the complex surfaces of rocks and sand. The dominant contrast between the light-beige hues of the sand and the slate-grey rocks is enlivened by small points of more varied colour such as the blue of the man's blouse and the little red flowers.

The picture was part of the remarkable private collection that Alfred Bruyas, patron of Delacroix and Courbet, presented to the museum of his native Montpellier.

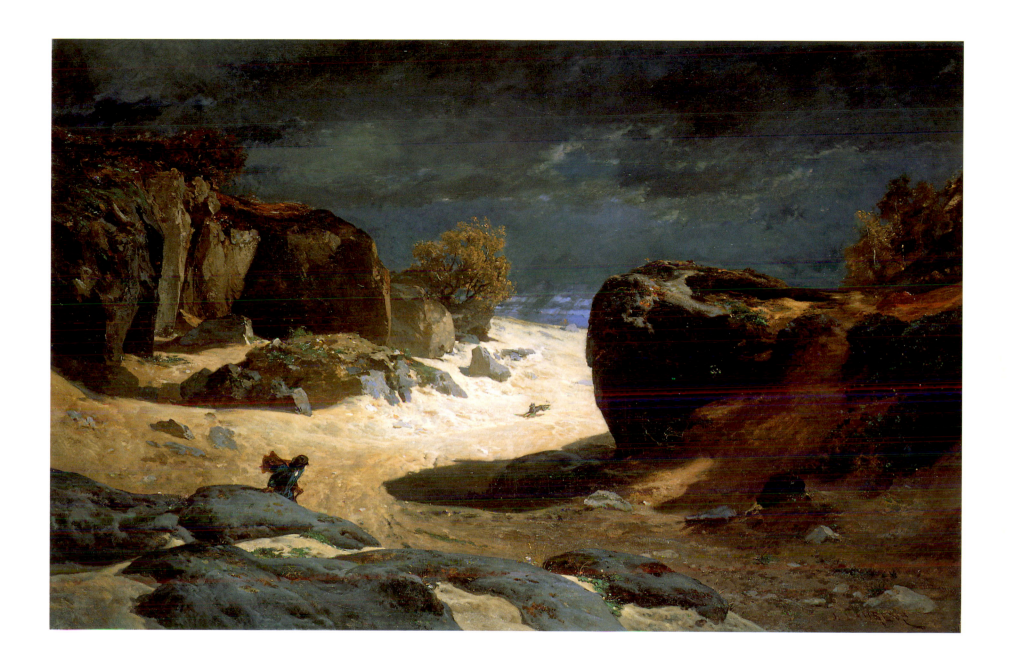

22

**The Oaks of Kertrégonnec
(Finistère)** *c.* **1869–70**
Les Chênes de Kertrégonnec (Finistère)
Salon of 1870, no. 2621
135 × 204 (53⅛ × 80⅜)
Musée des Beaux-Arts, Chartres
Exhibited in London only

The Oaks of Kertrégonnec (Finistère)
is a monumental evocation of the
landscape of a particular region, but it
can also be seen as an exploration of
man's relationship to nature. The wide
panorama, viewed from low rocky
hills, is very characteristic of Finistère,
the westernmost *département* of
Brittany, and the church spire seen
through the trees on the left is
distinctively Breton in form. Apart
from this the site was not well known,
and would have had little significance
for its Parisian viewers; Kertrégonnec
does not appear in gazetteers or
guidebooks.

The gnarled oaks exposed to the
elements introduce the sense of
elemental forces, but two details give
the scene a wider resonance: the church
spire and the startling episode in the
foreground, where a bird of prey tears
apart a small animal. There are hints
here of the contrast between matter
and spirit, between beast and man.

Ségé's study for the picture (Musée
d'Orsay, Paris) gives some insight into
the way in which he conceived the final
canvas. The wall of trees differs only
in detail, but the background
panorama is less spacious in the study,
and the church spire is a more humble
bell-tower, not an elaborate Gothic

spire. The key changes are in the
foreground, occupied in the study by
a sleeping shepherd with his sheep and
two horses, instead of rough heather;
the bird of prey is nowhere to be seen.

The composition of the picture does
not follow neo-classical formulae.
The oaks, the primary subject, are
presented frontally, as a complex screen
between foreground and background.
The many different textures in the
foreground plants and grasses are
indicated with some precision, and the
dark silhouettes of the oaks against
the sky are picked out in considerable
detail. Ségé's type of realism is
markedly different from Daubigny's
sketch-like notations of effects (see cat.
11) or Courbet's virtuoso palette-knife
work (cat. 16). Reviewing the picture in
1870, Sensier admired the precision
with which Ségé had treated the
distinctive forms of the oak trees and
the heather, but noted that it lacked
any real sense of light and atmospheric
nuances (Sensier 1870, pp. 388–9).

This was the first of Ségé's paintings
to be bought by the State. On several
occasions in the later 1860s he had
asked the authorities to buy one of his
works, in 1866 citing his long, hard-
working career, and in 1867 pointing
out that he had consistently painted

pictures too large for 'normal
placement' – that is, pictures of a size
suitable only for public spaces (AN F[21]
181). His request in 1870 that
The Oaks of Kertrégonnec (Finistère)
be purchased met with approval at last;
but when in 1872 he asked that the
painting be shown in the Musée du
Luxembourg in Paris, with a view to
eventual entry to the Louvre, the
Director of Fine Arts, Charles Blanc,
briskly told him that there was no
space available. However, immediately
after Blanc was replaced by
Chennevières in December 1873 (see
p. 49) it was admitted to the
Luxembourg, and it entered the Louvre
on Ségé's death in 1885. It did not
stay there, though – as Ségé must have
hoped it would – but was put on
deposit in the Château of
Fontainebleau in 1889, before being
transferred to Chartres in 1946
(see Paris 1974, p. 168).

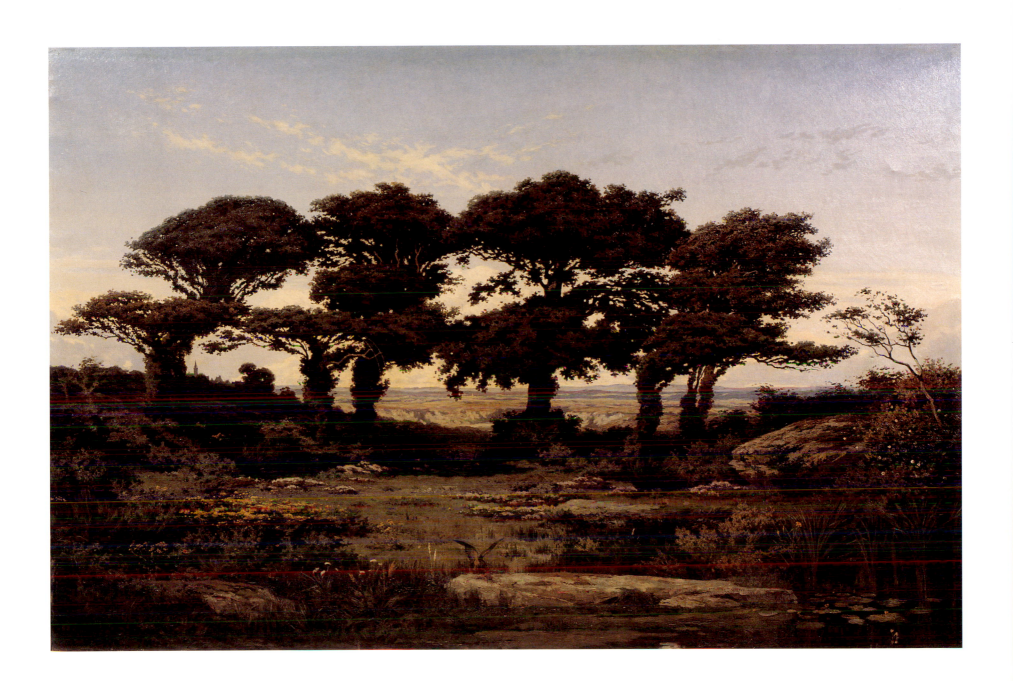

23

Roman City built at the Foot of the Alpes-Dauphinoises sometime after the Conquest of the Gauls 1870

Ville romaine bâtie aux pieds des Alpes-Dauphinoises quelque temps après la conquête des Gaules

Salon of 1870, no. 2212
131 × 208 (51⅝ × 81⅞)
Musée d'Orsay, Paris
Exhibited in London only

Penguilly's *Roman City built at the Foot of the Alpes-Dauphinoises* is a fascinating and unusual combination of two quite different types of painting. Its classical subject and its clear, orderly compositional and spatial structure mark it out as a neo-classical landscape, in the tradition of Poussin (see cat. 28 and fig. 8). Yet the subject also relates it to the historical genre paintings of artists such as Jean-Léon Gérôme that had recently become so popular.

Two things link it to historical genre painting: the care taken over its archaeological detail – not a major concern in neo-classical landscape – and the incident in the foreground. Correspondence from the Director of the Musée des Antiquités Nationales at Saint-Germain-en-Laye reveals that Penguilly had used the museum's collections to research the archaeological details in the painting (AN F²¹ 471). The incident in the foreground seems at first sight a casual occurrence, but in the Salon catalogue Penguilly added a text to the title of the picture in order to explain what is happening: 'A centurion accompanied by two soldiers applies to the ferryman in order to cross the river.' Explanatory texts such as this were usually included only for paintings of significant historical events; by explaining his scene in this way Penguilly clearly wanted to draw attention to it.

His own description of the incident is very bland, but when Ernest Chesneau wrote a memorandum recommending that the State should buy the canvas he described it rather differently: 'The foreground group – a Gaul resisting the orders of a Roman officer – succeeds in giving this landscape a real historical character.' (AN F²¹ 532.) Chesneau read a significance into the ferryman's gesture that had clear political overtones: Gaul resisting the authority of the Roman invader, and the native hut standing out against the classical city. This can be seen as a declaration of French nationalism but, in the context of Napoleon III's Empire, the position was in fact more complex. For Napoleon had in some ways modelled his empire on the example of ancient Rome: he explicitly wanted his new Paris to be the new Rome, and he had published a *History of Julius Caesar* in 1865–6. However, by 1870 Napoleon had a difficult relationship with present-day Rome: he was caught up in the struggles between Church and State in Italy, but was seeking to distance himself from Pope Pius IX's increasingly authoritarian pronouncements, which culminated in the declaration of papal infallibility in July 1870 (see Spencer 1954, pp. 219–36).

Chesneau's notes on the treatment of *Roman City built at the Foot of the Alpes-Dauphinoises* are a revealing example of informal art criticism: 'landscape of *grand style* with an execution that is curious but not mean; terrain of a delicious grey tone and yet very firmly treated; foliage very natural in its effect although precise; water very lively though highly finished; a few defects – a cabin which is too much like a pendant to the magnificent rock in the foreground; the mists in one part of the picture do not harmonise with the overall character of the whole; the sky unfortunately rather heavy. But it is very nearly a perfect work.' (AN F²¹ 532.) The one published comment on the picture that has been traced noted that it was so badly hung at the Salon that it was hard to see, but admired it except for the all-pervasive blue tint (Goujon 1870, p. 79).

Penguilly died soon after the State had bought the painting. In 1871 the authorities sent it to Saint-Germain-en-Laye, but without specifying which museum it was destined for. After a short period of confusion, during which the picture remained in its crate in the local railway station, it was sent to the Musée des Antiquités Nationales. According to the Director, Penguilly painted the canvas expressly for this museum, of whose Consultative Committee he had been a member, in order to complement its collections of antiquities. Another landscape, by Hector Leroux, was sent to the municipal museum of Saint-Germain-en-Laye (AN F²¹ 471). Penguilly's painting was returned to the Louvre at some stage during this century.

24

Apple Trees and Broom in Flower
c. 1871–2
Pommiers et genêts en fleurs
Salon of 1872, no. 330
101 × 225 (39¾ × 88⅝)
Musée d'Orsay, Paris
Exhibited in London only

In contrast to the small, mundane scenes and everyday weather effects of the Impressionists' contemporary works (see cats. 65, 68), Chintreuil's last paintings transformed the most fleeting moments into elemental epics.

In *Apple Trees and Broom in Flower* a flash of sunlight catches the apple blossom and the sharp yellow flowers of the broom along the roadside. The subject is simple but the picture is huge and its exaggerated horizontal format most unusual. There is an insistent symmetry: the sombre, wide-open wings of the composition, with a tiny ploughing scene in the gloom on the right, frame the plunging perspective and the gash of sunlight. Scattered across this are crystalline points of colour as the sun catches the flowers.

By this date Chintreuil was generally regarded as one of the leaders among younger landscapists, but his fascination with such extreme effects divided critics. For Paul Mantz there was a tension in *Apple Trees and Broom in Flower* between the subject and the effect: 'One can conclude that the composition ... is not adequately worked out, that the site is insipid, that the artist has made no great effort of the imagination to invent this row of trees that follow each other so methodically and disappear on the horizon. It would be easy to say that M. Chintreuil has created a landscape like a road surveyor, who plants young elms along the edges of a by-road. It's true that the artist has the idea of laying things out in line; but the insipidity of the motif was given him by nature, and M. Chintreuil has veiled it by an atmospheric effect that seems to us tender and charming ... there is a poet in Chintreuil the topographer.' (Mantz 1872, p. 44.)

Jules Claretie saw no such tensions: 'What charming spring-like poetry there is in *Apple Trees and Broom in Flower*! The road extends decked in green, coated with a milky powdering, and couples stroll away, chatting about the purity of the air and the beauties of love. It is a true rustic idyll, with a grace that honours M. Chintreuil's brush. Are there any *rustics* that understand the countryside like this!' (Claretie 1874, p. 293.) This 'true rustic idyll' did not depend on close observation of a particular site or engagement with the characteristic activities of the countryside. For Claretie, Chintreuil's 'truthfulness' lay in his ability to transcend such particulars and to find a persuasive image of an idea, or ideal, of a countryside where people could live in harmony with the elements. The next year, Chintreuil pared down his vision still further in his Salon exhibit *Rain and Sun* (Musée d'Orsay, Paris).

25

Near Arras *c.* 1872
Près Arras
Salon of 1872, no. 390
87.8 × 115 (34½ × 45¼)
Musée des Beaux-Arts, Arras

Corot's oeuvre is habitually divided into two parts: his small studies in oils made from nature (see fig. 4) and his elaborate studio works intended for the Salon (fig. 3). Yet much of his work, both paintings made for the market and Salon pictures, falls between these poles; for instance, his celebrated *Souvenir of Mortefontaine* (fig. 19), bought by the State at the 1864 Salon, transforms a lake to the north of Paris into an evocative world of reverie and poetry.

Similarly, in *Near Arras* Corot transforms a very ordinary northern French landscape, with the spire of a very ordinary church on the left, into something evocative and poetic. The brushwork is soft, the space is only vaguely defined, the figures – one woman gathering wood, the other holding a baby – are stereotyped. The background, as the title hints, is typical of the region rather than specific to a particular site.

This world is evoked with great economy of means. Little touches of colour in the foreground suggest flowering plants; softer speckled dabs and a few summary streaks create the trees silhouetted against the sky. The eye traces a path into space, travelling from the figures, across the lit patches on the ground in the wood – very inexplicit in their light source – then to the streak of luminous green across the meadow, which leads us into the wide spaces of the plain beyond.

Critics were divided about Corot's late Salon pictures. Paul Mantz felt obliged to apologise for what some might regard as *lèse-majesté* when he made some criticisms of his other exhibit of 1872 (Mantz 1872, p. 43). Duvergier de Hauranne was less respectful about *Near Arras*: '[Its] flickering effect is tedious. Isn't there a sign of decline in this? When the sentiment is exhausted, he becomes exaggerated and over-uses his effects.' (Duvergier de Hauranne 1872, p. 853.)

However, for Georges Lafenestre Corot's old magic was unimpaired: 'Screw up your eyes and look from a distance at the landscape which M. Corot has named *Near Arras*; you will feel strangely moved by the harmonious enchantment of colours, the delicate balance of lines, which are peculiar to the artist's work! Why? It is because the artist is a poet; it is because, before it is presented to you, this vulgar landscape that he has encountered near Arras – or Montrouge, or Fouillis-lès-Choux, it does not matter – has passed through his hard-working brain; it is because it has been transfigured there, and is presented to us in the form of a dream that we could never have had, a memory that we could not have embellished in the same way – a dream of M. Corot, a memory of M. Corot.' (Lafenestre 1881, I, pp. 293–4.) Evocative accounts like this are central to landscape aesthetics of the period, in their correlation of the sensory experience of the actual landscape with the artist's powers of transformation, and of the artist's response with that of the viewer of the picture (also see pp. 17, 21–2).

Near Arras entered the Louvre in the bequest of Alfred Chauchard in 1910; it was deposited in the Arras museum in 1957.

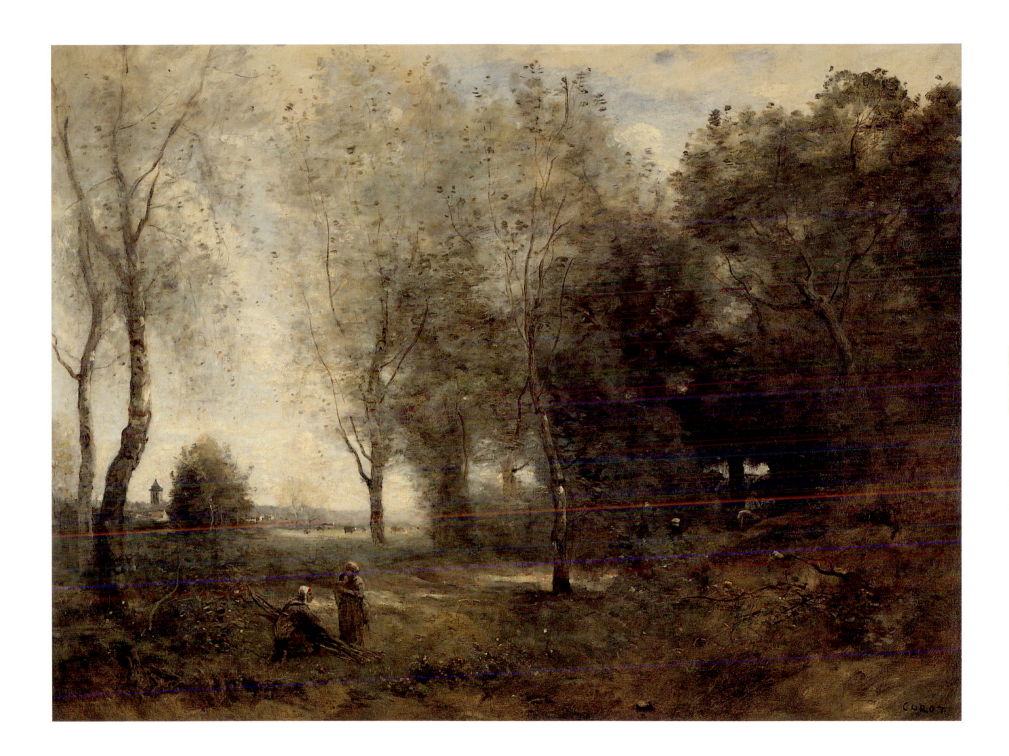

26

Ruins of the Château of Hérisson
1871
Ruines du château d'Hérisson
(Appartient à M. C. de B...)
Salon of 1872, no. 777
71 × 103 (28 × 40½)
Musée Fabre, Montpellier

Hérisson is a small town in the *département* of the Allier, on the River Aumance just to the north of the Massif Central, between Clermont-Ferrand and Bourges. The 'imposing ruins' of its castle are mentioned in the Joanne guide to the region, but it was not a celebrated site and, unusually, the title of the picture does not indicate the *département*; the painting would have been viewed first and foremost as an image of the heart of feudal France (compare Nazon, cat. 3). The humble houses beneath the castle, the three children on the rock by the river and the male peasant on the path on the left, all emphasise the contrast between the military power of the past and the humdrum rural present.

The painting is an intriguing combination of specific observation with an almost neo-classical composition. The light effect is sharp and distinctive, with the contre-jour lighting creating crisp shadows and throwing the main forms into silhouette. The bare trees heighten the sense of linearity, but the inscription 'AVRIL' at bottom right shows that spring is imminent.

The treatment of atmospheric effects makes a revealing contrast with the contemporary work of the Impressionists. Whereas they translated light into broken touches of colour that subordinated forms to the overall effect, the light effect here creates a taut and complex structure of form and space. The technique is rather simplified and schematic, which heightens the clarity of the forms in the view. The trees provide a sequence of accents across the whole picture and frame the scene, enhancing the effect of the winding recession; the white bands in the river where the light catches the water strengthen the sense of space. The château, though in the background, is the unequivocal focus.

In 1872 Jules Claretie was disconcerted by the technique of the painting: 'It is treated like a wash drawing. The silhouettes of the trees stand out vigorously, but the shadows on the ground look like cut-outs in Indian ink or in outline: one could take them for furrows dug out in brown in the earth.' (Claretie 1874, p. 296.)

By Salon standards *Ruins of the Château of Hérisson* is not a large picture and, unlike the vast majority of paintings displayed at the Salon, it had already been sold to a private collector before the exhibition; it was listed in the catalogue as belonging to M. C. de B. It was bequeathed to the Musée Fabre by Vincent Paulet in 1906.

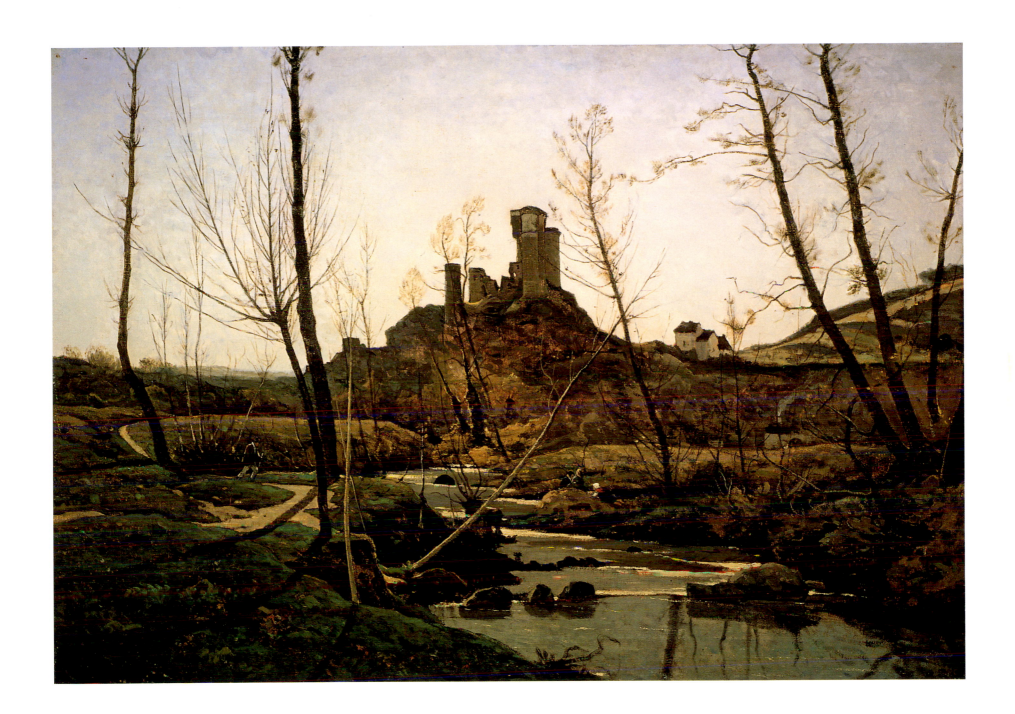

27

The Valley of Cernay (Seine-et-Oise)
c. **1873**
Vallée de Cernay (Seine-et-Oise)
Salon of 1873, no. 1167
201 × 272 (79⅛ × 107)
Musée des Beaux-Arts, Dunkerque
Exhibited in London only

The Valley of Cernay is a remarkable image of a modest subject translated into monumental form by the huge scale of the canvas and by the complexity and elaboration of the treatment. Surrounded by a tangle of plants and trees, an old woman gathers wood by a stream, while a man with a bundle of faggots walks away from us out of the wood. The theme of wood-gathering was controversial at this time, since the rights to gather wood were hotly disputed and unsupervised wood-gathering was seen as a contributory cause of the country's deforestation (see Clark 1973, p. 80; Clout 1983, pp. 124–6); however, there is little in Pelouse's painting to draw attention to this issue.

Cernay, a village to the south-west of Versailles, was one of the most popular artists' colonies in the countryside around Paris; Pelouse worked there regularly in the 1870s and became the leading figure of the colony. Henriet described the area in 1876 as a smaller alternative to the Fontainebleau Forest: 'It too has its rocks, its broom and its heather, its imposing beeches, its ponds and ruins, and, near these severe beauties, there is the verdant, fresh valley of the Yvette.' (Henriet 1876, pp. 8–9.)

Pelouse has chosen an austere autumnal effect; the dawn suffuses the scene with a soft overall light without strong highlights or clear-cut shadows, which allows the artist to focus on the complex play of stems and branches. Viewed from close to, the interweave of lines and textures is very complex and constantly varied, but the delicacy of the detailing does not distract from the coherence of the whole. Likewise, the strong sense of overall patterning is combined with a carefully orchestrated spatial structure that leads the eye into distance, down the path to the right and up through the trees on the left.

Critical response to the picture focused on the relationship between subject and scale. Charles Clément saw it as 'one of the most important landscapes in the exhibition ... The motif itself is of no great interest, and the canvas seems really vast; but M. Pelouse is a painter of great talent. His execution is frank and energetic; the ruddy tone of the foreground, punctuated by big green leaves, is superb.' (Clément 1873.)

For Lafenestre, the picture's scale was part of a wider problem: 'If there is a danger in giving too much importance to detail, isn't it also a mistake to choose a canvas whose dimensions are inappropriate to the significance of the subject? ... In truth, M. Pelouse's excellent study, *The Valley of Cernay*, is just a small corner of the valley of Cernay, prised apart from nature with extraordinary skill and almost without reduction in size; it would have lost nothing, we feel, if it had been enclosed in a smaller frame. M. Pelouse's execution is irreproachable, but he would do well to abandon this tendency to enlarge things too much; this will lead him straight to *trompe-l'oeil* illusionism, which is the negation of personal art and of original thought.' (Lafenestre 1873, pp. 58–9.)

Unruffled by such comments Pelouse exhibited a still larger canvas the next year of a woodland interior peopled only by a couple of rabbits; this picture, *Through the Woods; October Morning* (fig. 41), was immediately bought by the State. *The Valley of Cernay* was acquired by the State after its exhibition at the 1878 Exposition Universelle.

Fig. 41
Léon Pelouse
Through the Woods; October Morning, 1874, exhibited at the Salon of 1874
210 × 300 (82⅝ × 118⅛)
Musée des Beaux-Arts, Rennes

28

Souvenir of Provence *c.* **1874**
Souvenir de Provence
Salon of 1874, no. 733
90 × 116 (35⅜ × 45⅝)
Musée des Beaux-Arts, Dijon

Souvenir of Provence represents a belated and spectacular flowering of a highly academic form of neo-classical landscape. This style of landscape had been encouraged by the creation of the Prix de Rome for *paysage historique* at the Ecole des Beaux-Arts in 1816 (see fig. 8), but had been declared obsolete by the abolition of this prize in 1863.

The painting presents a vision of nature that is idealised in both form and detail: an Arcadian never-never land with generalised invocations of the classical past, but without direct historical or topographical points of reference. Yet Flandrin plays on one crucial cultural stereotype of the period, the association of the south of France – and specifically Provence – with the notion of classical, Mediterranean culture. The landscape certainly resembles the actual bays along the Mediterranean coast, such as L'Estaque near Marseille where Cézanne painted (see cat. 102), but the *Souvenir* title, combined with the two principal figures in their timeless classicising draperies, show this to be a Provence of the poetic imagination.

Flandrin's handling of the scene is unashamedly artificial and idealising. The textures of the foliage and the surfaces of the paths are highly elaborate, but make no concession to the distinctive forms of actual trees or rocks; and the space is constructed with artful complexity, creating a double recession, down to the left and up to the right, leading away from the parasol pine to the luminous distance. The colour and light are equally artificial, with luminous colour in the atmospheric blues and crisper hues in the foreground flowers, but all subordinated to the carefully delineated forms and the artfully placed trees on the left and shadows across the foreground, which funnel the eye into the vibrant space beyond.

In the mid 1870s, when the authorities were offering little support to landscape painting in general, the State bought several of Flandrin's works, including this one, as part of its policy to encourage a revival of elevated, academic values in art. One cannot imagine that pictures like *Souvenir of Provence* had wide popular appeal in 1874, but they had staunch defenders among the most academic critics. For Charles Clément in 1875 Flandrin's landscapes were, 'as always, distinguished in composition, so fresh, so elegant'; they were 'conceived with such an elevated sentiment, and their lines are so knowingly balanced; despite their systematic and tight execution, they speak so deeply to the poetic sensibility.' (Clément 1875.)

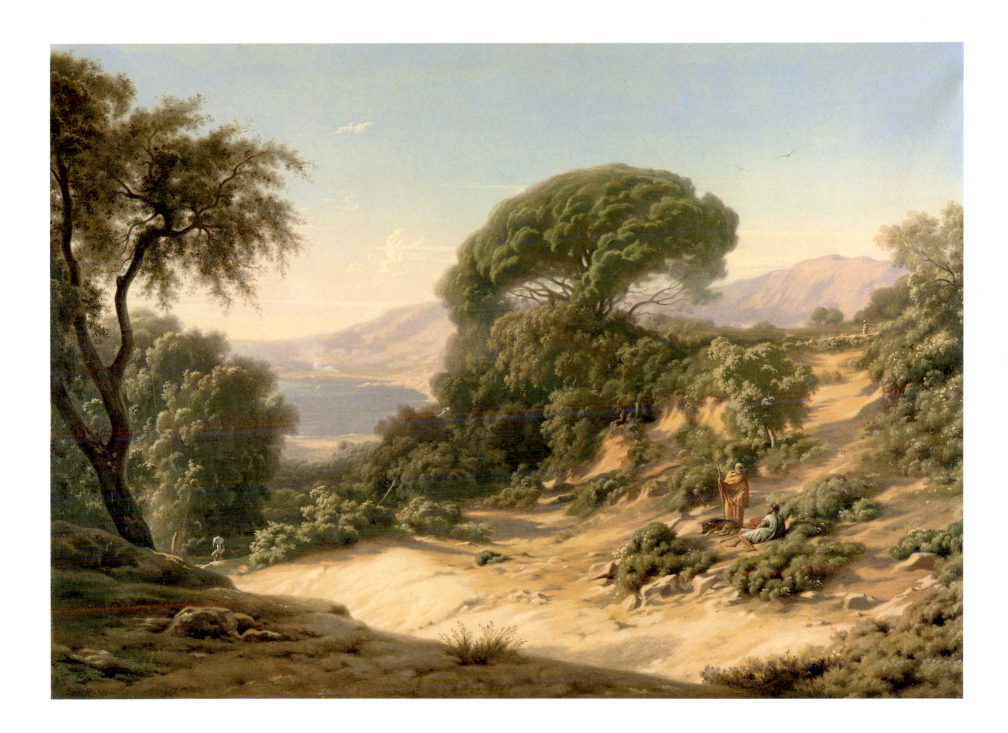

29

The Oaks of Château-Renard (Allier)
1875
Les Chênes de Château-Renard
(Allier)
Salon of 1875, no. 1016
167 × 109 (65¾ × 43)
Musée des Beaux-Arts, Orléans

The Oaks of Château-Renard (Allier) is an archetypal image of *la France profonde*, with a little hamlet, capped by a spirelet, seen across a river and framed by fine old trees. The exact identity of the site remains a puzzle: there is no village named Château-Renard in the *département* of the Allier, the area where Harpignies regularly worked (see cat. 26); presumably the trees gained their name from a nearby farm. The obscurity of the title suggests that the scene should be seen as a generic image of the French countryside.

The cluster of trees and the vertical format give a real monumentality to this unassuming scene; the low sunlight that catches the far hillside and hamlet across the river throws the whole scene into relief and leads the eye back in a clear and orderly recession. The shadowed foreground, and the deeper blue sky and dark foliage at the top, frame the luminous vista from above and below. This is an everyday view presented in a way that is reminiscent of the structures of neo-classical landscape, and is a particularly grand example of Harpignies's consistent concern to make true motifs out of the most ordinary scenes.

The brushwork is descriptive: varied strokes evoke different textures, but the paint is laid on broadly and directly, without finesse and without any overall rhythm. The dense foliage, seemingly of early autumn, demands a quite different treatment from the spare linearity of *Ruins of the Château of Hérisson* (cat. 26), but Harpignies uses a more graphic touch in places, to lend structure to the image and to define the forms of the trees and the left hillside more fully. The colour is quite subdued and emphatically local, with a hint of atmospheric blue in the glimpse of a far hillside beyond the hamlet.

The Oaks of Château-Renard (Allier) was much noted by critics in 1875. Clément praised it as a 'powerful painting, thoroughly studied'; for de la Fizelière it had an 'undeniably masterly appeal', although he regretted 'a certain dryness in the silhouettes which slightly harms the harmonious mass of the composition'; Véron claimed that Harpignies's 'mat, airless' pictures reminded him of tapestries (Clément 1875; de la Fizelière 1875, p. 35;

Véron 1875, p. 76). De Lagenevais, however, managed to make a virtue out of Harpignies's technique: 'At first sight it is coarse, bony and scrawny; one longs for more grace and flexibility ... But then one gets used to this rough taste, one feels affection for this individual and distinguished painting, that makes no concessions to fashion.' (De Lagenevais 1875, p. 932.)

The picture was acquired by the State at the Exposition Universelle of 1878; in 1879 it was attributed to Orléans, with an agreement that the city should pay half the cost price (AN F[21] 224, 469).

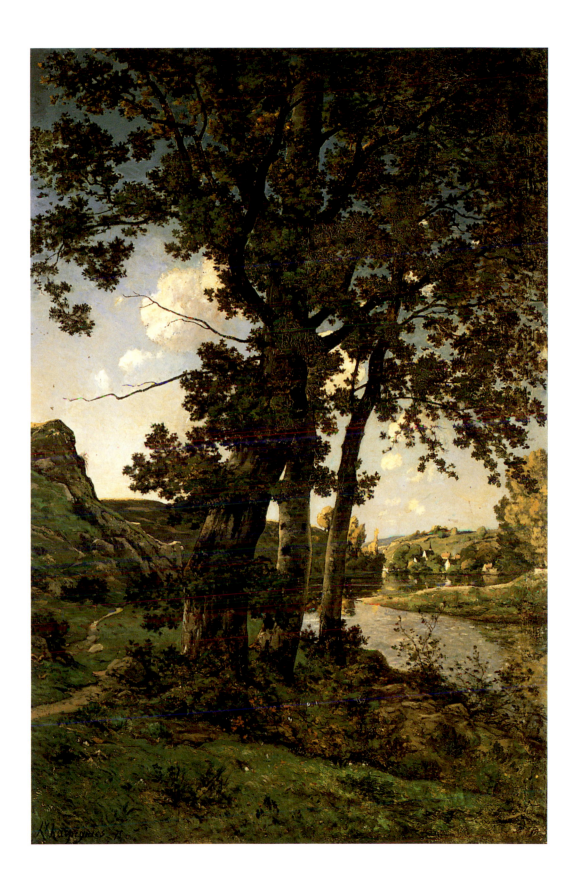

30

The Miroir de Scey, at Nightfall, Souvenir of the Franche-Comté
c. 1876

Le Miroir de Scey, à la tombée de la nuit, souvenir du Franche-Comté
Salon of 1876, no. 823
130 × 160 (51⅛ × 63)
Musée des Beaux-Arts et d'Archéologie, Besançon

The pattern of Français's Salon exhibits of the 1860s – specific scenes (see cat. 1) alternating with neo-classical idylls – was continued in the 1870s. After *Daphnis and Chloe* (fig. 42) in 1872 he turned to subjects from the French regions, including the dramatic valleys of the Jura.

The rock formations and still, reflecting water in *The Miroir de Scey* are comparable to those in Bavoux's *Entre-Roches on the Doubs* (cat. 4); and Courbet had painted the very same site, a still *miroir* on the River Loue just downstream from Ornans, which reflects the ruins of a medieval castle perched on a hilltop. But in Français's canvas the scene is presented with none of the physical immediacy of Bavoux or Courbet (see fig. 22); rather, it has the balanced structure and measured recessions of neo-classical landscape, with the castle dramatically spotlit by the setting sun, and a crucial line of light across the far water that leads the eye into space. The foliage of the foreground tree is treated with a curious mixture of softness and detail, of stylisation and apparent natural observation. Moreover, the *souvenir* title explicitly distances Français's vision from that of Courbet, insisting that, despite the specific site depicted, the painting is a poetic distillation with resonances beyond its physical starting point.

The previous year, the academic echoes and *grand style* of Français's view of the Puits Noir (another Courbet motif) had made de la Fizelière nostalgic for his more amiable and naïve earlier works, but Mario Proth welcomed this conversion to the realms of '*imagination*' and '*pensée*' (thought) (de la Fizelière 1875, p. 34; Proth 1875, p. 52). In 1876 Proth again celebrated Français's 'style' in this painting of the Miroir de Scey: 'On the river that flows mysterious and silent between two densely wooded banks, on the top of a hill surmounted by an ancient keep, nightfall slowly spreads its thick mantle. The impression is great, and as always has a strange poetry.' (Proth 1876, p. 61.) For Proth the true *impression* did not derive from fleeting visual experience, but from the evocative powers of association and memory.

The canvas was acquired in 1879 for the city of Besançon, the large cultural centre nearest to the picture's subject; part of the price was paid by the State, part by the municipality. The Mayor of Besançon had requested in 1876 that the painting should be allocated to the city, because it showed a local site and because Français had been a pupil of the local artist Jean Gigoux. After the purchase was finalised in 1879 the central government expressed its approval of the municipality's willingness to share the cost of acquiring the painting (AN F[21] 457).

Fig. 42
François-Louis Français
Daphnis and Chloe, 1872,
exhibited at the Salon of 1872
160 × 200 (63 × 78¾)
Musée des Beaux-Arts, Strasbourg

31

Villerville (Calvados) 1876
Villerville (Calvados)
Salon of 1876, no. 977
131.5 × 201.6 (51¾ × 79⅜)
Musée des Beaux-Arts, Caen

The paintings with which Guillemet won his reputation in the 1870s combined atmospheric effects of overcast skies, comparable to Daubigny's seascapes (cat. 6), with a more meticulous delineation of the cliffs and wide beaches of Normandy.

The scene in *Villerville (Calvados)* is a rugged, open coastline untouched by modernisation; above the low cliffs appear the roofs of the village, with a little church spire, and at the far end of the beach a low building stretches out to the sand's edge. Two female figures far away on the beach increase the sense of space, of the wide sands exposed by the tide. However, Villerville was not the remote refuge it appears to be here. It is six miles west of the busy port of Honfleur (see cat. 57), and four miles east of Trouville – by the 1870s the most fashionable seaside resort in the whole of France. A contemporary guidebook quotes an evocative description of Villerville's natural beauties, but then lists the members of the colony of 'artistic bathers' who had their villas there (Joanne 1866, pp. 396–7). Parisian viewers, even those who did not spend the summer on this coast, would have known that Villerville's apparent wildness was fringed by some of France's most highly developed tourism.

The brushwork in *Villerville (Calvados)* is very varied, responsive to the many changes of light and texture across the beach, from the loose stones and boulders of the foreground to the simple band of deep blue-green along the far horizon. The houses are deeply embedded in the terrain, and the sense of the roughness of the place is heightened by the irregular fences on the cliffs.

Critics responded very positively to the painting in 1876. The vigour and power of Guillemet's painting were consistently praised, and critics used the dramatic weather effect as the pretext for their own wordy evocations of the scene (see Proth 1876, p. 65); the apparent naturalness of the handling acted as a passport that allowed them to imagine passing through the picture to the actuality of the storm. More perceptively, Duranty noted the next year that Guillemet disliked 'closed' landscapes: 'he wants the landscape open, with deep recession, giving free play to the eye, leaving space for the sky, for the light ...' (Duranty, June 1877, p. 574). In *Villerville (Calvados)* Guillemet had accentuated this openness during the execution of the painting, by lowering the contour of the clifftop at its left end, making it descend in more even steps to the sea. The picture's openness makes a pointed contrast to the enclosed, framed spaces of Français's *The Miroir de Scey, at Nightfall, Souvenir of the Franche-Comté*, shown at the same Salon (cat. 30).

The canvas was bought in the 1870s by Alfred Sancède; it entered the Caen museum in 1974.

32

The Village of Lavardin (Loir-et-Cher) *c.* 1877
Le Village de Lavardin (Loir-et-Cher)
Salon of 1877, no. 347
175 × 220 (68⅞ × 86⅝)
Musée des Beaux-Arts, Angers
(depôt de l'Etat, 1878)
Exhibited in London only

One of only three landscapes purchased by the State in 1877, Busson's *The Village of Lavardin (Loir-et-Cher)* presents a traditional image of *la France profonde*: an old stone village with a church beneath a wooded hill and seen across a stream, with soft sunlight chasing away a shower of rain. Such a landscape, presented on a huge scale and treated in so measured and ordered a way, could be accommodated within the deeply conservative arts policies of the Marquis de Chennevières under MacMahon's 'moral order' presidency (see pp. 49–50).

Lavardin, a village north of Tours on the River Loir, a northern tributary of the Loire, was Busson's regular painting site. He often painted its castle ruins, but here he focused on the village alone. In 1880 Emile Michel wrote an extended celebration of Busson's vision of his *patrie*, as a 'well favoured, gracious countryside, bisected by streams and sprinkled with amiable villages crowned with picturesque ruins'. These sites would appeal to any painter, but Busson's deep knowledge of the place allowed him to penetrate its true beauty and poetry: 'The simplest motifs can gain a totally unexpected significance.' (Michel 1880, pp. 911–12.)

The composition of *The Village of Lavardin (Loir-et-Cher)* enhances the sense of a harmonious, integrated rural community, with the village protectively framed by trees and hills, and the figures peacefully going about their business. The pairing of sunlight and rain shower, the density of the trees, the vines growing on the hillside and cabbages growing by the river, all testify to the fertility of the land. The richness and density of the paint surfaces, varied in touch and texture but consistently solid and resolved, reinforce this effect.

The Impressionists' friend Duranty was much interested by the bold effects in Busson's painting, but Henri Houssaye criticised its lack of perspective: 'The hillside behind The Village of Lavardin threatens to crush the village and its inhabitants.' (Duranty, July 1877, p. 57; Houssaye 1877, p. 848.) Most remarkably, the picture incited Mario Proth to imagine the place as a scenario for a rural melodrama: 'M. Busson has the extraordinary ability to give us a landscape that is inexhaustible, like the magician's bottle. No longer can the spectator only read a page, but a book, or as many books as his imagination allows him. This beautiful village, so complete ... you can plan there and follow at your leisure whatever novel, drama, short story or idyll you please. "It was a hot day in August 186— The sun, in dispute with heavy dark clouds, was lighting with a fleeting ray the village of Lavardin, so picturesquely ranged along its verdant hillside. The old Gothic bell-tower had just struck three. The busybodies, joyously gossiping on their doorsteps, were suddenly fascinated by the arrival of an unknown young man, who got off his horse at the door of the Lion d'Or ...". At the end of the novel, the heroine (the young girl), seduced, then abandoned by the stranger, will throw herself into that pretty river, but ... or rather ...'. (Proth 1877, pp. 127–8.)

33

Dawn, Souvenir of the Alps *c.* 1877
L'Aube, souvenir des Alpes
? Salon of 1877, no. 728
113 × 170.2 (44½ × 67)
Leeds Museums and Galleries
(City Art Gallery)

Dramatic mountain landscapes were one of the means by which Doré sought to establish himself as a great painter and to transcend his reputation as a book illustrator. For him landscape could embrace themes of drama and tragedy, and thus complemented the vast biblical scenes on which he pinned his highest ambitions as an artist.

Dawn, Souvenir of the Alps presents a highly theatrical mountain view: far peaks in the dawn sunlight; the closer range in soft blue shadow; and, in the foreground, a mass of boulders and ravaged trees, with a surprisingly intense cascade of warm highlights down the hillside. The textures across the main area of the picture are richly varied, with heightened accents and points of emphasis designed to sustain maximum interest throughout the picture.

We are clearly witnessing the aftermath of some disaster, but are given no clue as to the cause, whether it is the elements or human intervention. The trees in the foreground look as if they have been struck by storm or lightning, whereas those in the distance seem to have been felled.

The image of mountains had tragic associations for Doré in the 1870s, for, after the Franco-Prussian War, the Vosges, where he had spent his childhood, had become part of Germany. Yet the ambiguities in *Dawn, Souvenir of the Alps*, combined with the *souvenir* title, suggest that the picture does not describe a particular event or a specific site.

A parallel to Doré's vision of the mountains can be found in Jules Michelet's influential meditations in *La Montagne*. Here, the high peaks of the Grisons in the Engadine in Switzerland lead the author to meditate on 'the death of the mountain', a sort of apocalyptic vision of destruction – of rock-falls and dead trees – that seems natural in origin, but then becomes a metaphor for the decadence of the human condition (Michelet 1868, pp. 277–83, 335–46).

In 1874 Jules Claretie had criticised Doré's landscapes, in terms that cause little surprise to us today, for the gaudiness and exaggeration of their colour effects (Claretie 1876, p. 265). Yet some reviewers of *Dawn, Souvenir*

of the Alps in 1877 were prepared to accept its vision at face value. For Proth its effect was superb and it had a 'truly scientific accuracy'. Houssaye went further: 'M. Gustave Doré's *Souvenir of the Alps* is too truthful not to appear fantastic. These savage sites, these mountain tops whitened by the snow and made blue by the dawn light, these tall pines ravaged and twisted by the tempests, always seem invented. The public believes only what it has seen, or rather what it sees every day.' (Proth 1877, p. 39; Houssaye 1877, p. 849.)

Houssaye's description makes it very probable that this painting was the one exhibited in 1877; it was presented to the Leeds City Art Gallery by Sir John Barran in 1888.

34

The Matterhorn, Sunset 1875
Le Mont Cervin, soleil couchant
Salon of 1878, no. 935
136 × 166 (53½ × 65⅜)
Musée Calvet, Avignon
(Ministère de la Culture et de la
Francophonie, Fonds National d'Art
Contemporain, Paris)

Français's *The Matterhorn, Sunset* was a dramatic change from the artist's usual subjects (see cat. 30). In contrast with Doré's *Dawn, Souvenir of the Alps* (cat. 33), Français's picture presents a distinctive and readily recognisable Alpine peak, the Matterhorn. Although depicting a Swiss subject, the painting is included here as an example of the many Alpine scenes, both French and Swiss, that explored the unique rock formations of the mountain range.

Français's picture is a fascinating combination of close observation and the rhetoric of the sublime. The economical, rather schematic modelling of the planes draws out the contours of the mountain with great clarity. Yet the effect is highly theatrical, with the peak reflected in the lake, the dark mountains framing the luminous vista, and the sunset spreading a glow across the picture.

The painter here assumes the place of explorer or mountaineer. By this date Alpine mountaineering was a popular middle-class sport, and the Matterhorn one of its prime goals. Français's image of a seemingly pure, unsullied encounter between viewer and peak has to be set against the already widespread fears that the tourist invasion would soon wreck this mountain paradise (see Michelet 1868, pp. 355–8).

For Mario Proth, Français's picture was an 'adorable souvenir' of a 'marvellous spectacle', and led him to philosophical musings: 'These heights never laugh. Their smile is melancholy. In full daylight they are severe. At night, they are terrifying. When one reaches them, one is intimidated and draws back, as if one had discovered some frightful mystery. This sunlight and this mountain, in this silence, are Gods. They say fearsome things to each other in a low voice. Anyone who has seen the sun setting from the high Alps will understand.' (Proth 1878, pp. 53–4.) Charles Clément praised the picture's truthfulness and observation, but thought it a most unwise detour in Français's career: 'Is this really the famous Mont Cervin? Has not the example of Calame, Diday and the whole School of Geneva proved that it was impossible to give a sense of the scale and majesty of the high mountains? This bare ground, worn away by glaciers through long winters, does not lend itself to the picturesque, and nothing can be made of it. M. Français excels in poetic, elegant, distinguished subjects ...' (Clément 1878).

The painting was bought by the State at the 1878 Salon, in the year that Chennevières left office as Director of Fine Arts and the authorities began, once again, to buy considerable numbers of landscapes (see pp. 24–5, 50–1).

35

The Quai National, at Puteaux 1878
Le Quai National, à Puteaux
Salon of 1878, no. 1458
85 × 164 (33½ × 64½)
Musée des Beaux-Arts, Nice
Exhibited in London only

Everyday riverside scenes were a commonplace in the Salon, notably in the work of Daubigny and his followers (see cats. 8, 11); likewise, bold overcast skies were frequent, whether over land or sea (cats. 14, 6). Loir's canvas is exceptional for the site he chose – one of the outer suburbs of Paris that was rapidly being transformed by industrialisation.

Puteaux is about five miles west of central Paris, on the left bank of the Seine, across the river from the Bois de Boulogne. According to Louis Barron, writing in 1886: 'Puteaux, built on the gentle slope of Mont Valérien, begins at the top with orchards, vines, cottages and fields of flowers, cultivated for the perfumers of Paris; it ends on the *quai* by the Seine with twenty factories from which rise twenty giant chimneys ... Before the invasion of the factories, Puteaux was a rural village ... Today, its life is concentrated on the banks of the Seine, where heavy barges, bringing in raw materials and taking away its products, sometimes give it the animation of a small commercial port.' With the arrival of the workers the population had trebled since 1860 (Barron 1886, pp. 27–8.)

The site was very similar to Argenteuil, which had fascinated the Impressionists in the early to mid 1870s (see cats. 65, 76). Puteaux was close to where Sisley had painted during the previous summer (cat. 87); in spring 1878, when Loir's picture was about to go on display at the Salon, Monet painted a few canvases on the Ile de la Grande-Jatte, just downstream from Puteaux (cat. 90), showing the same fragmented, modernised type of landscape.

The *Quai National* on the right of Loir's picture is evidently a man-made embankment, quite unlike the riverside tracks in rural river scenes like Pissarro's *The Banks of the Marne* (cat. 8); the trees on the left do not represent open countryside but the Ile de Puteaux, one of the sequence of islands in the middle of the Seine. This industrialised scene is complemented by the dramatic overcast sky. The broad, bold paint handling and sharp tonal contrasts are reminiscent of canvases such as Guillemet's *Villerville (Calvados)* (cat. 31), but the use of the palette knife, for instance on the right bank, testifies to the example of Courbet.

The painting was bought by the city of Nice in 1881 – an intriguing purchase, given its subject from the Parisian suburbs.

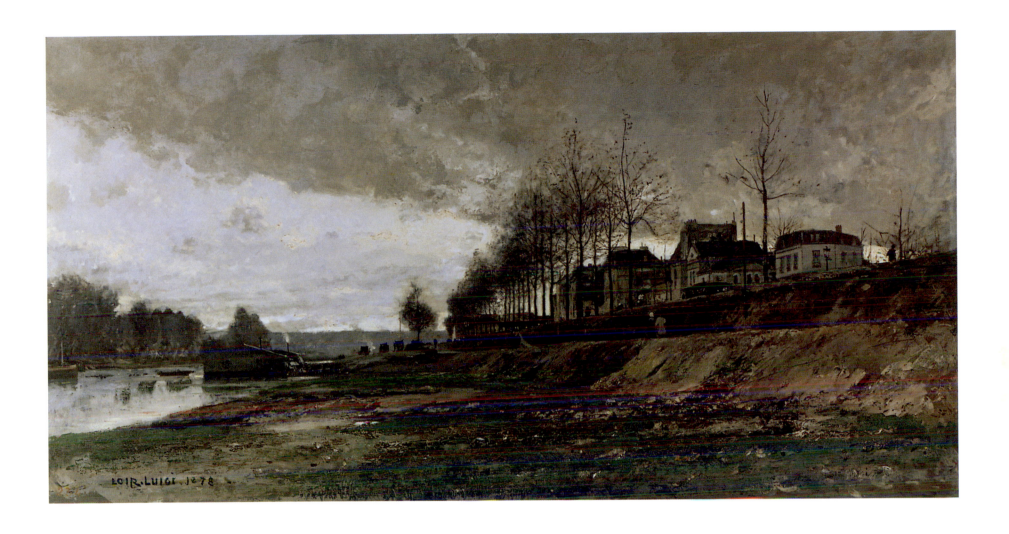

36

Lavacourt 1880
Lavacourt
Salon of 1880, no. 2681
98.4 × 149.2 (38¾ × 58¾)
Dallas Museum of Art
Munger Fund 1938.4.M

Lavacourt was the only painting by Monet exhibited at the Salon after 1868; this exhibition is the first time since 1880 that it has been displayed alongside paintings comparable to those that appeared with it on the Salon walls.

By the end of the 1870s Monet had become disillusioned with the results of the Impressionist group exhibitions and was seeking increasingly to separate his reputation from the past notoriety of the group. In 1880 he decided to submit to the Salon again. In part this was presumably because of the success that Renoir had enjoyed there the previous year with his *Portrait of Madame Charpentier and her Children* (Metropolitan Museum of Art, New York), but he may also have been responding to an initiative from the government authorities themselves. After the government changes of January 1879 the new minister responsible for the fine arts, Jules Ferry, appealed to the landscapists who were dedicated to 'the truth of the open air' to rejoin the ranks and show at the Salon (prizegiving speech at the 1879 Salon, in the 1880 Salon

catalogue, p. vii).

With the Salon in view, Monet embarked on a group of large paintings, executed in his studio from smaller studies begun out of doors. In early March 1880 he announced his plans to his friend the critic Théodore Duret: 'I'm working hard at three large canvases of which only two are for the Salon, because one of the three is too much to my own personal taste and would be rejected, and I have had to execute in its place something more judicious, more bourgeois.' He explained that the dealer Georges Petit had promised to buy from him if he showed at the Salon, but lamented that the press and the public had taken so little notice of the Impressionists' independent exhibitions, 'much preferable to this official bazaar' (Wildenstein 1974, p. 438).

Only one of the two paintings he submitted, *Lavacourt,* was in the end accepted; *The Ice-Floes* (fig. 44) was rejected. *Lavacourt* was evidently the 'more judicious, more bourgeois' canvas painted expressly to gain acceptance; the rejected picture is a radiant image of melting ice on the Seine, while the painting 'too much to my own personal taste' was *Sunset on the Seine in Winter* (fig. 43). Presumably he thought the latter would be unacceptable because of its similarity to *Impression, Sunrise* (fig. 9; see pp. 22, 28), yet, ironically, three years later the State bought a picture

of a very comparable subject from Monet's old friend Boudin (cat. 44).

In comparison with the other two pictures, it is easy to view *Lavacourt* as a compromised, conservative canvas, with its uncontroversial view of a sunbathed village and a little church spire on the far hilltop. Its execution is fine and delicate, without the ebullience of much of Monet's contemporary work. However, its open composition, its blondness and luminosity, and the pervasive soft blues that create its atmospheric effect must have made it stand out on the Salon walls. It was little noted by the Salon critics in 1880, but the Impressionists' friend Emile Zola briefly commented on it as 'a stretch of the Seine, with an island in the middle, and the white houses of a village on the right ... an exquisite note of light and open air'. This would have seemed scant praise from their former supporter, coming as it did in Zola's review after an attack on the Impressionists for failing to realise their promise by painting true epics of modern life. Zola's real enthusiasm at the 1880 Salon was reserved for Guillemet's panoramic view of the Seine, *The Old Quai de Bercy,* 'this swarming *faubourg*, this gash of light on the great city' (Zola 1970, pp. 340, 351; Guillemet's picture reproduced in House 1986, p. 219). Never again did Monet submit to the Salon.

Fig. 43 (above left)
Claude Monet
Sunset on the Seine, Winter, 1880
100 × 152 (39⅜ × 59⅞)
Musée du Petit Palais, Paris
Fig. 44 (left)
Claude Monet
The Ice-Floes, 1880, rejected at the Salon of 1880
97 × 150.5 (38⅛ × 59¼)
Shelburne Museum, Shelburne, Vermont

37

The Road to Concarneau 1880
La Route de Concarneau
Salon of 1880, no. 3015
107.6 × 202.6 (42⅜ × 79¾)
The Corcoran Gallery of Art,
Washington, D. C.
Museum Purchase, Gallery Fund

From the mid 1860s onwards a number of American painters spent their summers at Pont-Aven, a small town in southern Brittany well known at the time for its picturesque scenery and its regional customs and costumes, which provided the subjects for most of their paintings.

Picknell had explored these themes, but this painting, which established his reputation, shows a very different side of Brittany. The road to Concarneau, nine miles west of Pont-Aven, was one of the new main roads driven through the countryside in the 1860s during Napoleon III's reign; its surface of crushed quartz gave it the startling whiteness depicted in Picknell's canvas (see Sellin 1982, pp. 37–8). The straightness of the road and the white milestone on the left, inscribed 'PONT AVEN 4 KM', highlight its newness and mark out Picknell's rejection of the traditional vision of a picturesque Brittany. The creation of new roads in the French provinces was a topical subject for a painting exhibited at the Salon in 1880, for it coincided with the beginnings of the implementation of the Freycinet Plan, which linked even the most remote corners of France to the national transportation networks (see p. 14, note 8).

The picture's surface, much of it applied with the palette knife, shows great breadth and virtuosity; the knifework is clearly meant to signal allegiance to the example of Courbet. The greens are intense and the cast shadows are clearly blue even in the foreground, probably reflecting the impact of Impressionism. Yet the forms in the picture – especially the man with his cart and the foliage of the hedges – are indicated with considerable precision, while the sharpness of the light heightens the sense of immediacy. The effect of interwoven white and blue in the sky seems to have been achieved by delicately rubbing the painted surface with a pumice stone to reveal the white priming beneath.

Mademoiselle Julia, keeper of the Hôtel des Voyageurs where Picknell stayed in Pont-Aven, is said to have given him financial support that allowed him to produce the large Salon version of *The Road to Concarneau*. The existence of a smaller version of the subject might suggest that the Salon picture was painted in the studio, but according to the story of Mlle Julia's support he worked on the present monumental canvas on the spot (see Sellin 1982, pp. 37–8).

Even the Marquis de Chennevières, arch conservative and former Director of Fine Arts (see pp. 49–50), was much impressed by Picknell's picture: 'A certain American, M. Picknell, pupil of Gérôme, is showing a *Road to Concarneau*, all white and dusty between its green banks, which attracts you violently by its *trompe-l'oeil*: it is the concoction of an enameller, if you like, but by scumbling and the use of pumice stone it achieves extraordinary effects of illusion and tonal strength, which we have not seen since Decamps.' (Chennevières, July 1880, p. 66.) Maurice du Seigneur's praise was more down-to-earth: 'We have heard a visitor, who must be from the region, make a really typical comment: "My God! It feels so hot there, one wants to take off one's jacket!"' (Du Seigneur 1880, p. 94.)

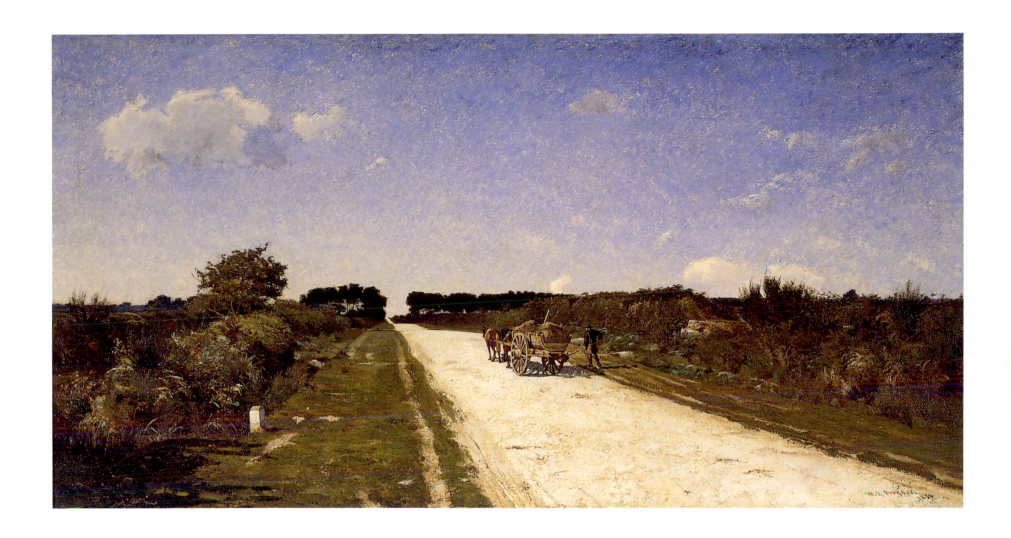

38

Hillside in the Jura c. 1881
Coteau jurassien
Salon of 1881, no. 1895
145 × 210 (57 × 82⅝)
Musée des Beaux-Arts et
d'Archéologie, Besançon
Exhibited in London only

Pointelin's pictorial vision of the Jura, in the uplands of eastern France, was quite unlike those of his contemporaries. In contrast to the rocky valleys on which Courbet, Bavoux and Français had focused (see cats. 4, 30), Pointelin chose his subjects on the open plateaux of the region.

Out of them he made landscapes of startling spareness and simplicity. In *Hillside in the Jura* the effect is of overwhelming emptiness, but a few small punctuation points allow the viewer to find some coherence in it: the two birds, the spindly trees on the left, the foreground pond and a sequence of boulders. The technique is consistently broad and not closely descriptive, but vigorous vertical accents hint at the foreground grasses, and there is just enough differentiation in touch and tone to allow the eye to work its way into space. The colour is very subdued; in part this suggests the effect of an overcast evening, but it also creates a simplified overall harmony. Late in the execution of the picture Pointelin increased its simplicity and frontality by lowering the line of the hilltop near the right margin.

In conventional terms Pointelin's motifs seemed insignificant (see Clément 1878), but some critics approached his work with quite different criteria, focusing on the emotional responses and subject-position of the viewer. Analyses such as that of Maurice du Seigneur, reviewing *Hillside in the Jura* in 1881, have clear associations with Symbolist aesthetics: 'A band of terrain that leads up to the horizon; a band of sky above ... Nothing more. And yet how much there is in the symphony of this landscape! What a range of multiple notes the artist passes before our eyes! The shimmering light on the grass, the half-tones here, the transparent shadows there; on the right one can make out a bush; on the left [sic] there is a pool of water as brilliant as a mirror; in the sky, the capricious flotilla of heavy clouds blown in the breeze. Man is absent from this countryside, no human figure animates it ... but it is you who people this solitude, it is you who are going to climb the hill to see what there is on the other side; you are in the foreground of the composition without realising it, your spirit is absorbed by the sense of contemplation that surrounds you, your ear listens to the formidable voice of the silence.' (Du Seigneur 1881, pp. 196–7.) Du Seigneur here insists on a dual role for the spectator, both as a potential wanderer in the landscape and as the passive receptor of nature's silent 'voice'.

Apart from du Seigneur's musical analogy, with its hint of a Baudelairean synaesthesia, critics regularly interpreted Pointelin's scenes in terms of the melancholy mood they evoked (see Dayot 1884, p. 80; Noulens 1885, pp. 145–6). There is no evidence that at the date of this picture Pointelin held the views about art and spiritualism that he explored in his writings after 1910 (see Dole 1993).

In 1881 the museum in Besançon, the main cultural centre of the Jura region, informed the authorities that it was keen to increase its holdings of local artists, and specifically asked that the government should purchase for it one of Courbet's major works at the posthumous Courbet sale. These wishes were not granted, but the museum was sent Pointelin's *Hillside in the Jura* later in the year. The newly established museum at Arbois, Pointelin's birthplace, asked – unsuccessfully – for the picture, but it received another of his works in 1882.

39

The Place de la Bastille in 1882
1882
La Place de la Bastille en 1882
Salon of 1882, no. 291
140 × 250 (55⅛ × 98⅜)
Musée National de la Coopération
Franco-Américaine, Blérancourt

The Place de la Bastille in 1882 is a key image of Republican Paris. The square was the site of the Bastille prison, whose capture on 14 July 1789 marked the beginning of the French Revolution; the monument at its centre, the Colonne de juillet, was erected in Louis Philippe's reign in 1840–1 in memory of those who had died during the revolution of July 1830, which had finally ended the Bourbon dynasty and put Louis Philippe in power. The square also evoked more recent memories: of the assassination of Affre, Archbishop of Paris, in June 1848, and of one of the final battles in the suppression of the Paris Commune in May 1871. During the 1870s, when the restoration of the monarchy was a real possibility, the associations of the site would have made its representation in a monumental painting quite unacceptable, but after the establishment of the 'opportunist' Republic in 1879 memories of Paris's revolutionary history became central to State policy. The festival of 14 July was re-established and became the focus of Republican celebrations; a succession of monuments to the Republic were erected; and a plaque commemorating the capture and destruction of the prison was installed in the Place de la Bastille in 1880.

Boggs presumably painted this picture in the hope that the State would purchase it; his hopes were well founded. It is not a straightforward celebration of the scene, despite the gilded figure of the Genius of Liberty by Dumont dramatically silhouetted against the sky. It was probably the combination of everyday life with the symbolic site and the presiding presence of the column that made the State consider the painting an effective emblem of the new Republic.

The painting's technique is deliberately sketch-like, with busy flickering strokes suggesting the movement of the figures and the play of light off the wet ground. The individual figures are not closely observed or carefully characterised; their movement is suggested by the direction in which they lean (compare with Monet, cat. 78). Even the forms of the buildings are brushed in loosely; little graphic marks suggest the details of their windows, roofs and chimneys, but without defining them with any precision. The handling is an interesting – and perhaps not wholly successful – attempt to combine atmospheric effect with a sense of detail, and to extend a sketch-like technique to a painting of a complex motif on a huge scale.

The State sent the picture to the Musée Vivenel in Compiègne to the north-east of Paris; it was transferred to the Musée National de la Coopération Franco-Américaine in nearby Blérancourt during this century.

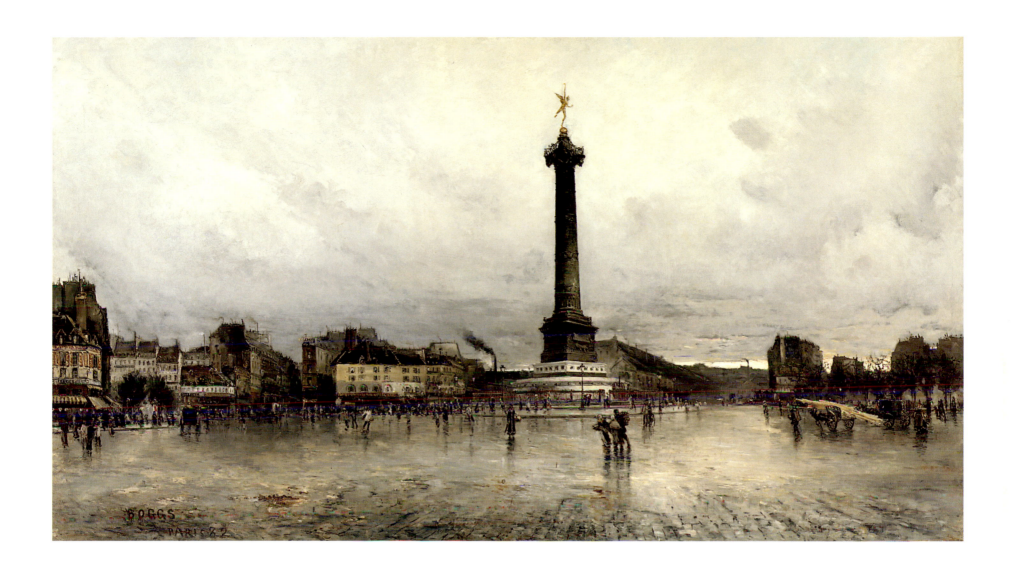

40

La Marcellerie _c._ 1882

La Marcellerie
Salon of 1882, no. 876
131.4 × 196.2 (51¾ × 77¼)
The Brooklyn Museum
Gift of George A. Hearn

Donoho was one of the many artists – mainly foreigners, from Britain, the United States and Scandinavia – who stayed and worked at Grez, a village on the River Loing near the southern edges of the Forest of Fontainebleau.

Although the forest, the traditional haunt of landscapists, was so close by, most of the paintings produced at Grez-sur-Loing were everyday scenes of the village and the river banks (see cat. 42). Donoho's _La Marcellerie_, by contrast, shows a field framed by woods and is dominated by the varied textures and hues of foliage and grasses. The composition is unconventional. There is no clear path of recession: the eye is led across the picture from one clump of grass to the next, and the one actual track into space is the path that enters the picture halfway up the right side. The high horizon line, too, with the bank of trees above it, closes out any sense of deep space. Moreover, the solitary figure does not act as a conventional focal point since he is placed off-centre and turned away from the light area between the trees in the background. Yet the gradations of touch and colour do suggest space, with the crisper, more distinct strokes in the foreground grasses giving way to softer less focused dabs beyond. The tree trunks, silhouetted against the lighter foliage behind them, enhance the sense of depth.

The graphic brushstrokes in the foreground are reminiscent of the distinctive manner of Jules Bastien-Lepage, whose images of peasants in fields had an enormous international influence in the early 1880s (fig. 45, p. 148). However, the touch in Donoho's painting is rather less specific and descriptive, and even at the base of the picture some of the grass is brushed in quite broadly. The paint surfaces are fuller and denser than Bastien's, the colour richer and more varied.

In the critical writing of the day this sort of handling and use of colour were described as a form of 'Impressionism'. Henri Houssaye wrote in 1882 about the admiration heaped on the 'Impressionists' who showed at the Salon – Bastien-Lepage, Duez, Bompard, Dagnan-Bouveret, Edelfelt, Salmson – in contrast to the scorn directed against Manet and those who showed in the group exhibitions (Houssaye 1882, p. 562). However, _La Marcellerie_ probably owes more to the treatment of grasses and foliage widely used by plein-air painters working at Grez (see also cat. 42) than it does to the impact of the artists who exhibited in the group shows.

41

The Vaugoing Pond, Sologne
c. 1882

L'Etang de Vaugoing, Sologne
Salon of 1882, no. 2411
114.3 × 198.1 (45 × 78)
Glasgow Museums: Art Gallery
& Museum, Kelvingrove
Exhibited in London only

The Sologne is a region to the south and south-west of Orléans, south of the River Loire. Vaugoing is probably the present-day Vaugoin, a pond and farm just to the east of the estate of the Château of Chambord, east of Blois; but there is no sign of Vaugoing's fine neighbours here, and the precise location would have been completely unknown to viewers. The Sologne was 'noted for its barrenness; a large part of it being waste land, heath and common; a dead flat of hungry sandy gravel, the surface slightly varied, and the scenery monotonous' (Murray 1877, p. 269). A guidebook published in 1911 pointed out that the condition of the Sologne, formerly 'proverbial for its unhealthiness and the poverty of its inhabitants', had been much improved in recent years by tree planting and the draining of its ponds (Joanne, *La Loire*, 1911); however, Sauzay's canvas clearly shows the region in its original state.

The handling of the painting, in a fluent, sketch-like style, and the varied yet comparatively subdued colour range are reminiscent of Daubigny. The focus is on the overall effect – on the play of light in the sky, on the meadows and in the reflections in the pond. Some sense of structure and focus is given by the darker sky in the top corners and the foliage in the lower corners, which frame the luminosity of the centre, crossed by the darker band along the horizon. All the activity in the picture is confined to this narrow band, with its trees, cattle and little houses.

The picture's broad horizontal format and frontal view of a wholly nondescript scene seem at first sight to be a complete rejection of traditional notions of landscape painting. However, Henri Houssaye was able to find 'style' in 'the beautiful calm line that stands out along the horizon', as well as praising it for 'the usual qualities of contemporary landscapists – the delicacy and clarity of tones, the satisfying distribution of light, the atmospheric effects, the broadly treated foliage and the infinite progressions of the perspectives' (Houssaye 1882, p. 863). This comment about the 'style' of the horizon shows how, by the early 1880s, academic notions of compositional organisation and of the significant motif had been abandoned in favour of an aesthetic that privileged the measured and controlled presentation of the informal and the seemingly 'natural'.

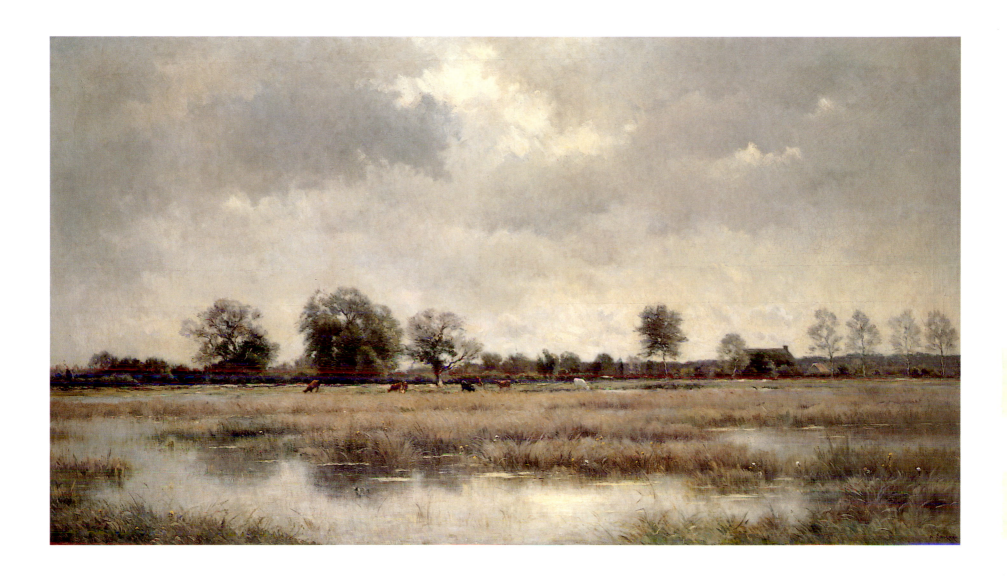

42

The Ferry *c.* 1882
Le Passeur
Salon of 1882, no. 2496
109.2 × 214 (43 × 84¼)
Private Collection
Exhibited in London only

In Stott's canvas Grez-sur-Loing, home to one of the largest of artists' colonies (see cat. 40), is presented as a typical rural village, with old houses beside a quiet, grass-banked, tree-lined river.

The painting is on the borderline between landscape and genre painting, with the two young girls in the foreground awaiting the ferryboat. The peasant paintings of Millet from the 1850s on, and of Bastien-Lepage in recent Salons (see fig. 45), had explored the same borderline, and a reviewer in 1882 saw it as particularly common in that year's Salon (Houssaye 1882, p. 861). *The Ferry* is included in this exhibition because the landscape plays so large a part and because it is so explicitly a view of Grez, even though the picture's title and the role given to the figures exclude it from the stricter definition of landscape current at the time (see p. 12).

The technique of *The Ferry* is clearly reminiscent of Bastien-Lepage in the crisp graphic delineation of the foreground grasses, but Stott's brushstrokes are more decoratively patterned than Bastien's; the silhouetting of grasses against water here seems a direct echo of Japanese art. The colour throughout is also fuller than Bastien's, in the foreground foliage and the atmospheric colours of the sunset beyond. The blue dress of the standing girl acts as a focal point against which the greens, pinks and mauves are played off. Like Donoho's *La Marcellerie* (cat. 40), this is the sort of picture that many critics at the time saw as 'Impressionist', though it probably reflects no direct influence from the painters who showed in the group exhibitions.

One reviewer was struck by the intensity of Stott's vision of the natural world: 'Eccentricity is often confused with originality. That is why M. Stott, who does have some talent, is taken for an original painter. M. Stott specialises in rivers decked with water lilies and other aquatic plants, miraculously reflecting the sky, the houses and the trees. The effect is fantastic; the objects in the water have more precise contours and brighter colours than in the landscape; the sky is bluer and the trees are greener.' (Houssaye 1882, p. 863.) Antonin Proust, though, praised Stott as one of a number of artists who had succeeded in achieving 'solidity' in their paintings by combining colour relationships with tonal values (Proust 1882, p. 148).

Fig. 45
Jules Bastien-Lepage
Hay-Making, 1878
exhibited at the Salon of 1878
180 × 195 (70⅞ × 76¾), Musée d'Orsay, Paris

43

**Edge of the Wood, near Eu
(Seine-Inférieure) 1883**
*Lisière de bois, environs d'Eu
(Seine-Inférieure)*
Salon of 1883, no. 247
140 × 245 (55⅛ × 96½)
Musée des Beaux-Arts, Caen
Exhibited in London only

The Normandy town of Eu, near the Channel coast between Dieppe and Abbeville, was celebrated for its castle (a favourite residence of King Louis Philippe in the 1830s and 1840s) and its fine church. The Forest of Eu was itself a tourist site, renowned for its wildness and the huge open spaces within it (see Joanne 1882, pp. 210–4). In *Edge of the Wood, near Eu (Seine-Inférieure)*, the church tower can be seen in the far distance on the right, and the edges of the forest on the left, but Binet's picture makes no use of the stock imagery of the forest: the primary subject is not a motif in the conventional sense, but a wide space of open terrain where a wood meets a field.

However, the themes of the picture would have been resonant. The church tower, combined with the title, would have linked it with Eu and its reputation; the presence of a church

tower beyond a fertile agricultural landscape (in one of the richest and most historic provinces of France) would have invoked divine providence (compare cat. 46). A painting like this can be seen as a monumental celebration of the French nation.

The picture is loosely composed and unbalanced in conventional terms, with the darker masses on the left sloping down to the low horizon and open spaces on the right, and the perspective of the path and the edge of the corn leading into space through the centre, with the sheep and the tiny figure of the shepherd giving some sense of scale. The effect is heightened by the picture's size – enormous for so open and featureless a scene.

The brushwork is varied but descriptive throughout, responding to the different textures in the scene but without any overall rhythm or sense

of conscious style; the colour, too, is essentially local and descriptive. There is none of the artful stylisation of natural forms that Bastien-Lepage made so popular in the early 1880s, let alone the broken brushwork and rich atmospheric colour of Impressionism. Even so, the vigour of the handling, sustained throughout so large a canvas, gives it great life and energy.

The picture was bought by the State and sent to the museum in Caen – in Normandy, but at the opposite end of the province from Eu.

44

Low Tide 1884
Marée basse
Salon of 1884, no. 316
115 × 160 (45¼ × 63)
Musée des Beaux-Arts de Saint-Lô
(Ministère de la Culture et de la
Francophonie, Fonds National d'Art
Contemporain, Paris)

Those familiar with Boudin's work would have assumed that this sunset was viewed from one of his favourite Normandy beaches, but the title gives no clue to the location; his other exhibit in 1884 was simply titled *High Tide*. The sunset and the sea are not a motif in the conventional sense, but the image can be seen as a meeting of the elements, of fire and water.

However, the sunset is not presented as an elemental drama, but rather as the source of the delicate web of atmospheric colours throughout the canvas. Its warmth is picked up in the foreground sand and the clouds at the top, as well as in the central band of the picture, and is set off by the blue in the upper sky and the duller tones at the base. The main activity lies in the central band: the prime focus is to the right, on the dark silhouettes – caught by the sun – of rocks, posts for fishing nets and figures, perhaps collecting seaweed; but a succession of smaller accents, boats and figures, also holds the composition in on the left.

The brushwork is soft, and very loose and informal for so large a picture. Feathery and slightly blurred in many places, the touch enhances the sense of integration and harmony. The silhouettes stand out crisply, but

even here the forms are treated softly and do not disturb the overall effect.

This was the first painting that the State bought from Boudin. It was purchased after a direct appeal from the artist to the Director of Fine Arts: 'Although I have exhibited for nearly twenty years in succession, I have never had the honour of being selected by the purchasing committees, although many of my colleagues have had the satisfaction of seeing their paintings purchased almost every year. I am far from grudging the success of my colleagues, but I feel obliged to draw your kind attention to an exclusion which does nothing for my reputation ...' (AN F[21] 2058).

The State's decision to buy the picture shows how acceptable it was by the mid 1880s for an artist to focus on light effects alone, even in a large-scale public painting. However, there is another possible reason for the purchase: the painting in many ways echoes the theme of Monet's notorious *Impression, Sunrise* (fig. 9; see pp. 22, 28). In some ways Boudin's picture can be seen as a homage to his younger friend, but at the same time it lacks some of the things that made *Impression, Sunrise* problematic: the subject of *Low Tide* has no obvious

contemporary references, and its viewpoint – from the beach, not an upstairs window – is quite conventional. So it may well be that the purchase of Boudin's work was a coded message to the Impressionists that they, too, might be accepted if they tempered their manner of painting.

When the picture was sent to the Saint-Lô museum in western Normandy in 1885 the minister added a handwritten postscript: 'I hope that the Municipality of Saint-Lô will see in the allocation of this painting a proof of the interest I take in the development of the museum, and that in return it will decide to remove the storage of wines and spirits in the cellar of the building assigned to the collections, about which a correspondence has already been exchanged, to no effect.' (AN F[21] 2224.)

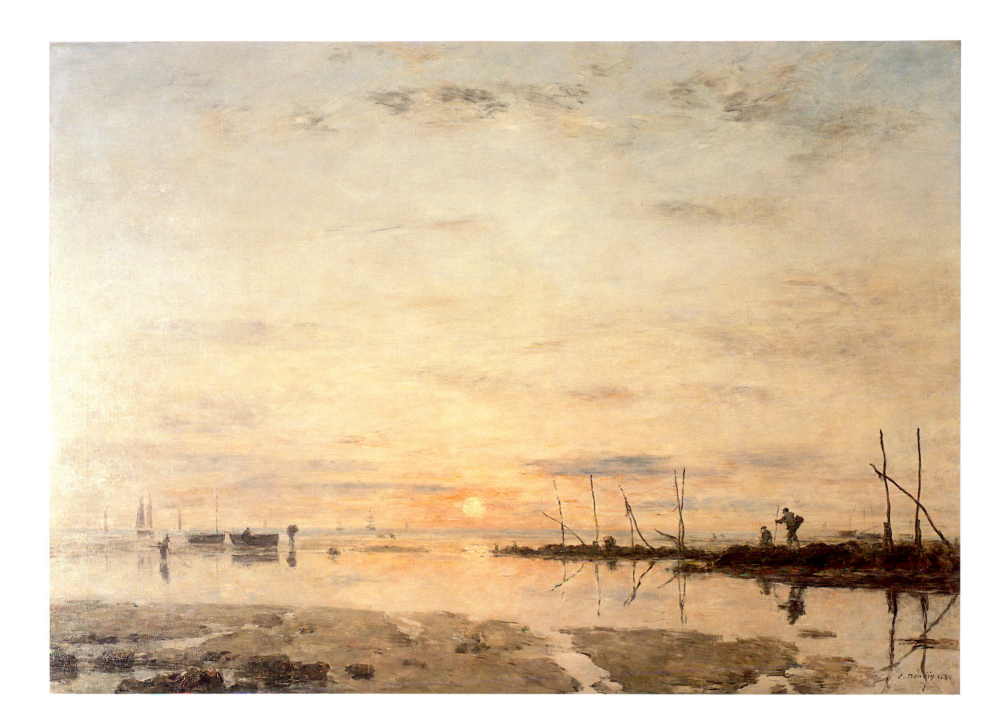

45

Grandcamp, Low Tide 1884
Grandcamp, marée basse
Salon of 1884, no. 1874
97 × 147 (38¼ × 57⅛)
Musée des Beaux-Arts, Carcassonne

In contrast to Boudin's *Low Tide* (cat. 44), a delicate effect of sunset, Pelouse's *Grandcamp, Low Tide*, shown at the same Salon, is a scene full of human interest and natural drama: a lowering storm cloud over a coastal village, with the figures of mussel-fisherwomen plodding along the beach. Grandcamp is on the Channel coast to the north-west of Bayeux, just west of what was to be named Omaha beach, site of the principal Allied landings of 1944. In the 1880s it was known as a seaside resort, and for its fishing fleet and artificial oyster-beds (see Joanne 1882, pp. 410–2). However, Pelouse's view of the place shows it as a remote seaside village, with no sign of such recent developments, apart from the breakwaters up on the beach to the left, installed to temper Grandcamp's notoriously violent seas. The paintings that Seurat executed there the following summer make a fascinating contrast (see fig. 46), since they focus on the ways in which the place had been altered by these changes.

Pelouse's handling is a virtuoso display of the possibility of combining breadth with the suggestion of detail. The overall effect is of a unified tonal harmony of greys and beiges, and the sky and open spaces of the beach are treated with great brio and fluency. Yet the picture is also full of local incident – the figures, the rocks on the beach and the silhouettes of the village. From a distance these appear to be treated in great detail but from close to, the rocks on the beach, and in particular, dissolve into a free play of deft, varied tonal dabs, with some delicate light-hued touches alongside them to suggest the play of light and water. The figures are defined closely enough to hint at the weight of their burdens and the effort of walking into the wind, but they also serve as stepping stones, together with the rocks and the bands of wet sand, to lead the eye into the distance.

Pelouse's art divided critical opinion. In 1880 Maurice du Seigneur had praised his exhibits, including the very comparable *Bank of Rocks at Concarneau* (Musée de Brest), as 'so marvellous in their impression, so full of the grandiose sentiment of nature that they put poetry in your soul and would make you compose alexandrine verses' (Du Seigneur 1880, p. 92). However, in 1884 Armand Dayot, while praising *Grandcamp, Low Tide*, criticised what he saw as the limitations of Pelouse's art: 'He paints with a prodigious skill, and possesses, like no-one else, the secret of reproducing precisely the objects that are reflected in his eye, like a faithful mirror. And yet, in front of his pictures … one remains cold: "It's marvellously painted. It really is." And then one passes on. This will not change, M. Pelouse, until this nature, whose plastic beauty you can reproduce so well, is reflected in your heart as it is in your eyes.' (Dayot 1884, p. 79.)

Pelouse's vision of the Normandy coast makes a revealing contrast with Monet's, in technique and in the effects the two artists sought; Monet's growing interest in creating a weave of richly coloured touches (see cat. 100) is quite unlike Pelouse's combination of detail with tonal breadth.

Fig. 46
Georges Seurat
Grandcamp, Evening, 1885
65 × 81.5 (25⅝ × 32)
Museum of Modern Art, New York

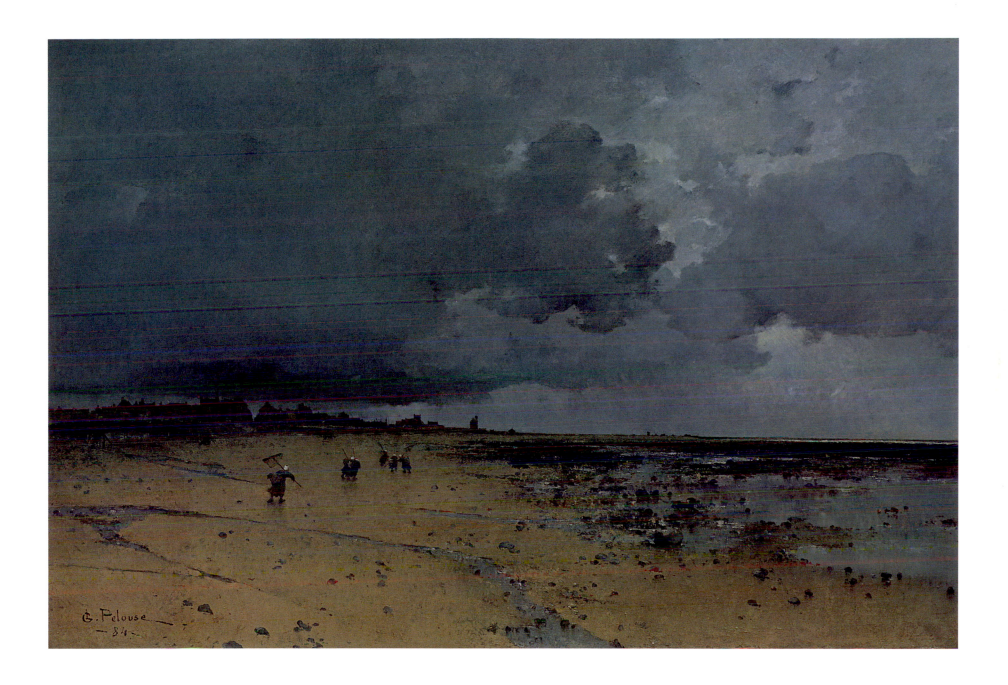

46

In the Land of Chartres *c.* **1884**
En pays chartrain
Salon of 1884, no. 2199
134 × 201 (52¾ × 79⅛)
Musée des Beaux-Arts, Chartres

The distinctive and immediately recognisable silhouette of the Cathedral of Chartres is seen here from the north-east across the open plain of the Beauce. Although the cathedral is seen from afar, it dominates the farm buildings in the foreground; it is treated like an illustration to the *Voyages pittoresques* (see pp. 14, 32), but the relentless flatness of the plain is clearly not picturesque in the conventional sense.

The image of the church spire in the background of a landscape was commonplace in French painting and seems to have been used to evoke the relationship between divine providence and natural forces, sometimes in productive harmony (see cats. 25, 43), sometimes in opposition (cats. 5, 22). *In the Land of Chartres* has recently been seen as a straightforward celebration, with the central cloud 'as if in benediction of this peaceful scene' (Thomson 1994, p. 123). Yet the dramatised contrast between this cloud (more like a diabolical head than a hand) and the sunburst behind it, and between sunlight and shadow on the landscape itself, might suggest other readings. The Beauce was renowned for its great number of churches (see

Murray 1877, p. 129), yet the diocese of Chartres was also one of the least observant in France – a focus of anxieties about dechristianisation (see p. 54). More broadly, too, the 1880s witnessed a struggle between ecclesiastical and secular forces in France, after the institution of the new secular primary education system. In this context the combat between sun and cloud over the cathedral could be seen as a re-enactment of the struggle in the Chartres region and in France as a whole. The sunrays at the summit of the canvas may hint at the final triumph of the godly, but the shepherd and his flock – obviously symbolic in their associations – are left in deep shadow.

In contrast with the spectacular effect of the image as a whole, the execution of the painting is comparatively literal and prosaic – an economical shorthand that makes no claim to the virtuosity so widely paraded in contemporary landscape painting (see by contrast cat. 45).

The State's acquisition of this picture gave rise to complications. Originally, a Breton subject by Ségé, *The Valley of Ploukermeur*, purchased in 1883, was allocated to Ségé's place of

origin, Chartres, with his support. However, the Quimper museum asked for the Breton canvas, and the State proposed to send *In the Land of Chartres* to Chartres instead, arguing: 'This exchange between the two collections would give each of them a work appropriate to local needs and thus provoke not only a more lively interest but also more useful instruction in the context in which it is placed.' Ségé was happy with this arrangement but the Mayor of Chartres objected, both because he preferred the other picture and because 'it would perhaps have been equally useful for the instruction of the local inhabitants to teach the Bretons about the plains of the Beauce and the people of the Beauce about the appearance of the heaths of Brittany.' This objection was overruled, though, and each region kept its own picture (AN F[21] 2208B).

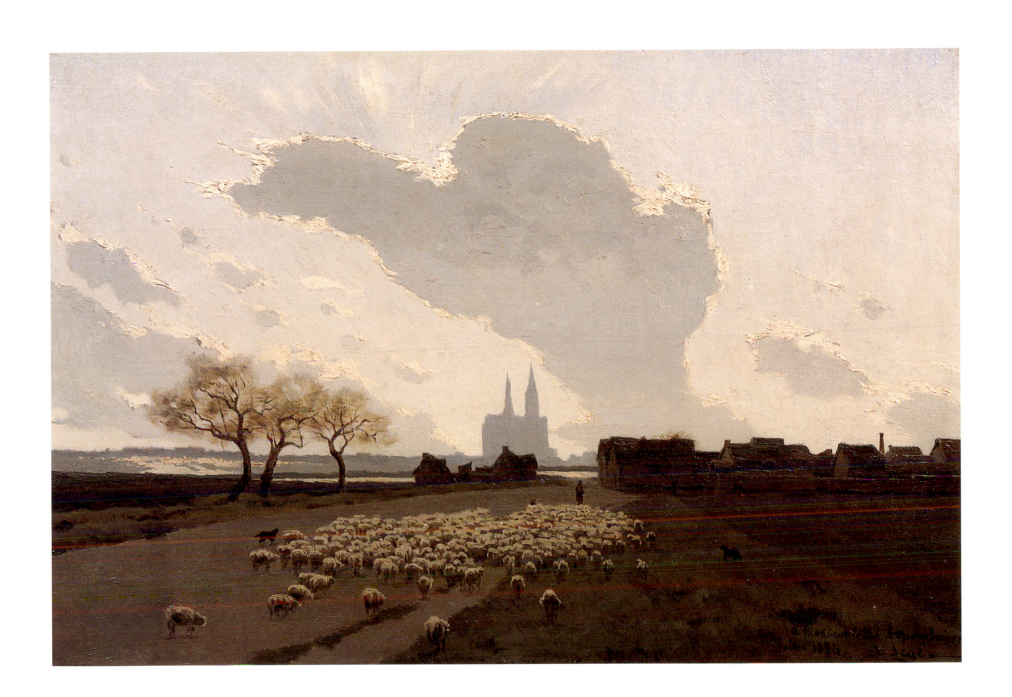

47

Evening *c*. 1885
Le Soir
Salon of 1885, no. 1935
132 × 163 (52 × 64⅛)
Musée de Grenoble
(photographed prior to restoration)

Although the forms of the village, with its church bell-tower, are very specific, the picture's title does not indicate the location, and these humble buildings would have been recognised by few viewers in Paris. We see the village from a rough sloping field; the bare trees, with a few clinging leaves, show that it is late autumn. The sky is clear above, but the sun has set behind a bank of clouds. Such images of rural France raise questions of interpretation. What at first sight may suggest harmonious coexistence between natural forces and a Christian community can also be read in more negative terms, with the unkempt field and cottages evoking the depopulation of rural communities and the contemporary agricultural depression, and the bank of clouds blocking out the life-giving light of the sun.

J. Noulens's response to the picture in 1885 tended towards the more pessimistic reading: 'M. Pelouse, with his crisp manner of painting, his overwhelming melancholy, his magisterial sense of grandeur and amplitude and the solidity of his touch, is one of our leading landscapists. His painting titled *Evening* reveals a passionate love of nature in its desolation: on the right, some tumbledown cottages, dominated by a far-off bell-tower, are silhouetted in the sallow light of evening against a grey and livid band along the horizon ... On the left is a leaning tree whose branches have shed their leaves; among the tall grasses and the thistles, a troop of turkeys are picking for food. The whole is bathed in a warm light and atmosphere. The countryside is going to sleep, everything is calm and silent, everything invites sorrow [*tristesse*] and reverie.' (Noulens 1885, p. 141.) However, it is unclear from this account whether the *tristesse* should be understood simply as the 'natural' mood of late autumn (see p. 36), or whether it hinted at more specific historical circumstances.

The technique is a remarkable display of Pelouse's versatility. The handling is extremely varied throughout and succeeds in combining the overall atmospheric effect with a very clear sense of draughtsmanship, notably in the silhouetted trees but also in the buildings. In both subject matter and technique Pelouse's art presents a deliberately anti-modern view of the French landscape, but at the same time his concern with light effects and his interest in approaching his motifs from odd angles (compare *Evening* with Pissarro, cat. 92) demonstrate his engagement with current developments in landscape painting.

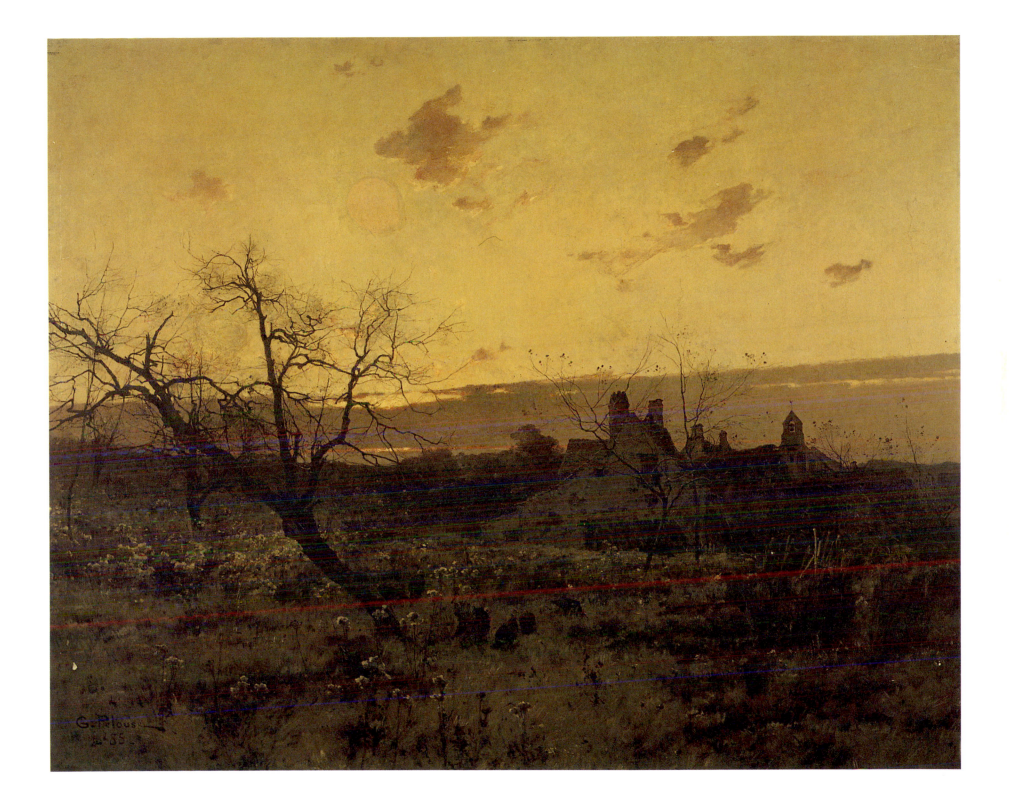

48

Morning Flowers *c.* **1885**
Fleurs du matin
Salon of 1885, no. 2052
160 × 165 (63 × 65)
Musée de Bernay
(Ministère de la Culture et de la
Francophonie, Fonds National
d'Art Contemporain, Paris)
Exhibited in London only

In contrast to the vast majority of landscapes at the Salon, Quost's *Morning Flowers* shows 'nature' in a private space, within the confines of a domestic garden. We view the garden through a screen of flowering plants; facing us an empty bench in front of a closed window awaits another viewer, from within the garden. The flowers are laid out before us, each clearly identifiable but treated with a soft touch. The tonality is blond, dominated by the greys of the bench and house and the muted greens of the foliage. The flowers create a sequence of varied coloured accents, but these are also muted and do not disturb the overall harmony. The darkest tonal points are the only animated elements in the picture, the two birds, one flying at right centre, one perching on the back of the bench.

The mood of the picture complements its subject – peaceful, private contemplation. The gaze is that of the dreamer or the aesthete, not the botanist. The soft, pastel tonality is comparable to the aesthetic ideas of James Abbott McNeill Whistler, who began to exhibit his work in Paris again in the early 1880s. However, Quost's interest in nuances of natural greens and his attention to plant forms are far from Whistler's concerns.

J. Noulens noted the finesse and aestheticism of the picture's effect: 'His *Morning Flowers*, pearly and veiled with dew and coloured with the most delicate and tender tints, are spread out along a flower-bed in which roses, convolvulus and daisies are intertwined ... It would be hard to achieve more mastery in this charming genre.' (Noulens 1885, p. 148.)

The picture was bought by the State in 1885 and sent to the museum of Bernay in Normandy.

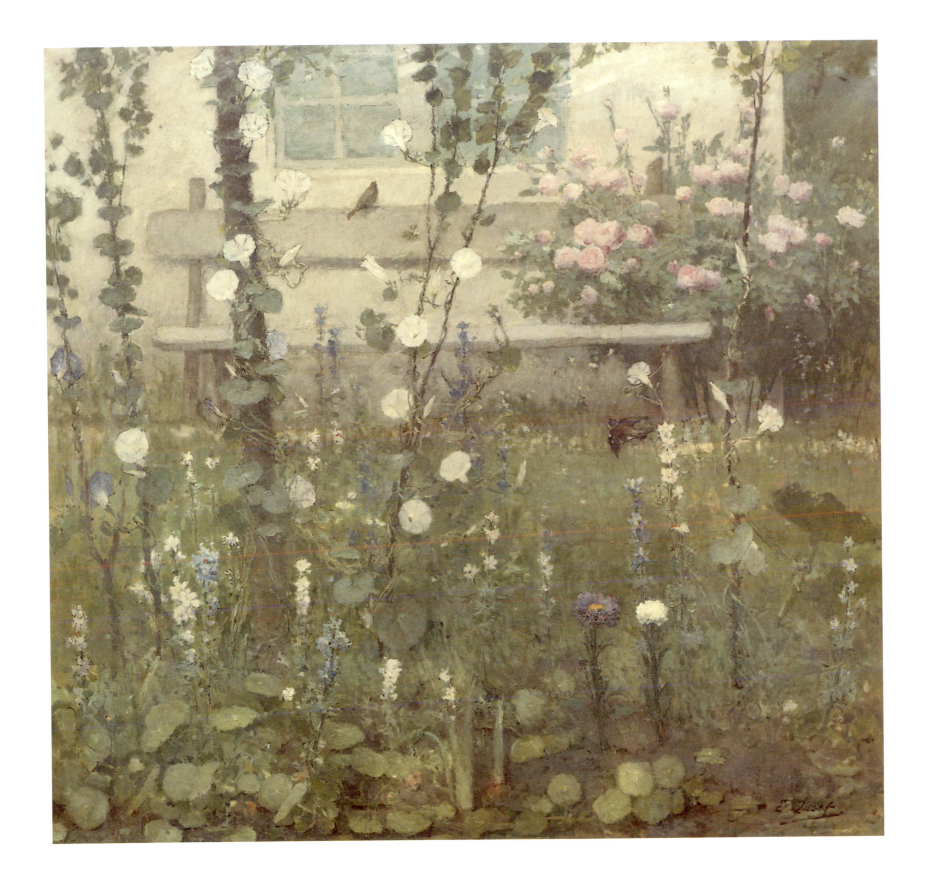

49

A Squall 1886
Un Grain
Salon of 1886, no. 302
117 × 160 (46 × 63)
Musée des Jacobins, Morlaix

Boudin's *A Squall* is perhaps the most monumental and dramatic canvas of his whole career. Like *Low Tide* (cat. 44), its title does not specify the location, although here the theme is elemental forces, not effects of light and atmosphere. It also reveals Boudin's sense of harmony and tonal integration, albeit in a very different way from his earlier canvas.

The two sailing boats emphasise the theme of man's struggle with nature; the far boat is spared the force of the storm. Boudin makes particular play with the contrast between the textures and forms of the sail of the nearest boat and the waves that buffet it. The gulls, silhouetted against the dark cloud, fly alongside, undisturbed by the storm that tosses the boats.

Overall the colour is muted, in a range of greys and blue-greens; the flag on the nearest mast provides a tiny pivotal red accent. As always in Boudin's work the brushwork is quite small-scale, without the calligraphic virtuosity of his friend Monet (see cat. 100) or the breadth of Pelouse (cat. 45). Yet here individual touches in the waves combine to suggest the movement of the sea, while the softer, more blended touches in the cloud build up to give a sense of its mass and density.

In 1886 Georges Lafenestre saw Boudin as one of a number of artists, including Pelouse, who countered the pernicious influence of Impressionism by producing 'healthy and strong paintings of *impressions*, carefully studied and conscientiously worked up' (Lafenestre 1886, p. 608).

A Squall was bought by the State in 1886 and sent to the recently created museum of Morlaix, in north-western Brittany.

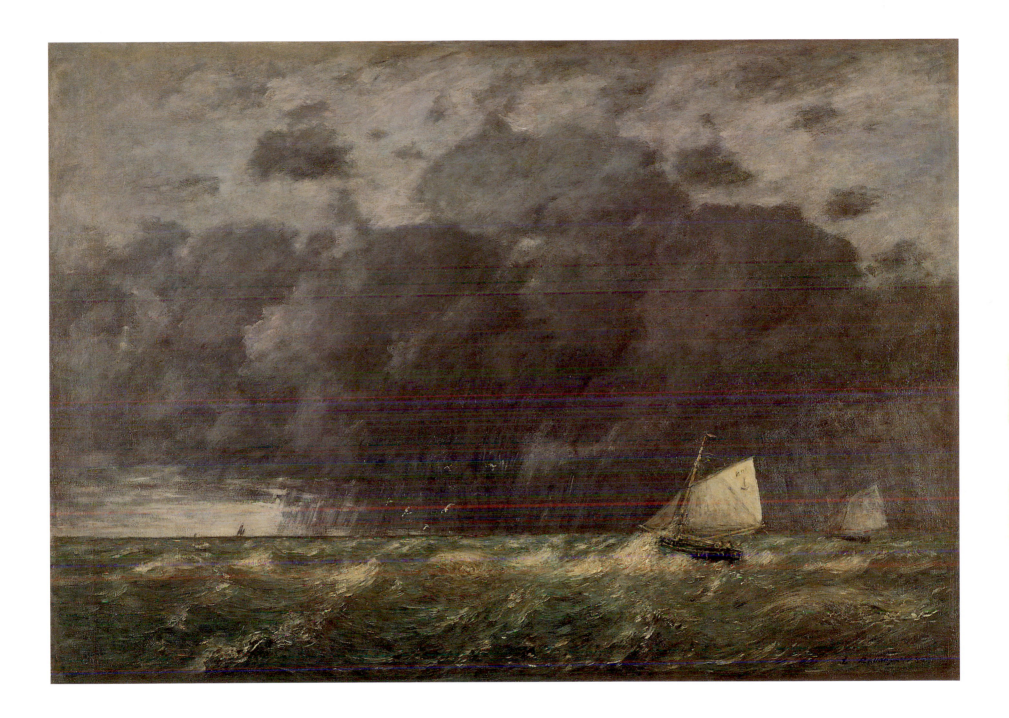

50

**The Bas-Fort-Blanc Path,
at Low Tide, Dieppe 1885**
*Chemin du Bas-Fort-Blanc,
à marée basse, Dieppe*
Salon of 1886, no. 1392
140 × 230 (55⅛ × 90½)
Musée des Jacobins, Morlaix

The position of Elodie La Villette at the Salon was exceptional: she was the only woman artist who was exhibiting monumentally scaled landscapes in the 1870s and 1880s. The scale and ambition of these pictures reveal her determination to be viewed as a professional artist on the same terms as the many male painters who exhibited similar subjects. At the same time she showed every year with the Union des Femmes Peintres et Sculpteurs, the first French exhibiting institution for women artists, from its first exhibition in 1882 (see Garb 1994).

The Bas-Fort-Blanc was an area of formerly derelict fortifications below the Château of Dieppe, occupied by the 1880s by the villas of a number of fashionable artistic families, including the family of Jacques-Emile Blanche. During the summers he entertained many artists there – among them, in 1885, Degas and Sickert (see Blanche 1927, pp. 58–60, 65–7). La Villette's painting shows the wide areas of the beach below these houses, looking south-west along the beach towards Pourville and Varengeville (the fisherman's cottage painted by Monet in cat. 100 was on the cliff seen in the distance here). Although the villas are unseen, to a certain audience the painting would have carried associations with those who lived nearby.

This is a typical image of the Normandy beaches, with the figure of a woman carrying a mussel-fishing basket, and nets hanging on posts beyond her. However, there are unobtrusive traces of modernisation: the steamboat in the background and the tiny group of figures high on the beach on the left, with a woman holding a red parasol. One of the minute figures out on the rocks to the right seems also to have a red parasol, and thus to be an intrepid tourist rather than one of the mussel-fisherwomen. Contemporary viewers would presumably have known who were the likely users of the rowing boat on the beach, distinctly inscribed 'RITA DIEPPE'.

The technique of the picture is broad and economical, indicating the various planes and textures of rocks and stones; the pebbles on the left are picked out with some precision but they do not disturb the coherence of the overall effect. The colour range is fairly limited but the whole scene is bathed with a blond luminosity, and the space is clearly indicated by the darker accents of boat, figures and rocks. Late in life La Villette spoke of her admiration of Courbet, whose impact on her art may perhaps be seen here in the breadth and simplicity of the rocks (see Carlier, p. 3).

Henri Olleris's comments on La Villette's Salon exhibit in 1880 are a clear example of the difficulties that critics had in dealing with the work of a woman working in an overwhelmingly male-dominated genre: 'The talent of Madame La Villette is a wholly virile talent. There is no trace of female frailty in her works. The terrain is solid, the horizons distant, the sea full of movement. The initial impression of her work, which is the true one, is of great sincerity and great finesse of observation. These qualities, combined with a skilful execution, produce paintings which are justly becoming more and more highly appreciated.' (Olleris 1880, p. 32.)

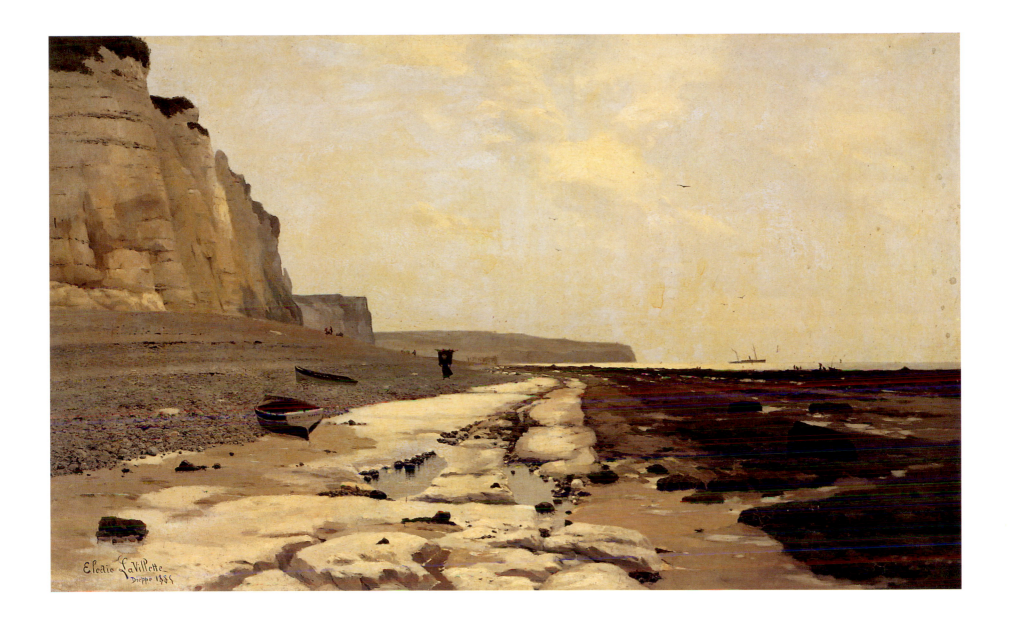

51

The Roadstead of Marseille, in Winter *c.* 1887
La Rade de Marseille, en hiver
Salon of 1887, no. 462
123 × 191 (48½ × 75¼)
Musée des Beaux-Arts, Béziers
Exhibited in London only

The Roadstead of Marseille, in Winter shows the outer part of the port of Marseille; the docks that had recently been built to expand the port are seen extending up the coast, beyond the entry to the old port on the right. The old port, the standard focus of topographical views of Marseille, is ignored here, and Casile's view seems deliberately to avoid those aspects of Marseille and its surroundings that were conventionally seen as picturesque. In this sense the painting is a deliberate rejection of the celebratory topographical vision of France's ports, pioneered by Joseph Vernet's views of the 1750s and 1760s (see fig. 47, cat. 7). Yet the port Casile shows was in a sense the modern equivalent of the one Vernet depicted, since it was from this new outer port that the principal trade of France's foremost seaport was conducted.

The scene is very open and spare, animated only by a few fishing baskets and two tiny seated figures. Beyond, the modern shipping and the very plain, regular buildings seen at far right enhance this effect; the white lighthouse acts as a pivot in pictorial and thematic terms.

The execution of the painting is correspondingly economical, responsive to the different elements and textures in the scene, but never assertive. The paint layers are quite thickly impasted across the foreground, soft blue-greys contrasting with the dominant muted sandy pinks; the masts in the distance are finely drawn, set against the softly brushed dull pinks and blues on the far hills. The overall effect, though, is quite unlike the standard view of the south of France as luminous and richly coloured (contrast cats. 19, 28, 55).

In 1881 Maurice du Seigneur characterised Casile's distinctive subject matter: 'To take a band of terrain with few features, spreading out its bareness beneath a sky without *effet*; to sit down in front of one's easel with the firm determination to make the interpretation of this vulgar site interesting, this seems to me audacious; to succeed in this seems to me more than fortunate; it is also more than mere talent.' (Du Seigneur 1881, p. 121.)

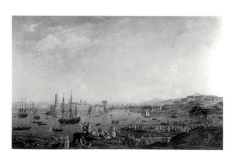

Fig. 47
Joseph Vernet
The Entrance to the Port of Marseilles, 1754
165 × 263 (65 × 103½)
Musée du Louvre, Paris

La Rade de Marseille — en Hiver —
Alfred Casile

52

A Shower, Rue Bonaparte 1887
Une Averse, rue Bonaparte
Salon of 1887, no. 1181
102.6 × 196.7 (40⅜ × 77½)
Terra Foundation for the Arts
Daniel J. Terra Collection
Exhibited in Boston only

A Shower, Rue Bonaparte, Hassam's first Salon exhibit, shows the view looking southwards from near the Place Saint-Sulpice towards the Luxembourg Gardens; on the left, behind the wall, is the seminary of Saint-Sulpice, one of the leading institutions in Paris for the training of priests.

Like Boggs's *The Place de la Bastille in 1882* (cat. 39), Hassam's canvas shows a distinctive Parisian site bustling with the everyday life of the city on a rainy day. But Hassam includes no striking central motif and the social world he depicts is both more complex and more legible than Boggs's. The austere walls of the seminary are plastered with posters, while in front of these vivid reminders of the city's entertainments stands a cluster of smartly-dressed cab-drivers at the head of a line of waiting, horse-drawn cabs. The nearest figures on the right pavement seem to be fashionably dressed, but the man and young girl dragging their cart along the gutter in the immediate foreground are impoverished workers; the disparity between this couple with their humble vehicle and the smart cabs beyond, and between the posters and the seminary, reflects the contrast of modern city street life.

The wide format of the canvas gives a sense of the open expanse of the street. The figures cut off in the foreground – a device frequently used in paintings of the 1880s to suggest immediacy – heighten the contrast between foreground and background. The dominant tonal effect is very similar to Boggs's painting (Hassam and Boggs were close neighbours at this time). However, Hassam's brushwork is more flexible and more attentive to detail than Boggs's. The gestures of the nearest figures are crisply delineated and the softer touch in the background creates a sense of atmospheric distance.

While *A Shower, Rue Bonaparte* was on view at the Salon, Hassam abandoned his delicately nuanced tonal painting in favour of a far more luminous and coloured vision that shows the direct impact of Impressionism. His new style was displayed at the Salon the next year, 1888, in *The Day of the Grand Prix* (The New Britain Museum of American Art, New Britain, Connecticut), a sunlit scene of fashionable carriages on a boulevard near the Arc de Triomphe.

53

**Demolitions at the Gare
Saint-Lazare 1888**
*Les Démolitions de la gare
Saint-Lazare*
Salon of 1888, no. 503
89.5 × 130 (35¼ × 51⅛)
Musée d'Art et d'Archéologie,
Moulins

Demolitions at the Gare Saint-Lazare portrays the demolition of parts of the original station during its reconstruction to the designs of Lisch in 1886–9. This is a key theme of urban modernity, showing the replacement of one recent structure, built for a new means of transportation, by another, larger and more advanced. Monet had painted his series of the old station in 1877 (see fig. 48); Pissarro was to paint the courtyard and façade of the new one in 1893.

The picture falls within the tradition of topographical townscapes, with its raised vantage point giving an overview of the scene. This formula had been widely used in the engravings published during the massive rebuilding programme in Paris instituted by Napoleon III; many of them showed the demolition of the 'old Paris' that made way for the new boulevards.

Seen in this context, Carrier-Belleuse's painting is unusual in a number of ways. Most obviously, such themes were virtually never treated in 'fine-art' exhibition pictures. Beyond this, the image is harder to interpret because it does not resort to the standard contrast between old and new Paris, nor does Carrier-Belleuse include any of the new structure alongside the original one. The figures, too, do not help us to read the picture: a few are at work on the right, beyond the cart that will remove the rubble, and a more complex group stands at bottom left, with bourgeois top-hatted men looking at the ruins, while a few workers walk past them and away from their work.

The execution is clear and essentially descriptive. Unobtrusive outlines define parts of the buildings, while the masonry and ground are indicated with broad sweeps of paint, sometimes applied with the palette knife. A sequence of highlights runs through the picture, resting primarily on the rough edges of half-demolished walls; these are not the result of the direct fall of sunlight but rather serve to structure the complex play of planes and textures in the painting. The colour is subdued, suggesting an overcast urban light, with variations of tone within a very limited range of greys and beiges.

Fig. 48
Claude Monet
The Gare Saint-Lazare, 1877
54.3 x 73.6 (21⅜ x 29)
The Trustees of the National Gallery, London

54

**Valley of the Eaugronne,
near Plombières (Vosges),
Sunset 1889**

*Vallon de l'Eaugronne, près
Plombières (Vosges), soleil couchant*
Salon of 1889, no. 1071
135 × 195 (53⅛ × 76⅞)
Walter Feilchenfeldt, Zürich

This view of the landscape near Plombières, Français's birthplace in the foothills of the Vosges in eastern France, can be seen as a summary of the changes that had overtaken the French countryside during his long life. The figures haymaking on the bank on the left belong to an agricultural community, with the man cutting and the women raking the hay. But the fisherman by the river seems to be a bourgeois holidaymaker: a reminder that under Napoleon III Plombières had become a highly successful thermal spa, where the Emperor himself liked to stay. The two sides of the picture bear witness to yet more recent developments, to the results of the Freycinet Plan that improved transportation links to the most remote parts of France during the 1880s. On the left we see a train puffing along a branch line, while the bridge in the right foreground, with the broad straight road it carries, is evidently new and presumably also part of the same campaign to modernise the countryside and integrate it firmly into France.

The scene is lively and humorously observed. The haymakers on the left seem to be looking at the fisherman, a figure with overtones of sexuality that had long interested Français (see cat. 1). The peasant woman and child on the bridge look directly at the viewer, a reminder that we, and the painter whom we imagine seated in our place, are also newcomers in this valley – an amusing recognition by Français of the position of the painter as outsider in the landscape (see pp. 16–19).

Reviewing the picture in 1889 Georges Lafenestre characterised Français as one of the older generation of landscapists who had made no great innovations but had, through experience, gained 'a sureness and a sense of unity which sometimes look like grandeur. The *Valley of the Eaugronne, near Plombières*, by M. Français is one of those accurate landscapes which would have been envied by the worthy painters of 1789, who were just as conscientious as their successors but lacked their confident skill and dexterity.' (Lafenestre 1889, p 652.)

Français 1889.

55

September Morning on the Road to Villeneuve-lès-Avignon, near Avignon *c.* **1889**

Matinée de septembre sur la route de Villeneuve-lès-Avignon, environs d'Avignon

Salon of 1890, no. 2127

124 × 200 (48⅞ × 78¾)

Musée de Carpentras

Exhibited in London only

Saïn's paintings, mostly of the countryside surrounding his home town, Avignon, represent an attempt to capture the brilliance of Provençal light by highly traditional, academic means. He presented his work in Paris explicitly as part of the contemporary revival of Provençal culture led by the Félibrige (see pp. 57–8); the revival of the Provençal language was a central part of the Félibrige programme, and in 1889 Saïn gave his contribution to the Salon a title in Provençal.

The dusty road leads up a hill, with olive trees on the right and houses on the hillside beyond. The sun floods the scene from the left, leaving the rock in the left foreground as a tonal repoussoir to the luminous vista beyond. In contrast to the Impressionists' canvases painted in the South (see cats. 88, 105, 112), this light is not re-created in terms of complex relationships of atmospheric colour; there is very little blue in the landscape itself, just slight bluish tints on the far hillside. The colour throughout is essentially local, seeking to render the actual colours of the elements in the scene; but its blondness and luminosity, combined with the dominant whiteness of the road and the rocks that are so central to the composition, give the whole image a remarkable immediacy and dazzle.

The painting makes a revealing contrast with the southern canvases of Cézanne, himself a friend and supporter of members of the Félibrige. Cézanne's *Mountains in Provence* (fig. 49) presents a very comparable scene, and both paintings adopt a predominantly light-toned palette to suggest the sunlight. But, as well as applying richer atmospheric colour, Cézanne presents his road at an oblique angle and integrates the surfaces of rocks and hillside beyond into a complex sequence of coloured planes that create taut relationships across the picture surface. Saïn, by contrast, treats the elements in the scene comparatively literally; his painting achieves its impact by an uncomplicated illusionism completely alien to the modernist tradition in which Cézanne's art has been so central.

Saïn demonstrated his conservative position by continuing to exhibit with the Salon des Artistes Français in 1890, when many of the more progressive and liberal-minded painters broke away to form the Société Nationale (the Salon du Champ de Mars). Saïn's painting, displayed at the Salon des Artistes Français, compared with Billotte's (cat. 56), shown with the Société Nationale at the same time, gives some sense of the different values for which the two bodies stood.

Fig. 49
Paul Cézanne
Mountains in Provence, *c.* 1885
63.5 × 79.4 (25 × 31¼)
The Trustees of the National Gallery, London

56

**Winter Fog at the Porte
de Courcelles** *c.* **1890**

*Un Brouillard d'hiver à la Porte
de Courcelles*
Société Nationale, 1890, no. 72
97 × 134 (38⅛ × 52¾)
Musée des Beaux-Arts, Bordeaux

The Porte de Courcelles was on the north-western side of Paris, beyond the Batignolles quarter, and remote from fashionable, tourist Paris. Billotte's painting shows the view across the rue de Courcelles as it crosses the line of fortifications built around Paris in the 1840s during the reign of Louis Philippe (now the site of the Boulevard Périphérique). In the left background we see the irregular silhouettes of apartment blocks within the city; out of view to the right extended the industrial suburbs of Champerret and Levallois-Perret.

Billotte overtly rejects the notion of the picturesque motif and the conventions of topographical townscape (see cat. 53); far from giving a more comprehensive view of the Porte de Courcelles, the oblique angle creates a perspective that leads down the totally empty moat of the fortifications, with the road – the active part of the scene – awkwardly cut off at both sides as it crosses the foreground.

The execution is simplified, with the forms of the buildings softened in the mist; the gestures of the working-class figures are slightly puppet-like. The brushwork is more varied where the snow catches the light, but Billotte had no interest in the lavish surfaces by which Monet suggested snow (see cat. 78), nor did he adopt the Impressionists' rich blue shadows. The dominant hue here is the warm golden light from the sun; the contrasting shadows are primarily grey.

The softening of the forms may reflect the impact of Impressionism, but the use of a misty effect such as this to transform a mundane scene is far closer to the aesthetic of Whistler, as expressed in his Ten O'Clock Lecture of 1885, published in France in 1888 in a translation by Stéphane Mallarmé. The effects in Billotte's painting can readily be compared with Whistler's famous images: 'the evening mist clothes the riverside with poetry, as with a veil ... and the tall chimneys become *campanili*, and the warehouses are palaces in the night.'

Léopold Mabilleau picked up on Whistler's imagery, whether consciously or not, when reviewing the picture. He saw Billotte as one of the artists 'devoted to the study of the corners of the Parisian *banlieue*, where the observer with sensitive eyes discovers so much picturesque originality and unexpected poetry. M. Billotte sees everything through a light fog, which conceals or transfigures the ugliness of the subject.' (Mabilleau 1890, p. 25.)

Winter Fog at the Porte de Courcelles was shown at the first exhibition of the Société Nationale, the new exhibiting group of artists, generally liberal in their views, who broke away from the Salon that year (see also cat. 55).

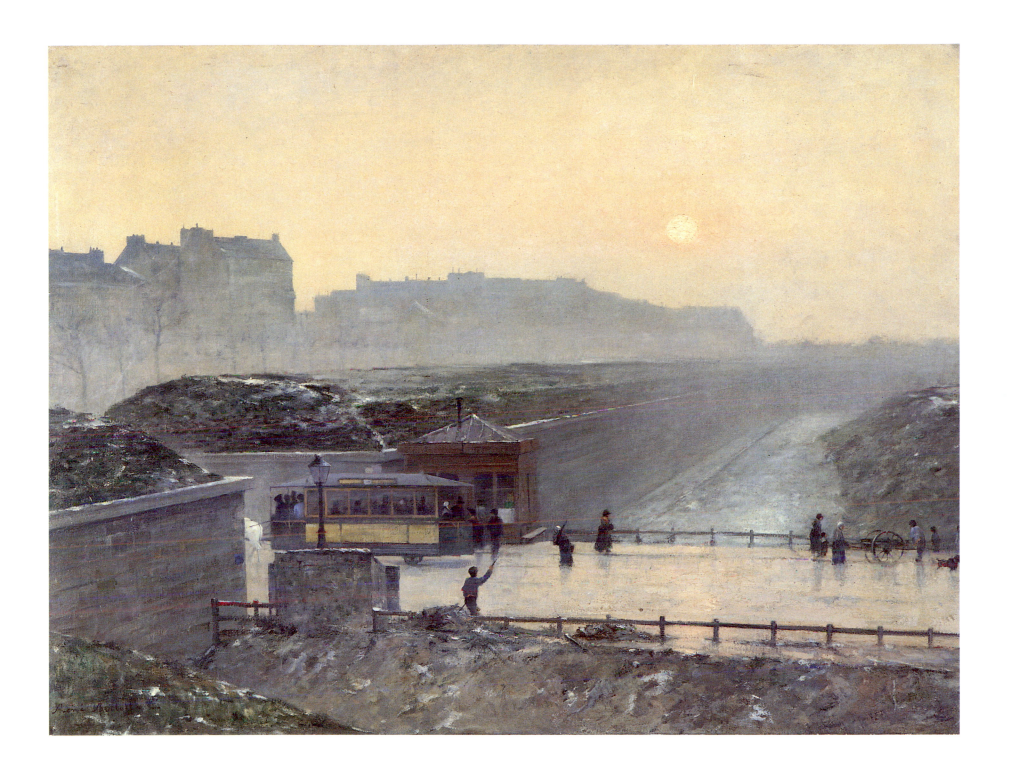

57

Rue de la Bavolle, Honfleur *c.* 1864

La Rue de la Bavolle, à Honfleur

55.9 × 61 (22 × 24)

Museum of Fine Arts, Boston

Bequest of John T. Spaulding

Monet's view shows one of the streets leading up from the most celebrated of Normandy's old ports, Honfleur, on the south side of the Seine estuary, opposite Le Havre (see Chapus 1862, pp. 261–71). The proximity of the newly developed seaside resort of Trouville, nine miles down the coast, increased its fame. Although the buildings in Monet's painting are not especially distinctive, they are obviously local in character, and the figures on the street and in the doorways complement this image of life in a small old town. It is a subject very much in the tradition of topographical townscape.

The execution is simple and direct; the buildings and the figures are blocked in with firm touches and sweeps of colour, and some dark outlining successfully defines the sequence of buildings receding on either side of the street. The contrast between sun and shadow, too, is absolutely clear-cut, heightening the sense of recession but also creating a distinctive yet strangely disembodied shape in the foreground. While he was working on the Channel coast in the mid 1860s Monet's two principal mentors were Boudin and Jongkind (see fig. 14), but the breadth and firmness of his paint handling in this picture are quite unlike their more delicate facture, and may suggest that Monet was already looking to the example of Courbet (fig. 22).

There has been much discussion of the date and the status of *Rue de la Bavolle, Honfleur* and of Monet's other version of the subject (Kunsthalle, Mannheim; see New York, 1994–5, pp. 80–3, 425–6). The second version is approximately the same size, with the same arrangement of shadows and clouds, but has quite different and more prominent figures in the foreground – a washerwoman and a boy carrying a basket of laundry. In letters to Bazille in 1864 Monet described his practice of painting 'studies' from nature and then making a second version of the subject in his studio (Wildenstein 1974, letters 11 and 12, p. 421); this pair of paintings is presumably an example of that practice, the Mannheim version, with more figures and more elaborately painted clouds, being the studio replica, and the painting shown here the outdoor 'study'. Although these views have recently been dated to 1866 (see New York 1994–5, pp. 425–6), their comparatively heavy paint layers make them more likely to belong among the pairs that Monet painted in 1864.

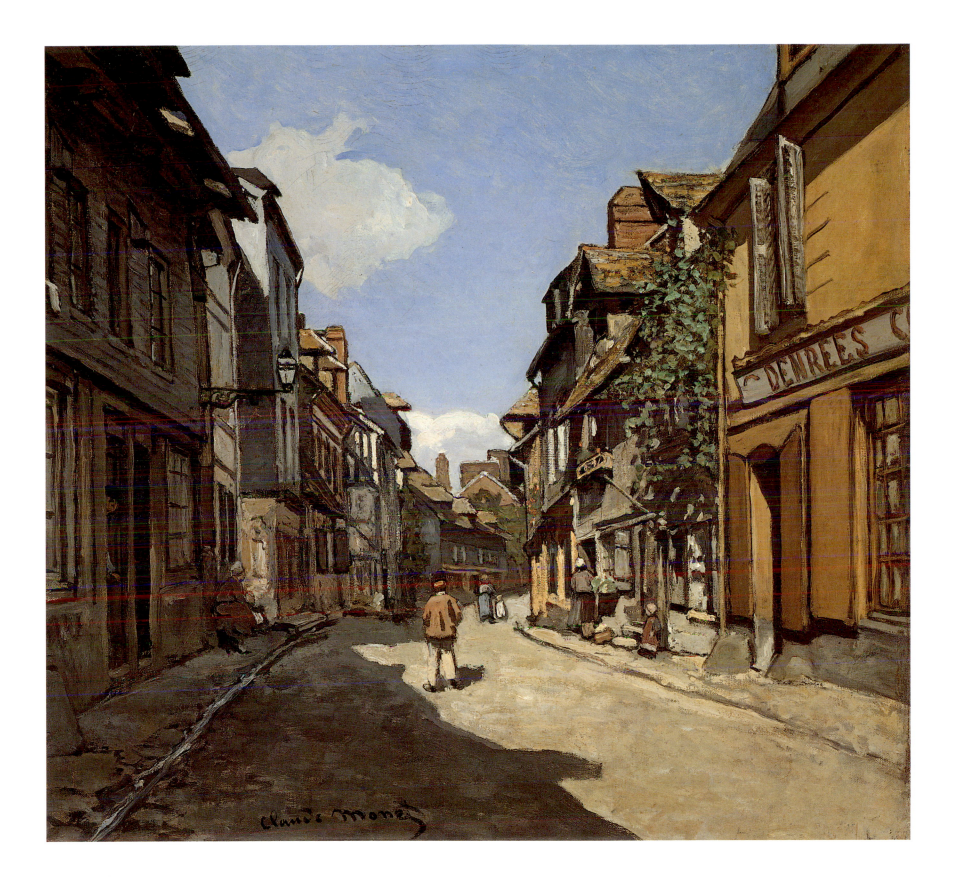

58

The House of Père Gallien, Pontoise 1866

La Maison du père Gallien, Pontoise

46 × 55 (18⅛ × 21⅝)

Ipswich Borough Council Museums and Galleries

In its size and its comparatively thorough finish *The House of Père Gallien, Pontoise* is characteristic of the smaller landscapes that were habitually sold through dealers during the 1860s (see pp. 27–8). However, its subject is distinctive and less obviously marketable.

Young couples beneath blossoming fruit trees in spring was a stock image in landscape painting, but here Pissarro did not follow the stereotype. The couple in the foreground stand in an open field, seemingly on dug earth rather than on a path, and their interchange has an awkwardness that hints at an illicit liaison rather than young love, although they are visible to all comers; the woman's simple dress looks markedly more humble than the man's evidently bourgeois costume.

There is nothing picturesque about their setting, either, with a featureless wall, evidently flanked by a path, and a few irregular houses seen across the blank band of the field. We are in one of those no-man's-lands where town meets country – a complete rejection of conventional notions of the picturesque.

Although the setting has been identified as being in the area of the sixteenth-century fortifications of Pontoise, the town about twenty miles north-west of Paris where Pissarro lived, there is no hint of historical associations in the scene itself (see Brettell 1990, pp. 148–9; Thomson 1990, p. 26). Nor, presumably, would viewers have known who Père Gallien was, or even which of the houses was his; the title, if it is Pissarro's, seems designed to evoke the ordinary, everyday character of the scene.

The handling of the painting is spare and economical, differentiating between the textures of different elements in the scene, but with simple, quite flat colour zones indicating the further field and the walls beyond. The canvas is firmly structured around the dark and light accents of figures, trees and buildings, but the scene is laid out in such a way that there is no clear focus apart from the foreground tree and figures, and no readily discernible path of recession. The studied awkwardness of the composition complements the picture's subject.

The colour is muted, with greens, browns and beiges played off against the light sky; even the blossom on the tree is very subdued in its effect. Only a few colour accents disturb the overall tonality, notably the harsh green-blue of the door in the wall on the left and the shutters above it: a clear man-made hue in this dominantly earthy image, again complementing the picture's theme of the meeting between town and country.

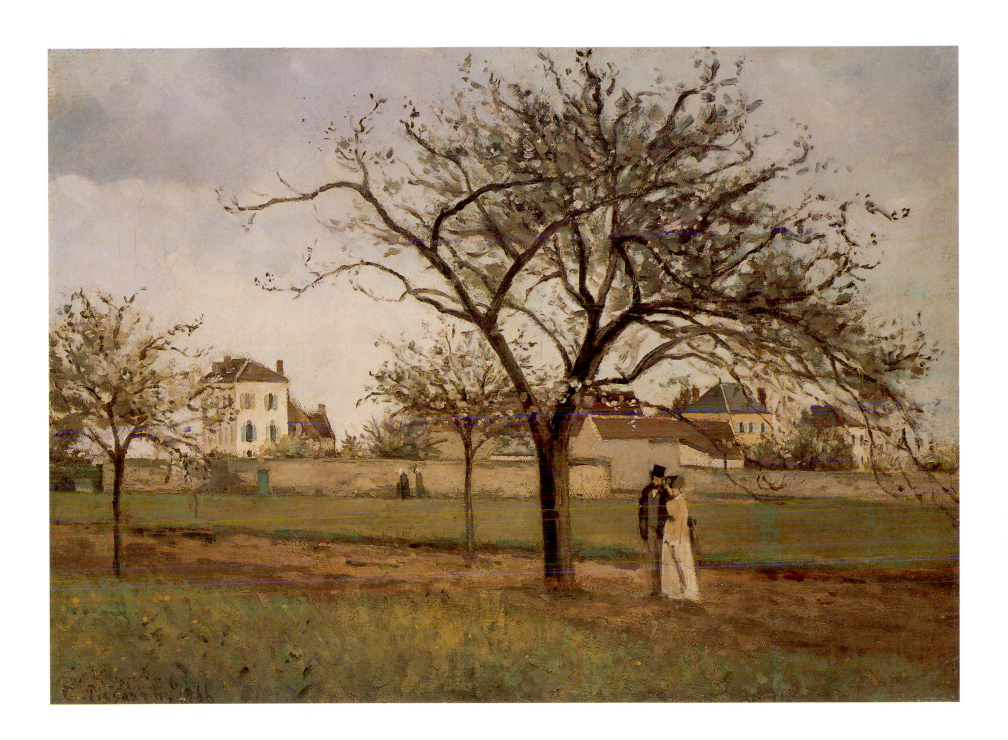

59

The Fortifications of Aigues-Mortes
1867

Les Ramparts d'Aigues-Mortes
46 × 55 (18⅛ × 21⅝)
Musée Fabre, Montpellier
Exhibited in London only

In the summer of 1866 Bazille's father wrote to his son advising him to paint the medieval walled town of Aigues-Mortes on the western edge of the Camargue near the family home in Montpellier, though he warned him against going there in the unhealthy heat of late summer. The following spring Bazille took his father's advice, producing three oils and a number of pencil drawings of the town. Sometimes he focused directly on the old walls, but in this painting, the smallest of the oils, he viewed the southern walls and gates from further away, across the marshy land that surrounded it (see Bazille 1992, pp. 129, 142; Montpellier 1992, pp. 98–103).

Although in his letter Bazille's father had commented that he knew of no paintings of Aigues-Mortes, the remarkable preservation of its walls made it a well-known tourist attraction. In this sense it was a very conventional landscape motif, but here the town is relegated to the background and the whole lower half of the canvas is filled with the rough grasses of the Camargue and the still water reflecting the luminous sky. While the sunlit walls with their distinctive towers remain the prime focus, the startling horizontality of the surroundings militates against conventional notions of the picturesque (see by contrast cat. 17).

In his technique Bazille adopted a fluent shorthand. Crisp strokes suggest the foreground grasses and fine outlines help to define the humble buildings on the left, but otherwise the scene is confidently sketched with economical yet skilfully differentiated sweeps of colour. The seagulls lend a touch of animation and some sense of scale.

Bazille's drawings of the town have been described as preparatory studies, but none of them correspond with any of the paintings; one is close in viewpoint, but shows the city walls from a different angle (Montpellier 1992, p. 101, fig. 44). It seems probable that the paintings were executed in the open air. In these terms *The Fortifications of Aigues-Mortes*, with its small scale, clearly belongs to the lineage of open-air studies that can be traced back to Corot's Italian paintings of the 1820s and to the sketches of predecessors such as Valenciennes. Yet Bazille considered it a complete painting: he signed it and presented it – with an inscribed dedication – to Joseph Fioupiou, a friend from Paris, who worked in the Ministry of Finance and was a print collector.

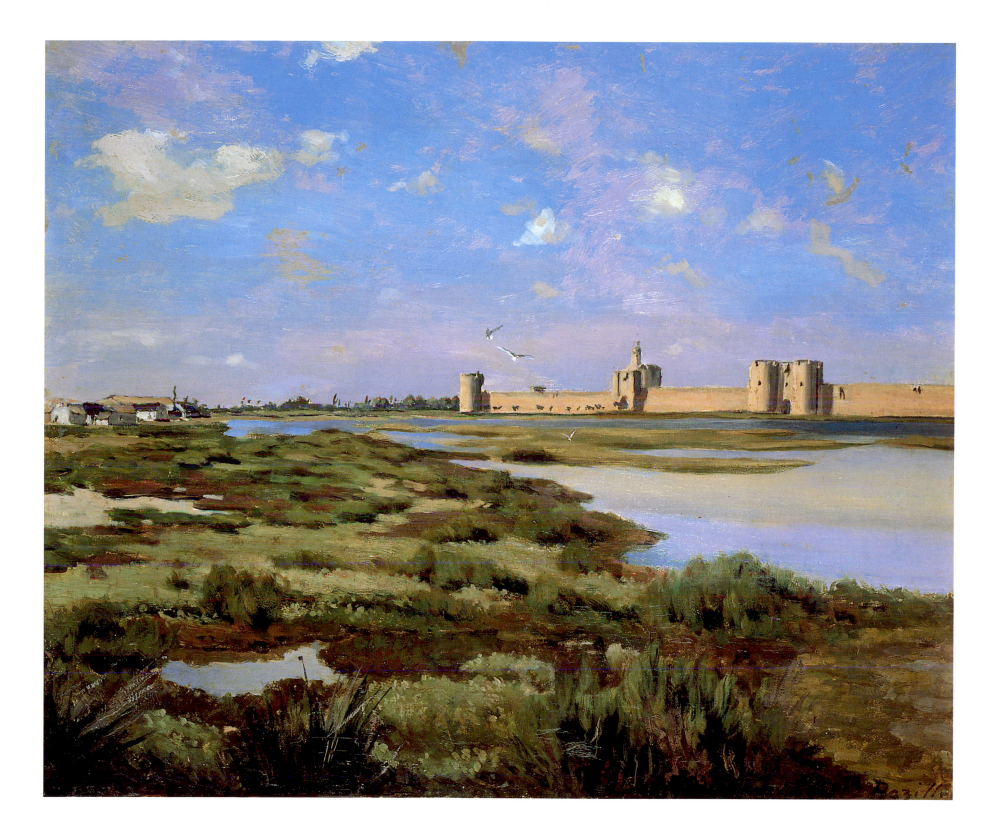

60

Street in Sainte-Adresse 1867

Rue à Sainte-Adresse

79.7 × 59 (31⅜ × 23¼)

Sterling and Francine Clark
Art Institute, Williamstown,
Massachusetts

Sainte-Adresse is a resort on the
Channel coast just north of Le Havre,
where Monet's family lived. Most of
his Sainte-Adresse views focus on its
beach, looking either towards the
northern headland, the Pointe de la
Hève, or south down the coast towards
Le Havre itself. However, in *Street at
Sainte-Adresse* there is no sign of the
proximity of the sea; he focused instead
on one of the few small streets that
lead inland.

The subject is comparable to *Rue de
la Bavolle, Honfleur* (cat. 57), and the
church spire was a common motif in
traditional landscapes (see cats. 5, 25).
Yet Sainte-Adresse, as shown here, has
none of Honfleur's picturesqueness.
The blank walls and the scruffy open
road in the foreground are closer to
Sisley's downbeat view of Marlotte
(cat. 13), shown at the Salon the
previous year.

Sainte-Adresse, like a number of
other places on the Normandy coast,
had been discovered by writers earlier
in the century but it had no great
reputation in the 1860s. Joanne was
unwontedly severe about it in his guide:
'[It] does not deserve the much inflated
reputation given it by Alphonse Karr ...

In its lower part, especially ... it is noisy
and dirty, as unpleasant to the smell
as to the sight.' (Joanne 1866, p. 105.)

Monet's overcast autumnal effect
emphasises the humdrum quality of the
scene, with the adroitly handled figures
and the little plumes of smoke lending
an air of everyday informality. The
brushwork throughout is a flexible
varied shorthand that acts as a notation
for the diverse elements in the scene
but also creates a constantly lively and
mobile effect. The touch is much
more delicate and nuanced than in
Rue de la Bavolle, Honfleur and is
closely comparable to the
contemporary work of Jongkind
(see fig. 14), whose technique played
a central role in the development of
the art of the future Impressionists
in the later 1860s.

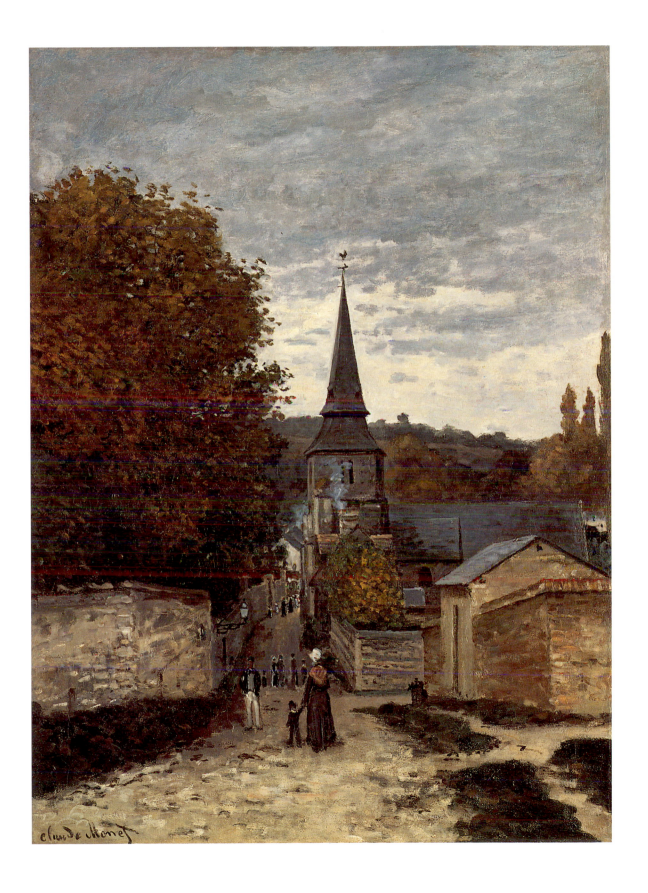

61

The Harbour of Lorient 1869
Le Port de Lorient
43.5 × 73 (17⅛ × 28¾)
Board of Trustees, National Gallery
of Art, Washington
Ailsa Mellon Bruce Collection

Lorient was a busy port on the southern coast of Brittany between Nantes and Quimper. The railway had been extended through southern Brittany only in 1862, making the area readily accessible to visitors from Paris. Berthe Morisot visited Lorient in the summer of 1869 to stay with her sister Edma, whose husband Adolphe Pontillon was stationed there as a naval officer. It was Edma who posed for this painting.

The fashionably dressed figure and the buildings along the quay mark the scene out as both urban and contemporary; there is no hint of the traditional imagery of Brittany (see cat. 22). Morisot's silent sunbathed port is also a far cry from the busy activity of Noel's recent view of the port of·Brest (cat. 7). The figure, presented as if she is looking down into the water, heightens the sense of stillness and reverie.

The painting's delicate pearly palette recalls Corot, with whom Morisot had studied, and the simplified yet crisply indicated forms of the background buildings can also be compared with his outdoor studies. The effect of light is suggested with great delicacy and freshness, but the picture is also carefully organised around the sequences of crisp, darker accents that punctuate its luminous space: the trees, the hulls of the boats and Edma's hat.

Morisot had met Manet in the previous year and her treatment of the figure here suggests the impact of his fluent painterly rendering of women's dresses, as seen most notably in the figure of Morisot herself in the foreground of his *The Balcony*, exhibited at the 1869 Salon (Musée d'Orsay, Paris). When she showed the painting to her friends in Paris, Puvis de Chavannes complimented her on her knowledge of perspective, and Manet admired the picture so much that she gave it to him (Stuckey and Scott 1987, p. 29; Rouart 1986, pp. 43, 45). It was probably Morisot's treatment of open-air effects, as much as the influence of the young Impressionists, that encouraged Manet to lighten his palette in the early 1870s.

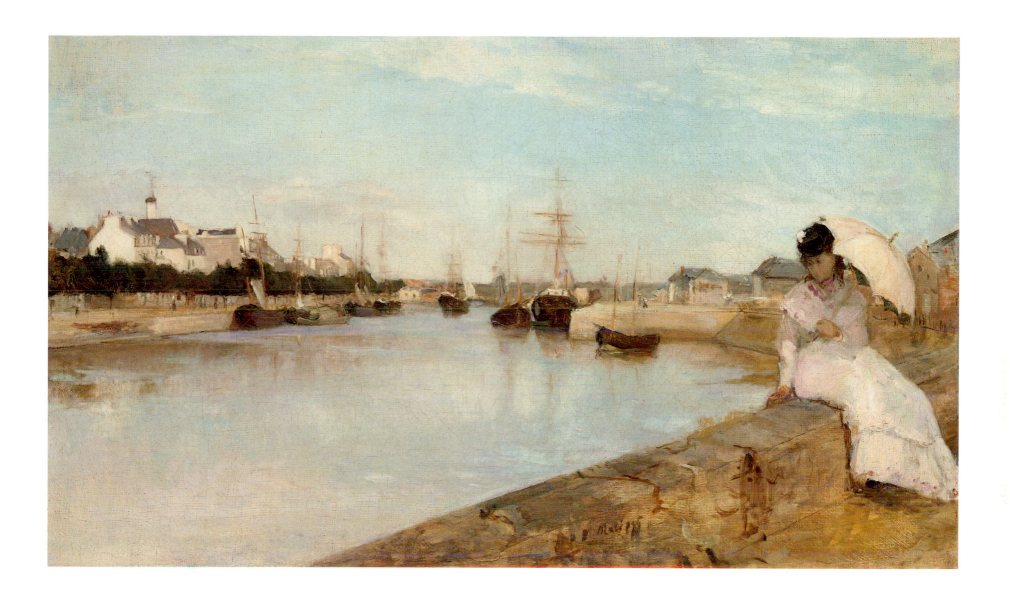

62

Train in the Countryside *c.* 1870

Train dans la campagne

50 × 65 (19⅝ × 25½)

Musée d'Orsay, Paris

Despite its title, *Train in the Countryside*, this picture more probably shows a public park. The distinctive double-decker carriages of the train travelled along the suburban lines running westward from the Gare Saint-Lazare; the line seen here could be the one from Paris to Saint-Germain-en-Laye or the *Chemin de fer de ceinture* in the Bois de Boulogne (see Wildenstein 1974, p. 186; Los Angeles 1984, p. 158; Herbert 1988, pp. 219, 312, note 27).

The picture's composition breaks all accepted codes of landscape form, with a shapeless open foreground wholly enclosed by the bank of trees and the railway, and no view through to the distance; the silhouetted coaches, with the smoke from the unseen engine, act as a most unconventional backdrop.

The brushwork is remarkably varied, ranging from the startlingly flat paint zones of the open grass, where only the direction of the sweeps of paint hints at the falling terrain, to the crisp stippling of the leaves on the near tree. The tufts of longer grass at lower left play a crucial part in leading the eye into the composition, but they are indicated with the greatest economy, in loose dabs of darker, duller green. There is great variety in the greens of grass and foliage, but the play of light is suggested by essentially tonal means, with scarcely a hint of the atmospheric blues that were so characteristic of mature Impressionism. The overall luminosity of the scene is reinforced by the use of a very light grey canvas priming, which can be glimpsed in several places; this appears as near-white in the shadowed foliage but as a clear grey when juxtaposed with the light tones of the sky.

The figures were added at the very end of the picture's execution, when the initial paint layers were already dry. They are sketched with great fluency, but on a miniature scale; the fall of light on them is indicated with great finesse though without tight detail. Their scattered placing enhances the informality of the scene. The three in the sunlight look out towards us, but we are so far away that we have no way of interpreting the focus of their gaze.

Although it has recently been suggested that the painting dates from 1872 (Herbert 1988, p. 312, note 27), the simplicity of the handling and the lack of colour in the shadows make the usual dating of 1870 more plausible; during the early summer of that year Monet was based at Bougival, not far from a raised section of the Paris to Saint-Germain railway line.

Train in the Countryside was probably the painting sold with the title *An Embankment* (*Un Remblai*) in the auction sale of the collection of Ernest Hoschedé in 1878 (Bodelsen 1968, p. 340; Wildenstein 1974, p. 186).

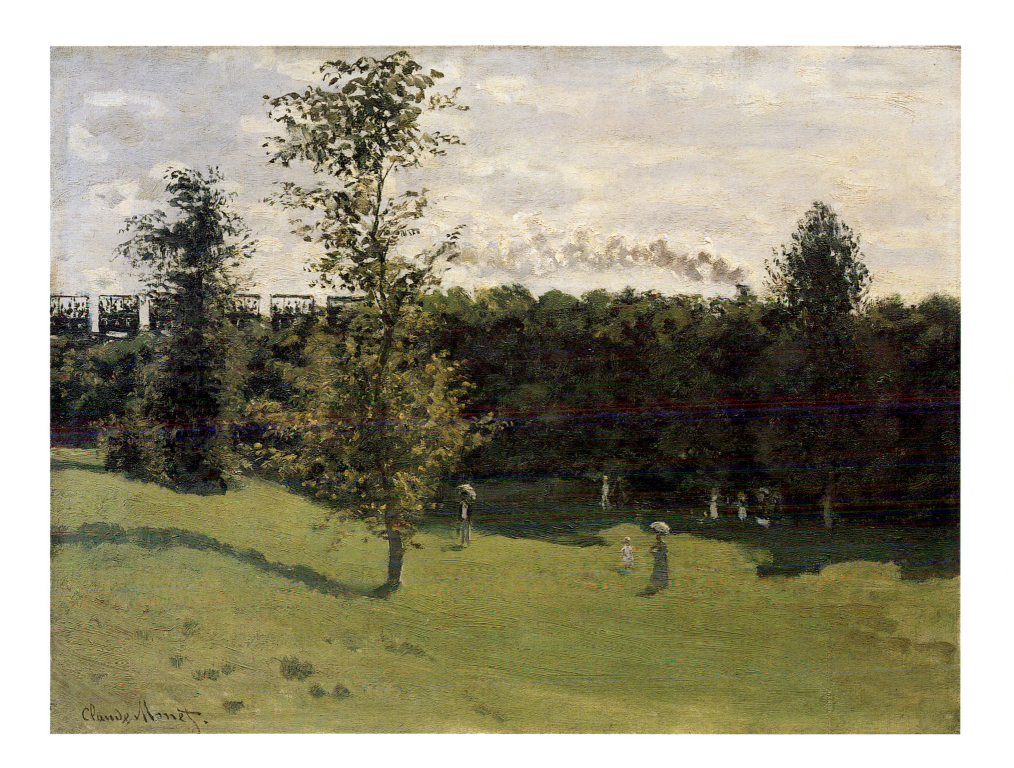

63

**The Versailles Road at
Louveciennes (Rain Effect) 1870**
*La Route de Versailles à
Louveciennes (effet de pluie)*
40.2 × 56.3 (15⅞ × 22⅛)
Sterling and Francine Clark
Art Institute, Williamstown,
Massachusetts

Pissarro's canvas is one of the most characteristic of early Impressionist paintings, treating a humble scene and a fleeting effect of weather with great delicacy and on a very intimate scale.

This road runs north from Versailles, past the village of Louveciennes and down into the Seine valley to the town of Saint-Germain-en-Laye. The view looks northward; Pissarro's own house was on the left of the road. Though the title is very specific there is nothing special about the road itself, with its scattered houses and trees; there were many such roads around the fringes of Paris. A spectacular structure ran alongside the road and across the end of Pissarro's garden: the Marly Aqueduct, part of Louis XIV's system for raising water from the Seine and pumping it across the hills to Versailles. It appears in a number of paintings made in this area (see cat. 64 and fig. 50, p. 192), yet in *The Versailles Road at Louveciennes*

(Rain Effect) there is no sign of it or of any of the other historical structures in the district (see also cats. 82, 83).

The focus of the painting is the play of grey light on the wet road. The handling is economical, yet far more delicate and variegated than in *The House of Père Gallien, Pontoise* (cat. 58). The most elaborate treatment is in the road itself, painted in sequences of soft but distinct dabs; yet throughout the picture nuances of texture in grass, trees and buildings are subtly suggested by inflections of touch and tone. The overall colour scheme is subdued – predominantly greens, beiges and browns – but there are small points of varied colour throughout. We see blues on the aprons of the women and in the hazy distance down the road, and a sequence of warm reddish touches in many parts of the canvas; most obvious are the roofs and chimneypots and the face of the woman on the left, but there are

other less explicable warm touches, for instance beneath the signature. The colour and handling give the canvas a great freshness.

As so often in Impressionist paintings, the figures were added very late in the execution, after the paint layers had dried; this emphasises how much calculation went into the final effect of so seemingly informal a scene.

This small elaborately finished painting is the type of picture that Pissarro sold through dealers in these years, though nothing is known of its early history.

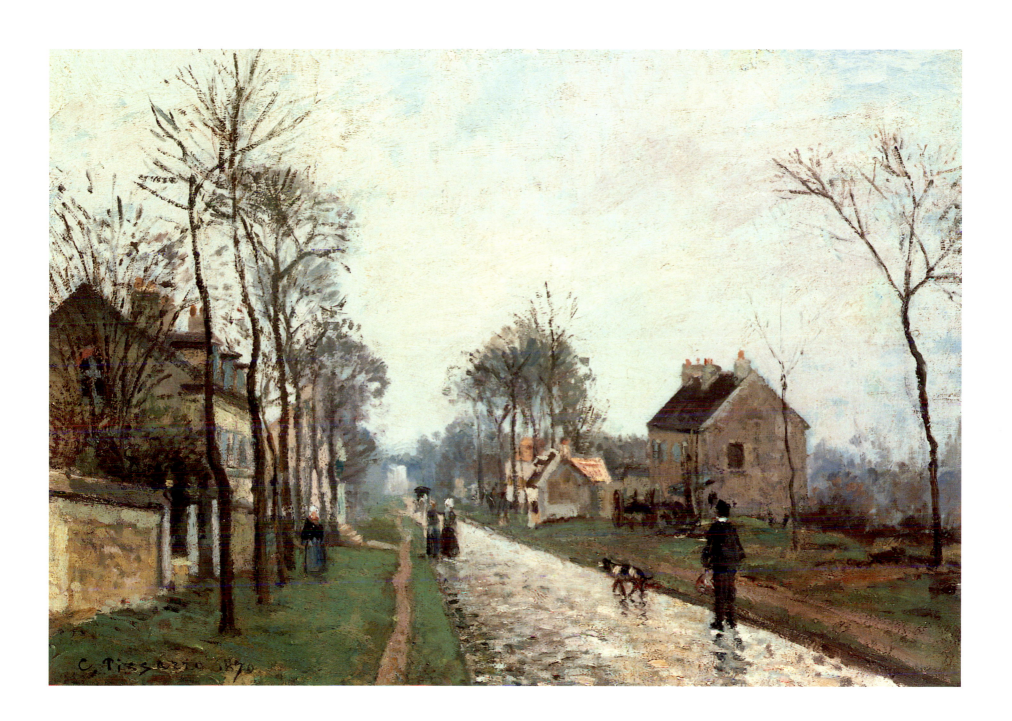

64

Road in Louveciennes *c.* 1870
Chemin à Louveciennes
38.1 × 46.4 (15 × 18¼)
The Metropolitan Museum of
Art, New York. Bequest of
Emma A. Sheafer, 1973

Renoir's canvas shows the view from the village of Louveciennes looking north-westwards, with the Marly Aqueduct, remnant of Louis XIV's water-pumping system for Versailles, on the left horizon; the road in Pissarro's *The Versailles Road at Louveciennes (Rain Effect)* (cat. 63) runs below the aqueduct.

Renoir's is a summer scene; Pissarro had painted the same view in early spring (fig. 50), with the aqueduct more visible. However, the key difference between the two paintings is in the figures: in Pissarro's a single peasant woman, with other local figures beyond; in Renoir's a fashionably dressed group coming towards us. This contrast is a reminder that Louveciennes lay in an area whose social identity was ambiguous: the agricultural life of the villages continued alongside the fashionable villas that were springing up along the Seine valley at Bougival, out of sight down the hill to the right in the

paintings. Beyond this, it shows how the choice of figures within a landscape can transform its effect: the same scene is presented as a workplace in Pissarro's picture, a pleasure-ground in Renoir's.

The lavish foliage of trees and bushes that enclose Renoir's scene enhance the sense of pleasurable escape; only the single house in the background suggests the village setting. The brushwork is consistently responsive to the varied textures, but never closely descriptive; its buoyant supple rhythms and the rich varied greens give the whole image a density and sumptuousness. The sunlit areas of the road are offset by the dense greens around them, and the effect is further variegated by smaller areas of contrasting colour: the red parasol and the pink of the cottage roof, the yellow of the grass or corn at the centre, and the blues in the clothing of the figures in the distance and the shadows on the road. Although the interplay of

light and shade, of lighter and darker tones, performs a crucial role in structuring the space and composition, the lavish use of colour is a clear presage of the future developments in Impressionist colour.

The spareness and breadth of handling of Pissarro's depiction of the scene (fig. 50) makes it likely to have been painted in spring 1869, the year before his more delicate and variegated *The Versailles Road at Louveciennes (Rain Effect)* of 1870. Renoir's canvas, with its elaborate surface, seems likely to belong to summer 1870; its handling is comparable to his *La Promenade*, dated 1870 (J. Paul Getty Museum, Malibu).

Fig. 50
Camille Pissarro
View from Louveciennes, c. 1869
52.7 × 81.9 (20¾ × 32¼)
The Trustees of the National Gallery, London

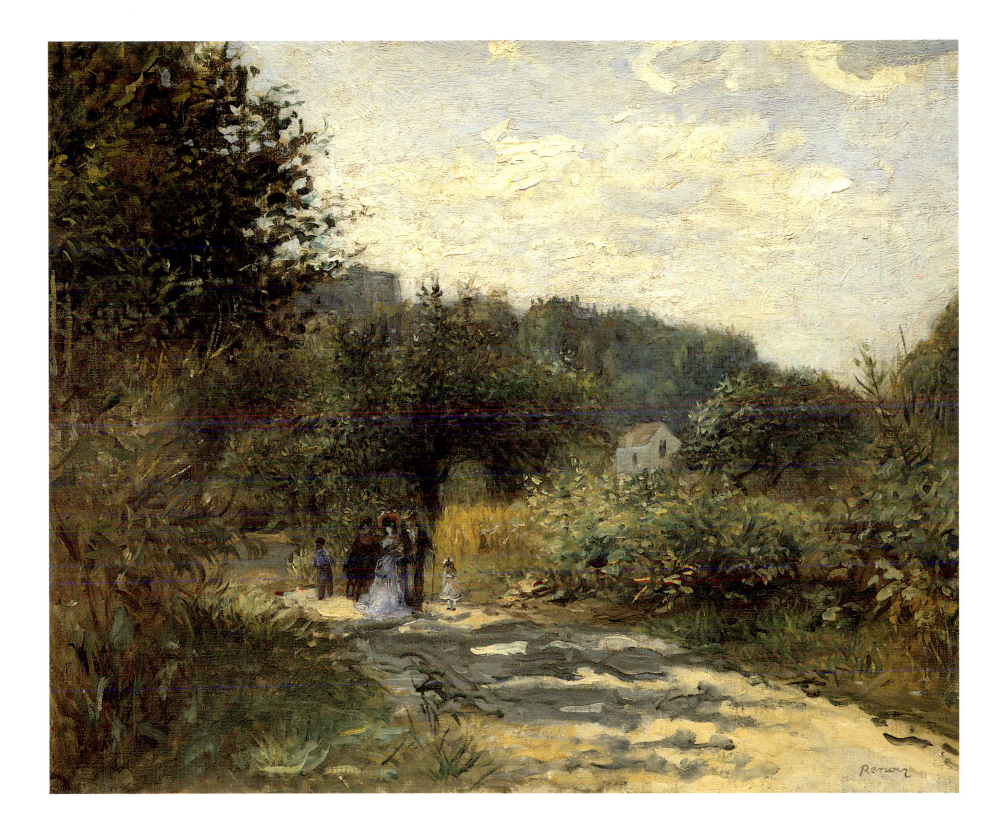

65

The Petit Bras of the Seine at Argenteuil *c.* 1872

Le Petit bras de la Seine à Argenteuil
52.6 × 71.8 (20¾ × 28¼)
The Trustees of the National Gallery, London
Exhibited in London only

The Petit Bras of the Seine at Argenteuil shows the side-channel of the Seine that left the main river just downstream from Argenteuil, where Monet lived from 1872–8; on the right is the Ile Marante. By this date Argenteuil was already partially industrialised and also a major centre for recreational sailing, but neither of these aspects is shown here. The format of the painting is comparable to Daubigny's stock river subjects (see cat. 11), but three elements suggest that this is not simply a 'rustic', 'untrammelled' view of the countryside (as proposed by Tucker in 1982, p. 20). The house seen through the trees is evidently a modern villa, not a rural building; areas of the foreground grass have been removed; and it is uncertain what the two crisp black figures are doing (they are not obviously fishing). Rather than a 'pure' landscape, we are presented with a scene that shows clear signs of the disruptive beginnings of modernisation.

Approached from the opposite direction, the *petit bras* led to the town of Argenteuil. Seen from one viewpoint, the place could be presented as a seemingly unspoilt village framed by trees (see fig. 51); but, viewed from a little nearer, the scene included a group of new villas down by the river (for example *The Seine at Argenteuil*, Musée d'Orsay, Paris). Again we see how a single site could provide material for dramatically different types of landscape subject.

In *The Petit Bras at Argenteuil*, with its overcast sky, the subject became the pretext for a remarkable exercise in coloured greys. The landscape is treated in muted mid-tones, some warm, some cool, with slightly stronger contrasts of colour and tone in the foreground; this is set against the luminous backdrop of the sky, with the reflective surface of the river leading the eye into space. Although none of the colours appear bright, technical analysis of the painting has revealed that they are made up of complex mixtures of more highly coloured pigments. This shows that, even in a comparatively subdued scene such as this, Monet visualised the effect from the start in terms of colour. He did, however, use pure ivory black for the figures, with a small admixture of chrome yellow and vermilion (see Bomford 1990, pp. 145–7).

The delicacy of the colour scheme is enhanced by Monet's addition of a second layer of priming, in pale mauve, on top of the original greyish-white ground. Although visible only at small points in the picture, this hue adds further complexity to the overall effect (Bomford 1990, pp. 144–5).

The brushwork is variegated throughout, ranging from firm distinct accents in the foreground to fine linear strokes for the tree branches and light feathery touches for their foliage. At a late stage in the picture's execution Monet lightly scraped away some of the paint in the tree area (probably with the handle of a brush), presumably to lighten the effect; such scraping is much more evident in the trees in *Autumn Effect at Argenteuil* (fig. 51).

The picture was in the hands of the dealer Durand-Ruel by the early 1880s, and may well have been one of those he bought from Monet in February 1873.

Fig. 51
Claude Monet
Autumn Effect at Argenteuil, 1873
55 × 74.5 (21⅝ × 29⅜)
Courtauld Institute Galleries, London

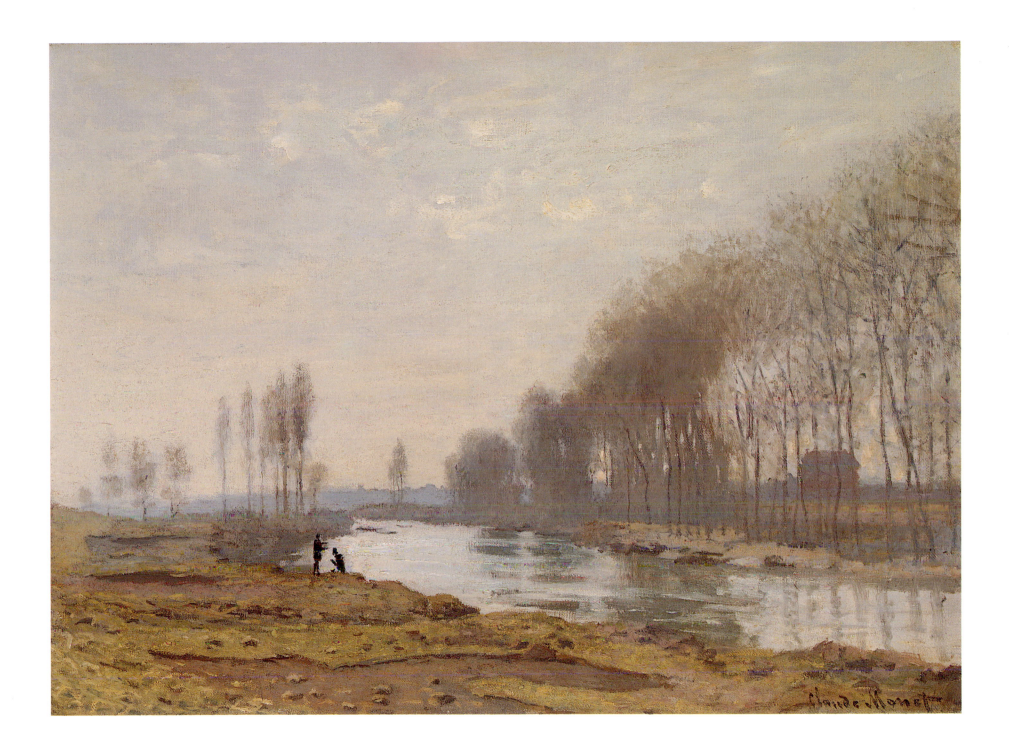

66

**View of Paris from the Heights
of the Trocadéro 1872**

*Vue de Paris des hauteurs
du Trocadéro*

45.8 × 81.4 (18 × 32)

Santa Barbara Museum of Art
Gift of Mrs Hugh N. Kirkland

This painting shows one of the great panoramas of Paris, from the hill of the Trocadéro, south-west of the city centre. In the background we see the silhouettes of the monuments of central Paris – most obviously, the gilded dome of the Invalides. To the right is the Pont d'Iéna and the open space of the Champ de Mars, which was used for military reviews and other events; the 1867 Exposition Universelle had been held on this site, and the Eiffel Tower was to be built there in 1888–9.

The picture is most unusual among panoramic scenes because two of the three figures in the foreground turn their backs on the view; only the child looks out over the city. The Trocadéro was on the eastern edge of the fashionable suburb of Passy where Morisot herself lived, and the two women are, in effect, looking back towards Passy and the domestic world of the bourgeoisie, away from the male-dominated public spaces of the city (see Adler 1988, pp. 10–13).

Though the women's attitude to the city has been described as one of indifference, the picture itself offers alternative interpretations of the scene: it contrasts the women with the child, and also implicitly with the painter and the viewers of the picture, whose gaze commands the vista of the city.

View of Paris from the Heights of the Trocadéro approaches this vista in a different way from Manet's 1867 *View of the Exposition Universelle* (Nasjonalgalleriet, Oslo), in which Paris is seen from much the same vantage point. Manet's canvas engages with the explicit modernity that Napoleon III so deliberately fostered in Paris, both through his rebuilding programmes and through the Expositions Universelles; the exhibition buildings play a central part, and the Trocadéro itself has been invaded by a cosmopolitan assembly of tourists. Morisot's canvas was painted less than two years after the city's siege by the Prussians, and the year after many of its public buildings had been destroyed in the overthrow of the Commune, yet there is no hint of these events. Its presentation of the modern has none of the spectacular quality that had engaged Manet in 1867, but it, too, raises questions about the relationship between city and suburb and about the place of gender in urban life.

The complex buildings and spaces in the distance are suggested with great economy; the luminous and delicate light effect is reminiscent of Corot (see cat. 25) but Morisot makes much of the contrast between the panorama of Paris and the harsh slab of green grass on the near hillside and the formal flowerbeds at its base. Paris, as she presents it, is made up of a set of contrasts: between old and new, far and near, male and female.

Morisot put the painting on deposit with the dealer Durand-Ruel in February 1873 and it was at once sold to Ernest Hoschedé, the spendthrift owner of a company that made women's clothing fabrics (Stuckey and Scott 1987, pp. 50, 180, note 124) – an appropriate first owner for a picture so concerned with the definition of female spaces. At one of Hoschedé's sales, in 1876, it passed to the homeopathic doctor Georges de Bellio (Lindsay 1990, p. 81).

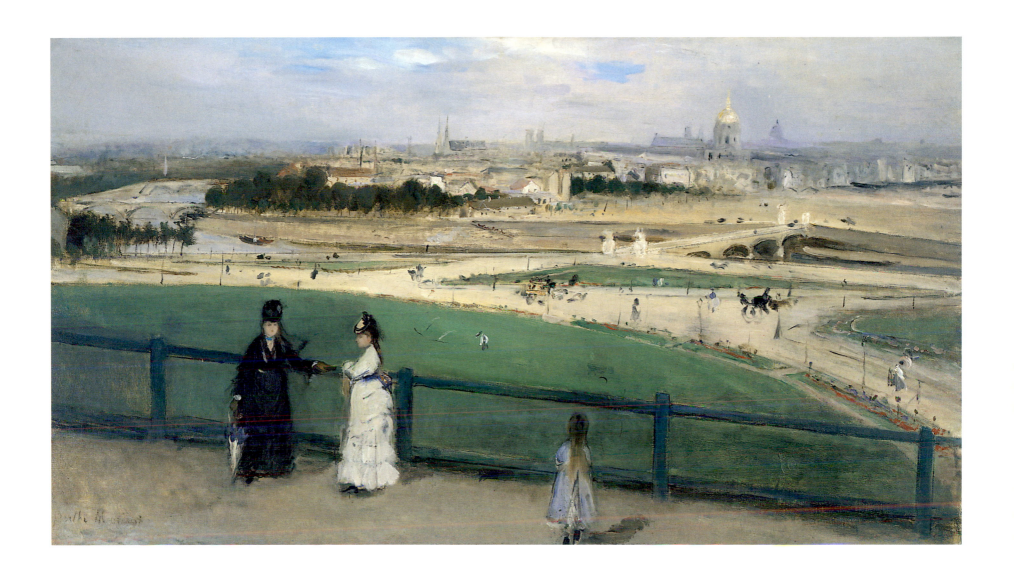

67

The Fence 1872
La Barrière
37.8 × 45.7 (14 ⅞ × 18)
Board of Trustees, National Gallery
of Art, Washington
Collection of Mr and Mrs Paul Mellon

The Fence shows a nondescript patch of countryside on the edge of a very ordinary village. But out of this humdrum material Pissarro created an image of surprising richness and complexity. Unusually, the only real perspective leading into the picture is at the extreme right, along the path.

Pissarro's image of a distant sunlit village beyond dominant foreground trees can be compared to rural scenes such as Harpignies's *The Oaks of Château-Renard* (cat. 29) or Busson's *The Village of Lavardin* (cat. 32). But in all its details Pissarro's painting challenges the carefully harmonised vision of pictures like these. The near tree is bent and awkwardly shaped; it has clearly been broken by a past storm. The fence places an emphatic barrier across the picture, denying the viewer a smooth passage into the rural landscape and reminding us that the countryside, as seen here, is decisively man-made in its forms; the many small plots testify to the complexities of land-ownership in peasant communities. And the village itself consists of a set of very plain buildings straggling up a hillside, not a picturesque ensemble around a church.

The figures stress that this is an agricultural village, with the peasant couple talking together across the foreground fence; they make an amusing contrast to Sisley's bourgeois couple in *The Seine at Bougival* (cat. 68), who also communicate across a barrier. In *The Fence*, Pissarro's viewpoint is from the path that traverses the foreground, but artist and viewer are placed at a distance from the figures, surveying the whole scene rather than becoming part of it.

The brushwork, variegated to suggest the textures of the scene, is generally solid and quite dense, complementing the earthiness of the subject. The colour is muted all across the foreground, but the pinkish hues of the woman's headdress and the foreground soil are picked up by the more vivid warm accents of the sunlit roofs, while the single blue-grey roof finds an echo in the soft blues of the peasants' clothing.

68

The Seine at Bougival *c.* 1872
La Seine à Bougival
49.5 × 63.5 (19½ × 25)
Yale University Art Gallery,
New Haven. Gift of Henry Johnson
Fisher, B. A. 1896

By the 1860s Bougival was well known for its fashionable villas along the banks of the Seine and for its places of popular entertainment – most notably the restaurant and bathing place of La Grenouillère, on an island in the Seine facing the village (see Herbert 1988, pp. 202–19). It could be described by writers as a rural idyll that had been made accessible to the urban tripper, or as a site where 'nature' had been definitively spoilt.

As presented in *The Seine at Bougival*, the river is at man's disposal. A group of houses crowds the far bank; in the foreground is a tow-path with mooring posts; a cluster of boats is moored there, and the willows have been pollarded. Indeed the river itself seems to run along as straight and artificial a track as the tow-path and the posts. The painting makes a fascinating contrast with another of Sisley's views of the Seine near Bougival, painted at about the same date (fig. 33, p. 66), in which he presented a stretch of the river as if it really were remote and rural.

The sense of informality and modernity in this picture is enhanced by the figures. The one with a cap, leaning on the barrier with his back to us, seems to be a bourgeois man on an outing; the one beyond him is very sketchily indicated, but is clearly female and wearing a summer dress. We can imagine that they have come here in the moored rowing boat, but we are given no clue of their relationship or of what exactly they are doing. The figures and setting form an interesting contrast with Français's image of a bourgeois couple, far more legibly depicted, on a nearby stretch of the Seine (see cat. 1)

The dominant effect of the painting is of diffused luminosity, created by the softly varied tones of sky, water and foreground bank; against this, the jumble of boats at the centre gives the picture a crisp darker focus. Fuller colour appears in the greens of the grassy banks and tall trees, set off by the little red accents on the man's cap and the far roofs. The picture reveals the debt of early Impressionism to what was known as *peinture claire*:

the use of soft, light tones to suggest outdoor light, pioneered by Corot (see cat. 25).

Sisley's brushwork here is extremely varied and flexible. Some passages are very broadly and simply brushed in, but these are set off against the lively mobile touch that defines the principal features of the scene.

It seems likely that *The Seine at Bougival* was one of the paintings that Durand-Ruel bought from Sisley in 1872–3.

69

Near Paris 1873
Environs de Paris
116.4 × 89 (45⅞ × 35)
Musée Fabre, Montpellier

Guillaumin, a close friend of Pissarro and Dr Gachet (see cat. 72), found most of his subjects in the immediate surroundings of Paris, where he lived, especially its industrial landscapes. Here, though, we see open countryside, with a village across the background hill; the site has not been identified.

In a sense Guillaumin's wide view down from a hill can be compared with panoramas such as Chintreuil's *Space* (fig. 20). But the subject is presented in ways that work against the conventions of the panorama. The foreground is filled by the rough track and verge but there is no spatial link between this and the distance; the view beyond is open at the sides of the picture, with no features to frame the vista. There is a small, dark vertical accent, near the centre of the village, where in traditional views of villages we would expect to find a church spire; but its form is so imprecise that we cannot tell whether it is a spire or a tree. The foreground poplar – the only element to break into the huge area of sky that fills the top half of the canvas – is also awkward and shapeless, as unpicturesque as the scrubby road below it. The figure of a male worker, picking we know not what from the stunted hedge, reinforces the downbeat mood.

The picture's vertical format also works against the idea of the panorama, emphasising instead the upward movement of the curving road and the dramatic vertical of the tree. The format, combined with the scale of the picture – unusually large for the Impressionists' open-air subjects at this date – gives this humdrum scene a surprising monumentality.

The brushwork is varied and confident, rather more literal in its recording of forms and textures than in Pissarro's contemporary work (see cat. 71), but gradated so as to suggest the deep space in the picture. In the foreground the colours are essentially local, in greens, browns and beiges; but the little accents of soft orange-red on the far roofs glow against the muted blues in the far distance and sky.

70

The Sheltered Path 1873

Chemin creux

54.5 × 65.5 (21½ × 25¾)

Philadelphia Museum of Art
Given by Mr and Mrs Hughes
Norment in honour of William
H. Donner

In this canvas Monet chose an extremely ordinary subject – presumably a scene from around Argenteuil – without notable features or intriguing vistas. The whole lower half of the picture is taken up with the path and the scrubby grass and bushes beside it; the trees above are no more distinctive, and stand in such an even row that they seem purposely planted, perhaps alongside a road that we cannot see. But nothing else allows us to define the scene; the male figure gives a sense of scale but is so summarily treated that we have no idea what sort of person he is. The whole scene is a deliberate rejection of the idea of the significant motif.

The interest lies in the painting's brushwork and colour. The touch is delicate and flexible throughout, with flecks, dabs and dashes of colour animating the surface and creating a sense of shimmering light and heat. In earlier canvases (see cat. 65) Monet had used the brush to differentiate between the elements in a scene;

it was only in the summer of 1873 that he adopted a more uniform touch, using the brush as much to evoke the play of light as to suggest the distinctive forms of objects. The colour is rich and diverse; local colours are modified by the sunlight falling across the foreground and by the blues of aerial perspective in the distance. Yet neither touch nor colour is illusionistic, and both create complex rhymes and rhythms across the surface. The bush at front right, with its deep shadow, provides a comparatively conventional repoussoir, while the figure on the path, combined with the clear blues in the far trees, produces a strong sense of recession through the centre of the painting.

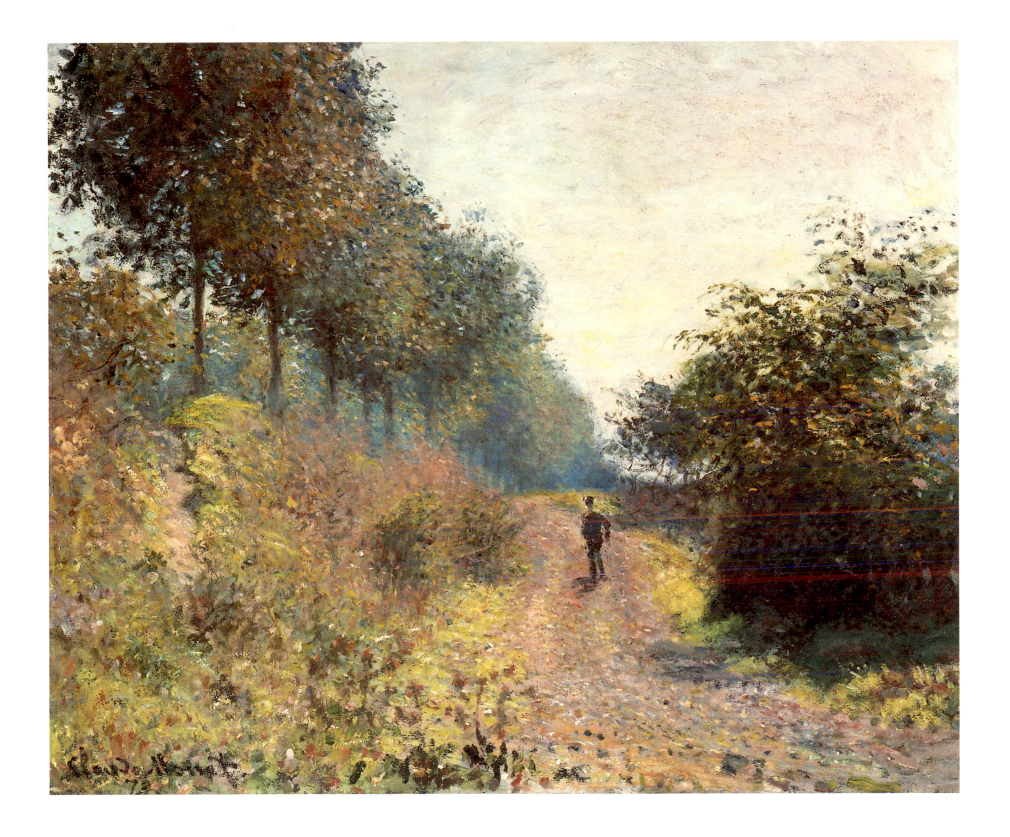

71

Factory near Pontoise 1873
Usine près de Pontoise
45.7 × 54.6 (18 × 21½)
Museum of Fine Arts,
Springfield, Massachusetts
The James Philip Gray Collection

In 1873, and again in 1876, Pissarro painted sequences of canvases showing factories by the River Oise at Pontoise. Of these, *Factory at Pontoise* presents the industrial buildings most starkly and frontally within their surroundings. The factory represented was absolutely new when Pissarro painted it, built for Chalon et Cie for the distillation of sugar beet into industrial and commercial alcohol (Brettell 1990, pp. 23–5).
These factories, and especially the one seen here, transformed the riverbanks; the image of the Oise as rural refuge, popularised by Daubigny (see cat. 11), was destroyed for ever on this stretch of the river. Indeed, paintings such as this one can be read as deliberately transgressive, challenging that idyllic vision.

In a way the factory here is presented as a motif in the traditional sense, as a monumental structure that is the unequivocal focus of the composition. The industrial landscape frequently appeared in topographical engravings such as those in the Joanne guides (see fig. 16). However, the blatant modernity of a scene such as this marked a rejection of the conventional notions of what constituted an appropriate subject for fine art. In fact the roofs, gables and chimneys of the Chalon factory, as shown here, can be seen as a travesty of the characteristic forms of churches and castles, traditional choices for such motifs.

Despite its immediacy, Pissarro manipulated his subject with some care. According to Richard Brettell, the two tiny vertical buildings on the left – themselves modern in type – did not actually exist at this site (Brettell 1990, pp. 82–3); they serve to emphasise both the scale of the factory and the newness of the whole scene. The poplars behind the buildings do not appear in Pissarro's other view of the scene (Brettell 1990, p. 83), but we do not know whether they were there in reality. Their rough silhouettes contrast with the crisp lines of the chimneys, but chimneys and poplars together create a single sequence of verticals across the composition. The dark smoke stands out from the lighter clouds, yet the puff of white steam below blends in with the sky beyond and leaves the thin chimneys behind it seemingly suspended in mid air.

From a twentieth-century standpoint it is easy to read the picture in environmentalist, ecological terms, as an attack on the spoiling of the countryside. But in terms of debates about modernity in art in the 1860s and 1870s (see p. 23), Pissarro's choice of subject can be seen as a positive manifesto for a truly contemporary form of landscape painting.

The brushwork is flexible and fluent, broader and less heavy than in *The Fence* (cat. 67), notating forms and textures with economy and finesse. The picture marks Pissarro's mastery of the painterly shorthand so characteristic of the Impressionism of the early 1870s, before he began to adopt a denser, more structured touch in 1874 (see cat. 75).

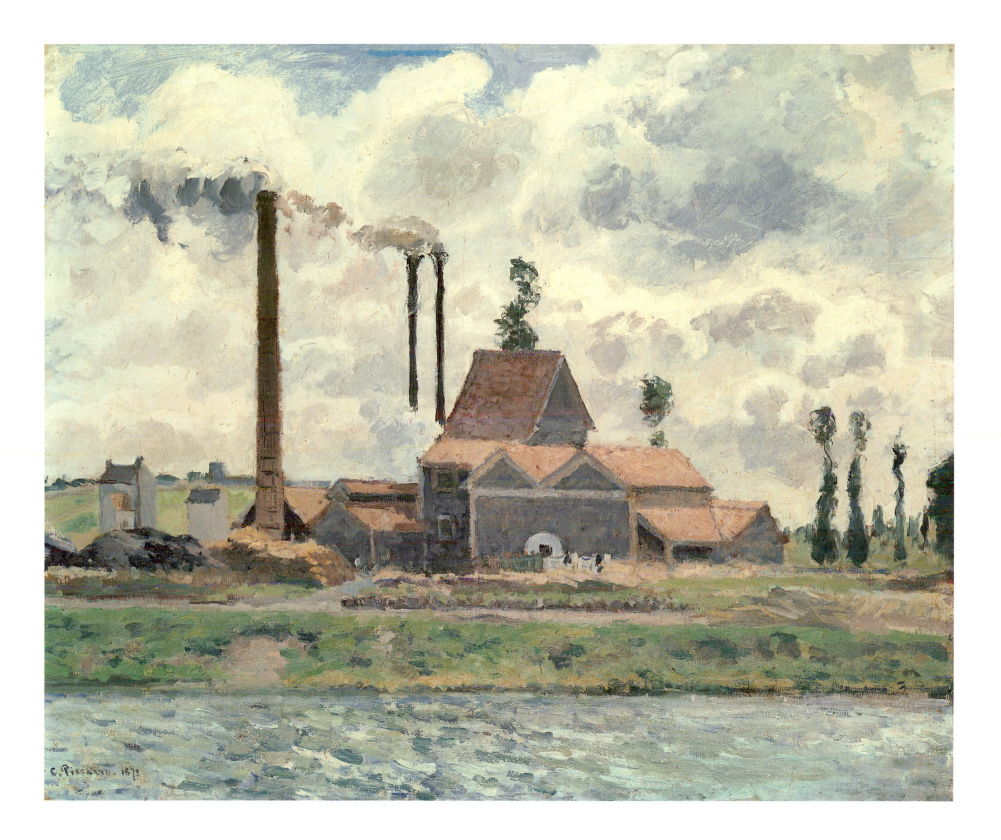

72

**The House of Doctor Gachet
at Auvers** *c.* **1873**

*La Maison du Docteur Gachet,
à Auvers*

61.6 × 51.1 (24¼ × 20⅛)

Yale University Art Gallery,
New Haven. Collection of Mary C.
and James W. Fosburgh, B. A. 1933,
M. A. 1935

In 1873 Cézanne was based in Auvers-sur-Oise, four miles east of Pontoise, where Pissarro lived. He had spent some time in Pontoise in 1872 and during these years he was in close contact with Pissarro; the two men sometimes painted side by side. Cézanne's decision to move to Auvers was probably partly due to the presence there of Pissarro's friend Paul Gachet, a doctor and amateur artist, whose tall house is a focal point in the background of Cézanne's canvas. Auvers had a distinctive church (later painted by Van Gogh) but as depicted here it appears a typical Ile de France village.

Although Cézanne had been painting landscapes out of doors with close attention to the play of natural colour since the mid 1860s, his contact with Pissarro led him to refine his observation and to adopt a finer, more nuanced facture. Yet comparison of *The House of Doctor Gachet at Auvers* with Pissarro's contemporary work (cat. 71) reveals the differences between the fluency and flexibility of Pissarro's brushwork and Cézanne's heavier, more awkward touch. In 1874 Pissarro

adopted a denser, more elaborate paint surface (see cat. 75), which probably reflected the impact of Cézanne.

The House of Doctor Gachet at Auvers is not finished in a conventional sense; there are marked differences in the degree of working across the canvas. The foliage of the trees on the left, in particular, is laid on quite broadly and flatly without reworking, giving little idea of the form or texture of the trees. Gachet's house, however, is much more precisely notated, and the leaves of the foreground tree are a bold play of coloured dabs. The colour is quite muted where the painting is least worked, but elsewhere Cézanne introduced delicate nuances to help model the forms. The reds of the chimneys are strong warm-hued accents, while the slate-blue of the roof to its right is picked up in the soft grey-blues in the shadows and tree trunk.

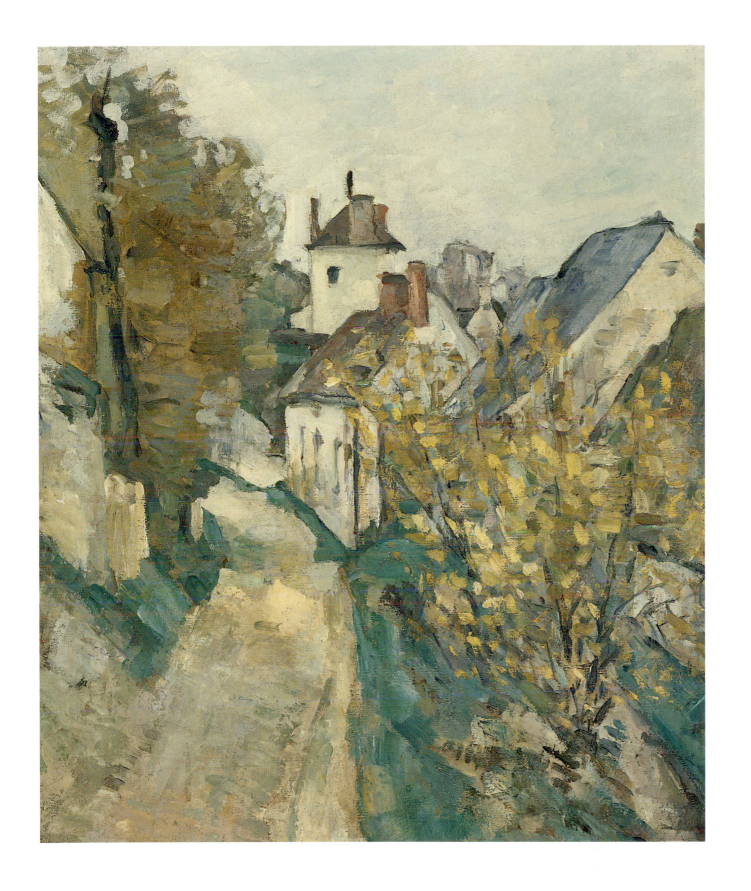

73

Landscape, Auvers *c.* 1874
Paysage à Auvers
46.3 × 55.2 (18¼ × 21¾)
Philadelphia Museum of Art
The Samuel S. White III and
Vera White Collection

In contrast to the quite straightforward perspective in *The House of Doctor Gachet at Auvers* (cat. 72), *Landscape, Auvers* presents the houses of the village in a strangely compressed space, between the hillside, the trees and the wall that bars our entry into the foreground. We catch scarcely a glimpse of the ground, and the elements in the picture are tautly stacked one behind the other; the space is indicated only by the way in which the forms overlap each other.

The composition, with its raised viewpoint and multiple focal points, has been appropriately compared to Pissarro's *The Climbing Path, L'Hermitage, Pontoise* of 1875 (cat. 81); yet the complexity of Pissarro's composition derives from its spatial organisation and alternative paths of recession, while in *Landscape, Auvers* Cézanne builds the composition out of rhyming shapes and contrasts of tone and colour (see Rishel 1983, p. 4). The orange-red roofs and smaller

warm accents enhance the rich greens, and the darker roofs and areas of foliage heighten the effect of the sunlit walls. The walls themselves are ordered into sequences of planes whose shape and tone echo each other in their simple verticals and diagonals. Comparable rhymes recur in the colour: the deep green door in the foreground wall is very close in hue to much of the surrounding foliage. Yet this formal structure does not give the picture a straightforward focal point; the slab of the wall across the base and the sharp hot accent of the shed roof in the lower left corner create a surprisingly sharp emphasis, quite detached from the houses in the centre.

Parts of the picture are elaborately and densely worked, but the trees on the left and the far hillside are only lightly indicated. At top right, light touches have been added late in the picture's execution to suggest the sky, though without obliterating the roughly sketched hillside that originally

reached to the top of the canvas.

It has tentatively been suggested that this may have been the canvas that Cézanne exhibited with the title *Study: Landscape at Auvers* in the first group exhibition in 1874 (San Francisco 1986, p. 126). However, its uneven degree of finish makes this unlikely; the exhibited picture may well have been *The House of Père Lacroix* (National Gallery of Art, Washington), which is dated 1873 and more consistently worked throughout. *Landscape, Auvers* has been dated to about 1873, but the subtlety and elaboration of the touch in its most finished parts may imply a slightly later date.

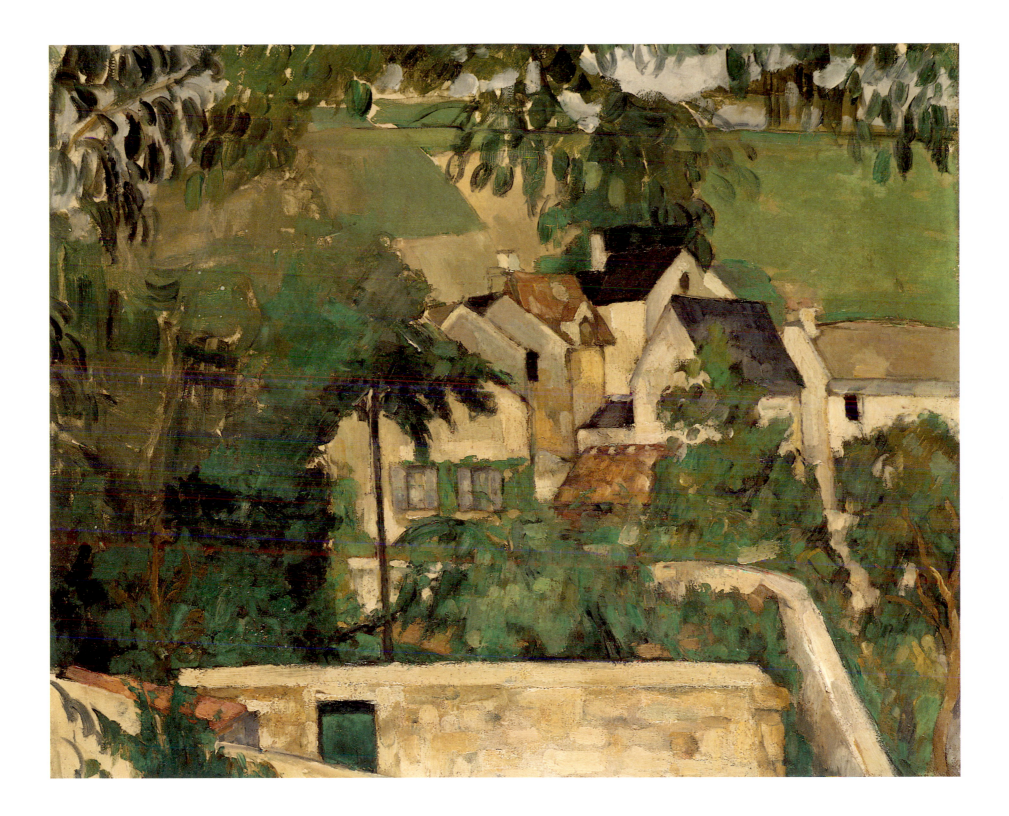

74

Environs of Paris *c.* **1874**
Environs de Paris
61 × 100.3 (24 × 39½)
Birmingham Museums and
Art Gallery

Unlike *Near Paris* (cat. 69), the processes of modernisation are evident throughout this panorama of a landscape near Paris: in the newly laid road with its regular lines of recently planted trees; in the red-roofed suburban villa in the centre; and in the little band of smoke in the left distance, so indistinct that we cannot tell whether it comes from a train or a factory. The exact site has not been identified but the tiny yet prominent accent on the far-left horizon may well be the gilded dome of the Invalides (see cat. 66); if this is so, the view must be from one of the hills to the south or south-west of the city.

Again unlike *Near Paris*, the panorama here is framed by hills in a quite conventional way (see Chintreuil, fig. 20), but the insistent regularity and harsh contours of the road and the mundane buildings in the landscape counteract the sense of wonder generally associated with the panoramic view. The touch is broad and economical, suggesting varied textures but also creating wider sweeps of colour; some of these were applied with the palette knife, which may reflect Guillaumin's close association with Pissarro and Cézanne in these years.

Throughout the picture warm hues set up contrasts with the greens of the landscape: the little roofs that crisply punctuate the landscape, the beginnings of autumnal colouring on some of the trees, and the play of the afternoon sunlight on the road. Even in the foreground, though, there are soft blues in the shadows, which pick up the atmospheric blues in the far distance and the sky.

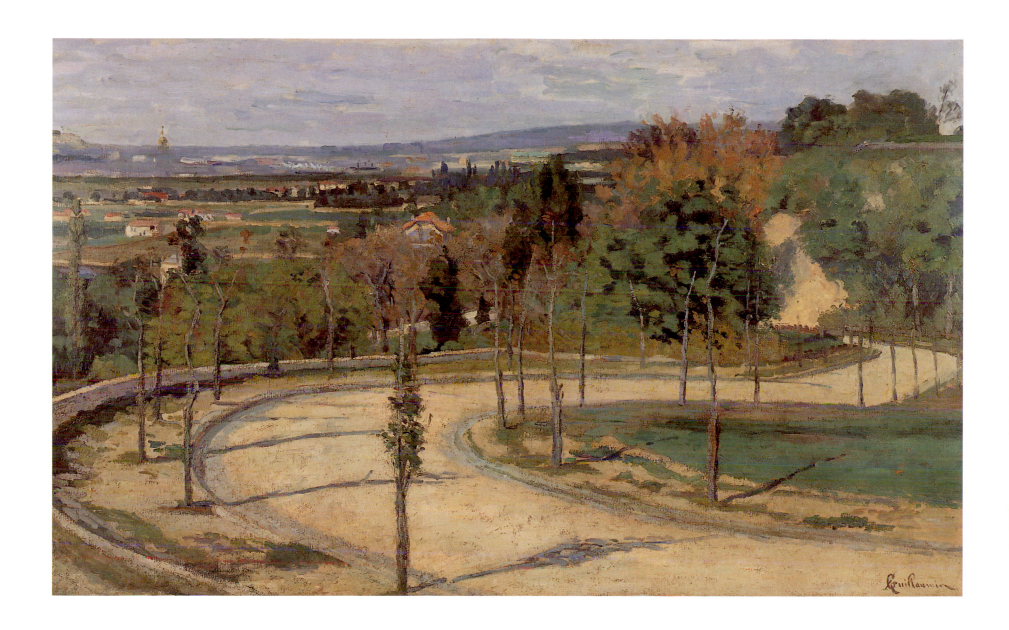

75

**Landscape in Sunlight,
Pontoise 1874**

Paysage, plein soleil, Pontoise
52.3 × 81.5 (20⅝ × 32⅛)
Museum of Fine Arts, Boston
Juliana Cheney Edwards Collection

Landscape in Sunlight, Pontoise marks a turning point in Pissarro's career in two ways: in its subject matter and in its technique. Here he has abandoned the explicitly contemporary themes that had dominated his work during the past year, in favour of images focusing on the life of the local peasantry; and the handling is denser and more structured than in his recent work.

In December 1873 Pissarro's friend Théodore Duret wrote to offer him advice: 'I continue to think that rural, rustic nature with animals is what best suits your talent ... Do not think of Monet or Sisley, but follow your own path of rustic nature.' (Pissarro and Venturi 1939, I, p. 26.) Although Pissarro initially responded by noting the difficulty of finding models for peasant subjects (Bailly-Herzberg 1980, p. 88), his paintings of 1874 show that he had heeded this advice: he focused on the agricultural life on the north-eastern edge of Pontoise. This change has been associated with his moving house in Pontoise, but it clearly reflected a basic change in his artistic policy and in the type of landscapes he painted. *Landscape in Sunlight, Pontoise* presents a drastically different view of the Pontoise riverside from

Factory near Pontoise (cat. 71): the landscape is now enclosed, domesticated and unmodernised.

Although Duret's argument was that Pissarro should follow his own talent and temperament, there were clearly commercial interests to consider, too. By the early 1870s, peasant painters such as Millet and Jules Breton were finding real success, and Pissarro's new subjects, often with echoes of Millet, seem to have been an attempt to capitalise on this vogue (his attempt to produce a more saleable type of picture coincided with the financial problems that led the dealer Durand-Ruel to withdraw his support from Pissarro early in 1874). However, in pictures like this one Pissarro made no concessions to the sentimentalised, ingratiating view of the peasantry that had made Jules Breton so popular.

The changes in Pissarro's technique in 1874 can be interpreted in two ways. His move towards a denser, more ordered paint handling has clear affinities with Cézanne, whose work Pissarro was studying in these years (see cats. 73, 81); the foliage on the right here may be compared with the foreground tree in cat. 72. However, he may also have evolved this new technique in order to

complement his new subject matter. In 1872 he had treated a peasant theme such as *The Fence* (cat. 67) in a solid earthy way, but the handling in *Landscape in Sunlight, Pontoise* is more assertively structured. His touch remains varied, according to the textures represented, but it is consistently denser and broader than in *Factory near Pontoise*; he did not use the palette knife (see cat. 81). The picture's sense of structure derives from the brushwork and from its composition, decisively framed by the strong axes of the rather simplified tree trunks on the right.

Creamy tones and strong varied greens dominate the picture, but animation is added by the soft blue accents, including muted blue shadows on the tree trunks and the even smaller warm touches in the buildings and on the figures.

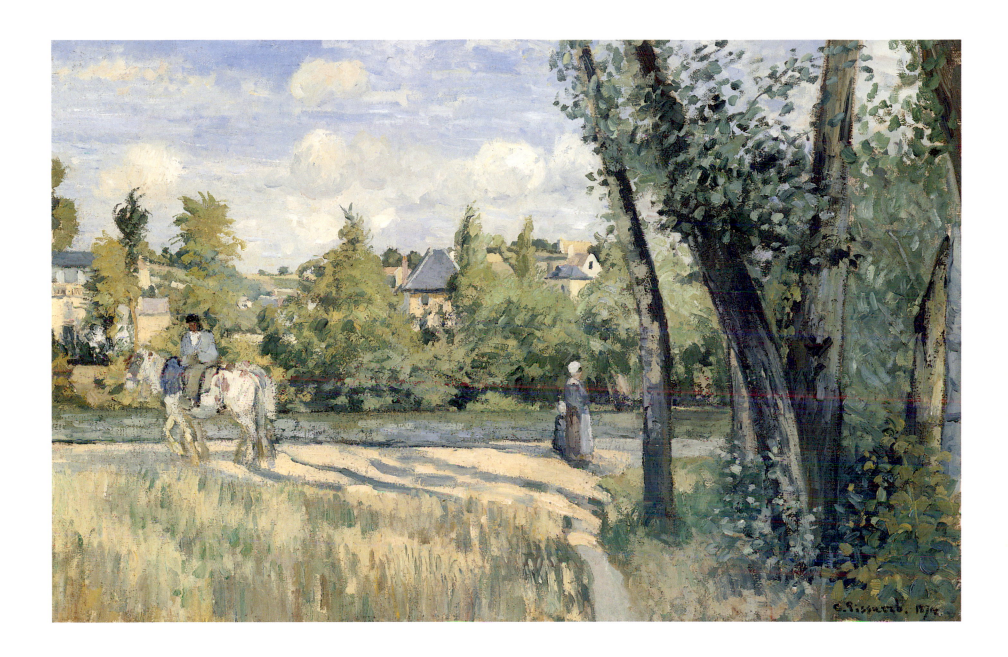

76

The Seine at Argenteuil 1874
La Seine à Argenteuil
50.2 × 65.4 (19¾ × 25¾)
Portland Art Museum,
Portland, Oregon
Bequest of Winslow B. Ayer
Exhibited in London only

The paintings that Renoir and Monet executed while working together at Argenteuil in the summer of 1874 are seen as the quintessential images of Impressionism, evoking carefree outdoor pleasures and recreation.

The viewpoint of *The Seine at Argenteuil* is from the south bank of the Seine, looking across the river towards Argenteuil itself, which lies beyond the trees that line the river bank. At the far right is the bridge that carried the road from Argenteuil to Paris. The area from which boats were rented was just beyond the right margin of the picture.

The Seine at Argenteuil is very similar to a painting by Monet (fig. 52); the two differ only in the placing of the figures, ducks and background boats, and were presumably painted at the same time, with the two men working side by side. The placing of the elements in Monet's picture creates a more spare, open composition; in Renoir's painting the elements fill the canvas and give a stronger sense of the

bustle of the river life. The two men and their boat by the gangplank are the focus of the picture, but they are only one part of the busy scene.

By academic standards the forms are treated in a very summary way (compare cat. 29), but the many features in the scene are differentiated with great delicacy. There is no clear perspective: smaller sails lead the eye across the space, but the diagonal of the gangplank is blocked by the principal boat, whose sunlit white sails form a huge flat shape. The space is conveyed by the changing weight of the touches of colour across the water surface and by the soft atmospheric blues in the far trees.

Fig. 52
Claude Monet
Oarsmen at Argenteuil, 1874
59 × 79 (23¼ × 31⅛)
Private Collection

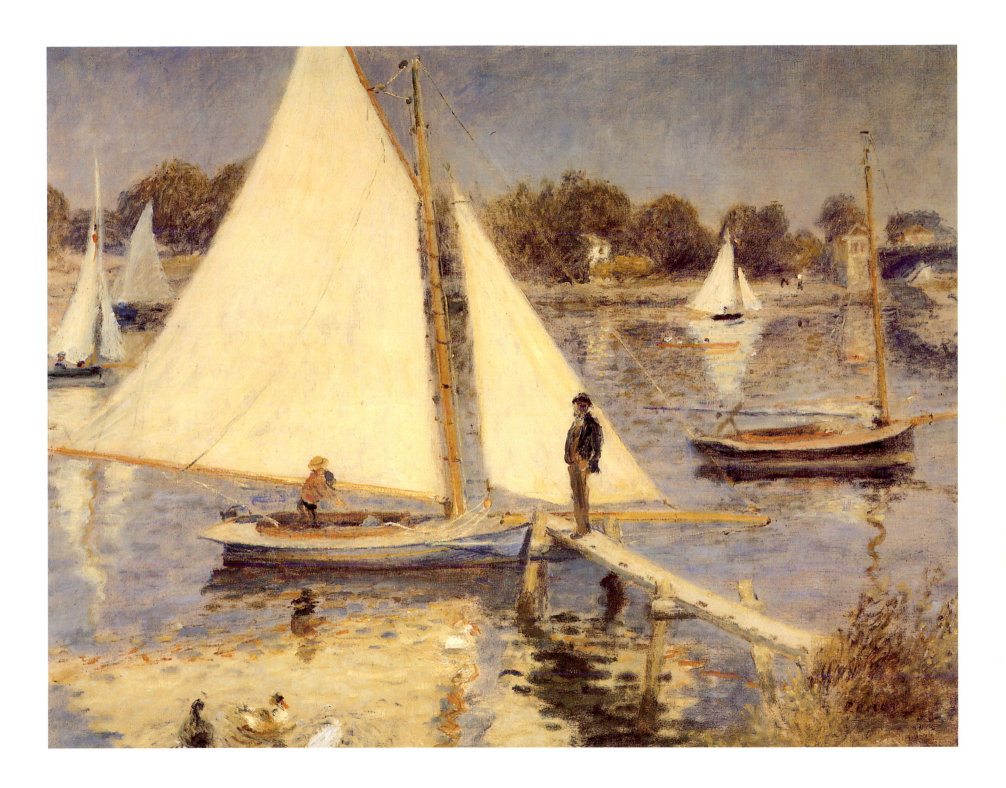

77

Snowy Landscape *c.* 1874–5
Paysage de neige
51 × 66 (20⅛ × 26)
Musée de l'Orangerie, Paris
Collection of Jean Walter and
Paul Guillaume
Exhibited in Boston only

In the early to mid 1870s Renoir painted some of the most informal and unpicturesque of all Impressionist landscapes. Here we look across a scruffy field or garden plot, past a tumbledown row of shapeless trees to the backs of a row of undistinguished houses. The site has not been identified but it may well be Argenteuil, where Monet painted many comparable snow scenes around 1874–5; one of these, *Hoar-Frost* (Private Collection; see Wildenstein 1974, no. 363) seems to show the same view as Renoir's picture.

Renoir was well known for his antipathy to the snow effects that fascinated the other Impressionists (see cats. 78, 79, 92). Late in his life he told the dealer Vollard why he had painted so few snow scenes: 'Even if one can stand the cold, why should one paint the snow, that leprosy of nature?' (Vollard 1938, p. 166.) Yet he was well aware that the play of light on snow offered great opportunities to the colourist. In 1910 he told a young artist: 'White does not exist in nature. You admit that you have a sky

above that snow. Your sky is blue. That blue must show up in the snow. In the morning there is green and yellow in the sky. These colours must also show up in the snow when you say that you painted your picture in the morning. Had you done it in the evening, red and yellow would have to appear in the snow.' The shadows, too, he said, should be full of reflected colour (Rewald 1973, p. 210; see London 1985–6, p. 207). Presumably Renoir was able to enjoy the colour effects in *Snowy Landscape* from the shelter of an upstairs window.

The vivid blue accents in the shadows on the snow and buildings and the varied muted colours in the darker areas of the trees and bushes are played off against the warmth of the sunlight, presumably an afternoon light, and some surprisingly rich orange-reds are added on the left tree trunks. Yet the scene is not structured by colour alone: the darker parts of the trees and the scatter of dark touches across the foreground – some of them hard to read in representational terms –

create points of tonal emphasis across the entire picture.

Even so, neither the forms of the landscape nor the organisation of tone and colour create what in conventional terms would have been regarded as a coherent composition; the eye is drawn hither and thither across the scene. Likewise the brushwork is very varied and establishes no overall rhythm; at times it is quite broad and heavy but elsewhere it is fluent and calligraphic. The ebullient range of coloured touches transforms this deliberately awkward, incoherent subject into one of the freshest and most informal of Impressionist landscapes.

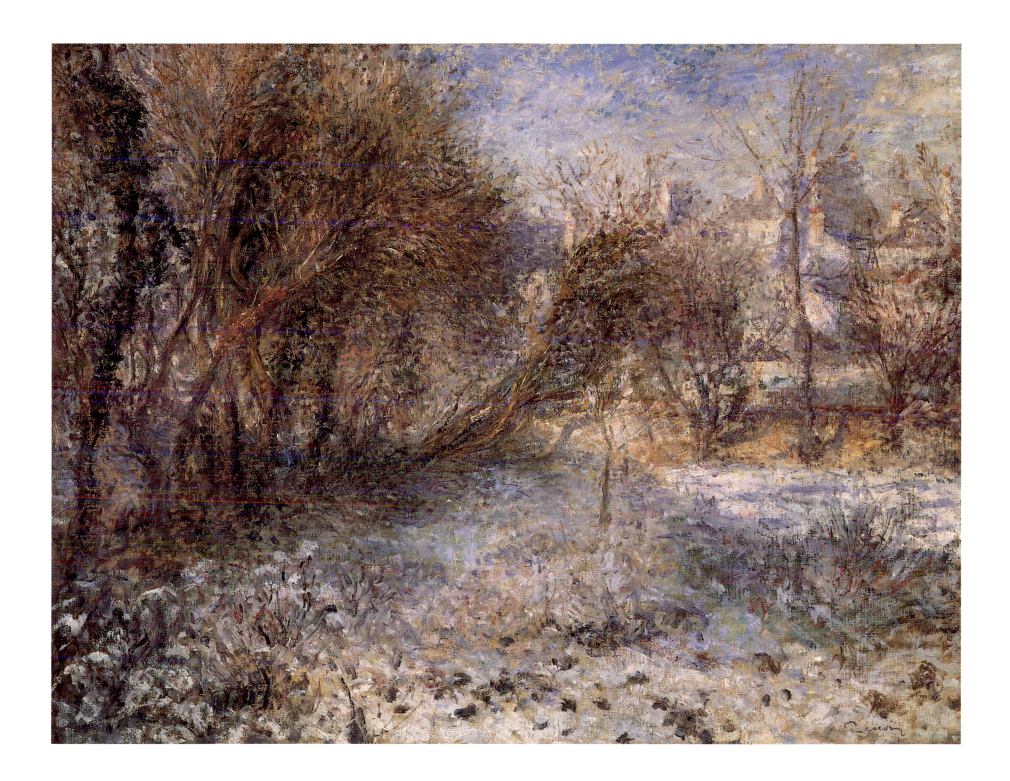

78

**The Boulevard Saint-Denis,
Argenteuil, in Winter 1875**
*Boulevard Saint-Denis,
Argenteuil, en hiver*
60.9 × 81.5 (24 × 32⅛)
Museum of Fine Arts, Boston
Gift of Richard Saltonstall

Argenteuil was originally an agricultural town and in the 1870s it was still a centre for the production of low-grade wine, but it was being transformed by industrialisation and by the suburban development that resulted from the proximity of Paris and the popularity of Argenteuil itself as a centre for recreational boating. Monet's paintings of the area ranged from open country scenes to overtly contemporary landscapes (see Tucker 1982; see also cat. 65).

In *The Boulevard Saint-Denis, Argenteuil, in Winter* we look south down the boulevard; on the right there is a prominent bourgeois villa, while the railway ran parallel with the road on the left. The view Monet presents is built up of fragments, with the hut on the scrubby slope on the left, the houses scattered across the background, and the foreground dominated by tall fencing. The figures, too, are isolated from each other.

The leaden sky, the snow on the ground and the sprinkling of snowflakes across the scene bring all these elements together. The pinks and oranges around the sun are picked up in the muted tones in the buildings, figures and foliage, and are set against the atmospheric blues that are threaded through the picture. The brushwork is a richly varied shorthand, ranging from the long raking strokes on the foreground fence to the tiny white flecks that suggest the falling snow in the distance.

The subject of falling snow and the crisp silhouettes of the figures and fencing are reminiscent of the effects in Japanese colour prints. Monet was a great enthusiast for Japanese prints and his own collection included a number that portrayed figures in falling snow; though he probably acquired these after 1875, they show effects very comparable to those in *The Boulevard Saint-Denis, Argenteuil, in Winter* (see Hiroshige's *Ochanomizu*, in Aitken and Delafond 1983, no. 132).

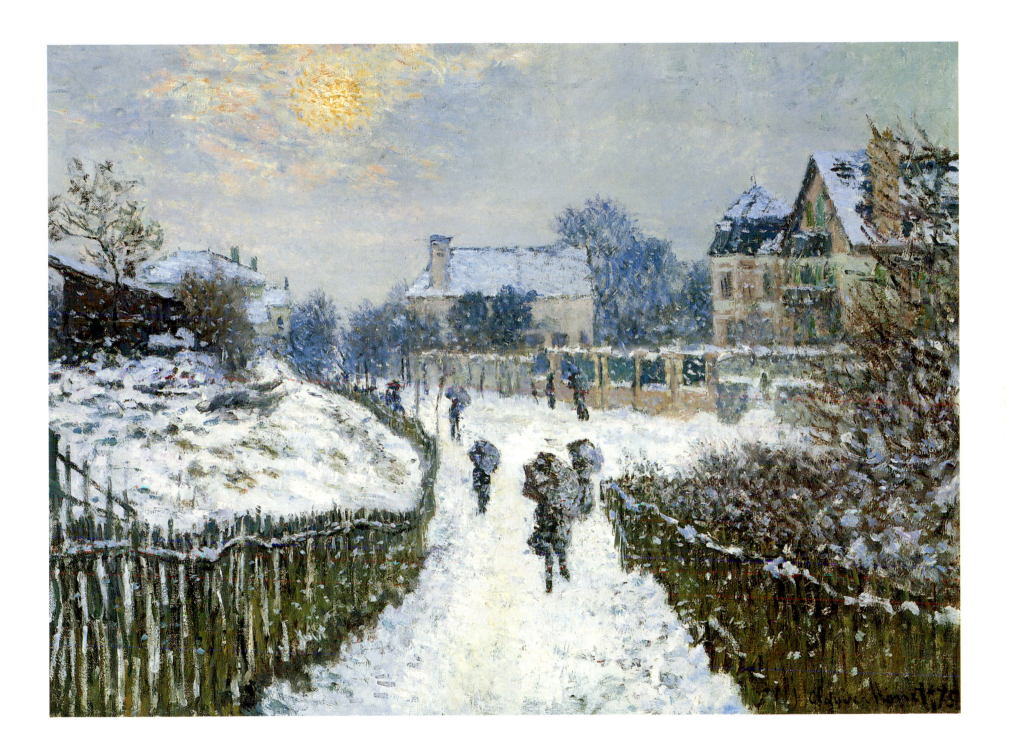

79

**The Watering Place at
Marly in Winter 1875**

L'Abreuvoir de Marly, en hiver
49.5 × 65.4 (19½ × 25¾)
The Trustees of the National
Gallery, London

In contrast to the elaboration of Monet's Argenteuil snow scene (cat. 78), *The Watering Place at Marly in Winter* presents a seemingly ordinary scene with great simplicity and breadth. Yet the subject Sisley chose was far from trivial: the watering place at Marly was all that remained of one of Louis XIV's most lavish palaces, the Château de Marly, destroyed in the Revolution; water flowed through the wall that we see on the right of the picture from the palace park above to the humble villagers below. In Sisley's paintings of the place this monumental piece of symbolic architecture, a motif in the traditional sense, is in no way distinguished from its modest surroundings.

In many paintings (see cat. 58) the site's historical associations would have been known to few, if any, of the viewers. But the memories and remains of *ancien-régime* architecture in the area around Louveciennes and Marly, about ten miles west of Paris, were constantly evoked by travel writers throughout this period. Indeed, the lack of major sights in these landscapes meant that writers had little to describe apart from past glories. Louis Barron described this area in 1889: 'Marly – and you will be tempted to go and seek amid the riotous foliage, in the confused paths of the park, the almost untraceable remnants of the splendid

palace … Of these much vaunted splendours … scarcely anything remains except the site, a few rotting gates, and the melancholy watering place where Coustou's [sculpted] horses used to rear.' (Barron 1889, pp. 312–13.)

It is not clear what part such associations played in Sisley's choice of subject. He did not need to travel to find the subject, since he lived very close by. Nevertheless, his interest in themes with monarchic associations coincided with the years when the fledgling Third Republic was flirting with the possibility of a restoration of the monarchy. Viewed from one standpoint paintings such as these are pure examples of the Impressionist technique, focusing on the immediate visual effect of the scene and excluding the fruits of memory or prior knowledge. However, the artists' insistence on seeing everything as equivalent, in terms of visual *sensations*, was in the 1860s and 1870s a subversion of the values and hierarchies by which social theorists and philosophers sought to make sense of the world around them. Applied to so loaded a subject, this technique was not neutral: such a painting was an attack on the traditional notion of the landscape motif, and also in some sense on the values for which this particular motif stood.

Most of the canvas was probably completed at a single sitting, with just a few touches added when the paint was dry, such as the violet above the water spout at lower right (see Bomford 1990, p. 151). The light creamy-beige priming, now probably somewhat darkened, plays a major part throughout the picture; it supplies the underlying warm tone in the sky and elsewhere, and is picked up by the orangey wall and the warm focus low in the sky at the end of the road. Against this, much of the painting is in soft blues, evoking the play of light across the cold snow. The palette, unlike Monet's in the same years, is very restricted, consisting of only five colours plus black and white. These were used pure or in simple mixtures (Bomford 1990, pp. 150–1).

The painting was exhibited in the second Impressionist group exhibition in 1876 and is an example of their willingness to include in these shows particularly sketchy and, in conventional terms, unfinished canvases.

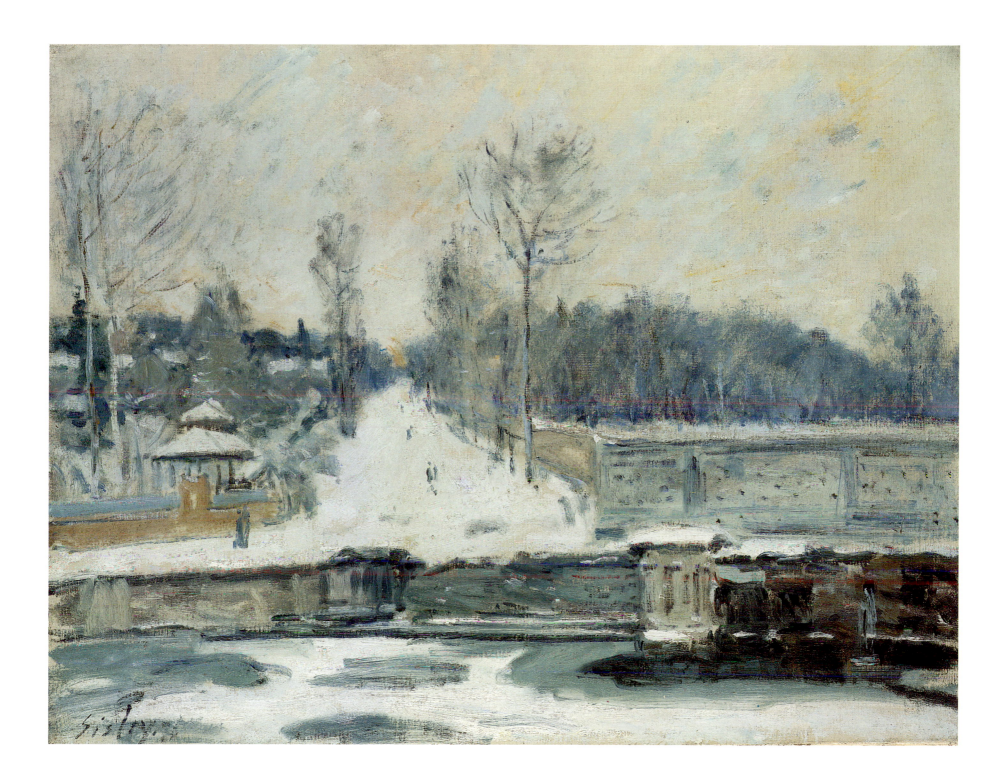

80

**Laundresses Hanging out
the Wash 1875**

Un Percher de blanchisseuse
33 × 40.6 (13 × 16)
Board of Trustees, National Gallery
of Art, Washington
Collection of Mr and Mrs Paul Mellon

In March 1875 Morisot, Monet, Renoir and Sisley mounted the auction of their paintings that aroused such hostile criticism (see p. 26). Morisot painted *Laundresses Hanging out the Wash*, one of the sketchiest and most informal of Impressionist canvases, early that summer and showed it in the second group exhibition the following spring. By taking this course, she was insisting that she should be seen as a central and fully committed member of the group, not merely a woman artist and an amateur.

Laundresses Hanging out the Wash was painted while Morisot was staying at Gennevilliers, about six miles north-west of Paris on the wide plain across the river from Argenteuil. The Gennevilliers plain was then the subject of much controversy; it had been the site of an experimental project to fertilise agricultural land with human sewage from Paris, and in 1874–5 there were further plans to expand the area irrigated in this way. Supporters of the project vaunted the gains in agricultural productivity; opponents claimed that in summer the place was transformed into a stinking open sewer (Tucker 1982, pp. 151–2).

In this context, the image of laundresses hanging up washing has real poignancy. Although the location was not specified when the picture was exhibited in 1876, many viewers would have recognised the site; even those who did not would have sensed the anomaly between the clean washing and the line of smoking factory chimneys along the horizon (see also Clark 1984/1985, pp. 161–3). The quantity of washing suggests that this is the drying area of a commercial laundry, not a domestic garden.

The composition of the picture is unusual. We seem to be looking on from an upstairs window, and our entry to the scene is barred by the fence right across the foreground; the paths of recession created by the washing lines are then blocked by the blank sweeps of colour of the open field beyond. The execution is extremely summary and sketch-like throughout; the forms are indicated in the most abbreviated, even casual way. And yet the whole picture gains a remarkable coherence from the links between colours and tones: the pinks and muted blues, the whites and near blacks, interspersed among the greens.

From one point of view, this coherence can be seen as an insistence that aesthetic values overrode the social connotations of the scene; but, in the artistic debates of the period, the supporters of an aesthetic of modernity maintained that the subject kept its meanings even when transformed into fine art by the artist's sensibility (see pp. 23–4).

In 1876 several critics praised Morisot's powers as a colourist whilst censuring the extreme abbreviation and sketchiness of her technique; one wonders whether any of the male members of the group would have been treated with such leniency. Albert Wolff's verdict was that 'her feminine grace lives amid the excesses of a frenzied mind' (San Francisco 1986, p. 182).

The homeopathic doctor Georges de Bellio bought the painting in 1876 – in the same year that he acquired Morisot's *View of Paris from the Heights of the Trocadéro* (cat. 66; Lindsay 1990, p. 83).

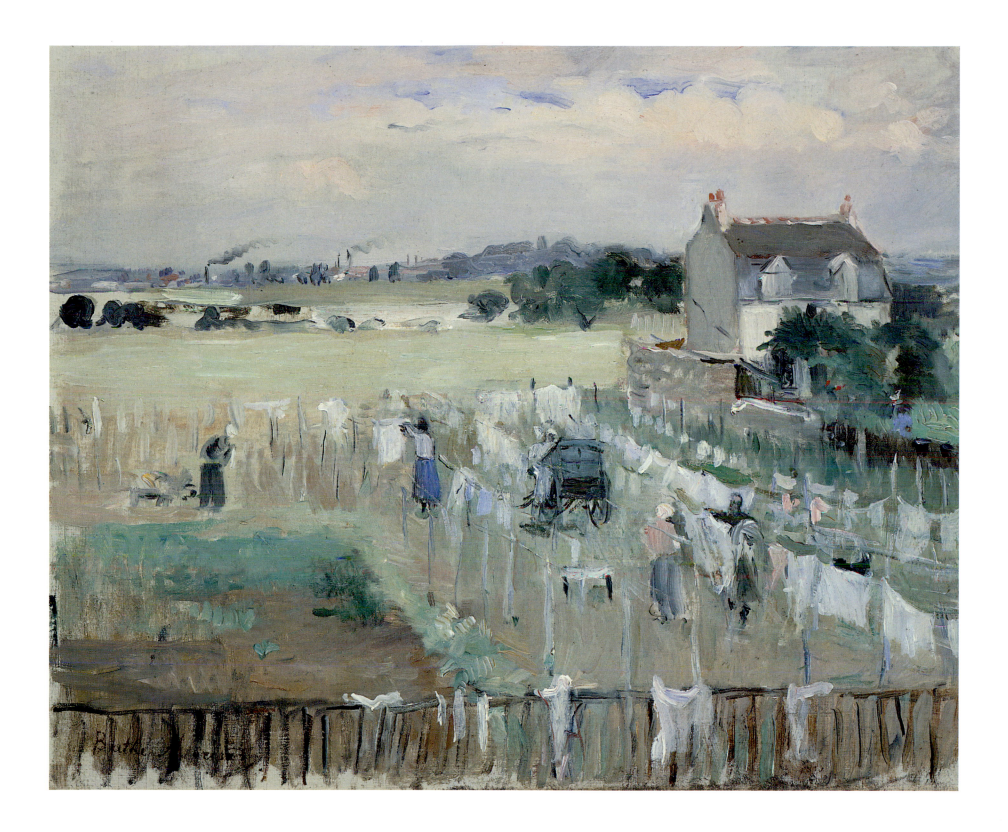

81

**The Climbing Path,
L'Hermitage, Pontoise 1875**
*Le Chemin montant,
L'Hermitage, Pontoise*
53.7 × 65.4 (21⅛ × 25¾)
The Brooklyn Museum
Gift of Dikran K. Kelekian

In its composition *The Climbing Path, L'Hermitage, Pontoise* is one of the most striking and unconventional of all Impressionist landscapes. Unlike most of Pissarro's paintings of the mid 1870s it does not include any figures; instead, by his choice of viewpoint, he made his subject the contrast between the climbing path and the view out over the valley, transforming it into a remarkable composition.

L'Hermitage was a valley to the north-east of Pontoise, near the house to which Pissarro moved in autumn 1873; it was in this quarter that he found most of the agricultural and peasant themes on which he focused at Pontoise from 1874 onwards. In many of his pictures of L'Hermitage we look up at the hillside, which rises behind the houses (see fig. 53); here we are half-way up the hill, perched above the nearby houses. With their white walls and tile or slate roofs these are recent buildings, not old cottages; they stand out from the landscape with a deliberate awkwardness that stresses the disjunction between the natural setting and human intervention.

The picture has three distinct directions of spatial recession: down to the left, up into the left distance, and up the path on the right. Yet Pissarro managed to integrate these contrasting axes into a coherent whole. In part this is achieved by the use of the screen of trees, which provide an accent in the centre of the picture and hold in its left margin, as a balance to the path on the right. But colour also plays a critical role. The sequences of creams, soft blues and pinks on the path are echoed in the walls and roofs of the houses on the left; on both sides these colours are flanked by areas of green, often intense in hue. At the same time the darker tonal accents of the shadows in the foliage and on the buildings also lead the eye step by step up both sides of the picture. So colour and tone together create a coherent alternative to the order and balance that the picture's spatial arrangement so decisively rejects.

The paint handling is very diverse. Much of it is applied with the palette knife but the knife strokes are mainly quite small-scale, used with great flexibility to suggest different textures. At the time, the palette knife was seen as the implement that most completely marked the painter's rejection of conventional notions of drawing and modelling (see pp. 23–4), but Pissarro used it here to show that complex effects of form and space could be achieved by the most anti-academic means.

Though the palette knife often created effects that (to twentieth-century eyes at least) look very flat and two-dimensional, this was clearly not Pissarro's purpose in using it as he did here. Rather, it gave his paint surfaces a solid, emphatically material quality, developed from his use of the brush in his paintings of 1874 (see cat. 75). This materiality helps to give unity to the picture but also functions as a visual equivalent to the subjects Pissarro chose, with their humble forms and rough textures.

Fig. 53
Camille Pissarro
The Côte des Boeufs at l'Hermitage, 1877
115 × 87.5 (45¼ × 34½)
The Trustees of the National Gallery, London

82

**The Terrace at Saint-Germain:
Spring 1875**

*La Terrasse de Saint-Germain:
printemps*
73.6 × 99.6 (29 × 39¼)
The Walters Art Gallery, Baltimore

The Terrace at Saint-Germain: Spring is one of the largest and most ambitious of all Impressionist landscapes of the mid 1870s. It shows the view looking north from above Port-Marly towards Saint-Germain-en-Laye, with the château of Saint-Germain-en-Laye seen on the hilltop to the left, and the terrace extending far beyond it along the escarpment above the Seine.

In the scale and breadth of the view the picture clearly belongs to the tradition of the panorama, in contrast to the narrower, more enclosed views that the Impressionists usually favoured. In one sense, the scene can be interpreted as a motif in the most traditional manner, with the wide vista overlooked by the celebrated castle, mostly built under François I in the mid-sixteenth century, and by the huge terrace constructed by Le Nôtre for Louis XIV in the 1670s. Yet nothing special is made of the site's historical associations. The castle buildings are not indicated with any precision and the terrace is reduced to a line along the hilltop. Contemporary viewers would of course have recognised the site, but as shown here it is relegated to an atmospheric backdrop for the lively everyday scene in the foreground. The orchard and little vineyard are busy with tiny figures; a single substantial house looks out over the trees; and, across the watermeadows, steam-barges ply up and down the river.

As with *The Watering Place at Marly in Winter* (cat. 79), we are not certain whether to view this painting simply as an exercise in Impressionist technique – in terms of visual *sensations* translated into touches of colour – or whether there was more at stake in Sisley's decision to treat this famous royalist site so casually, at the very moment when the restoration of the monarchy was a live issue.

The handling is of the greatest delicacy and flexibility, differentiating between forms and textures with subtle variations of touch and colour. Soft greens and blues dominate, punctuated by smaller light-toned and warm accents, which articulate the space and the composition. The whole complex scene is evoked with great fluency and informality.

The painting was probably exhibited as *The Terrace at Marly* in the third Impressionist group show in 1877; Durand-Ruel bought it from Sisley in 1880.

83

The Pumping Station at Marly
c. 1875

La Machine de Marly
46.5 × 61.8 (18¼ × 24⅜)
Museum of Fine Arts, Boston
Gift of Miss Olive Simes

The original pumping station at Marly was built in Louis XIV's reign to pump water up from the Seine, along the Marly Aqueduct (see cat. 64) and over the hills to his new palace at Versailles. However, it fell into ruin during the eighteenth century and the system seen in Sisley's painting was constructed under Napoleon III in the 1850s. Thus Sisley's subject had associations with both the *ancien régime* and Napoleon's Empire, as well as being a remarkable technological achievement.

The painting has usually been described as a flood scene and dated to 1876 but its simple, thinly brushed paint surfaces make a date of around 1875 more likely (contrast cat. 85). There is no sign that the river is in flood; the water level here is identical to that seen in Sisley's celebrated 1873 view of the pumping station with the buildings viewed head-on (Ny Carlsberg Glyptotek, Copenhagen; see London 1992–3, pp. 122–3).

The sharp structured accents are in the wings of the picture. The busy forms on the left are condensed; the end of the station is seen beyond the gangway across the water, with its staccato posts; while on the right the dark mooring posts stand out with great clarity. The centre is filled by the bank of autumn trees but these are carefully anchored to the rest of the picture by the sequence of little posts that mark the position of a weir and by the few elongated horizontal strokes that lead the eye across the broken touches of the water surface. The scene is enlivened by a few unobtrusive figures – two fishermen at the sides and three tiny figures alongside the weir.

The overall tonality is blond, with sharp tonal accents providing a foil to the soft pastel hues that dominate the scene in the diffused grey light. The flat pink walls of the station are played off against the seemingly natural colours of the trees and grass to its right. These rigorously co-ordinated elements show how carefully Sisley organised even the most informal scene.

84

The Seine at Champrosay 1876

La Seine à Champrosay
55 × 66 (21⅝ × 26)
Musée d'Orsay, Paris

Renoir visited Champrosay in September 1876 and stayed with the novelist Alphonse Daudet, whom he had met through his patrons, the publisher Georges Charpentier and his wife Marguérite. It was probably during this stay that he painted the very delicate, almost fussy, portrait of Madame Daudet (fig. 54). *The Seine at Champrosay*, a radiant outdoor sketch, is startlingly different in its effect, and a vivid illustration of Renoir's willingness to vary his manner of painting according to the project in hand.

Champrosay was a small village on the edges of the Forêt de Senart some fifteen miles south of Paris, and a favoured weekend retreat for fashionable Parisians. However, apart from its title, there is little in Renoir's picture to evoke a particular site.

The canvas is painted with great immediacy and brio, and is dominated by rich blues and greens, but in many ways its composition and structure are more traditional than his *Snowy Landscape* (cat. 77). Here, the eye readily follows the wide curve of the river, and the narrow band of luminous yellows along the far bank anchors the composition in the background. Just above the yellow band, in the centre of the picture, is a distinct creamy touch with a tiny pink accent within it; in naturalistic terms this is illegible – does it represent a villa? – but it plays a key role in linking the background to the warm hues that appear in the foreground reeds. The brushwork throughout is freely descriptive, with the crisp strokes of the foreground reeds set against the fluid softer brushing of the river and the breeze-tossed clouds.

When the picture was shown in the third group exhibition in 1877 Renoir's friend Georges Rivière, arch proselytiser for the Impressionists, praised it as a 'superb landscape, one of the most beautiful ever done. No one before has so strikingly given the feeling of a windy autumn day.' The critic Jacques, though, could not accept the technique: '[Its] touch is quite brutal despite its impression of truthfulness. It is the tall grass of the bank that ruins the river for me.' (Both quoted in San Francisco 1986, p. 238.)

The painting was bought by Gustave Caillebotte and entered the national collections in 1897 as part of his bequest.

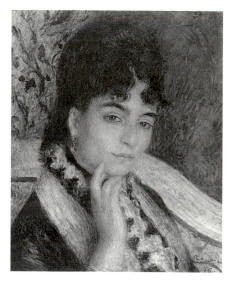

Fig. 54
Pierre-Auguste Renoir
Madame Alphonse Daudet, 1876
46 × 38 (18⅛ × 15)
Musée d'Orsay, Paris

85

View of Marly-le-Roi from Coeur-Volant 1876

Marly-le-Roi vu de Coeur-Volant
65.4 × 92.4 (25¾ × 36⅜)
The Metropolitan Museum of Art, New York. Bequest of Miss Adelaide Milton de Groot (1876–1967), 1967

View of Marly-le-Roi from Coeur-Volant is a stark presentation of the changes that were transforming the landscape around Paris. As in so many scenes shown at the Salon in these years, we see in the distance a village crowned by a church spire (see cats. 25, 29), but our viewpoint here is from the garden of a modern villa, whose elaborate chalet-like façade dominates the picture. The irregular jumble of buildings in the old village is reduced to a mere backdrop to this domesticated landscape of leisure, with its orderly pattern of lawns and flowerbeds. In the foreground a small child plays with a toy wheelbarrow: a delightful parody of the rural labourers who recur so frequently in the foregrounds of the more conventional landscapes of the period (see cats. 25, 27).

Coeur-Volant was a cluster of houses just to the west of the Marly aqueduct (see cat. 64), between Louveciennes and Marly-le-Roi (where Sisley lived); it was at the top of the hillside and to the left of the road seen in *The Watering Place at Marly in Winter* (cat. 79). The villa belonged to Robert Le Lubez, an amateur singer and patron of the composers Saint-Saëns and Gounod.

View of Marly-le-Roi from Coeur-Volant shows a marked change in Sisley's technique. In contrast to the delicacy of *The Terrace at Saint-Germain: Spring* (cat. 82), the touch is now busier and more assertive, while the palette is brighter and includes sharper contrasts. Even the grass and the foreground path are treated with brisk, distinct accents. The colour is dominated by the contrast between the hot hues of the autumnal foliage and the clear blues that run throughout the scene, including the wide area of shadow across the foreground.

These changes in Sisley's technique can be compared with the more emphatic touch adopted by Monet in the mid 1870s (see cat. 78), but they also bring his work closer to that of Pissarro, who was seeking to give greater coherence and animation to his paint handling at that time (see cat. 86).

86

The Plain of Epluches (Rainbow)
1876–7
La Plaine des Epluches (Arc-en-ciel)
53 × 81 (20⅞ × 31⅞)
Kröller-Müller Museum, Otterlo

The Plain of Epluches (Rainbow) is an intriguing combination of different landscape traditions. The panoramic view and the elemental emblem of the rainbow can best be compared to the work of Chintreuil, and especially to his *Rain and Sun* shown at the 1873 Salon (Musée d'Orsay, Paris; see cat. 24 and fig. 20). However, Pissarro's landscape is a humble scene of rolling fields punctuated with small buildings and, in the centre, a small factory, a contemporary note quite foreign to Chintreuil's art. Though the factory here is less prominent than in some of Pissarro's paintings of 1873 (see cat. 71), it still acts in counterpoise to the agricultural landscape around it. Epluches is just across the River Oise from Pontoise, but it was not well known, and the title of the painting, when it was included in the third Impressionist group exhibition in 1877, gave no further indication of its whereabouts.

The dominant colours in the landscape are greens and reds; although the colour is largely muted, individual strokes of more intense hue heighten the liveliness of the effect and sharpen the contrasts that run throughout. The darker forms of the shadowed bushes and trees create steps into space, while the white walls of the buildings provide vital accents across the central band. The subdued bluish tints that recur in many parts of the picture give it an overall atmospheric harmony.

The brushwork marks a significant change from Pissarro's palette-knife work of 1875 (see cat. 81). The knife has now been abandoned and the brushstrokes are smaller and more even in weight than in Pissarro's previous work. They are not systematically organised, but the similarly sized small touches across the foreground enliven the effect and give some sense of a coherent rhythm. The paint layers in the background are more homogeneous, but still include richly varied nuances of colour.

Léon de Lora's harsh criticism of Pissarro's paintings at the 1877 exhibition reveals a significant problem that they raised for their viewers: 'Seen up close, they are incomprehensible and hideous; seen from a distance, they are hideous and incomprehensible. They are like a rebus that does not add up to any word.' (San Francisco 1986, p. 232.) Critics had previously said that the Impressionists' sketch-like technique required the viewer to stand back from the picture; however, the surface elaboration of Pissarro's new handling of paint invited closer scrutiny, yet proved incoherent – by conventional standards – from both near and far.

The fact that this autumnal effect is dated '1877' and was included in the Impressionist group exhibition of April 1877 may indicate that Pissarro completed it in his studio during the winter, after beginning it out of doors in autumn 1876. The painting was lent to the 1877 exhibition by Ernest Hoschedé; it was bought by Durand-Ruel for the very low sum of eighty francs at the auction sale in 1878 that followed Hoschedé's financial collapse (Bodelsen 1968, p. 340).

87

Boats on the Seine *c.* 1877

Bateaux sur la Seine

37.2 × 44.3 (14⅝ × 17½)

Courtauld Institute Galleries, London
(Courtauld Bequest)

This canvas is smaller and more sketchily treated than most Impressionist paintings of the 1870s, but the fact that it is signed shows that Sisley regarded it as complete. Throughout the decade the landscapists of the group painted rapid sketches such as this alongside more elaborate canvases (see also cats. 79, 90); the sketches were particularly appreciated by fellow artists and the most 'artistic' of collectors, whereas their more highly worked pictures were more likely to find buyers through dealers.

The subject, dominated by the unloading of wood from a river barge, with a passing passenger-ferry on the river, is explicitly contemporary, presenting the Seine at Billancourt (across the river from Sèvres on the south-western outskirts of Paris) not as a rural retreat but as a commercial and recreational waterway. In theme and composition it is comparable to Loir's *The Quai Nationale, at Puteaux* (cat. 35, exhibited at the Salon in 1878),

which shows the commercial life of the Seine downstream from Billancourt; but Sisley's lively touch and bright colour, combined with the different weather effect and small scale of his picture, create a wholly different mood. Sisley's canvas has an air of almost festive relaxation in contrast to the sombreness of Loir's.

By 1877 Sisley's brushwork had become more broken and energetic (see also cat. 85); the whole scene is animated by hooks, dashes and streaks of colour that evoke with great vigour the effect of a sunny, breezy day. Figures can be distinguished on the near bank, but they are treated just as sketchily as the other elements. However, for all the picture's apparent speed of execution, the light and weather on a day like this must have changed far too quickly for Sisley to capture them at once; he must have relied on memory and synthesis to achieve so fresh an effect.

The light-toned canvas priming, seen in many places, enhances the

luminosity, but the true highlights of the picture are the vigorous white accents in the clouds and on the barges and far houses. Even the darkest tones in the scene – in the barges and on the bank – are coloured, built up of very deep blues and reds, and the distance is suggested by gradations of blue set against the green foliage and the sharp red accents of the faraway roofs. These warm accents, picked up in the floating logs and on the near bank, act as an important contrast to the dominant blues and greens of the picture, and sharpen the overall colour effect.

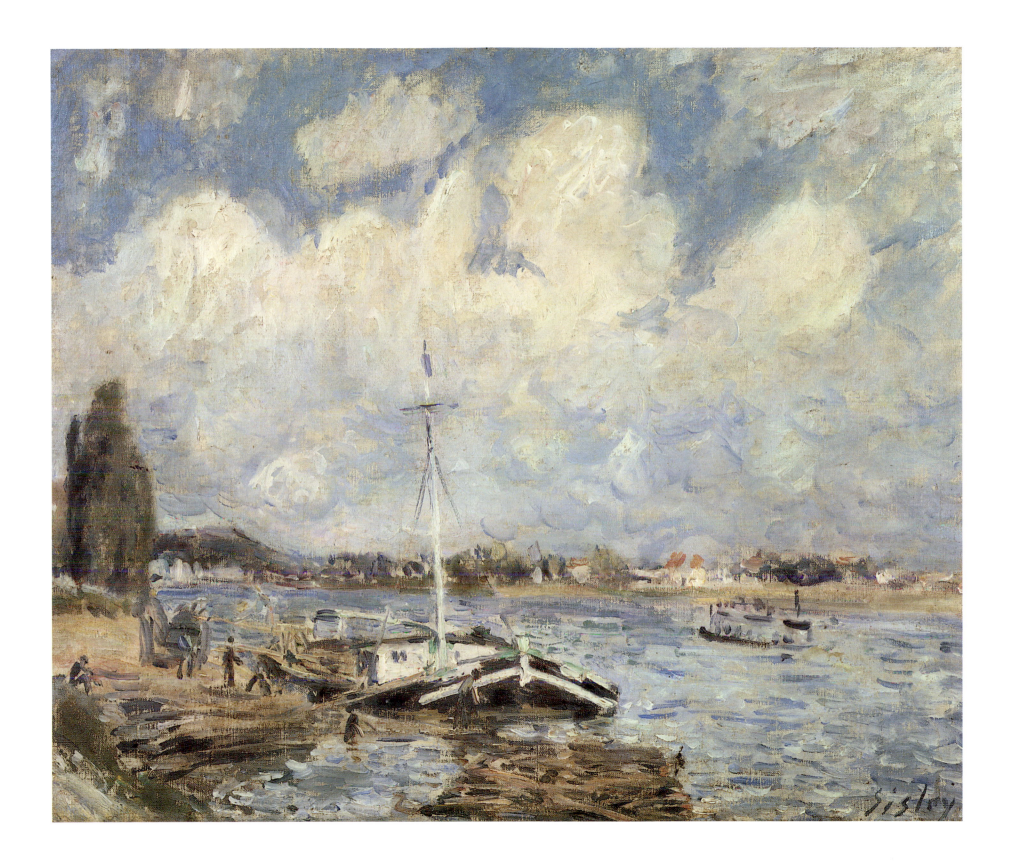

88

**The Chaîne de l'Etoile with
the Pilon du Roi** *c.* **1878**

*La Chaîne de l'Etoile avec
le Pilon du Roi*

49.2 × 59 (19⅜ × 23¼)

Glasgow Museums: Art Gallery &
Museum, Kelvingrove

Throughout the 1870s Cézanne alternated between the north of France, often working alongside Pissarro (see cat. 72), and the south, where he spent much time in his parents' home at Aix-en-Provence and painted regularly at L'Estaque, on the Mediterranean coast just outside Marseille (see cat. 102).

The Chaîne de l'Etoile with the Pilon du Roi shows the view looking southwards from a vantage point near Aix to the range of mountains that lie to the south of Gardanne, with the prominent knob-like peak of the Pilon du Roi that dominates the escarpment. Guigou's *The Hills of Allauch* (cat. 2) shows a comparable scene on the other side of the Chaîne de l'Etoile, with the range of mountains acting as a grandiose backdrop to the sweep of terrain in the foreground. But Guigou's composition leads the eye in measured steps across the plain into the distance, whereas Cézanne arranged his in virtually parallel bands, one in front of the other; the eye can move up the picture from one to another but the viewer cannot imagine entering the scene and exploring its spaces.

It was in the south of France that Cézanne pursued his boldest experiments in the use of colour to suggest form and space. In 1876 he had

written to Pissarro of his experience while painting the bay of Marseille: 'The sunlight here is so intense that it seems to me that objects are silhouetted not only in black and white, but also in blue, red, brown and violet. I may be mistaken, but this seems to me to be the opposite of modelling.' (Cézanne 1978, p. 152.) These observations were realised in *The Chaîne de l'Etoile with the Pilon du Roi* in the rich oranges of the buildings and fields, set against the strong greens and clear accents of blue shadow. Cézanne also introduced more subtle colour variations and tiny coloured flecks, which enliven and enrich many parts of the canvas.

The brushwork reflects Cézanne's exploration in the later 1870s of ways of combining colour and form. Across the most highly worked band of the picture – the houses, trees and nearer hills – the brushstrokes are comparatively regular, often unobtrusively aligned in parallel sequences, which mark the beginnings of the so-called 'constructive stroke' that would dominate his work in the early 1880s (see cats. 96, 102, 103). Over the far mountains, though, the paint is laid on far more thinly and flatly, and a quickly drawn, darker blue outline along much of the ridge separates the hills from the sky.

Like most of Cézanne's paintings, this one is not finished. He seems to have abandoned it with the foreground and sky particularly lightly worked, and it was probably Cézanne who slashed the canvas in the sky area above the right houses, where the repairs to a long vertical tear can be seen clearly. The Glasgow dealer Alexander Reid remembered: 'When we bought it from Vollard, [the sky] had been slashed by the artist, a thing Cézanne was wont to do if something did not come out as he wanted it to do. It was eventually most skilfully restored by Helmut Ruhemann.' (Quoted in Isetan 1994, p. 204.) We cannot tell how far the sky was reworked at the time when these repairs were made, but the central band of the landscape is an exceptional example of Cézanne's experiments at a critical point in his career.

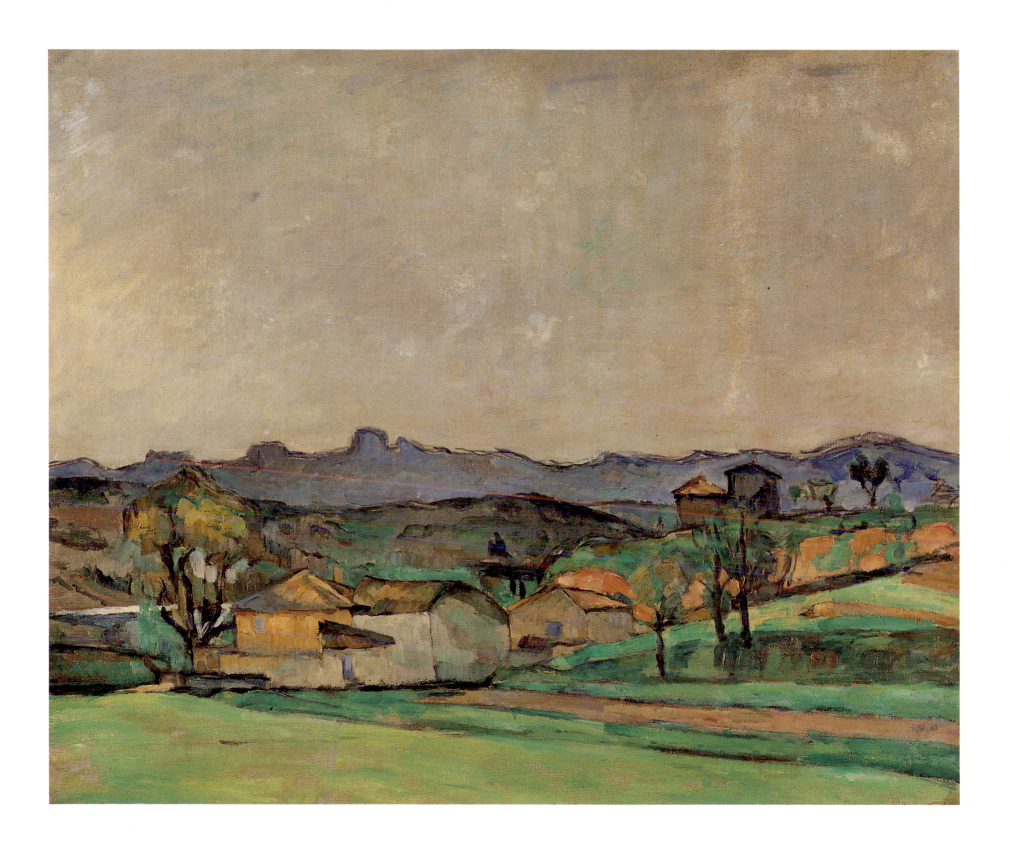

89

The Rue Mosnier with Flags 1878

La Rue Mosnier pavoisée

65.5 × 81 (25¾ × 31⅞)

Collection of the J. Paul Getty
Museum, Malibu, California

The scene depicted here is the view from Manet's studio in the Rue de Saint-Pétersbourg, looking on to the newly built Rue Mosnier (renamed Rue de Berne in 1884), in the Batignolles quarter of north-western Paris. Manet painted the view three times, first in the spring, when the street was still being paved, and then twice including the parade of *tricolor* flags that celebrated the *fête nationale* of 30 June 1878.

At first sight it looks like a typical Impressionist street scene, with a vivid sketch-like technique rapidly notating the comings and goings in a sunlit city street; indeed, the luminous sunlight and soft clear blue shadows make this, in technical terms, one of Manet's closest approaches to Impressionism.

However, the picture's subject and technique are in fact more complex than they at first appear. The *fête nationale* of 1878, coinciding with that year's Exposition Universelle, occurred at a political crossroads, after the authoritarian President MacMahon had lost his full authority but before the elections of 1879 had established a confidently republican government. The *fête* itself was a curiously ambivalent celebration, designed to appease both monarchists and republicans (see Roos 1988).

In addition to this, the Rue Mosnier already had a complicated social life. Some idea of the nuances of this part

of the new Paris can be gained from the description of the street in Zola's *Nana*, written shortly after Manet painted the scene: 'a new, silent street ... without a single shop, whose fine houses, with tiny narrow apartments, are inhabited by *dames*' (New York 1983, p. 396).

Monet's views of Paris during the *fête* (Musée d'Orsay, Paris; Musée des Beaux-Arts, Rouen) focus on the flags and crowds in the old streets of the city centre, and present a seemingly unproblematic image of celebration. By contrast, Manet's flags hang over a virtually empty street, and the celebratory associations are set against the figure of the one-legged man on crutches – a pointed reminder of the recent conflicts that the *fête* sought to obliterate from public memory (see Roos 1988, pp. 391–4).

The other figures in the picture hint at the social scenario that Zola spelt out: several lightly sketched figures of single women and a single man on the right pavement, and a small carriage with (perhaps) a servant boy. At bottom left, by contrast, we see a ladder and the cap of a – presumably – able-bodied worker, which makes a startling contrast to the crutches alongside it. With his insistence on seemingly documentary detail, Zola identified the character of the street and its inhabitants, but Manet was far more allusive and inexplicit.

The ambivalence of the subject is complemented by the technique. Despite the generally luminous atmosphere the image is punctuated by the darker tones of the coaches and figures, and framed on the left by the rectangle of the advertising hoarding, which seems to counteract the perspective of the rest of the picture. Likewise, the highlights are scattered across the canvas – from the building materials at far left and the skirts and flag on the right to the small but illegible sunlit accent at the far end of the street. The brushwork, too, complicates our perception of the picture; the various elements float in and out of focus.

In his later work Manet turned decisively away from the pseudo-scientific 'naturalism' propagated by writers such as Zola. Using the studied imprecision of the Impressionists' sketch-like technique he found a way of conveying the sense of ambivalence and uncertainty that many commentators felt to be the most distinctive characteristic of modernity in the city.

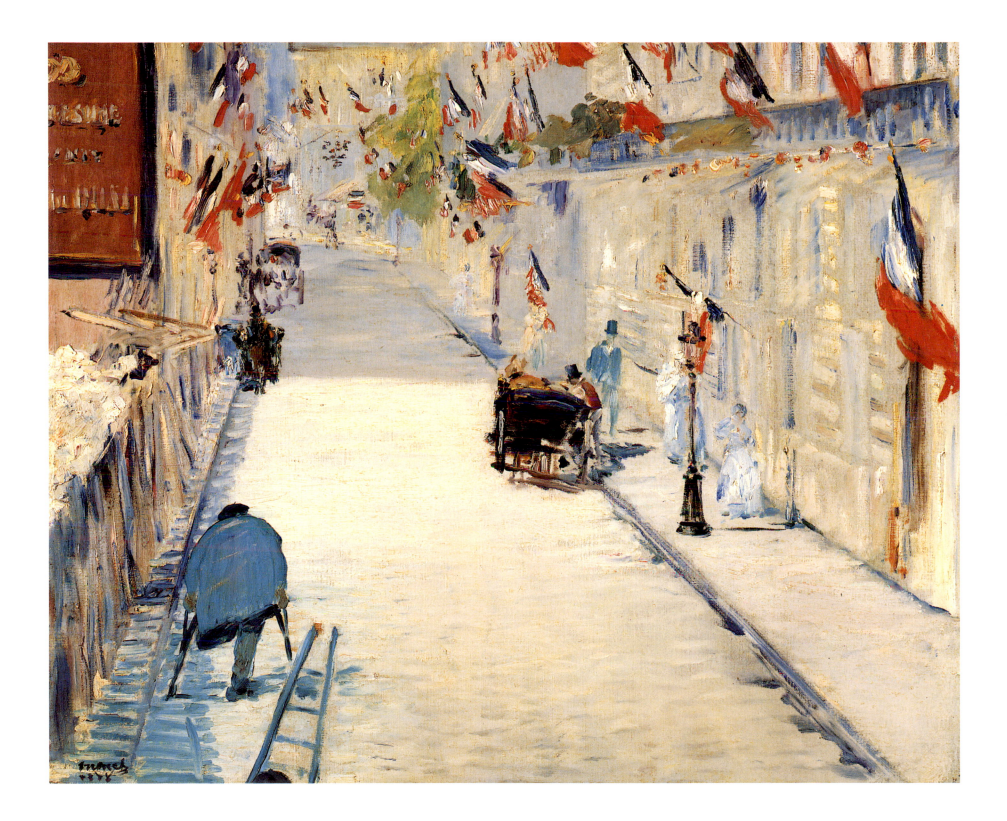

90

Spring on the Ile de la Grande-Jatte
1878
Printemps à l'Ile de la Grande-Jatte
50 × 61 (19⅝ × 24)
Nasjonalgalleriet, Oslo

Spring on the Ile de la Grande-Jatte is one of the last of Monet's quickly executed sketches of the 1870s. These show his technique at its most ebullient and improvisatory, but they did much to harm his reputation among contemporary critics, who were unable to accept such paintings as complete works of art (see Zola in 1880, Zola 1970, p. 341).

Early in 1878 Monet moved his base from Argenteuil to Paris, then in September he moved again, to Vétheuil on a bend of the Seine far from the city (see cat. 94). His departure from Argenteuil has been attributed to his disillusion with the growing industrialisation and pollution of the place (Tucker 1982), yet the principal group of paintings executed during his short spell in Paris in 1878 were of a still more industrialised and polluted stretch of the river, on the Ile de la Grande-Jatte just to the north-west of Paris, half-way between the city centre and Argenteuil.

Spring on the Ile de la Grande-Jatte is one of the most overtly

industrialised landscapes Monet ever painted, with the factories of Clichy ranged across the background and the Asnières railway bridge seen beyond the end of the path. The background is the same scene that appears in Seurat's *Bathing at Asnières* of 1883–4 (fig. 56); it is viewed from the left bank of the river with the Ile de la Grande-Jatte on the right.

There are contrasts between the natural and the artificial throughout Monet's painting. The dominant effect is of the play of afternoon sun across the spring trees and the water, but at every point this is punctuated by man-made elements – not only the factories and buildings across the river, especially the prominent and assertively new building on the right, but also those on the island itself. Figures walk along the path towards the structure on the left, which is presumably the entrance to one of the places of entertainment.

The Ile de la Grande-Jatte had an equivocal reputation as a pleasure-ground for the Parisian *demi-monde*; this has been much explored in discussions of Seurat's great *tableau* of Sunday on the island (fig. 55; see Chicago 1989). Although Monet's painting does not address these issues directly, there is a hint of uncertainty in the couple, who appear to hesitate on the path outside the entrance gate. The man may be trying

to persuade the woman to come in with him; but, as so often with the figures in Monet's paintings of the 1870s, the inexplicitness of their gestures leaves open the possibility of alternative interpretations.

The theme of nature and artifice is echoed in the colouring of the picture. The harsh blue-green of the painted wood structure on the left stands out from the greens and blues of the foliage and sky beyond, while the glow of the sunlight is picked up in the far buildings, in the faces of the figures, and in the warm accents on the top of the nearest mooring post. The overall tonality is luminous and highly coloured, but this is achieved by leaving the light grey priming visible in many parts of the canvas; it takes on a slight greenish tinge alongside the blues in the sky.

The brushwork shows Monet's handling at its most informal, with extreme contrasts in the weight and density of the touch, ranging from the vigorous ribbons of colour at bottom left to the soft feathery strokes in the central trees. This fluency and openness is comparable to Sisley's *Boats on the Seine* (cat. 87), but Monet's brushwork creates more flowing and graphic patterns than Sisley's staccato touch.

Fig. 55 (above left)
Georges Seurat
Sunday Afternoon on the Ile de la Grande-Jatte
1884–6, exhibited at the eigth Impressionist group
exhibition of 1886, 207.6 × 308 (81⅞ × 121¼)
The Art Institute of Chicago
Fig. 56 (left)
Georges Seurat
Bathing at Asnières, 1883–4, rejected at the
Salon of 1884, 201 × 301.5 (79⅛ × 118¾)
The Trustees of the National Gallery, London

91

The Market Gardens of Vaugirard
1879

Les Marachers de Vaugirard

66 × 100.3 (26 × 39½)

Smith College Museum of Art,
Northampton, Massachusetts

Exhibited in the fifth group exhibition in 1880, *The Market Gardens of Vaugirard* constituted a remarkable début for Gauguin as a painter among the Impressionist group. In 1879 he had shown a small and comparatively conventional sculpture (a portrait bust of one of his children) but, as seen in *The Market Gardens of Vaugirard*, his work as a painter revealed a far more unexpected vision. The picture is an unusual size for an Impressionist landscape; the site has no obvious picturesque potential; and it is viewed from an odd, oblique angle. This is the reverse side of the 'new' Paris created by the building projects of Baron Haussmann and his successors: we see only the backs of the buildings, and all of them are irregular and haphazardly grouped.

The Vaugirard quarter, where Gauguin lived, is in the fifteenth arrondissement in south-western Paris. Gauguin's house was a short distance south-west of the Gare Montparnasse, in an area that still had open spaces and small market gardens such as those seen here. Presumably our viewpoint is the large house in which Gauguin (then employed as a stockbroker)

lived, but there are no signs of this being a bourgeois residential area. Beyond the chimney tucked in beneath us the garden plots extend in a double band, viewed at an awkward angle rather than frontally or in a clear perspective; behind the harsh line of the wall the buildings are faceless and virtually without windows.

Gauguin's technique is dominated by small oblong touches, laid in roughly parallel sequences, in a way that echoes both Cézanne (see cat. 96) and Pissarro (cat. 97). It has been suggested that *The Market Gardens of Vaugirard* was primarily indebted to Cézanne (Los Angeles 1984, p. 204), but it seems closer to Pissarro, in the finer and more graphic touch and in the use of the sharp red accents of roofs and chimneys in contrast with the prevailing greens.

92

**The Warren at Pontoise,
Snow Effect 1879**

La Garenne à Pontoise, effet de neige
59.2 × 72.3 (23⅜ × 28½)
The Art Institute of Chicago
Gift of Marshall Field

Like *The Climbing Path, L'Hermitage, Pontoise* (cat. 81), *The Warren at Pontoise, Snow Effect* approaches its subject from an unexpected angle and combines two very different focal points and paths of spatial recession. Both scenes seem to be viewed from the hillside of L'Hermitage but here we are looking not into the enclosed valley but down towards the main town, with a wide vista in the right distance that contrasts with the close-packed roofs of the middle ground and the tangled and spatially illegible forms of the trees and bushes on the foreground hillside. We do not know whether the 'warren' indicated in the picture's title was simply an old name or still the home of a colony of rabbits.

The figure of a peasant, seemingly collecting wood on the hillside, faces out to the right and away from the landscape. The man and his activity mediate between the houses and the rough overgrown foreground.

Unlike Pissarro, he takes no interest in the scene's picturesque qualities.

The colour scheme depends upon the dominant white tones. These include soft nuances of blue and yellow, which pick up the colour of the buildings and the soft atmospheric tints that run throughout the canvas. Greens and muted reds appear where there is no snow, and the two crisp red chimneypots just left of centre, wittily framed by two saplings, provide an unexpected warm focus in this chilly scene.

The brushwork is fluent and animated throughout, broader and more flowing than in cat. 97; the strokes that define the foreground terrain create cursive rhythms, set off against the brisk verticals of the saplings and the structures of the buildings beyond – an interesting set of contrasts between the natural and the man-made. Certain areas, like the top-left corner, are less highly worked and

the sky is thinly brushed, but overall the picture has been brought to a consistent degree of finish, and Pissarro clearly regarded it as complete. Unlike Monet and Sisley (see fig. 9 and cat. 79), he rarely exhibited his less highly finished paintings. *The Warren at Pontoise, Snow Effect* was not shown in one of the group exhibitions but he did include it in the retrospective of his work that Durand-Ruel organised in 1892.

93

Landscape at Wargemont 1879
Paysage à Wargemont
80.6 × 100 (31¾ × 39⅜)
The Toledo Museum of Art,
Toledo, Ohio
Purchased with funds from the
Libbey Endowment. Gift of
Edward Drummond Libbey

Renoir first began to travel and paint outside the Paris region in the late 1870s. One of his key patrons in these years was the banker Paul Berard, who invited Renoir to stay with him at his country estate at Wargemont near Dieppe. But Renoir's move to the landscapes of rural Normandy also coincided with his decision to separate himself from the Impressionist group, and to exhibit again at the Salon, in the hope of establishing himself among a wealthy bourgeois clientele.

As at Champrosay in 1876 (see cat. 84), the paintings he made at Wargemont fall into two distinct groups: relatively conventional portraits, and landscapes of great freshness and expansiveness. *Landscape at Wargemont* is in some ways a traditional rural theme, comparable to Binet's panorama of the landscape near Eu, not far away up the coast (cat. 43). But both the angle from which Renoir views his subject and the way he treats it transform it into a remarkable interplay of touch and pattern, presented on a surprisingly large scale for an Impressionist landscape.

The picture's effect is achieved with an extraordinary economy of means. The priming is all-important: a dense opaque white layer over a canvas with a very fine weave. Over this, much of the paint is laid on in thin translucent veils of colour, which gain their luminosity from this white underpinning. Most of the highlights in the picture are provided in this way; the yellow accents are the only light, high-key points that are created by opaque touches rather than by the priming. Otherwise, the denser working is confined to the darker accents on the trees, bushes and hedges that structure the composition; even these are treated with a deft freehand that wholly ignores the details of their form and foliage but, from a distance, vividly evokes their overall effect.

The composition is very open. The bushes at bottom right act as a tonal repoussoir but our elevated viewpoint prevents us from imagining any direct physical access to the scene. The eye is led into space along the dizzying curves of the road; alternatively, we scan the picture from one dark accent to the next, using them as stepping stones that lead the eye across the surface and back into space. There is no sign of human presence and no clear indication of scale; the eye ends up in the soft muted blues of the far valley.

Unlike the clear greens, blues and oranges of his scenes of bright sunlight (see cats. 76, 98), Renoir here combined deeper reds and carmines with bluer, more emerald greens, all of which recur in many parts of the canvas. This colour scheme complements the fluency of the handling to create an overall atmospheric harmony; Renoir's success in sustaining such an economical, loosely brushed technique across so large a canvas is an astonishing tour de force.

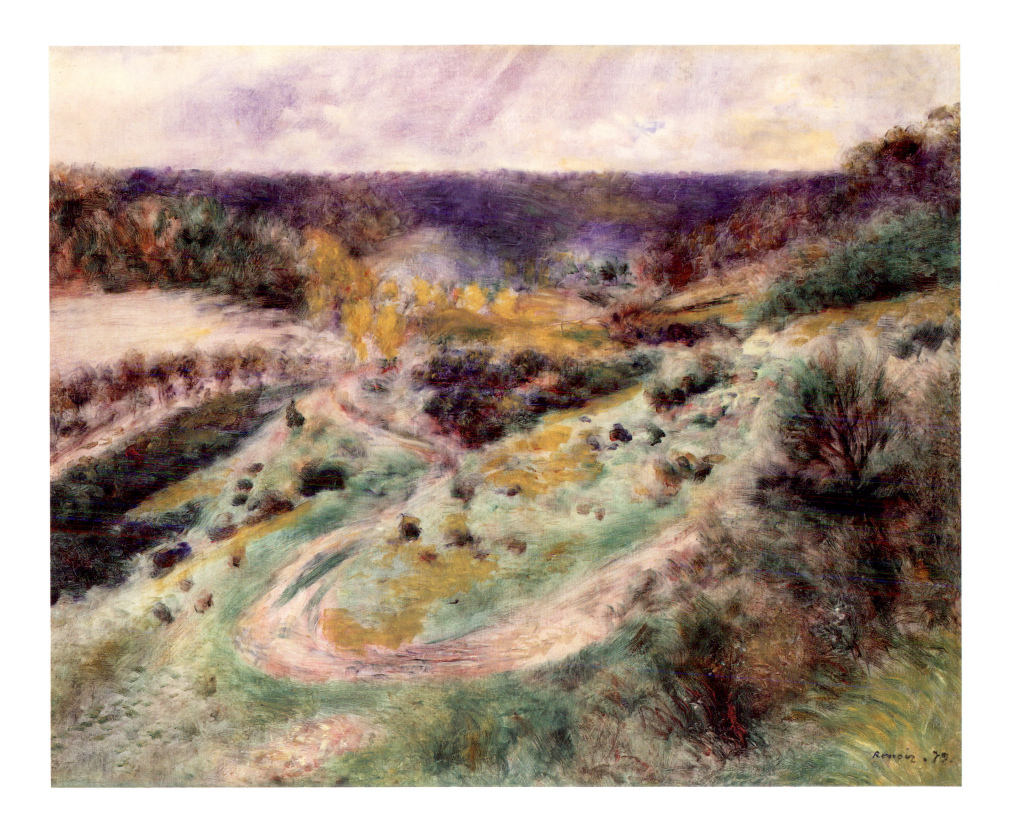

94

**Entrance to the Village of Vétheuil
in Winter** *c.* 1879

Entrée du village de Vétheuil, l'hiver
60.6 × 81 (23⅞ × 31⅞)
Museum of Fine Arts, Boston
Gift of Julia C. Prendergast
in memory of her brother,
James Maurice Prendergast
Exhibited in Boston only

In the late summer of 1878 Monet and his family moved from Paris to the village of Vétheuil, on a remote reach of the Seine about forty miles north-west of Paris. They were accompanied by Monet's former patron Ernest Hoschedé and his family (after Hoschedé's financial ruin). That autumn the two families rented a house at the entrance to the village, a far cry from the former Hoschedé residence – a *château* in the village of Montgeron to the south-east of Paris, whose drawing room Monet had decorated two years before. The house they shared at Vétheuil was the further part of the building seen here on the left of the road.

The move to Vétheuil marked a turning point in Monet's career: his abandonment of the explicitly contemporary landscapes of the Paris region in favour of typical village scenes (compare cats. 78, 90); in his paintings of Vétheuil, the medieval church often dominates the rural houses around it and the banks of the river below. At first glance *Entrance to the Village of Vétheuil in Winter* seems to repeat this stereotype; however, the turreted building on the left is not the church but the modern chalet belonging to the Monets' landlady, which was perched on the hill behind their house (see Wildenstein 1974, pp. 93–4).

In his first year at Vétheuil Monet adopted a particularly delicate paint handling, treating all the elements in his paintings with soft, finely nuanced touches that subordinate individual forms to the overall effect. Though the chalet stands out boldly in *Entrance to the Village of Vétheuil in Winter*, nothing is made of its detail or its modernity, in contrast to Monet's treatment of the villas at Argenteuil (see cat. 78). Like the modest houses below it, it is one of many soft blue shapes; the fine, lightly brushed outlines on the buildings give a sense of their form, but without detail or crisp contour. The liveliest handling is in the scruffy verge on the left, where the constantly varied coloured flecks evoke with surprising vividness the effect of melting snow on rough grass. Further back, to the right of the road, the final touches were added over an area where previous paint layers had been scratched away. Such a device is rare in Monet's work (but see cat. 65 and fig. 51, p. 194); here it may be a camouflaging of some erased form rather than a deliberate textural effect.

The overall colour is muted, dominated by the whites and soft atmospheric blues; but where the grass, bushes and earth show through there are stronger accents of green and red-brown, echoed at points in the background, which heighten the picture's liveliness.

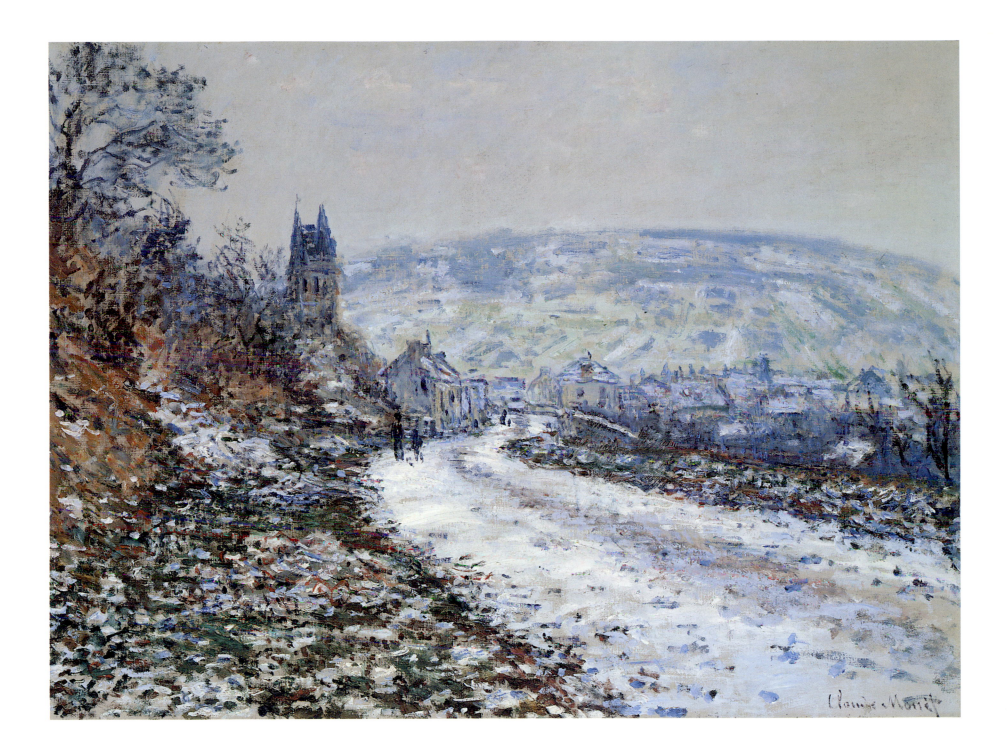

95

The Petits Près in Spring *c.* 1880

Les Petits Près en printemps
54.3 × 73 (21⅜ × 28¾)
Tate Gallery, London
Presented by a body of subscribers in
memory of Roger Fry, 1936

The Petits Près in Spring marks a turning point in Sisley's career: his move away from the landscapes on the western fringes of Paris to the area around Moret, to the south-east of the Forest of Fontainebleau, on the River Loing, close to the point where it meets the Seine (see cat. 99). Sisley focused on this area throughout the 1880s, painting the open scenery of the riverbanks and the villages that punctuated them.

The subject is the Chemin des Petits Près, a path that ran beside the Seine just below the confluence with the Loing, but there is little to mark it out as a distinctive site. It is early spring. The foreground figure of a girl enhances the sense of youthfulness; she stands self-absorbed, off the path, looking down at something in her hands, but we cannot tell what this is. The figures beyond are far less clearly defined, and the seated peasant woman acts an an unobtrusive contrast to the dominant effect of the picture.

Sisley's paint handling retains the stronger, more emphatic touch of his work of 1876 (see cat. 85), but by 1880 he was using the brush to emphasise the flowing, graphic patterns of foliage and branches, which give the whole

scene a cursive, decorative quality. However, this is not at the expense of the rendering of light and space. The sunlight, coming into the picture from low on the left, produces a delicate dappling of light and shade on the slender trunks and across the path. Muted blues and carmine reds appear in the shadowed stems, creating crisp tonal contrasts that help to lead the eye across the surface and into space. A few small off-white highlights act as pivotal points amid the softer tones around them: the accents on the girl's collar and the woman's head; the unidentifiable horizontal form beyond them along the path (perhaps a fallen tree-trunk); and the equally inexplicit highlight on a structure across the river on the right.

The picture was purchased for the National Gallery in London in 1936 from money raised in memory of the art critic Roger Fry. The original intention was to purchase a work by Cézanne, the painter whom Fry had most championed (see House 1994, p. 23); however, the funds raised (£1,500) were only enough to buy a canvas – albeit a particularly fine one – by Sisley. The Trustees of the National Gallery welcomed the gift as 'a pleasant

example of a master much admired by Roger Fry' (Board Minutes, 14 July 1936; see also Minutes for 30 July and 17 December 1935). The choice of a Sisley to commemorate Fry was not inappropriate, for Fry felt that Sisley transcended the limitations he found in Impressionism as a whole: 'Sisley was, I think, the only one of this group who was able to use the intenser, more brilliant colours, which the study of atmospheric effects had revealed, with as perfect a harmonisation as Corot had attained in a less extended scale. He surpassed the others no less in the significance of his design, in his infallible instinct for spacing and proportion. His designs have, to a high degree, that pictorial architecture which Monet's so conspicuously lack.' (Fry 1932, p. 129.)

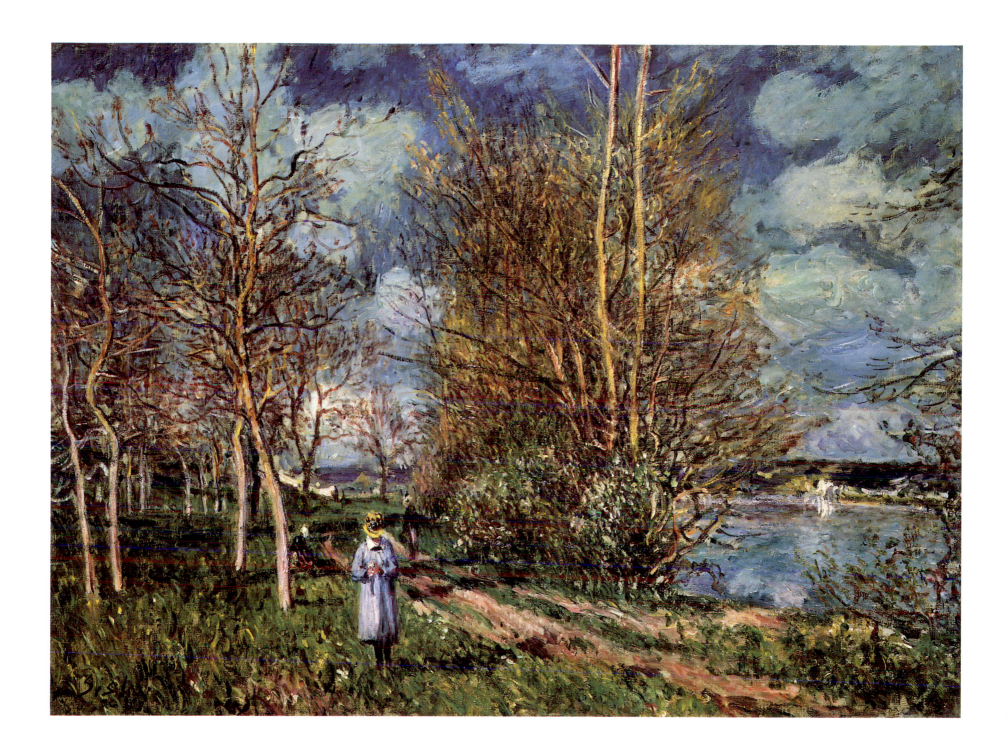

96

Bend in the Road *c.* 1881
La Route tournante
60.5 × 73.5 (23⅞ × 28⅞)
Museum of Fine Arts, Boston
Bequest of John T. Spaulding

Although the exact subject of *Bend in the Road* has not been identified, it probably represents one of the hamlets on the north-eastern outskirts of Pontoise, in the area where Pissarro painted in the early 1880s. A painting by Pissarro of 1880 (reproduced in Brettell 1990, p. 195) shows a similar turning road at Le Valhermeil, flanked by low walls, though the forms of the cottages in the two pictures do not coincide exactly. Cézanne's painting was probably made in the summer of 1881, when he spent several months in the Pontoise district.

Bend in the Road vividly reveals Cézanne's attempts to combine the close observation of natural effects with a tautly structured composition. A road leads into the composition past the central house with the red roof, and the picture is framed on both sides by the verticals of the trees; yet Cézanne did not create a conventional perspectival space. There is little sense of recession up the road, and the rough terrain on the right reads more as a sequence of planes stacked one on top of the other than as a continuation of the road behind the trees.

The surface coherence is achieved primarily by the brushwork. On the road and the walls the surfaces are comparatively smooth, with delicate variations of colour and tone, while the areas of foliage are mostly treated in sequences of firm strokes, often running parallel to each other. This treatment of the surface in sequences of parallel brushstrokes has been described as Cézanne's 'constructive stroke'; it can be compared with the evenly weighted, rhythmic handling adopted by Pissarro in the same years (see cat. 97), but Pissarro's brushstrokes are always finer and more supple, and are subordinated to the overall effect of atmospheric space in the picture. As so often in Cézanne's work, the handling here is sketchier and less resolved round the edges of the painting – an indication of his disregard for conventional notions of finish.

Apart from the bold accent of the central roof, the colour range in *Bend in the Road* is dominated by subtly modulated greens and browns, played off against the light tones of the road and the plastered walls of the houses. In contrast to Cézanne's paintings of the south of France (see cats. 88, 103), blue is used scarcely at all to suggest form and space.

The first owner of the painting was the critic Théodore Duret; later it passed to Monet and was one of the significant group of paintings by Cézanne that took pride of place in his collection.

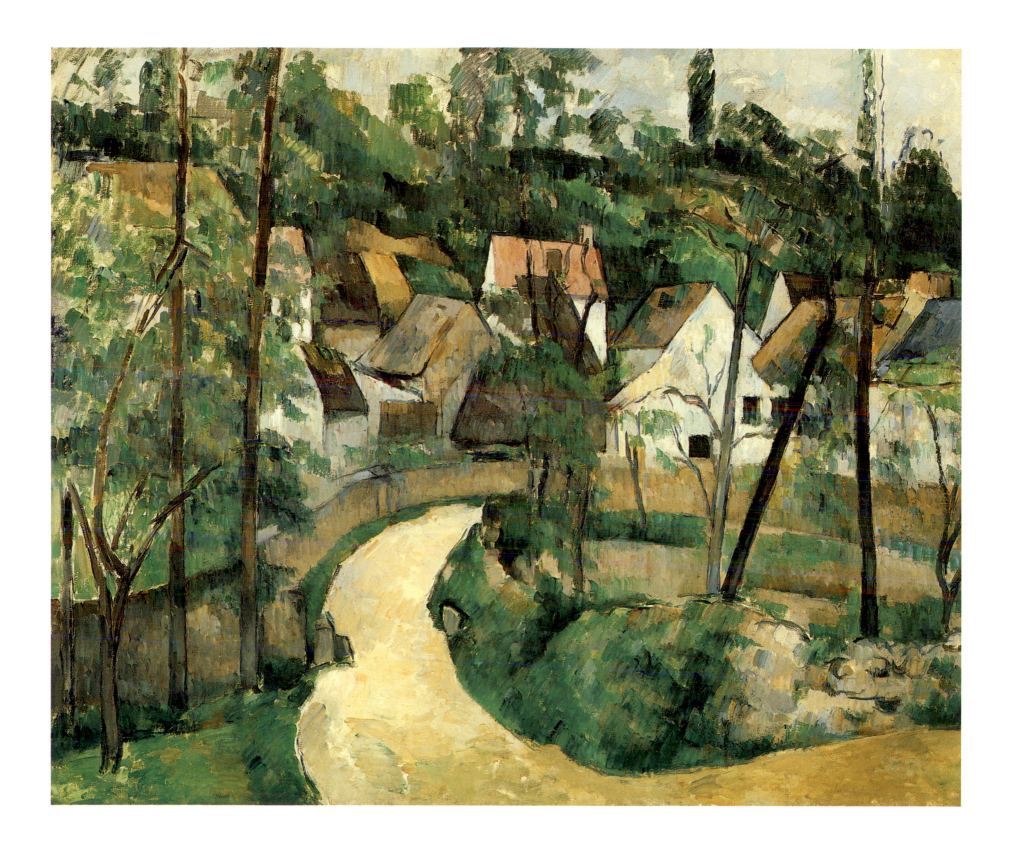

97

View of the New Prison at Pontoise
1881
Vue de la nouvelle prison à Pontoise
60 × 74 (23⅝ × 29⅛)
Private Collection
Exhibited in Boston only

View of the New Prison at Pontoise is one of the most radiant and elaborately finished of Pissarro's landscapes of the early 1880s. It was painted at a time when he was concentrating mainly on peasant subjects.

In a sense this is a picture with a traditional motif: the eye is led immediately to the distinctive building on the far hillside. This presumably is the new prison – not the sort of building that would normally provide the focus for a landscape. The rest of the scene presents a rather fragmented image, with little houses scattered across the background and the lower part of the picture taken up by undistinctive plots of land with unidentifiable small plants. This is very much a man-made landscape; it bears witness to the division of the agricultural countryside into small individual plots and to the intrusion of the town – in this case the penal system – into the countryside.

The picture's unity and coherence is achieved by touch and colour. The brushwork of small dashes and flecks runs in various directions – sometimes parallel, sometimes crisscrossing, sometimes more cursive – but is consistent in scale throughout. Greens and blues dominate the colour scheme, their effect heightened by smaller warm touches, most prominent on the roofs of the prison but recurring in many parts of the canvas. The full blues in the cast shadows and poplar trunks pick up the hues of sky and distance, but tonal contrasts are also used to model the forms and to structure the composition. The complex succession of spatial planes across the central band of the picture is conveyed by nuances of colour and delicate inflexions of brushwork alone.

This careful integration of touch and colour marks a stage in what Pissarro later described as his search for 'unity'; it was in about 1880, he later wrote, that he had 'formulated the idea of unity, but without being able to render it' (letter to Esther Isaacson, 5 May 1890, in Bailly-Herzberg 1986, p. 349). Initially this seems to have been a matter of translating atmospheric effects into highly coherent pictorial form, but later it involved a more social vision, of the harmonious life of the peasant in the fields.

The painting was exhibited in the seventh Impressionist group exhibition, organised by the dealer Durand-Ruel in spring 1882. Critical attention focused more on Pissarro's peasant paintings than on his landscapes, but the Impressionists' friend Philippe Burty aptly described the landscapes on show: 'Three or four of his landscapes, which one would have no difficulty in picking out, have a sobriety of line, a force of tone and a breadth of effect that one cannot deny. Displayed under glass, they look like powerful pastels.' (Burty 1882.) In these years Pissarro seems to have glazed his pictures when exhibiting them in order to play down the roughness of their surfaces and to make them look more mat (see Ward 1991, p. 612).

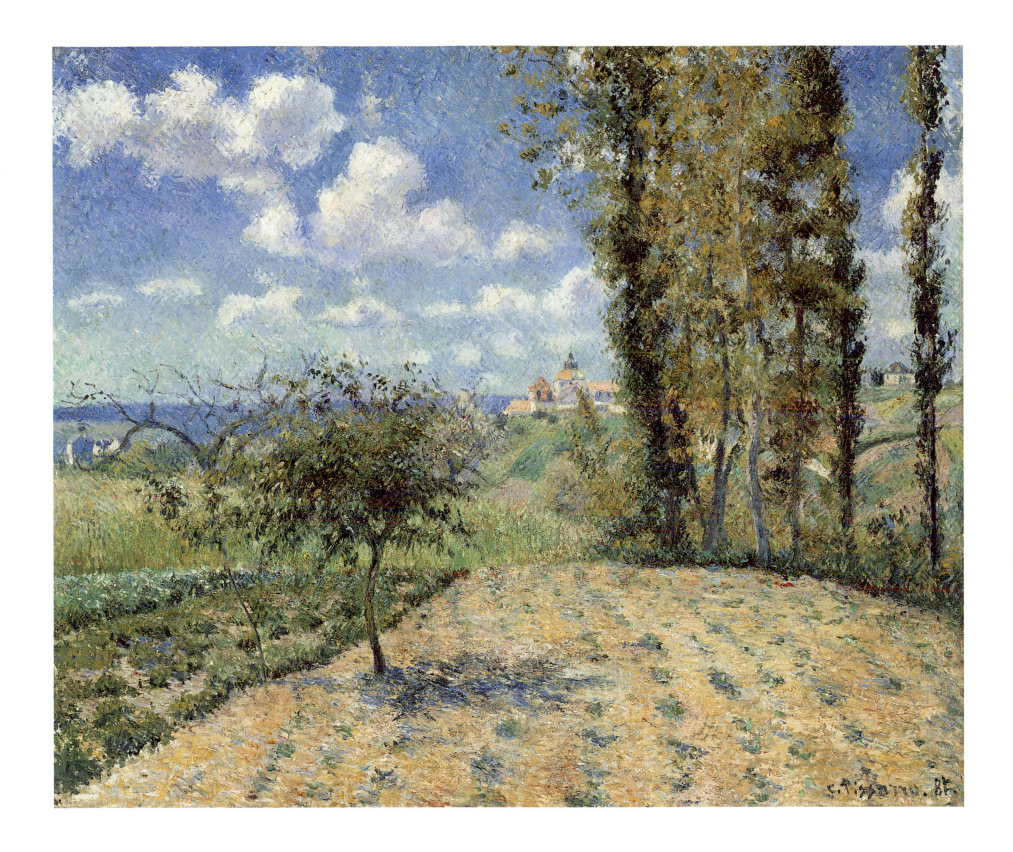

98

The Seine at Chatou *c.* 1881
La Seine à Chatou
73.5 × 92.5 (28⅞ × 36⅜)
Museum of Fine Arts, Boston
Gift of Arthur Brewster Emmons

The Seine at Chatou is one of Renoir's most ebullient landscapes, vibrant and variegated in both colour and technique. It shows the river bank near Chatou on the Seine, about ten miles west of Paris and a short distance north of Bougival. The stretch of river is probably the same as that seen in Français's *On the River Bank, near Paris* (cat. 1), but seen from the opposite bank.

Renoir worked at Chatou in the summer of 1880, concentrating on his *Luncheon of the Boating Party* (Phillips Collection, Washington), set at the nearby Fournaise restaurant. He painted there again at Easter 1881 and wrote to a friend: 'I'm struggling with trees in flower, with women and children, and I don't want to look at anything else.' (Florisoone 1938, p. 40.) *The Seine at Chatou* is probably one of these paintings of 'trees in flower'.

The composition offers some sense of recession towards the figure, but the flowering tree on the left provides an alternative – and lavish – centre of attention; the lively accents that recur throughout the painting prevent the eye from resting on any single point. The figure of the girl on the right and the bunch of flowers she carries are absorbed into the play of dabs and dashes of colour, rather than being differentiated as a distinct focus of interest. But her presence, together with the sailing boats and the apparently suburban houses on the far bank, shows that this is a site on the fringes of Paris rather than a rural scene; with its title, the painting would have evoked the freshness of a late spring day in one of the most famous of the pleasure-grounds surrounding Paris.

The canvas is dominated by the varied greens of the foliage and the blues of water, sky and shadows, but the whole picture is threaded through with warm hues, orange-reds and pinks, which constantly enliven the scene; duller carmines appear in the shadows, along with fuller blues, enhancing the warmth and the variegation of colour throughout. The overall tonality is startlingly different from Renoir's treatment of an earlier, more overcast scene, *Landscape at Wargemont* of 1879 (cat. 93).

The brushwork has no overriding order to it. The hatching strokes in the sky are comparable to Pissarro (see cat. 97), while the hooks and dashes in the grass are similar to Monet's contemporary paintings of Vétheuil. But the busy flowering tree and the soft feathery touches in the distance create an overall diversity quite unlike the more homogeneous textures that both Monet and Pissarro, in their different ways, were seeking at this date.

The dealer Durand-Ruel owned the painting by 1891, and it was probably one of the Chatou scenes that he bought from Renoir in 1881 and included in the seventh Impressionist group exhibition in 1882.

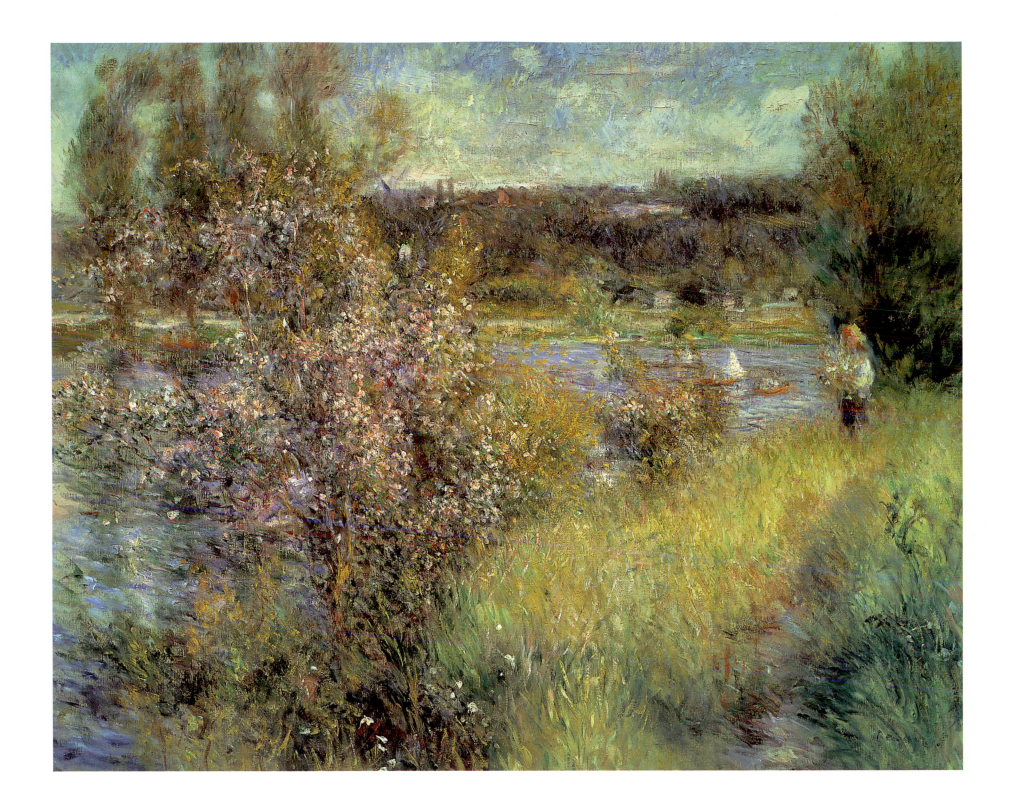

99

Saint-Mammès: Morning 1881

Saint-Mammès: le matin

50.2 × 73.7 (19¾ × 29)

Museum of Fine Arts, Boston

Bequest of William A. Coolidge

Saint-Mammès: Morning shows the confluence of the Seine, flowing from the left, and the Loing, entering from back centre, to form the larger river that flows out to the right and past the eastern fringes of the Forest of Fontainebleau. Facing us across the river is the village of Saint-Mammès. The subject was very close geographically to that of *The Petits Près in Spring* (cat. 95), a view on the opposite bank of the Seine, slightly further downstream.

In a letter to Monet written at about the time when he painted this picture, Sisley described the nearby town of Moret as 'not a bad spot, a bit of a chocolate-box landscape', with 'a very beautiful church and quite picturesque views', but he pointed out that trees were being cut down, banks straightened and quays built for the construction of a canal (Paris 1933, p. 7, partly quoted in London 1992–3, p. 198). The view presented here is of a modernised landscape; a decade later Sisley came to focus on the far more conventional motif of the church and old buildings of Moret itself.

In contrast to the humdrum scene beyond, the grasses across the foreground are a dense and lavish array of colours and textures. The touches of white and red suggest flowers, but the clear blues are more ambiguous: do they, too, stand for flowers, or are they introduced in order to create an atmospheric harmony with the rich blues of water, sky and shadows? Throughout, warm and cool hues are played off against each other: emphatic reds and pinks on the far roofs and along the bank on the right strengthen the effect of the blue. Tonal contrasts also play a part, in the forms of the buildings and boats across the background and the distribution of light amid the grasses at the front.

The horizontal composition is carefully punctuated by a number of small but salient accents: the little verticals of chimneys, masts and trees, and a horizontal blue stroke across the water of the Loing as it flows towards us at the centre of the canvas. Although by conventional standards this scene had no picturesque potential, Sisley has transformed it into a picture of surprising interest and complexity.

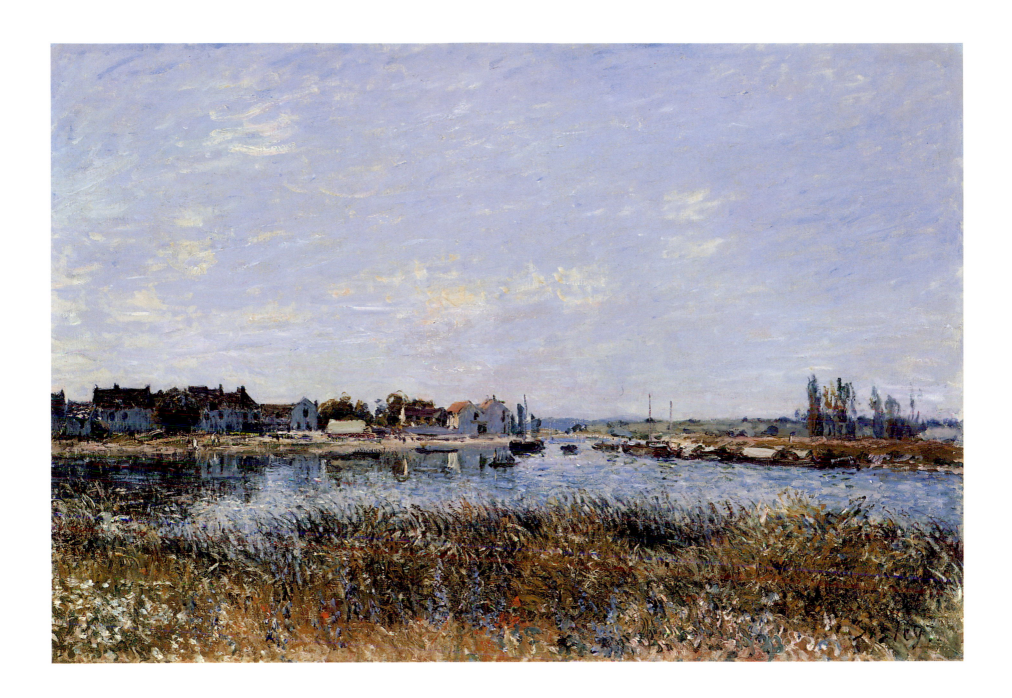

100

Fisherman's Cottage at Varengeville
1882

La Maison du pêcheur, Varengeville
60.5 × 81.5 (23⅞ × 32⅛)
Museum of Fine Arts, Boston
Bequest of Anna Perkins Rogers

Between 1880 and 1886 Monet made regular visits to the Channel coast in Normandy, and painted the same themes of sea and cliffs that appeared so frequently on the Salon walls (see cats. 45, 50). Sometimes he focused on the beaches and on the fisherfolk who found their living there, but more often he found his viewpoints on the cliffs, contrasting foreground terrain with the luminous spaces beyond – a composition anticipated by Millet in *End of the Village of Greville* (cat. 12).

In 1882 he spent two extended periods at Pourville, a hamlet on the coast just west of Dieppe. One of his favoured motifs here was a little cottage on the cliff edge, originally built for coastguards during the Napoleonic Wars of the early nineteenth century, but used by fishermen by the 1880s (see Wildenstein II, 1979, p. 68). Sometimes he titled these pictures 'fisherman's cottage' and sometimes 'coastguard's cottage', apparently without making any significant distinction by the title he chose; both lend a resonance to the image of the building looking out over the sea. Sometimes we see the dark sails of fishing boats far out at sea; the boats seen here are, however, recreational sailing boats.

The painting's composition creates a dramatic contrast between the foreground mass and the space beyond.

The viewer cannot imagine entering the picture space: there is no legible path from our viewpoint to the cottage, or from cottage to distance. We are presented with the view as spectacle, and are not invited to explore the site. Off-centre compositions such as this, with marked breaks in space, reflect the impact on Monet of Japanese colour prints, but here the forms are simpler than in most Japanese landscape scenes and the prime emphasis is placed on smaller-scale effects of touch and colour, which belong within the traditions of western oil painting.

Fisherman's Cottage at Varengeville is one of the most highly worked and elaborate of Monet's coastal paintings of 1882. Its brushwork, particularly in the central band of foliage, is crisp and densely textured, its colour richly harmonised. In some areas there are bold contrasts of complementary colours: at the base of the canvas red flowers are set against green foliage, while the blue shadows on the cottage contrast with its orange-red roof and walls. But elsewhere a wide range of hues are interwoven in complex patterns, notably in the central foliage, where soft salmon pinks and blues, together with the varied greens, create an elaborate interplay of warm and cool. The brushwork is varied throughout; the vigorous slightly

calligraphic strokes give the paint surface an overall rhythmic coherence, especially across the central band.

An effect as intricate as this cannot have been achieved in front of the subject in the short periods before the light changed, and we know that by this date Monet used his studio to complete the paintings that he had begun out of doors (see House 1986, pp. 147–50). The forms in the picture were significantly altered during its execution. Initially the cottage was considerably smaller: blue paint underlies the area of the cottage that cuts the horizon, and blue-greens the right half of the lower parts of the cottage. Without X-rays we cannot tell exactly what the original positioning was, but these alterations reveal the care Monet took in composing his canvases.

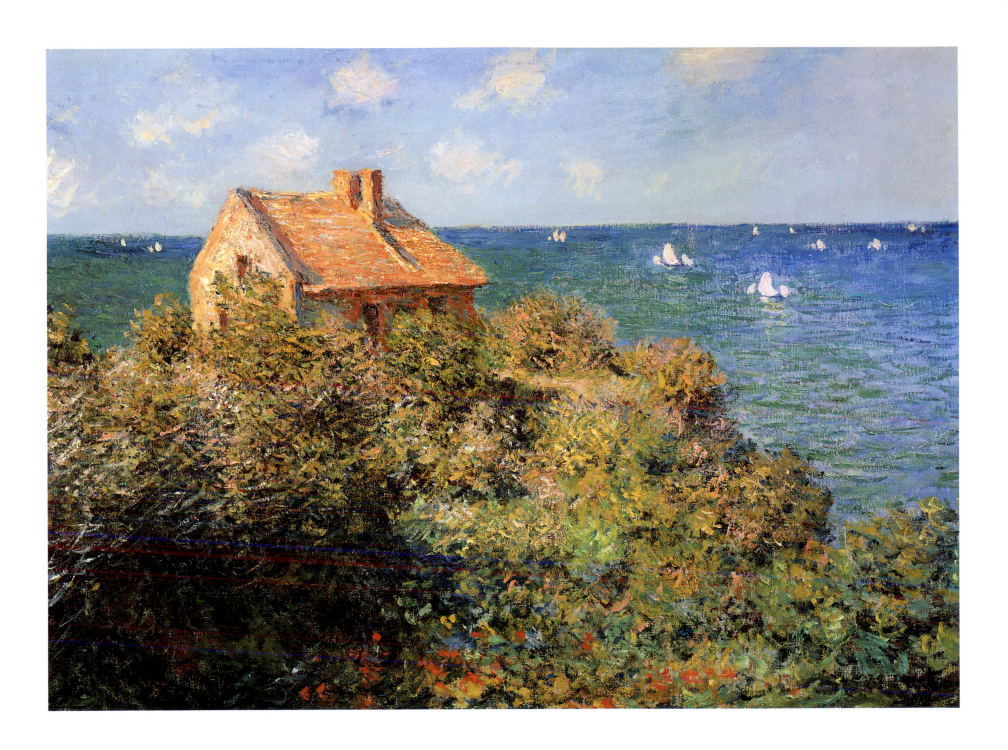

101

The Basin at Argenteuil *c.* 1883
Le Bassin d'Argenteuil
65 × 81 (25 ⅝ × 31 ⅞)
Private Collection

Caillebotte had become a firm friend and supporter of the Impressionists in the mid 1870s, during the period when Argenteuil was one of their most important painting sites (see cats. 65, 76); but he only came to paint there himself in the 1880s, after he and his brother Martial had bought a house by the Seine at Petit-Gennevilliers, on the south side of the river facing Argenteuil. Their main reason for moving there was, it seems, their shared passion for sailing rather than Gustave's art.

The Basin at Argenteuil was painted from the riverbank near their house, a short distance downstream from the viewpoint that Renoir had chosen in 1874 for *The Seine at Argenteuil* (cat. 76). Unlike Renoir's busy view, in Caillebotte's picture the river is still and inactive, with the sail-boats moored in a stately row. Across the river the bank and avenue of trees are flanked by the long white shapes of the wash-house boats – reminders of a social world far from the recreational boating that had drawn Caillebotte to the place.

In the mid 1870s Caillebotte's sharper, more precise treatment of forms distinguished his work from that of the rest of the Impressionist group. *The Basin at Argenteuil* shows how far, by the early 1880s, he had adopted the chief characteristics of Impressionist technique: the vigorous broken brushwork and use of full colour. Unlike Monet's more lavish overall effects of colour and pattern of this date (see cat. 100), Caillebotte adopts distinctive textures for each zone of the canvas: a handling closer to the Impressionism of the early 1870s (see cats. 65, 68), though broader and more vigorously accented. Viewed from close to, the brushwork is very economical with considerable areas of white primed canvas left unpainted, especially in the sunlit areas of the boats. The boats' hulls and masts stand out as emphatic separate elements in the composition. This formal structure gives a sense of order and monumentality, which is set against the diffused atmospheric colour of the background.

The painting was bought by the baritone Jean-Baptiste Faure from the retrospective exhibition organised by Monet at Durand-Ruel's gallery after Caillebotte's death in 1894.

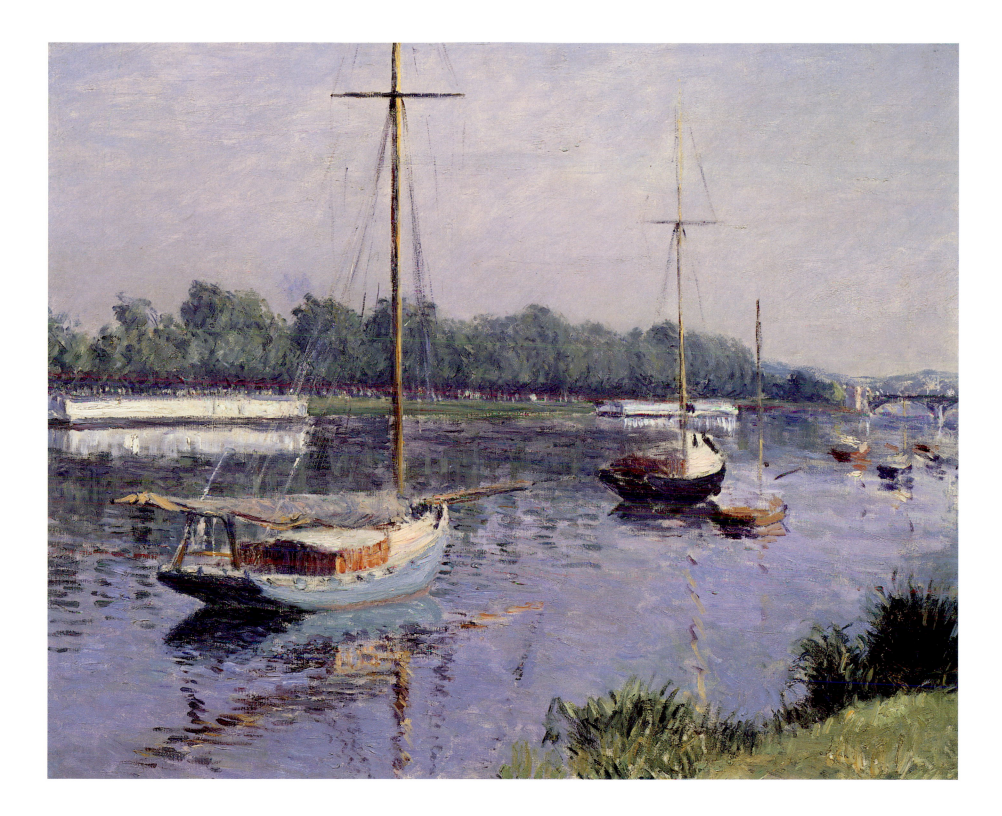

102

The Viaduct at L'Estaque *c.* 1883
Le Viaduc à l'Estaque
54 × 65.5 (21¼ × 65¾)
Collection Antell Ateneum, Helsinki
Exhibited in London only

L'Estaque, on the Mediterranean coast just to the west of Marseille, was a favoured site for mid-nineteenth-century Provençal painters; the view down over the bay to Marseille, flanked by its hills, appeared in celebrated pictures by landscapists such as Emile Loubon (fig. 34 p. 68). Cézanne worked there on many occasions from about 1870 onwards. The view over the bay was his principal motif, but he included evidence of the changes that were taking place on the coast: the factory chimneys in L'Estaque and, as here, the railway track that ran from Paris to Marseille.

Both at L'Estaque and at Aix-en-Provence he was willing to include explicitly contemporary elements in his landscapes when his Impressionist colleagues had largely abandoned them. By 1902, though, he considered the place ruined: 'I well remember the ... once so picturesque coastline at L'Estaque. Unfortunately, what we call progress is nothing but the invasion of bipeds who do not rest until they have

transformed everything into odious *quais* with gas lamps and – what is still worse – with electric illumination. What times we live in!' (Cézanne 1978, p. 290.)

In May 1883 he wrote to his friend the novelist Emile Zola: 'I have rented a little house with a garden at L'Estaque just above the railway station, and at the foot of the hillside where the rocks and pines start just behind me ... I have some beautiful viewpoints here, but they cannot really be called motifs. Still, at sunset, when one climbs up to the heights, one can see the beautiful panorama with Marseille and the islands in the background.' (Cézanne 1978, p. 211.) *The Viaduct at L'Estaque*, however, makes nothing of either the rocks or the view over the bay. With its houses framed by trees, its subject is comparable to *Bend in the Road* (cat. 96).

The Viaduct at L'Estaque may well date from this stay at L'Estaque in 1883. However, the taut network of

parallel brushstrokes – one of the most consistent examples of Cézanne's 'constructive stroke' (see cat. 96) – may suggest that it was painted slightly before this. The parallel strokes are not confined to the foliage but reappear, in a slightly less emphatic form, in the sky and on the buildings.

As so often with Cézanne's paintings, the fall of light and shade is inexplicit; none of the shadows allow us to determine the exact direction of the sunlight. The darker hues in the pines frame the play of warm hues in the centre; the reds of the roofs and yellows of the walls stand out from the greens of the foliage around them.

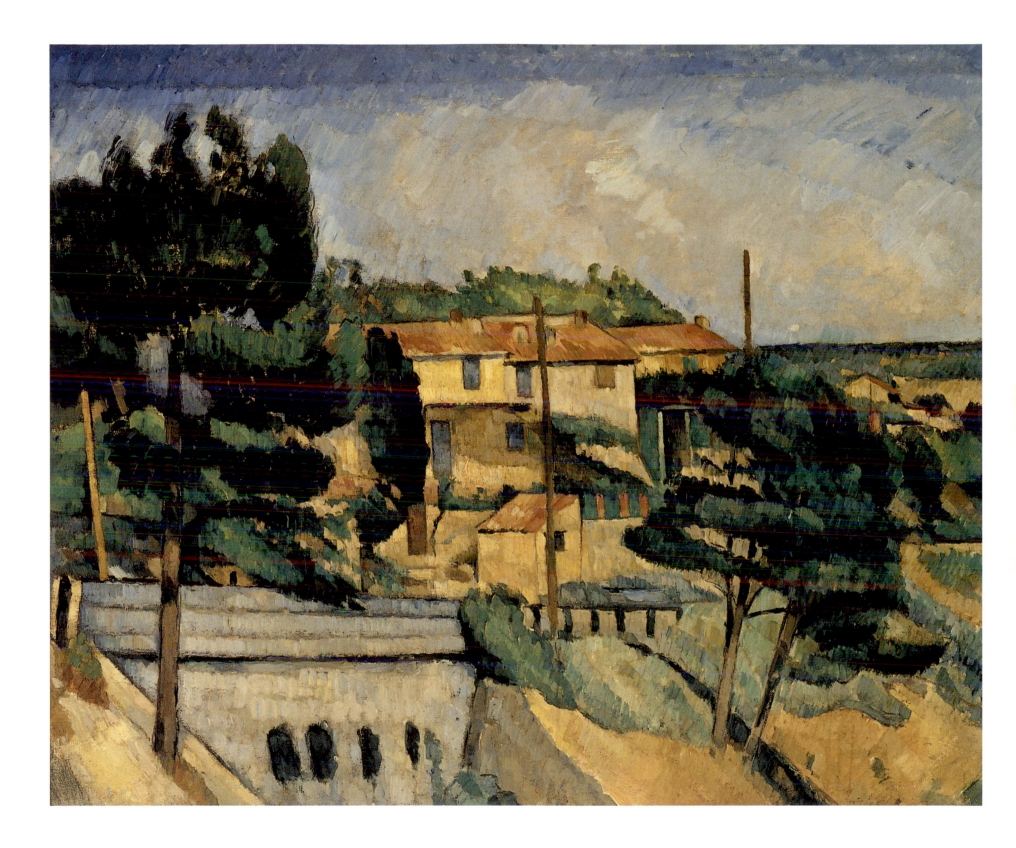

103

Tall Trees at the Jas de Bouffan
c. **1883**

Grands arbres au Jas de Bouffan
65 × 81 (25⅝ × 31⅞)
Courtauld Institute Galleries, London
(Courtauld Bequest)

The Jas de Bouffan was the house and estate that had been owned since 1859 by Cézanne's father, Louis-Auguste Cézanne, a wealthy banker; it lies about a mile and a half west of Aix-en-Provence. Cézanne often worked in the countryside around the house, painting the views out over the valley towards the Montagne Sainte-Victoire; but from 1866 until he sold the estate in 1899 he also painted many views of the house and grounds, finding there the solitude he needed in order to work, both in the garden and in his studio in the house.

Tall Trees at the Jas de Bouffan is a particularly clear illustration of Cézanne's painting technique during that period. Working from a light creamy priming (still seen unpainted in places, for instance near the bottom right corner), he first laid on simple layers of colour, such as those seen at the lower right, to establish the essential planes of the composition. These were gradually refined by the addition of variegations of colour in crisper, more distinct brushstrokes; he did not work up the whole composition simultaneously but focused on certain salient points, leaving other areas scantily painted.

In its more highly worked parts, the canvas is covered with a network of rhythmic strokes, often running in parallel sequences; their varied colour gives a shimmer and richness to the whole surface and a sense of light and atmosphere, but their ordered arrangement and the simplified monumentality of the tree trunks give the painting a structure that transcends the mobile effects of light on foliage (see also cats. 96, 102). Although it is quite elaborate in parts, some forms are only vaguely indicated; the structure of the building or wall behind the trees on the left is unclear, as is the spatial position of the alternating planes of warm and cool colour that lead into the distance on the right.

The colour in the picture is clear and sumptuous, with reds and oranges set off against the dominant network of blues and greens; even the more subdued areas, such as the tree trunks amid the foliage, are enlivened by accents of stronger, warmer colour. This heightened range of colours, adopted to evoke the rich coloured light of southern France, is a contrast to the rather duller, denser greens of cat. 96, painted a few

years earlier in the north.

The composition is tautly structured, in part by the strongly articulated pattern of the tall tree trunks, but also by the colour and lighting. The two principal sunlit areas – the view into distance on the right and the building beyond the trees at far left – frame the scene, while between these luminous warm zones a stronger reddish accent, just below the bushes near the centre of the canvas, anchors the whole image. The picture gains an overall coherence, too, from the treatment of the tree foliage, especially the sunlit parts, where broader bands and patches of softly varied light greens create a pattern of rhyming shapes up the canvas. Yet the nuances of colour and touch ensure that these patterns also contribute to the sense of three-dimensional form and space.

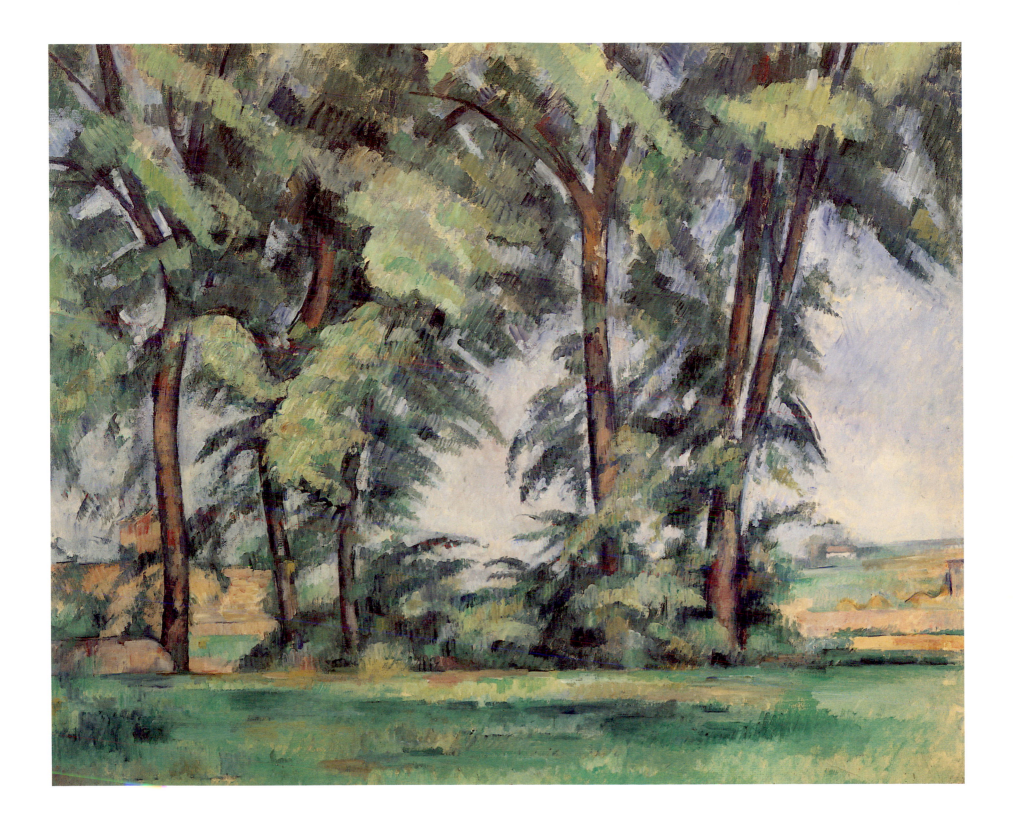

104

Entrance to the Village of Osny
c. 1883
Entrée du village d'Osny
60 × 72.6 (23⅝ × 28⅝)
Museum of Fine Arts, Boston
Bequest of John T. Spaulding
Exhibited in Boston only

Osny is a small village on the north-western edge of Pontoise; Pissarro was based there from late 1882 until the spring of 1884 and Gauguin's painting probably dates from the summer of 1883, when he is known to have stayed with Pissarro.

Entrance to the Village of Osny is comparable to Pissarro's informal scenes of the edges of the villages around Pontoise. The technique is also reminiscent of Pissarro: in its distinct, slightly rhythmic brushstrokes and its colour scheme of dominant greens and blues set off by smaller, sharper warm accents (compare cat. 97). However, in detail it shows marked differences from Pissarro's work. The play of light and shade is not as precise and legible in naturalistic terms, and the brushwork is in some places softer and more decoratively patterned, less closely integrated into the spatial structure of the scene. The coloured areas, too, are broader and sometimes harsher; it is difficult to read some of the red

accents as elements in a three-dimensional space.

The paint is applied quite thickly and drily; many strokes are briskly brushed over underlying layers in a way that leaves the paint below visible, and the texture of the comparatively coarse-grained canvas can also be seen at many points. This handling gives the picture a much rougher surface than paintings by Pissarro (see cat. 97).

These divergences from the art of his mentor reflect Gauguin's relative inexperience in painting – still a part-time recreation for him until about this date. However, the move towards a more emphatic sense of surface structure and pattern can also be seen as the beginning of developments that took his art in very different directions from Pissarro's. In some ways Gauguin's concerns can be compared with those of Cézanne (see cat. 103), with whom he had worked and many of whose paintings he owned; but Gauguin never shared Cézanne's

central concern with direct visual observation (see also cats. 106, 108).

In these years Gauguin remained committed to the exhibitions of the Impressionist group, to which he was a recent recruit. Early in 1883 he criticised Pissarro's decision to hold a one-artist show in Durand-Ruel's gallery, arguing that the effect of the Impressionists' art was far greater when they were seen as a 'movement' (Merlhès 1984, pp. 39–40). It was through art dealers such as Durand-Ruel, however, that Pissarro, and later Gauguin himself, were able to find a wider public and market for their art.

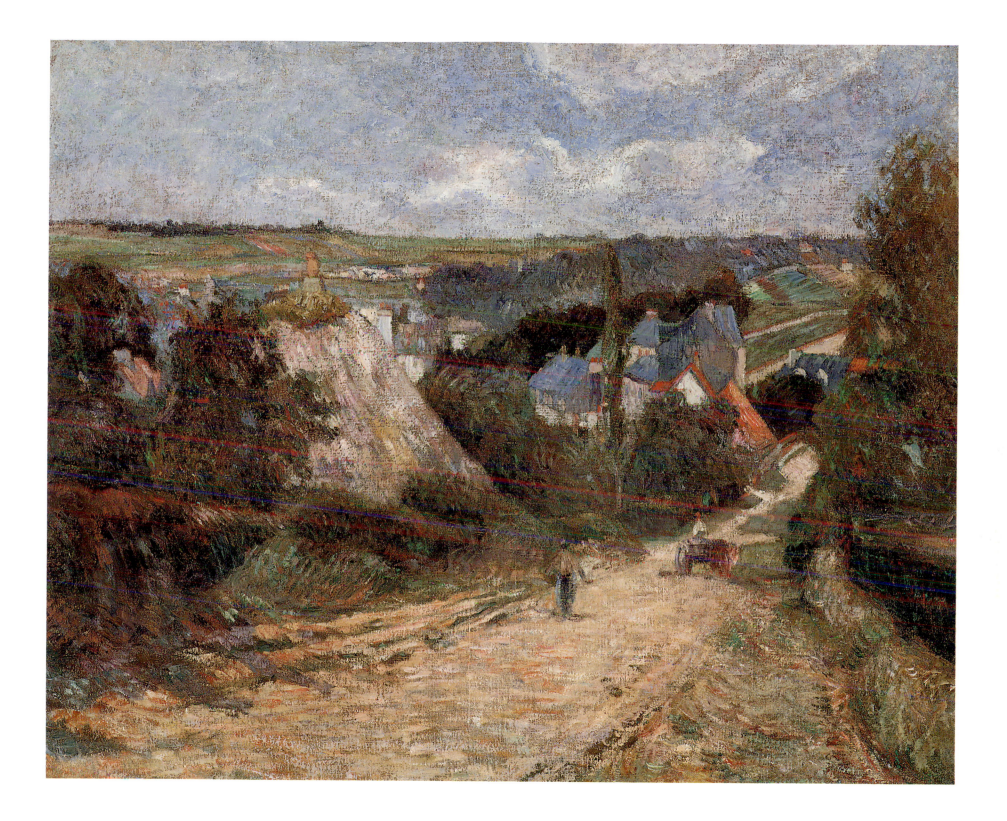

105

Landscape near Menton 1883

Paysage près Menton

65.8 × 81.3 (25 ⅞ × 32)

Museum of Fine Arts, Boston

Bequest of John T. Spaulding

In December 1883 Renoir and Monet made a short trip together along the Mediterranean coast between Marseille and Genoa; it was Renoir's first stay on this coastline, where he would settle in later years. He was enthused by what he saw there and wrote to his patron Berard: 'What lovely landscapes, with distant horizons and the most beautiful colours ... the delicacies of hue are extraordinary ... alas, our poor palette can't match up to it.' (Extracts in sale catalogue, Drouot, Paris, 16 February 1979, lot 76.)

Menton is at the extreme east end of the French Riviera, near the Italian border, but Renoir's motif here is a stereotype image of the Mediterranean coast; indeed, its view past trees to a sunlit bay is in some ways an Impressionist reinterpretation of the idyllic neo-classical image of the south in Flandrin's *Souvenir of Provence* (cat. 28).

The colour is richly varied, but has some overall coherence. A sequence of accentuated oranges and reds runs through the painting, from the foreground terrain and the tree trunks to the hot touches along the far shorelines; the blues of sea and sky are picked up in the foreground shadows.

As in *The Seine at Chatou* (cat. 98) the brushwork alters according to the natural textures depicted, but here, unlike the earlier painting, the directions and rhythms of the brushmarks are co-ordinated to create a rippling movement up the picture, through grasses, trunks and foliage. This greater degree of surface organisation is a sign of the concerns that led Renoir, in his figure painting of the mid 1880s, to return to more traditional and academic notions of drawing and modelling. In his search to combine colour and form in his landscapes, Renoir looked to the example of Cézanne, and especially to paintings like *Tall Trees at the Jas de Bouffan* (cat. 103). Cézanne's work is much sparer and more controlled in its touch, but there are clear similarities in the way in which both artists used the brushstroke to structure their scenes.

In *Landscape near Menton* there is some tension between Renoir's concern with the play of sunlight and shadow – never as explicit in Cézanne's work – and the organisation of the touches on the picture surface; as a result, the sense of form and space becomes somewhat blurred in the left foreground and in the rocks beneath the trees. In his landscape paintings of the next five years – no longer 'Impressionist' in any obvious sense – Renoir explored these tensions between form, light and pattern in a much more sustained and rigorous way.

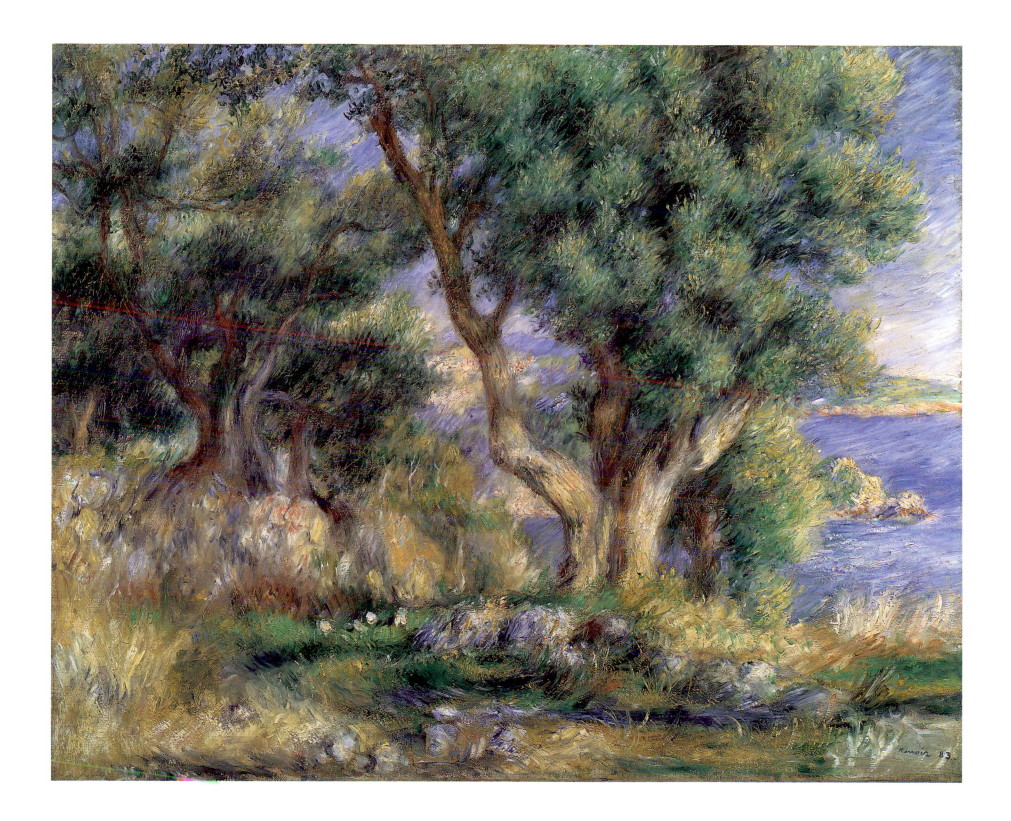

106

Cows Resting 1885

Vaches au repos

64 × 80 (25¼ × 31½)

Museum Boymans-van Beuningen, Rotterdam

Paintings of farm animals resting or grazing in fields and drinking at watering-places were a staple diet at the Salon. However, the composition of *Cows Resting* is unusual, with two divergent perspectives leading out to the sides, around the central mass of foliage.

The brushwork is still reminiscent of Pissarro's paint handling (see cat. 97) but, unlike Pissarro, Gauguin reduces the complex movement of spatial planes, as in the terrain at lower left, to cursive patterns that make little claim to evoke form and space; equally, there is scant observation of the reflections in the water – the cow is barely reflected at all. In other parts the individual brushstrokes often read as distinct marks on the surface, rather than blending into an overall effect. In its colour, too, there are echoes of Pissarro in the play of the dominant greens against the smaller warm accents on the cows and elsewhere, but Gauguin makes little use of the atmospheric blues that played so central a role in the spatial and atmospheric effects that Pissarro pursued (see cat. 97).

The picture has an awkwardness that can be interpreted as a deliberate attempt to create a sense of naïveté and rusticity – to make the formal composition complement the theme. Although the subject conforms so closely to naturalist stereotypes Gauguin was already beginning to evolve an aesthetic that rejected the primacy of the visual *sensation* – the cornerstone of Impressionist theories of art. Early in 1885 he had written of his interest in the possibility of suggesting emotions through lines and through colours and their combinations (Merlhès 1984, pp. 87–9).

This painting is probably the one shown with the title *Cows Resting* at the final Impressionist group exhibition in spring 1886. Critics of this exhibition focused on the startling novelty of the pointillist technique of Seurat and his associates (see fig. 55 p. 244), among whom Pissarro was a recent recruit. However, Félix Fénéon, one of the leading exponents of Seurat's theories, also noted Gauguin's work, with perceptive characterisation: 'M. Paul Gauguin's tones are very close to each other; hence, in his pictures, this dull harmony. Dense trees spring out from rich, fertile, moist earth, encroaching on the frame, blotting out the sky. A heavy atmosphere. A glimpse of bricks indicates a nearby house; hides lying on the ground, muzzles emerging from the thickets – cows. This painter constantly opposes the reds of the roofs and the animals to his greens, and doubles them in the water that flows past the tree-roots, obstructed by long grasses.' (Fénéon 1966, p. 62.)

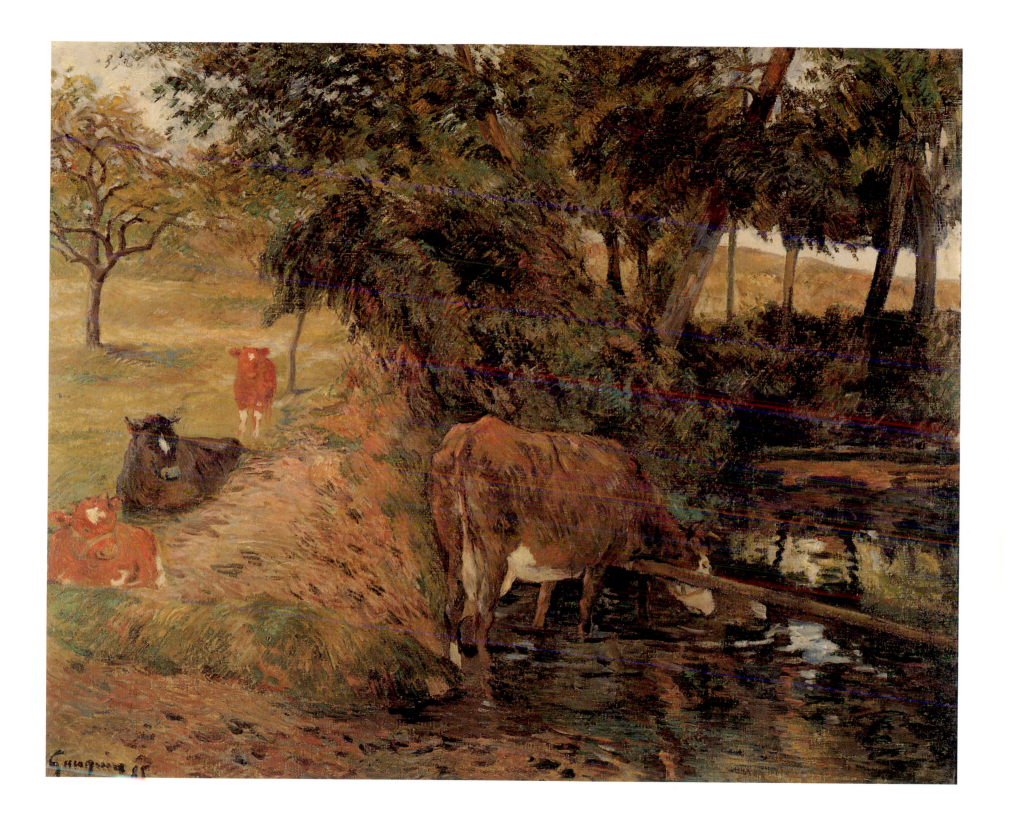

107

Meadow at Giverny 1885
Pré à Giverny
74 × 93.5 (29⅛ × 36¾)
Museum of Fine Arts, Boston
Bequest of Arthur Tracy Cabot

The theme of a tree-flanked meadow is not at all unusual in the landscape painting of the period (see cat. 40), yet Monet here uses it as the pretext for a lavish illustration of late-afternoon sunlight. The theme of haystacks was also common at the time, but Monet has minimised their usual associations with agricultural labour and the seasons by omitting any figures and by focusing exclusively on the play of atmospheric colour. His series of stacks of grain, of 1890–1, similarly defuses the familiar connotations of the theme (see House 1992).

During his first years at Giverny, to which he moved in 1883, Monet found most of his subjects on the broad sweep of water meadows that lie between the village and the River Seine. The blue shape seen in the distance through the trees on the left represents the hills along the far bank of the river. The scene lacks distinctive features and any

conventional sense of recession; the eye can trace a haphazard path through the haystacks and down the row of trees to the right but any access to a deeper space is screened off by the further trees.

Instead, our attention is drawn to the complex play of light and colour in the picture's elaborately worked surface. The underlying paint layers are quite broad but the final touches of colour are smaller and define the light effect more sharply. Yellows and blues were added at a late stage across the foreground field, as were the little red-orange dashes at lower left and, most startlingly, in sparkling sequences across parts of the trees on the right. These vibrant strokes evoke the light filtering through the trees and are set off against the soft blues and greens of the foliage, but they are no longer used as shorthand for a specific natural form; rather, they were added in order

to enliven the pictorial effect.

The dried layers of paint beneath the picture's elaborate coloured skin show that it was reworked over an extended period; but, even in its final stages, the coloured marks were added with great fluency and directness (see House 1986, pp. 92–6, 238, note 30).

As Robert Herbert has suggested, this is probably the canvas that Monet was painting when John Singer Sargent depicted him at work (fig. 57; see Herbert 1994, 97–9).

Fig. 57
John Singer Sargent
Claude Monet Painting at the Edge of a Wood, c. 1885
54 × 64.5 (21¼ × 25⅛)
Tate Gallery, London

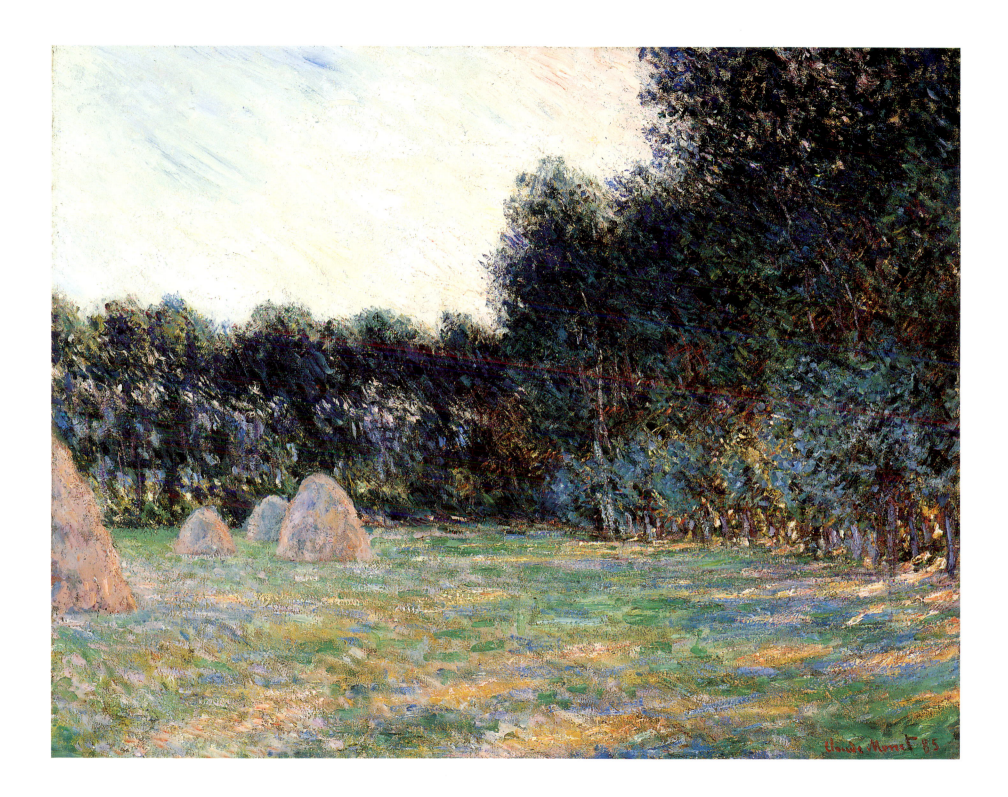

108

The Breton Shepherdess 1886
La Bergère bretonne
60.4 × 73.3 (23¾ × 28⅞)
Laing Art Gallery,
Newcastle upon Tyne
(Tyne and Wear Museums)

Gauguin paid his first visit to Brittany in the summer of 1886, after the final Impressionist group exhibition; it was here that he was able to develop his ideas about expressive form and colour (see cat. 106). His Breton paintings – with their image of Brittany as a rugged, primitive land – marked a return to subjects long popular at the Salon (see cat. 22; Orwicz 1987; Delouche 1988); yet Gauguin used this imagery as the raw material for an art that transformed natural elements into the stylised, 'synthesised' forms that, according to his aesthetic theory, expressed the essence of their subjects. His associate Henri Delavallée remembered that Gauguin talked much in 1886 about 'synthesis'; by this he meant both a process of technical simplification, in reaction against the Impressionist concern with specific effects, and a search for more lasting, expressive forms (see Chassé 1965, p. 24).

The Breton Shepherdess dates from this first stay in Brittany, at Pont-Aven. It presents the local landscape as secluded and unchanging: the hills and trees blend in with the cottages and the old stone wall to create an image of harmony and integration. There is no single focus: the eye looks up to the figure on the wall on the right, back past the sheep to the cottage and down to the left into the little pocket of space with the male figure in it. This spatial fragmentation recalls both Pissarro (see cat. 81) and Degas; Delavallée remembered Gauguin talking often about both artists at Pont-Aven in 1886 (Chassé 1965, p. 24).

Although *The Breton Shepherdess* can readily be viewed in the context of the Impressionist open-air landscape, the slightly simplified drawing and the concern with integrated rhythms and patterns reflect his search for 'synthesis'. Alongside this, there is a witty rhyming of the forms of the shepherdess and the dark cow behind her; this figure in her regional costume is presented as an integral part of the animal world around her. The painter, of course, looks into this world from outside, from a viewpoint that is unclear in spatial terms.

The technique and colour scheme are also reminiscent of Pissarro's work from the period 1879–83, when the two artists had worked together. Yet, as in *Cows Resting* (cat. 106), the overall tonality of the picture is quite sombre, despite the comparative brightness of individual accents of red, orange and green; and the brushwork in places creates cursive, rhythmic patterns that largely ignore the forms of the objects depicted.

Gauguin made a number of preliminary drawings for *The Breton Shepherdess*, studying the poses of figures and sheep separately; combined with the rather schematic brushwork, this could well suggest that the canvas was entirely or largely executed in the studio – an overt return from Impressionist to academic practice. Indeed, this may well be the 'size 20' canvas that Delavallée remembered seeing Gauguin begin in his studio, declaring: 'I'll finish it out of doors.' (Chassé 1965, p. 24.)

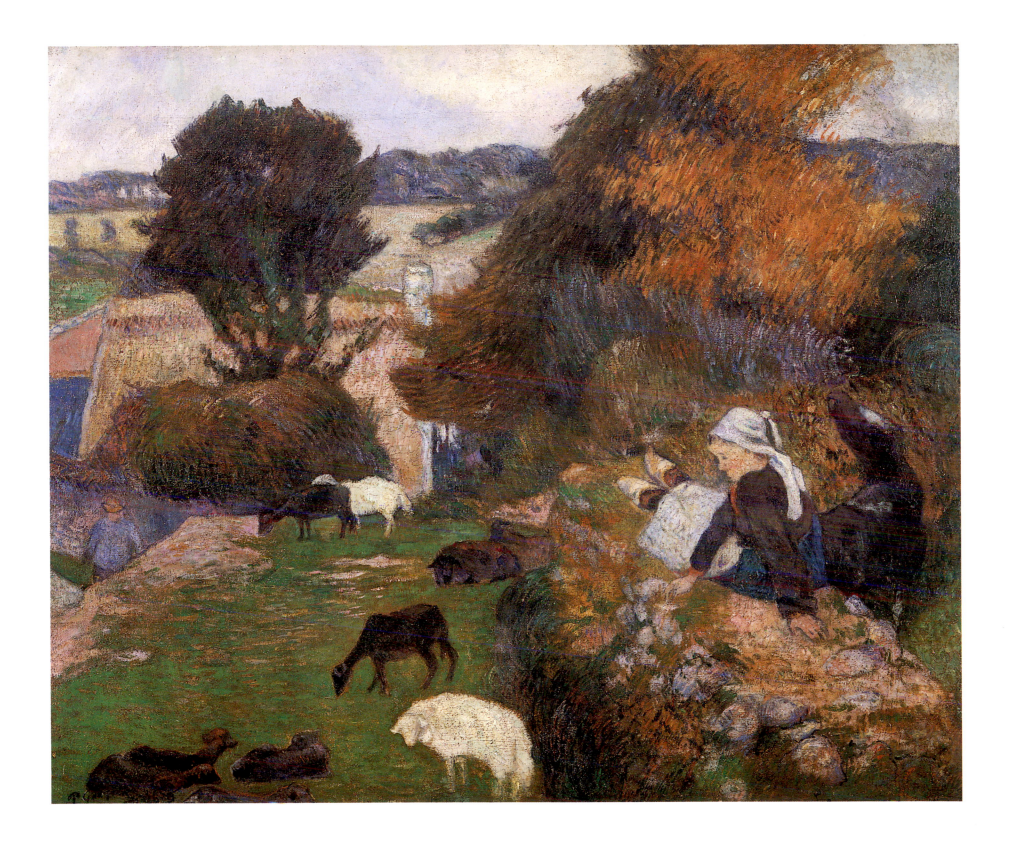

109

September Morning *c.* **1887**
Matinée de septembre
55.5 × 73.5 (21⅞ × 29)
Musée des Beaux-Arts, Agen
(Ministère de la Culture et de la
Francophonie, Fonds National d'Art
Contemporain, Paris)

Despite its modest scale and subject, *September Morning* is a painting of exceptional significance in the history of Impressionism: it was the first picture by a member of the Impressionist group to be bought by the French State. Most unusually for a State purchase in the 1880s, it was bought from the artist in person, not at the Salon. The initiative came from the State, in the short period when the critic Jules Castagnary, the Impressionists' long-standing associate, was Director of Fine Arts. It was bought in February 1888; Castagnary died in May; and later that month the new Director, Larroumet, agreed that Sisley could borrow it back in order to exhibit it at Durand-Ruel's gallery. The dealer included it in the mixed exhibition of Impressionist paintings that he mounted that summer to fill the vacuum left by the now-defunct group exhibitions and Expositions Internationales organised by Georges Petit. In 1889 the authorities deposited the painting in the museum of Agen in south-western France, far from the site depicted. Sisley commented a few years later that 'a canvas exhibited in such conditions is as good as lost' (see Angrand 1971, pp. 33–4; London 1992–3, pp. 272–3).

We have no clear evidence of the authorities' reasons for buying a picture such as this from Sisley at this point, but a number of factors may have been involved. Of all the group who had exhibited together in the 1870s, Sisley had most clearly emphasised his distance from the group's former notoriety; it may also have been an example of the State's support for artists in financial difficulties. Beyond this, it was presumably a first attempt by Castagnary to compensate for the State's previous neglect of the Impressionists – a policy that ended when he died. The next canvas by one of the group to be bought by the authorities was Renoir's conventionally prettified *Young Girls at the Piano*, acquired in 1892 (see London 1985–6, pp. 260–2).

Although the title gives no hint of the site's location, we can assume that it is a scene near Moret, where Sisley was living and painting throughout these years (see cats. 95, 99). A peasant woman, half-hidden by the tangled foreground foliage, walks along the road that crosses the picture from the left; small trees punctuate the landscape and frame the humble buildings beyond, while the mass

of the tall tree on the right acts as a (perhaps too emphatic) frame and repoussoir.

The surface throughout is busy and densely painted, animated with broad, constantly variegated brushmarks that stress the distinctive 'Impressionist' quality of the picture's treatment. The more fluent and cursive strokes in the foreground are set against the flecked touch beyond. Blues recur in the shadows, but warm dark hues – deep carmines and purple-reds – are also used, especially for branches and tree trunks, to lend warmth even in the shadows of the painting.

110

The Seine at the Pointe d'Epinay
c. 1888

La Seine à la Pointe d'Epinay
65 × 81 (25⅝ × 31⅞)
Private Collection

The Seine at the Pointe d'Epinay shows the Seine valley, looking eastward from the hill to the north-east of Argenteuil. This hill is seen in the far back right of *The Basin at Argenteuil* (cat. 101), but the view from it offered a subject quite unlike the familiar riverbank scenes of the Seine valley. Instead, *The Seine at the Pointe d'Epinay* marks a return to grandiose panoramas such as those of Chintreuil (see fig. 20); the Impressionists rarely painted such sweeps of landscape, and even the broadest of Guillaumin's, Pissarro's and Sisley's vistas (see cats. 74, 86, 83) depicted more confined, enclosed spaces.

Caillebotte's view looks down on to the Pointe d'Epinay, the extreme western tip of the Ile Saint-Denis, which divided the Seine to the north-west of Paris. The immediate effect is of a huge expanse of open countryside; the presence of the village of Epinay is only hinted at (by the bridge to the left of the river). Caillebotte played down the effects of modernisation on the landscape and there is no sign of the railway track of the *Ligne du Grande Ceinture* that linked Epinay to Argenteuil and ran along the river bank directly below our viewpoint. But the puffs of smoke along the far horizon mark out our position, looking across towards the industrial town of Saint-Denis; the wide water-meadows on the right flanked the village of Gennevilliers and were well known as the site of a controversial project to fertilise agricultural land with human sewage from Paris (see cat. 80).

The space in this huge panorama is suggested by the differentiation of touch and colour; even the more accented brushwork across the foreground fields does little to define the precise forms of foliage and crops. The whole scene is knitted together by recurrent greens, pink-mauves and soft blues. Small areas of off-white priming that are seen all over the canvas enhance the sense of luminosity.

The Seine at the Pointe d'Epinay is a remarkable synthesis of many elements in the landscape painting of the period: it presents the fringes of Paris with the grandiose rhetoric of the panorama, and uses the informal and sketch-like Impressionist touch to evoke the complex space and forms.

111

Avenue at Chantilly 1888
Allée à Chantilly
89 × 76.2 (35 × 30)
The Trustees of the National
Gallery, London
Exhibited in London only

Cézanne spent some time at Chantilly, to the north-east of Paris, in the summer of 1888 and *Avenue at Chantilly* is one of a group of canvases of the park that he painted during this stay. Instead of focusing on Chantilly's celebrated château he depicted the roads through the forest, where the natural forms of the trees had been tailored to the design of the landscape gardener. The sense of man-made control within the scene is heightened by the wooden barriers that cross the avenue and by the single post that intrudes into the foreground. The site's historic associations lead us to see the subject as a motif in the traditional sense, but the buildings at the end of the avenue are not precise enough for us to tell what they are.

Avenue at Chantilly illustrates the looser, more open technique that Cézanne adopted in the later 1880s. There are still vestiges of his use of parallel marks in the foliage (see cats. 96, 102, 103), but elsewhere the surfaces are simpler and flatter. However, the crisp margins, such as the verge at lower right, and the symmetry of the forms give the whole scene great order and clarity.

The colour enhances this effect, the key hot accent of the roof at the end of the avenue picking up the warm hues that recur throughout the canvas, and contrasting with the greens of the foliage and barriers and the blues in the shadows. The light creamy-beige priming is left unpainted at many points, reading as a soft warm tone amid the cool foliage, but as a cool grey amid the sunlit patches on the ground. The eye is led into space along the avenue, across the barriers and the patterns of alternating light and shade. The sunlight must fall from one side or other, but, despite its role in structuring the space, it is so inexplicit that we cannot be sure from which side it is coming.

This lightly, rapidly worked canvas makes a revealing contrast to Monet's contemporary *Cap d'Antibes in the Mistral* (cat. 112), also more quickly executed than most of his work of this period. Whereas Monet used a virtuoso sketch-like technique to capture the force of the wind, Cézanne's spare, economical surfaces use colour and touch to establish a sense of order and permanence in the scene, rather than capturing a passing *impression*.

112

Cap d'Antibes in the Mistral 1888

Cap d'Antibes: mistral

66 × 81.3 (26 × 32)

Museum of Fine Arts, Boston

Bequest of Arthur Tracy Cabot

After his first, quick survey of France's Mediterranean coast with Renoir in 1883 (see cat. 105), Monet spent two extended periods painting there; on the second of these, early in 1888, he was based at Antibes. Some of his Antibes subjects were motifs of the most traditional type, showing the medieval towers of the old town set against the far mountains (Harpignies was painting similar subjects at that time). Others, like this picture, have less distinctive features and are more generic. In this sense *Cap d'Antibes in the Mistral* is comparable with Renoir's *Landscape near Menton* (cat. 105), but Monet studiously avoided echoes of neo-classical composition such as those in Renoir's canvas. Instead, the scene is laid out in three parallel bands with no clear path from one to the next, and the tree is placed virtually at the centre, inviting comparison with the compositions of Japanese colour prints, which Monet was avidly collecting by this date.

Cap d'Antibes in the Mistral is exceptional among Monet's Antibes paintings because it is not elaborately worked; it translates the effect of the sweeping wind into vigorous hooks and dashes of colour. During the 1870s Monet had ceased work on many canvases when they were still in a sketch-like state (see cat. 90), partly because this conveyed the effects he sought in the freshest way, and partly in order to produce pictures for quick sale; much of the harshest criticism of his work had focused on these seemingly unfinished canvases.

In the 1880s dealers such as Durand-Ruel encouraged him to finish his paintings more fully but he still occasionally left a canvas in a more summary state. Some of these were simply paintings that he never regarded as finished in any sense, but others, like *Cap d'Antibes in the Mistral*, he signed and presented as complete works; in the 1880s these *esquisses* were usually of the most transient subjects, like storms at sea or effects of wind. However, other canvases that initially recorded similar effects were later worked up to a far fuller finish; X-rays show that beneath the elaborate surface of *Antibes* (Courtauld Institute Galleries, London; see House 1986, pp. 168–70) there is an animated, freely sketched first layer, probably similar to *Cap d'Antibes in the Mistral*.

The painting uses two distinct means to capture the effect of the Mediterranean sun: heightened colour and an overall blondness of tone. The pinks and greens in the foreground are set against the blues and deeper greens in the sea, but much of the painting of the foreground trees is very light in tone and relates to the soft blues and pinks of the far mountains, which create a luminous backdrop to the whole scene. The final touches of colour are applied over more summary underpainting; some of these seem particularly improvisatory, especially the long sequence of light pink dabs that runs along the mountain peaks. There are in fact extensive layers of paint that had dried before the final layers were added, belying the apparent informality of the painting; these do not coincide with the forms of the present picture, and presumably belong to a false start on the same canvas, probably of another view across the bay.

Despite its comparative lack of finish Monet included the painting in the major retrospective of his work that the dealer Georges Petit mounted in 1889.

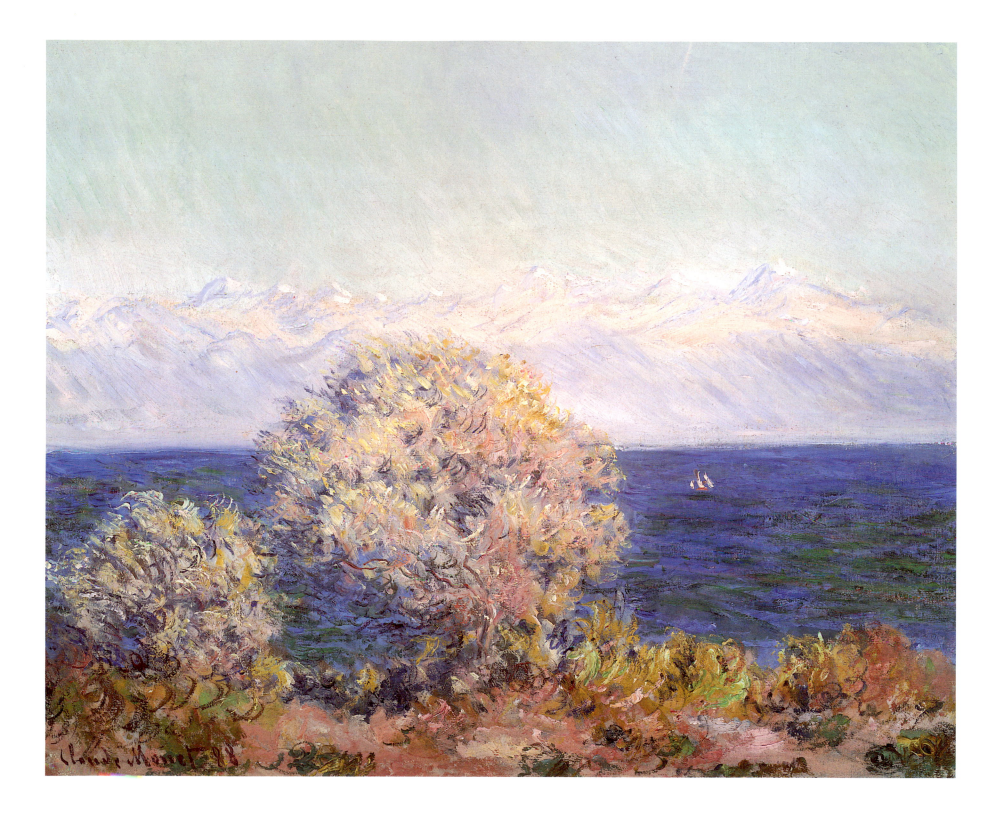

113

Valley of the Petite Creuse 1889

Vallée de la Petite Creuse

65.5 × 81.3 (25¾ × 32)

Museum of Fine Arts, Boston
Bequest of David P. Kimball in
memory of his wife Clara
Bertram Kimball

In the 1880s Monet travelled in pursuit of the most extreme effects, both in the physical scenery he painted and in the light effects he sought to capture. Most of his excursions were to France's coasts, but his final trip of the decade was to the heart of France, to the Creuse valley on the north side of the Massif Central. He wanted the paintings he did there to show the 'terrible savagery' he found in the place, in contrast to the 'tenderness' he had sought the previous year at Antibes (Wildenstein III, 1979, letters 855, 943, pp. 232, 244). These comments reveal that by the late 1880s he was seeking a dominant mood in his works, something more than the immediate visual stimulus of the scene. This concern with mood was one of the qualities that critics sought in the landscapes shown at the Salon (see cats. 38, 47).

His Creuse paintings focus on the dramatic scenery where the Grande Creuse meets the Petite Creuse: rough, boulder-covered hillsides spill down to the rapidly flowing water. The brushwork is a remarkable combination of breadth and elaboration. This is not a rapidly painted sketch like *Cap d'Antibes in the Mistral* (cat. 112); its effect is achieved by complex superimposed layers of colour. But at a late stage in its execution Monet restated the highlights where the hillside is caught by the raking sun, using broad rippling strokes of deep reds and mauves. There is no attempt to blend these touches into any overall atmospheric effect, but their very energy and colour perform a leading role in suggesting the play of light.

When he began painting on the Creuse, Monet intended to show the place in winter, but he was delayed by bad weather and when he was able to resume work he found that spring buds had transformed his winter subjects. In order to finish one of these he employed workmen to strip the buds from an old oak tree that he was painting: 'Isn't it extraordinary to finish a winter landscape at this time of year?' he wrote on 9 May (Wildenstein III, 1979, letter 976, p. 248). The tree in question seems to be the one seen down by the river on the right of the painting, where it, and the trees to the far right, show clear signs of spring leaves. Happily, the tree recovered from its ordeal.

Soon after he returned from the Massif Central Monet included many of his Creuse paintings in the major retrospective exhibition of his work mounted by Georges Petit. However, these formed only one part of an exhibition of 145 works; they were not singled out as a separate group. For this reason, and because they so clearly continue Monet's preoccupations of the 1880s, it seems inappropriate to consider the Creuse paintings as the first of Monet's true 'series'. The paintings of grain stacks of 1890–1 introduced new preoccupations in his work, in the ways in which they were executed and exhibited; *Valley of the Petite Creuse* should be seen as the end and culmination of Monet's exploration of the diversity of the landscapes of France.

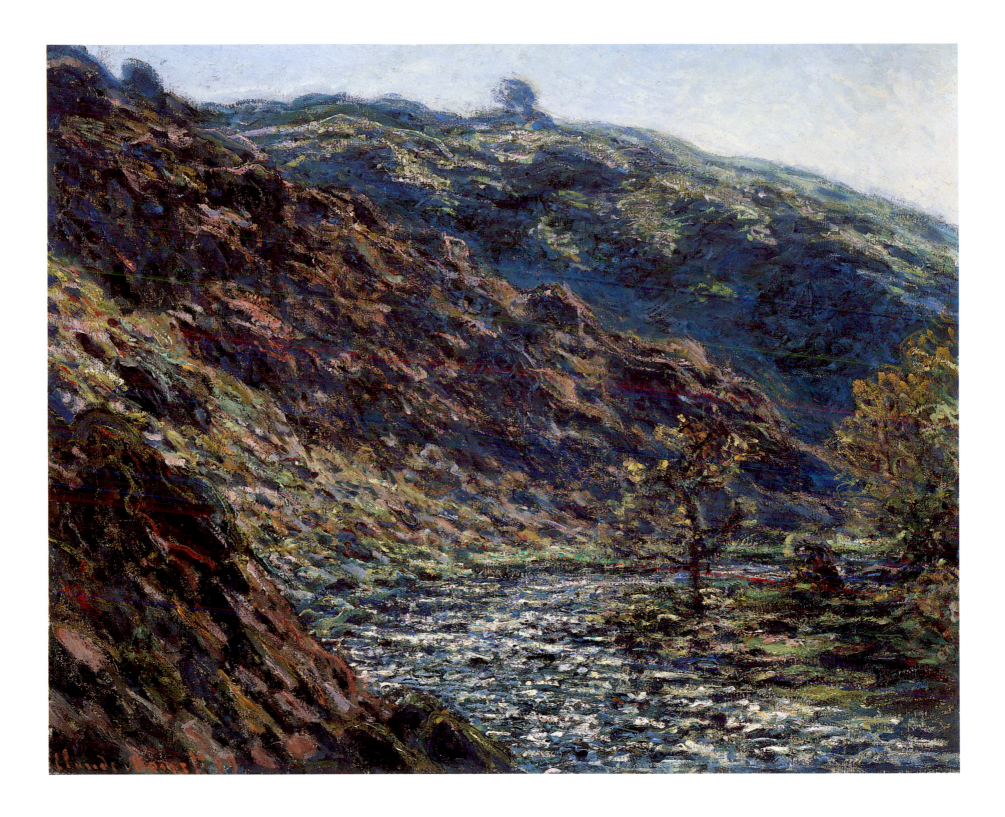

Biographies

Ann Dumas

Louis-Auguste Aiguier
Toulon 1814 – Le Pradet 1865
The son of a peasant, Aiguier was apprenticed to a wig-maker in Toulon and then in Marseille. He drew and sketched in his spare time, attended Aubert's drawing school and studied informally with Ziem. He was encouraged by Loubon and also by Hébert, who urged him to go to Paris to study Claude's paintings in the Louvre. This had a lasting effect on him and his large exhibition works of Mediterranean views are suffused with an idealised Claudian light. Aiguier made his mark at the 1855 Exposition Universelle with *Autumn Evening at Catalans*. He exhibited at the Salon in 1859, 1861, 1863, 1864 and 1865, receiving a mention at the last two.

Jacques Barthélémy Appian (known as Adolphe)
Lyon 1818 – Lyon 1898
A leading figure in the Lyon school of landscape painters, Appian began his training in that city under Grobon and Thiérriat at the Ecole des Beaux-Arts. An early career drawing designs for the silk industry was abandoned when he became a full-time landscape painter in about 1848. During the 1850s he worked regularly in the Forest of Fontainebleau; Daubigny was his close friend and chief mentor. He was also in contact with Corot. In addition to his paintings Appian was known for his charcoal drawings and especially his etchings, which were published by Cadart, his dealer. He was drawn to the countryside around Lyon, especially the Isère and the Ain, but he also painted in the Pyrénées and Savoie in the 1860s, and frequently in the Midi after 1870. He enjoyed great success in his lifetime, exhibiting regularly at the Salon where he was awarded fourteen gold medals and twenty-one silver medals. He was made a Chevalier de la Légion d'Honneur in 1892.

Charles Bavoux
Villers-le-Lac (Doubs) 1824 – died after 1882
Little is known about Bavoux. After training at the Ecole des Beaux-Arts in Paris under Picot he returned to Besançon. Apart from some early still lifes he spent the rest of his life painting landscapes of his native region, the Franche-Comté. The sites he painted along the River Doubs and on the plateaux above Besançon are similar to those made famous by Courbet. He worked from drawings he made of the area, some of which he exhibited at the Salon. He sent paintings to the Salon from 1861, exhibiting there for the last time in 1882.

Frédéric Bazille
Montpellier 1841 – Beaune-la-Rolande 1870
Bazille was born into an affluent family of wine-growers in Montpellier. He was introduced to the works of Delacroix and Courbet by Courbet's patron, Alfred Bruyas, who was a family friend. In 1862 he went to Paris to continue the studies in medicine that he had begun in Montpellier. At the same time he enrolled in Gleyre's studio, where he met Renoir, Sisley and Monet. He became a close friend of Monet and accompanied him on outdoor painting trips to Chailly in 1863, Honfleur in 1864 and again to Chailly in 1865. He exhibited at the Salon in 1866, 1868, 1869 and 1870. Following the rejection of two works in 1867 he organised an unsuccessful petition for a Salon des Refusés, signed by Pissarro, Sisley, Renoir and others. At the end of the 1860s he moved away from outdoor landscape painting and turned to figure painting inspired by Manet and Renoir. His promising career was cut short when he was killed in the Franco-Prussian War.

René Billotte
Tarbes 1846 – Tarbes 1915
Billotte was a pupil of his uncle, Eugène Fromentin. He exhibited regularly at the Salon from 1878 and was awarded an honourable mention in 1881 and a silver medal in 1889. In 1890 he was one of the founder members of the alternative salon, the Société Nationale des Beaux-Arts, where he exhibited until 1914. Apart from some landscapes painted in Holland, Billotte is known mostly for his views of Paris and its suburbs, often painted in evening light. His large decorative panel, *The Seine at the Quai d'Orsay*, is in the Hôtel de Ville in Paris.

Victor Binet
Rouen 1849 – Saint-Aubin-sur-Quillebeuf 1924
Binet began his career as a painter of decorative panels but later turned to landscape painting. He was influenced by the Barbizon painters in his choice of subjects: usually fields, sometimes including herds of cattle, with an emphasis on light and weather effects. He painted mostly in the Seine-Maritime region, especially around Saint-Aubin and Arceuil. He exhibited at the Salon from 1878 and in 1889 he won a silver medal at the Exposition Universelle in Paris. His work was well received in his lifetime and his paintings are in several French museums.

Frank Myers Boggs
Springfield (Ohio) 1855 – Meudon 1926
Became a French citizen in 1923
Boggs designed sets and costumes for the theatre until, aged sixteen, he left the United States for Paris. He studied in Gérôme's studio at the Ecole des Beaux-Arts, but thereafter painted landscapes and city views, principally of Paris. The State purchase of his *The Place de la Bastille in 1882* (cat. 39) marked the beginning of his success. He was influenced by the Impressionists and his interest in atmospheric effects of sea and sky led him to paint in Brittany, Belgium, Holland, Venice and London, where he painted a series of views of the Thames in 1886. Water-colour was his preferred medium but he was also a prolific draughtsman and etcher. During 1890–2 he made a number of trips to the United States, Italy and the Near East. He exhibited regularly at the Salon and was awarded a silver medal at the Exposition Universelle in 1889.

Eugène Boudin
Honfleur 1824 – Deauville 1898
Boudin ran a stationery and framing shop in Le Havre where he showed the works of Troyon and Millet, who encouraged him to paint. In 1850 a scholarship enabled him to go to Paris to pursue a career as an artist, although he returned regularly to Normandy to paint. Jongkind was the artist who had the most significant influence on him, and like Jongkind he was committed

to painting out of doors. His seascapes and views of fashionable resorts on the Normandy coast appeared regularly at the Salon after 1864. His reputation grew after 1871 and he travelled more extensively to Belgium, Holland, the Midi and Venice. In 1874 he exhibited several canvases and pastels at the first Impressionist exhibition. Boudin received official honours only late in life: a third-class medal at the 1881 Salon and a gold medal at the 1889 Exposition Universelle. In 1892 he was made a Chevalier de la Légion d'Honneur.

Emile Breton
Courrières (Pas-de-Calais) 1831 – Courrières 1902
Breton was trained by his better-known brother, the peasant painter Jules Breton. He spent his life in Courrières in the Pas-de-Calais, painting the surrounding landscape in weather conditions and light that emphasise its barren, melancholy character. The emotional quality of his works was admired by Van Gogh. He exhibited at the Salon from 1861 to 1890, receiving medals there in 1866, 1867 and 1868 and at the Exposition Universelle in 1889. He was made a Chevalier de la Légion d'Honneur in 1878.

Charles Busson
Montoire 1822 – Paris 1908
Busson trained with the neo-classical painter Rémond and with Français, whom he met on a trip to Italy in 1844. On his return to France he established a studio in Paris but he painted in several different regions of France: Brittany, the Auvergne, Berry, Touraine and especially along the Loir in his native Bas-Vendômois. He was in contact with Corot, Daubigny, Troyon and Fromentin. Busson exhibited regularly at the Salon from 1843, winning a third-class medal in 1855 and a first-class medal in 1878. He was decorated with the Légion d'Honneur in 1866 and made an Officier in 1887. The State bought many landscapes by him.

Gustave Caillebotte
Paris 1848 – Petit-Gennevilliers 1894
Caillebotte initially studied law, but after a visit to Italy in 1872 his interest in art

intensified and he trained with the Salon painter Léon Bonnat, entering the Ecole des Beaux-Arts the following year. It was probably through Degas that Caillebotte met the members of the Impressionist group in about 1874. He played an active role in organising their exhibitions and exhibited with them in 1876, 1877, 1879, 1880 and 1882. At first he painted Paris street scenes and interiors in which he exploited perspective to dramatic psychological effect, but after 1882 he painted mostly portraits, still lifes and boating scenes in a looser, more colourful style. Caillebotte used his personal wealth to give much-needed support to his Impressionist friends by buying their paintings. After his early death his remarkable collection of Impressionist works was bequeathed to the French State and most of these are now in the Musée d'Orsay.

Louis-Robert Carrier-Belleuse
Paris 1848 – Paris 1913
Carrier-Belleuse was the son of the sculptor Albert Carrier-Belleuse. He was taught by his father, by Gustave Boulanger and by Alexandre Cabanel at the Ecole des Beaux-Arts. He worked in different media including sculpture, metalwork and especially ceramics, becoming artistic director of the ceramics factory at Choisy-le-Roi. In addition to society genre subjects he painted Paris street scenes, often including tradesmen engaged in their work, in an almost photographic realist style. He exhibited regularly at the Salon from 1870 and was made a Chevalier de la Légion d'Honneur.

Alfred Casile
Marseille 1848 – Marseille 1909
Employed in the offices of the docks company in Marseille, Casile at first painted in his spare time. Encouraged by the success of *Normandy Cliffs*, which was awarded a mention at the Salon of 1879, he moved to Paris in 1880 and trained under Antoine Guillemet, who influenced him to paint on the Channel coast. He was also in contact with Pissarro, Sisley, Guillaumin and Monet and painted with Boudin and Jongkind along the Seine and the Marne. Later in life he returned to Marseille and adopted

brighter colour and a more precise touch. He spent the years 1900–3 in Belgium. Casile was awarded an honourable mention at the Salon in 1881 and a third-class medal in 1885.

Paul Cézanne
Aix-en-Provence 1839 – Aix-en-Provence 1906
In 1861 Cézanne abandoned his law studies and went to Paris, where he studied painting. There he met Pissarro, who introduced him to outdoor painting. Under Pissarro's influence in the early 1870s he dropped the melodramatic subjects and violent execution of his early work and began painting landscapes in a more controlled manner. He exhibited in the first and third Impressionist exhibitions in 1874 and 1877, but was accepted only once at the Salon, after years of rejection, in 1882. He retired to his native Aix-en-Provence and from the 1880s on lived a reclusive life painting still lifes, the Provençal landscape and bathers. In these works his declared aim was to invest Impressionism with the weight and permanence of Old Master painting. His reputation grew after the exhibition of his work organised by Vollard in 1895 and the retrospective held in 1907, a year after his death.

Antoine Chintreuil
Pont-de-Vaux (Ain) 1814 – Septeuil (Seine-et-Oise) 1873
The son of a hatter, Chintreuil arrived in Paris in 1838 and worked there as a bookseller. In 1842 he studied briefly with Delaroche but was inspired to become a landscape painter by Corot, who had a profound influence on him. He met Daubigny in about 1850 when he joined a small community of landscape painters at Igny in the Bièvre valley south of Paris. Chintreuil's most productive period began in 1857 when he settled permanently at La Tournelle-Septeuil near Mantes. He was especially admired for his mastery of effects of light and weather. He had little success in the early years of his career, but after three paintings rejected at the Salon of 1863 were accepted at the Salon des Refusés his works began to be well received. He was awarded a medal at the 1867 Salon.

Jean-Baptiste-Camille Corot
Paris 1796 – Ville d'Avray 1875
Trained by Bertin and Michallon in the neo-classical manner, Corot spent the years 1825–8 in Italy, painting from the motif in the countryside around Rome. On returning to France he associated with the Barbizon painters, especially Daubigny with whom he travelled frequently. He settled at Ville d'Avray but painted in many different parts of France including the Auvergne, the Morvan, Burgundy and the Forest of Fontainebleau, and made two further trips to Italy in 1834 and 1843. Corot painted landscapes in both neo-classical and naturalist manners but after about 1850 his work was dominated by nostalgic Arcadian scenes. He was known as a generous teacher and he influenced many landscapists, including the Impressionists. Corot first exhibited at the Salon in 1827 and was awarded medals in 1833, 1848 (first class), 1855 and 1867. In 1846 he was made a Chevalier de la Légion d'Honneur.

Gustave Courbet
Ornans (Franche-Comté) 1819 – La Tour-de-Peilz (Switzerland) 1877
Courbet arrived in Paris in 1839. He had no formal training but studied at the Académie Suisse and copied in the Louvre. His submissions to the Salon of 1850–1, including *The Burial at Ornans*, caused great controversy and throughout the 1850s his realist subjects and seemingly crude manner repeatedly aroused hostility and incomprehension. His independent 'Pavilion of Realism' in 1855 established him as the leader of the new Realist school. The scenery of his native Franche-Comté was his principal subject and his landscapes of the area painted after 1860 achieved commercial success. Courbet exhibited fairly regularly at the Salon between 1848 and 1870. He was nominated for the Légion d'Honneur in June 1870 but refused on the grounds of his opposition to the Imperial government. He was active in the Paris Commune and his alleged part in taking down the Vendôme Column led to his exile in 1873. He was an important example to the Impressionists, partly for the independent exhibitions of his work that he organised.

Charles-Francois Daubigny

Paris 1817 – Paris 1878

Daubigny was trained by his father, a painter of classical landscapes. He was briefly engaged by Granet in the conservation studios at the Louvre. In 1838 he entered Delaroche's studio and made his début at the Salon. He became exclusively a landscapist, worked in the Forest of Fontainebleau and was particularly drawn to river subjects, building a studio boat from which he painted on the Seine, Marne and Oise. His reputation as a landscapist was established after 1844 and he received numerous awards: a first-class medal and Chevalier de la Légion d'Honneur in 1857 and Officier de la Légion d'Honneur in 1874. During 1870–1 he travelled in Holland and London. He was greatly revered in his lifetime and influenced many landscape painters including Boudin, Jongkind, Chintreuil and the Impressionists.

Ruger Donoho

Church Hill (Mississippi) 1857 – New York City 1916

Donoho joined the Art Students' League in New York and worked for the landscape painter R. Swain Gifford before leaving for Paris in 1879. In Paris he attended the Académie Julian and studied under Lefebvre and Robert-Fleury. In the summer months he was a member of the artists' colony at Grez-sur-Loing on the edge of the Forest of Fontainebleau and painted the surrounding countryside in the style of the Barbizon painters. Donoho returned to New York in 1887 but lived an increasingly reclusive life in East Hampton, Long Island. There he painted sunlit garden scenes and nocturnes that reflect the influence of his neighbour Childe Hassam and of Whistler.

Gustave Doré

Strasbourg 1832 – Paris 1883

Doré is better known as a book illustrator than a landscape painter. He went to Paris at the age of fifteen and began producing caricatures for the *Journal pour Rire*. He later illustrated the Bible and many works by the great European writers including Dante, Cervantes, Shakespeare and Tennyson. On his first visit to London in 1868 he opened the Doré Gallery, which

became highly successful. As a landscape painter Doré was drawn to grandiose sites, particularly mountains, and he painted many views of the Alps, the Vosges and the Pyrénées. In addition to landscapes he painted large religious pictures and also made sculptures. He first exhibited a painting at the Salon in 1851 and after this his works were regularly accepted. Doré became a Chevalier de la Légion d'Honneur in 1861 and an Officier in 1879.

Paul Flandrin

Lyon 1811 – Paris 1902

Younger brother of Hippolyte Flandrin, painter of religious and history pictures, Paul received his initial training at the Ecole des Beaux-Arts in Lyon. He went to Paris in 1829 and became a favourite pupil in Ingres's studio. Painting from the motif in the countryside around Rome from 1833 to 1835 confirmed his vocation as a landscape painter. In 1834 he met Caruelle d'Aligny and was influenced by his idealising approach to landscape. He returned to France in 1839 and began to exhibit regularly at the Salon, where he was respected as an exponent of classical landscape. After 1850 he worked regularly in the Forest of Fontainebleau, returning in the winter months to his native Bugey, the region to the east of Lyon. He was a refined draughtsman and drew and painted portraits. He also decorated a chapel in Saint-Séverin, Paris, from 1844 to 1846. Flandrin was awarded a medal at the 1839 Salon and was made a Chevalier de la Légion d'Honneur in 1852.

François-Louis Français

Plombières (Vosges) 1814 – Paris 1897

Français arrived in Paris in 1829, working at first in a bookshop and producing caricatures. He entered the studio of Jean Gigoux and met Corot, who influenced him and helped finance a trip to Italy from 1845 to 1849. Français first exhibited at the Salon in 1837 and thereafter he continued to achieve success and critical acclaim. He painted landscapes almost exclusively, combining a luminous classicising style – sometimes including mythological figures – with a more naturalistic approach. He worked regularly in the Forest of

Fontainebleau, admired Daubigny and made lithographs of a number of landscapes by the Barbizon painters. Although he painted in different provinces of France he preferred the countryside surrounding Paris, especially Cernay and Bougival. After 1873 he spent the winters in Nice and the summers in his native Plombières. Français received a medal at his first Salon in 1839. He became a Chevalier de la Légion d'Honneur in 1853, an Officier in 1867 and in 1890 he became the first landscapist to be elected to the Academy.

Paul Gauguin

Paris 1848 – Atuona, Hivaoa (Marquesas Islands) 1903

Gauguin first worked as a stockbroker, but was also an amateur painter who collected paintings by the Impressionists. He showed at the Salon in 1876 and participated in the Impressionist group exhibitions in 1879, 1880, 1881 and 1882, receiving valuable encouragement from Pissarro. He lost his job in about 1882 and began to paint full-time. Apart from a stay in Martinique in 1887, from 1886 to 1890 he lived mostly in Brittany. There he moved away from Impressionism and developed a flatter, stylised manner often using non-representational colour, and drawing on sources ranging from medieval art to the art of Japan and the Far and Near East. Gauguin settled in Tahiti in 1891 but returned to France from 1893 to 1895. He finally settled permanently in the Marquesas Islands in 1901.

Paul-Camille Guigou

Villars d'Apt 1834 – Paris 1871

Guigou moved with his family to Marseille and was apprenticed there to a lawyer; in his spare time he drew from the motif in the surrounding coutryside. He was encouraged to paint by Emile Loubon, the leader of the Provençal school, and he exhibited at the Société Artistique des Bouches-du-Rhone. In 1862 he moved to Paris, yet although he painted in the Ile-de-France, Provence was always his primary inspiration and he returned there every summer. *The Hills of Allauch* (cat. 2) was Guigou's first work to be accepted at the Salon (in 1863) and after that his works were exhibited every year. In

Paris he mixed with the future Impressionists Monet, Sisley and Pissarro but was not influenced by them. He is renowned, above all, for rendering the strong outlines and bright light of the Provençal landscape.

Armand Guillaumin

Paris 1841 – Paris 1927

Guillaumin worked on the Paris-Orléans railway and painted in his spare time. He met Pissarro and Cézannne in 1861 at the Académie Suisse and painted with them around Pontoise in the early 1870s. One of the most committed members of the Impressionist group, he showed at six of their exhibitions. He was able to take up painting full-time in 1891 when he won a sum of money in the National Lottery. The bright colour and vigorous brushstrokes of his later work have an affinity with Van Gogh, with whom he was friendly.

Jean-Baptiste-Antoine Guillemet

Chantilly 1843 – Mareuil-sur-Belle (Dordogne) 1918

Taught by Corot and Daubigny, Guillemet first exhibited at the Salon of 1865. In the late 1860s he met Monet, Pissarro, Courbet, Cézanne and Zola (who became his close friend). As a member of the Salon jury in 1882 Guillemet was influential in getting a painting by Cézanne accepted at the Salon for the first and only time. Despite his friendship with the Impressionists and his interest in light and atmosphere, Guillemet never adopted an Impressionist technique. His reputation rests on his views of Paris and of the Brittany and Normandy coasts, especially Villerville, where he spent every summer. He was awarded a medal at the Salon of 1874 and a silver medal at the Exposition Universelle in 1889.

Henri Harpignies

Valenciennes 1819 – Saint-Privé (Yonne) 1916

Harpignies was a pupil of the landscape painter Jean Achard, with whom he travelled round France. He spent the years 1849–52 and 1863–5 in Italy. Of all artists Corot had the most significant influence on him; he painted in an essentially Barbizon manner and worked regularly in the Forest

of Fontainebleau from 1854. After 1869 the village of Hérisson in the Allier was another favourite site, but he painted in other regions including the Auvergne and the Bourbonnais. After 1878 he stayed mainly at his home in Saint-Privé, spending winters in Nice from 1885. Harpignies exhibited at the Salon from 1853 onwards. He was awarded a gold medal in 1866 and further medals in 1868 and 1869. He became a Chevalier de la Légion d'Honneur in 1875, an Officier in 1883 and a Commandeur in 1901.

Frederick Childe Hassam
Dorchester (Massachusetts) 1859 – East Hampton (New York) 1935
Born into a prosperous New England family, Hassam began his career as a wood-engraver and illustrator. Influenced by a group of landscape painters whom he met at the Boston Art Club, he painted landscapes of the countryside around Boston. He was introduced to the work of the Barbizon painters by his distant relative William Morris Hunt. During his first visit to Europe in 1883 he travelled through Britain, Italy and Spain but seems not to have visited Paris. In 1886, though, he did go to Paris, where he spent three years, studying briefly at the Académie Julian. He was much influenced by the Impressionists and adopted their use of vivid flecks of varied colour. Returning to the United States he settled in New York and became a leading American Impressionist, painting city views of New York and the New England landscape. In 1898 he was one of the founders of the Ten American Painters group of Impressionists.

Paul Huet
Paris 1803 – Paris 1869
Huet studied under Guérin and Gros but soon rejected neo-classical painting to become one of the chief exponents of Romantic landscape painting. His friendships with Bonington and Delacroix and his admiration for Constable helped him develop a looser and more emotive style. Huet travelled extensively in France in search of wild scenery and picturesque motifs; he was particularly attracted to Normandy and the Forest of Compiègne.

Owing to ill health he often spent winters in Nice or the Pyrénées. Huet was awarded many honours early in his career, but later on critics tended to consider his paintings outmoded. Nevertheless, his works were regularly acquired and commissioned by the State. He also produced engravings and many water-colours. Huet exhibited at the Salon from 1827 onwards, winning a second-class medal in 1833 and first-class medals in 1848 and 1855. He was awarded the Légion d'Honneur in 1841.

Emmanuel Lansyer
Ile-de-Bouin (Vendée) 1835 – Paris 1893
Lansyer began by training as an architect under Viollet-le-Duc. Turning to painting, he studied first in Courbet's short-lived informal studio in 1861 and then with Harpignies, with whom he painted in the Forest of Fontainebleau. He pursued his interest in architecture in many crisply rendered paintings of historic monuments, particularly the châteaux of the Loire; he also painted regularly on the Brittany coast. As a result of trips to the Midi and Italy his later work is more fluent and luminous. He eventually settled at Loches, where his house is now a museum containing his collections of prints, drawings, paintings and Japanese objects. His work was consistently well received at the Salon, where he exhibited regularly, receiving medals in 1865, 1869 and 1873.

Jules Laurens
Carpentras 1825 – Saint-Didier (Vaucluse) 1901
Laurens spent his early years in Montpellier, where he was taught by his brother, Jean-Joseph Bonaventure, and worked as a theatrical scene-painter. He entered the studio of Paul Delaroche in Paris in 1842 and also painted landscapes with the Barbizon painters in the Forest of Fontainebleau. From 1846 to 1849 he accompanied a scientific mission to Persia, Turkey, Bulgaria and Moldavia; the numerous drawings and water-colours that he brought back provided illustrations for several travel publications as well as material for paintings that established his reputation as an Orientalist. His oriental landscapes and his views of France –

especially Provence, the Auvergne and the Channel coast – appeared annually at the Salon after 1855. He was equally renowned for his etchings and lithographs. Laurens won third-class medals at the 1857 and 1867 Salons. He became a Chevalier de la Légion d'Honneur in 1868.

Elodie La Villette
Strasbourg 1842 – Portivy, Morbihan 1917
La Villette was taught by Coroller in Lorient and then by Schuler in Strasbourg. In Arras, where she lived from 1868 to 1875, she trained with Dubois and Dourlens. She mixed in artistic circles there and met Jules and Emile Breton as well as Corot, whom she much admired. Her subjects are almost exclusively seascapes and beach scenes along the Normandy and Brittany coasts, especially Lorient and the area around Quiberon, where she settled in the last years of her life. She often worked on a very large scale. She first exhibited at the Salon in 1870; after that her works were shown there regularly and she won a third-class medal in 1875 and a bronze medal in 1889.

Luigi Loir
Goritz (Austria) 1845 – Paris 1916
Became a French citizen.
Loir studied at the art school in Parma before going to Paris in 1863, where he worked for the painter-decorator Pastelot. His first paintings were scenes of Parma, Rouen and Dieppe. In 1870 he began painting the views of Paris and its suburbs that were to become his principal subject. He worked extensively in gouache and water-colour and found these fluid media well suited to his interest in light and weather conditions. He also painted a number of large decorations for public buildings, including the Hôtel de Ville in Paris. Loir first exhibited at the Salon in 1865. He obtained a third-class medal in 1879, a second-class medal in 1889 and a gold medal at the Exposition Universelle in 1890. He was awarded the Légion d'Honneur in 1898.

Edouard Manet
Paris 1832 – Paris 1883
Son of a high-ranking civil servant in the

Ministry of Justice, Manet was born into the Parisian *haute bourgeoisie*. He studied with Couture from 1850 to 1856, supplementing his artistic education by copying in the Louvre and travelling to Holland and Italy. Despite a lasting respect for Old Master painting he painted modern-life subjects in a radically new style. Manet's work in the early 1860s aroused almost universal anger and incomprehension among the critics: *Déjeuner sur l'herbe*, rejected at the Salon but shown at the Salon des Réfusés in 1863, and *Olympia*, shown at the 1865 Salon, provoked the most hostility. Manet refused to participate in the independent exhibitions of his friends the Impressionists, although in the 1870s he began to adopt a more Impressionistic handling of paint and colour, influenced by Monet and Morisot. He always craved official recognition, but although his works were accepted fairly regularly at the Salon critical reaction was usually hostile. He was made a Chevalier de la Légion d'Honneur only eighteen months before his death.

Jean-François Millet
Gruchy, near Gréville (Manche) 1814 – Barbizon 1875
Born into a prosperous peasant family, Millet displayed an early talent for drawing and was first taught by Mouchel, a portrait painter in Cherbourg. A fellowship enabled him to go to Paris, where he trained in the studio of Paul Delaroche at the Ecole des Beaux-Arts. Although Millet was cultivated and well-versed in classical literature, his subjects are mostly drawn from the rural life he observed around Barbizon where he settled in 1849. He was a central figure in the Barbizon group and was associated with Rousseau, Troyon, Daubigny and Diaz. He first achieved notoriety at the Salon of 1850–1 with *The Sower*. His monumental canvases of peasant subjects were viewed as politically subversive. After the mid 1860s he increasingly favoured panoramic views. Although his early career was a struggle, Millet achieved official recognition and commercial success in the 1860s. He won a first-class medal at the 1867 Salon and was made a Chevalier de la Légion d'Honneur in 1868.

Claude Monet

Paris 1840 – Giverny 1926

Monet grew up in Le Havre and it was there that he met Boudin and Jongkind, who introduced him to *plein-air* painting. He had no formal training but worked in Paris at the Académie Suisse, where he met Pissarro. At Gleyre's studio he came into contact with Renoir, Sisley and Bazille. He showed at the Salon in 1865, 1866 and 1868 but was not accepted again until 1880. In 1874 he participated in the first Impressionist exhibition and was one of the leaders of that group. During the 1870s Monet was based at Argenteuil on the Seine, painting mostly landscapes. In 1878 he moved further along the river to Vétheuil, living there until 1881. In the 1880s his quest for more dramatic sites led him to the Normandy coast and the Mediterranean. He settled at Giverny in 1883 and devoted the last part of his life to painting the garden he had made there and to series of paintings of a single motif.

Berthe Morisot

Bourges 1841 – Paris 1895

Morisot was first taught to draw by her father, a top-ranking civil servant. Corot, who had a profound influence on her, advised her to work in the Forest of Fontainebleau where she met Daubigny and Guillemet. She was most influenced, however, by Manet, whose younger brother, Eugène, she married. After Manet's death Renoir's work had an impact on the development of her loose, spontaneous style. She painted domestic scenes, portraits and landscapes around Paris, along the Normandy and Brittany coasts and in the south of France. She was a leading member of the Impressionist group and exhibited at all their group exhibitions except the fourth. Her first submissions to the Salon in 1864 were well received and she exhibited there regularly until 1873.

François-Henri Nazon

Réalmont (Tarn) 1821 – Montauban 1902

Although trained by the figure painters Gleyre and Delaroche, Nazon was principally a landscapist, inspired most of all by his native region, the Tarn. He first exhibited at the Salon in 1848 and from then on regularly showed views of the Tarn, the Aveyron, the Forest of Fontainebleau and some marines. His works were frequently acquired by the State. Nazon was awarded medals at the 1864 and 1866 Salons.

Jules Noel

Quimper 1815 – Algiers 1881

Noel was a leading marine painter, often linked with Eugène Isabey. He studied with Charioux in Brest and made his début at the Salon of 1840. He painted storm scenes and shipwrecks in the Romantic tradition, and a combination of precise detail and brilliant colour enhance the documentary animation of his many views of the ports, beaches, ships and sea along the Normandy and Brittany coasts. A trip to the Near East produced some Orientalist scenes. Many pupils attended his studio and he influenced a number of younger artists. His works were regularly accepted at the Salon, and he was awarded a third-class medal in 1853.

Léon Germain Pelouse

Pierrelaye (Seine-et-Oise) 1838 – Pierrelaye 1891

Self-taught, Pelouse abandoned his job as a salesman in a fabric shop to become a painter. He made his début at the Salon in 1865 and then exhibited regularly, showing mostly views of Brittany, Normandy, the suburbs of Paris and sites around Cernay-la-Ville. He settled in Cernay, became a prominent figure in the artists' colony there and attracted many students. He was acclaimed early in his career and many of his works were bought by the State. In 1880 he visited Holland and Belgium. Pelouse was awarded a second-class medal at the Salon in 1873, a first-class medal there in 1876, and a second-class medal and the Légion d'Honneur at the 1878 Exposition Universelle. He won a gold medal at the 1889 Exposition Universelle. The Ecole des Beaux-Arts organised an exhibition of his work after his death.

Octave Penguilly l'Haridon

Paris 1811 – Paris 1870

An officer in the artillery, Penguilly pursued a parallel career as an artist and trained with Charlet. He painted genre scenes, history paintings and landscapes and exhibited at the Salon from 1835 to 1870. In his history subjects he employed a highly detailed manner, while his views of Brittany, Alsace and the Pyrénées were admired by Baudelaire for their combination of observation and poetic fantasy. He was very successful during the Second Empire and a number of his paintings were acquired by Napoleon III. He was also a prolific illustrator. In 1854 he became curator of the Artillery Museum and in 1868 Inspector of Studies at the Ecole Polytechnique. He was awarded a third-class medal at the 1847 Salon and a second-class medal in 1850. He was made a Chevalier de la Légion d'Honneur in 1851 and an Officier in 1862.

William Lamb Picknell

Hineburg (Vermont) 1853 – Marblehead (Massachusetts) 1897

Picknell studied with the American painter, Innes, in Rome and with Gérôme at the Ecole des Beaux-Arts in Paris. He joined the colony of artists at Pont-Aven, where he was strongly influenced by the American Robert Wylie; Léon Pelouse was another mentor. Picknell exhibited at the Salon from 1876 and won special acclaim in 1880 for *The Road to Concarneau* (cat. 37). He went back to America in 1880 but over the years he returned frequently to Normandy and the Côte d'Azur.

Camille Pissarro

Saint Thomas (Danish West Indies) 1830 – Paris 1903

Pissarro received his early education in France but in 1847 he returned to Saint Thomas to work for his father, a shopkeeper. On returning to France in 1855 he enrolled at the Académie Suisse in Paris and at the Ecole des Beaux-Arts. Corot and Courbet were important influences. His principal subjects were the landscapes and the rural life of the environs of Paris, especially Pontoise where he lived, although in the 1890s he painted a number of cityscapes. His works were shown regularly at the Salon in the 1860s and he was one of the leading members of the Impressionist group, showing in all eight of their exhibitions. Extremely prolific, he was also an accomplished graphic artist. Pissarro had a formative influence on Cézanne and Gauguin among others.

Auguste Pointelin

Arbois 1839 – Paris 1933

Pointelin became a mathematics teacher so that he would have time to paint in the school holidays. He was encouraged by Victor Mairea (drawing teacher in Arbois), went to Paris in 1865 and made his début at the Salon the following year. His first critical success was at the 1876 Salon with *On a Jura Plateau, Autumn*. This was acquired by the State with the help of the scientist Louis Pasteur, another native of Arbois. Pasteur also helped him secure a teaching post at the Lycée Louis-le-Grand in Paris. Pointelin employed a subdued palette and large simplified masses to create melancholy landscapes of the hills and plateaux of the Jura. In 1897 he retired to Mont-sous-Vaudrey in the Jura but he continued to exhibit at the Salon until 1933. He was awarded medals at the 1878, 1884, 1889 and 1900 Salons. He was made a Chevalier de la Légion d'Honneur in 1886 and an Officier in 1904. His ideas on nature and mysticism were expressed in his *Credo spiritualiste* (1912) and *Art et Spiritualisme* (1925).

Ernest Quost

Avallon (Yonne) 1844 – ? 1931

Primarily a flower painter, Quost began his career decorating porcelain for the Sèvres factory. He studied at the Académie Julian in Paris and attended classes given by Aumont. After 1870 he settled for a while in Belgium but then returned to Paris and lived in Montmartre, its gardens providing a constant souce of inspiration. He frequently returned to his native Avallon and to Montigny-sur-Loing to paint landscapes. He was admired by Van Gogh, whom he met in 1886. The State regularly commissioned and acquired Quost's paintings and he also benefited from a considerable private clientele, including Van Gogh's patron, Dr Gachet. Quost was awarded medals at the Salons of 1880, 1882 and 1890 and at the Expositions Universelles in 1889 and 1900. He was made a Chevalier de la Légion d'Honneur in 1883 and an Officier in 1903.

Pierre-Auguste Renoir

Limoges 1841 – Cagnes 1919

Renoir trained as a porcelain painter and then attended the Ecole des Beaux-Arts in Paris and copied in the Louvre. He also attended Gleyre's studio, where he met Bazille, Sisley and Monet. Renoir exhibited regularly at the Salon in the late 1860s but was a prominent member of the Impressionist group throughout the 1870s. He exhibited at the Impressionist group's first three exhibitions in 1874, 1876 and 1877. He returned to the Salon in 1878 and came to rely increasingly on the support of his affluent patrons. Landscape played an important part in his early work but he later turned to figurative work and painted many portraits. From the 1880s on Renoir concentrated on painting the female nude. He spent his last years at Cagnes in the south of France. He was made a Chevalier de la Légion d'Honneur in 1900, an Officier in 1911 and a Commandeur in 1919.

Paul Saïn

Avignon 1853 – Avignon 1908

Saïn trained at the Ecole des Beaux-Arts in Avignon before obtaining a grant to go to Paris. He then studied with Gérôme and shared a studio with Avril, Gibelin, Bérard and Hugues, exhibiting regularly at the Salon after 1879. He painted landscapes in Provence, Corsica and the area around Alençon at Saint-Cénery where he lived for twenty-five years before returning to Avignon. In 1887 he visited Algeria. Saïn was awarded a silver medal at the 1889 Exposition Universelle and a bronze medal at the 1900 Exposition Universelle.

Adrien Sauzay

Paris 1841 – Paris 1928

Sauzay exhibited regularly at the Salon from 1863, obtaining a third-class medal in 1881 and a second-class medal in 1883. He painted freely brushed landscapes – usually of villages or rivers set in panoramic vistas – that convey a sense of freshness and spontaneity.

Alexandre Ségé

Paris 1818 – Coubron (Seine-et-Oise) 1885

Ségé was trained by Cogniet and Flers. He painted in different regions of France

especially the area round Paris, the Pas-de-Calais and, above all, Brittany. He specialised in broad, panoramic views and was also known for his etchings. Despite exhibiting regularly at the Salon from 1844 he had little commercial success, although after *The Oaks of Kertrégonnec* (cat. 22) was bought by the State in 1870 he achieved modest recognition. He was awarded a second-class medal at the 1873 Salon and a third-class medal at the 1878 Exposition Universelle. He was made a Chevalier de la Légion d'Honneur in 1874.

Alfred Sisley

Paris 1839 – Moret-sur-Loing (Seine-et-Marne) 1899

Born in Paris of British parents, Sisley entered the studio of the history painter Charles Gleyre in 1862, and it was there that he met Renoir, Monet and Bazille. His early style was influenced by Corot, Courbet and Daubigny. He was in England from 1870 to 1871 (during the Franco-Prussian War), and again in 1874. In the 1870s he painted landscapes of the region around Paris at Argenteuil, Marly, Louveciennes and Bougival, but in 1880 he moved to the area around Moret-sur-Loing to the south of the Forest of Fontainebleau. He showed at the first, second, third and seventh Impressionist exhibitions. He was accepted at the Salon in 1866, 1868 and 1870. After the failure of the family business in 1871 Sisley endured financial difficulties, but in the later years of his life he enjoyed reasonable commercial success.

William Stott (of Oldham)

Oldham 1857 – at sea 1900

After training in England Stott went to Paris in 1879 and entered Gérôme's studio. He made his Salon début in 1881 and won a third-class medal the following year. He was a member for a while of the international colony of artists at Grez-sur-Loing on the edge of the Forest of Fontainebleau and he was strongly influenced by Millet and Bastien-Lepage. He acquired a reputation for delicate light effects, particularly sunsets. He returned to England in 1881, settled in London and exhibited at the Royal Academy.

Index of artists

Apple Trees and Broom in Flower,
Salon of 1872, cat. 24

Jean-Baptiste-Camille Corot
Near Arras, Salon of 1872, cat. 25

Gustave Courbet
*The Hunted Roe-Deer, on the Alert,
Spring*, Salon of 1868, cat. 16

Charles-François Daubigny
Villerville-sur-Mer, Salon of 1864,
cat. 6
Morning Effect on the Oise,
Salon of 1866, cat. 11

Ruger Donoho
La Marcellerie, Salon of 1882, cat. 40

Gustave Doré
Dawn, Souvenir of the Alps,
? Salon of 1877, cat. 33

Paul Flandrin
Souvenir of Provence, Salon of 1874,
cat. 28

François-Louis Français
On the Riverbank, near Paris,
Salon of 1861, cat. 1
*The Miroir de Scey, at Nightfall,
Souvenir of the Franche-Conté*,
Salon of 1876, cat. 30
The Matterhorn, Sunset, Salon of 1878,
cat. 34
*Valley of the Eaugronne, near
Plombières (Vosges), Sunset*,
Salon of 1889, cat. 54

Paul Gauguin
The Market Gardens of Vaugirard,
1879, cat. 91
Entrance to the Village of Osny,
c. 1883, cat. 104
Cows Resting, 1885, cat. 106
The Breton Shepherdess, 1886, cat. 108

Paul Guigou
The Hills of Allauch, near Marseille,
Salon of 1863, cat. 2
*The Valley of Chinchon, at l'Isle-sur-
Sorgues (Vaucluse)*, Salon of 1869,
cat. 19

Armand Guillaumin
Near Paris, 1873, cat. 69
Environs of Paris, c. 1874, cat. 74

Antoine Guillemet
Villerville (Calvados), Salon of 1876,
cat. 31

Henri Harpignies
Ruins of the Château of Hérisson,
Salon of 1872, cat. 26
The Oaks of Château-Renard (Allier),

Salon of 1875, cat. 29

Frederick Childe Hassam
A Shower, Rue Bonaparte,
Salon of 1887, cat. 52

Paul Huet
*The Ruins of the Château of
Pierrefonds*, Salon of 1868, cat. 17

Elodie La Villette
*The Bas-Fort-Blanc Path,
at Low Tide, Dieppe*, Salon of 1886,
cat. 50

Emmanuel Lansyer
The Château of Pierrefonds,
Salon of 1869, cat. 20

Jules Laurens
The Chemin des Sables, Storm Effect,
Salon of 1869, cat. 21

Luigi Loir
The Quai National, at Puteaux,
Salon of 1878, cat. 35

Edouard Manet
The Rue Mosnier with Flags, 1878,
cat. 89

Jean-François Millet
End of the Village of Greville,
Salon of 1866, cat. 12

Claude Monet
Rue de la Bavolle, Honfleur, c. 1864,
cat. 57
Street in Sainte-Adresse, 1867, cat. 60
Train in the Countryside, c. 1870,
cat. 62
The Petit Bras of the Seine at Argenteuil,
c. 1872, cat. 65
The Sheltered Path, 1873, cat. 70
*The Boulevard Saint-Denis, Argenteuil,
in Winter*, 1875, cat. 78
Spring on the Ile de la Grande-Jatte,
1878, cat. 90
*Entrance to the Village of Vétheuil
in Winter*, c. 1879, cat. 94
Lavacourt, Salon of 1880, cat. 36
Fisherman's Cottage at Varengeville,
1882, cat. 100
Meadow at Giverny, 1885, cat. 107
Cap d'Antibes in the Mistral, 1888,
cat. 112
Valley of the Petite Creuse, 1889,
cat. 113

Berthe Morisot
The Harbour of Lorient, 1869, cat. 61
*View of Paris from the Heights of the
Trocadéro*, 1872, cat. 66
Laundresses Hanging out the Wash,

1875, cat. 80

François-Henri Nazon
*The Banks of the Aveyron, Autumn
Evening*, Salon of 1863, cat. 3

Jules Noel
The Port of Brest, Salon of 1864, cat. 7

Léon Pelouse
The Valley of Cernay (Seine-et-Oise),
Salon of 1873, cat. 27
Grandcamp, Low Tide, Salon of 1884,
cat. 45
Evening, Salon of 1885, cat. 47

Octave Penguilly l'Haridon
*Roman City built at the Foot of the
Alpes-Dauphinoises sometime after the
Conquest of the Gauls*, Salon of
1870, cat. 23

William Lamb Picknell
The Road to Concarneau,
Salon of 1880, cat. 37

Camille Pissarro
The Banks of the Marne, ? Salon of
1864, cat. 8
*Chennevières, on the Banks of the
Marne*, Salon of 1865, cat. 10
The House of Père Gallien, Pontoise,
1866, cat. 58
*The Versailles Road at Louveciennes
(Rain Effect)*, 1870, cat. 63
The Fence, 1872, cat. 67
Factory near Pontoise, 1873, cat. 71
Landscape in Sunlight, Pontoise,
1874, cat. 75
*The Climbing Path, L'Hermitage,
Pontoise*, 1875, cat. 81
The Plain of Epluches (Rainbow),
1877, cat. 86
The Warren at Pontoise, Snow Effect,
1879, cat. 92
View of the New Prison at Pontoise,
1881, cat. 97

Auguste Pointelin
Hillside in the Jura, Salon of 1881,
cat. 38

Ernest Quost
Morning Flowers, Salon of 1885, cat. 48

Pierre-Auguste Renoir
Road in Louveciennes, c. 1870, cat. 64
The Seine at Argenteuil, 1874, cat. 76
Snowy Landscape, c. 1874–5, cat. 77
The Seine at Champrosay, 1876, cat. 84
Landscape at Wargemont, 1879, cat. 93
The Seine at Chatou, c. 1881, cat. 98
Landscape near Menton, 1883, cat. 105

Paul Saïn
*September Morning on the Road to
Villeneuve-lès-Avignon, near Avignon*,
Salon of 1890, cat. 55

Adrien Sauzay
The Vaugoing Pond, Sologne,
Salon of 1882, cat. 41

Alexandre Ségé
The Oaks of Kertrégonnec (Finistère),
Salon of 1870, cat. 22
In the Land of Chartres, Salon of
1884, cat. 46

Alfred Sisley
*A Road in Marlotte, near
Fontainebleau*, ? Salon of 1866, cat. 13
*Avenue of Chestnut Trees, near La
Celle-Saint-Cloud*, Salon of 1868,
cat. 18
The Seine at Bougival, c. 1872, cat. 68
The Watering Place at Marly in Winter,
1875, cat. 79
The Terrace at Saint-Germain: Spring,
1875, cat. 82
The Pumping Station at Marly, c. 1875,
cat. 83
*View of Marly-le-Roi from Coeur-
Volant*, 1876, cat. 85
Boats on the Seine, c. 1877, cat. 87
The Petits Près in Spring, c. 1880,
cat. 95
Saint-Mammès: Morning, 1881, cat. 99
September Morning, c. 1887, cat. 109

William Stott (of Oldham)
The Ferry, Salon of 1882, cat. 42

Bibliography

Full references are given here of all publications cited in abbreviation in the catalogue entries and the notes to the essays. Other publications of particular relevance to the exhibition are also included.

Exhibition catalogues are listed under their first or primary location. Books published to accompany exhibitions are listed under their author.

Page references are to the edition cited; except where otherwise indicated, all sources are quoted from their first publication.

About, E., *Salon de 1864*, Paris, 1864

About, E., 'Le Salon de 1867', *Le Temps*, 22 June 1867

About, E., 'Le Salon de 1868', *Revue des deux mondes*, 1 June 1868

Adhémar, J., *Les Lithographies des paysages en France à l'époque romantique*, Paris, 1938

Adler, K., 'The Suburban, the Modern and "une Dame de Passy"', *Oxford Art Journal*, vol. 12, no. 1, 1989

Agulhon, M. (ed.), *Histoire de la France urbaine*, IV, Paris, 1983

Aitken, G. and Delafond, M., *La Collection d'estampes japonaises de Claude Monet à Giverny*, Paris, 1983

Albert, M., 'Le Salon de 1890 aux Champs-Elysées', *Gazette des beaux-arts*, 1 June 1890

Alexis, P., 'Aux peintres et sculpteurs', *L'Avenir national*, 5 April 1873

A. M., 'Le Salon de 1861', *L'Illustration*, 31 August 1861

AN = Archives Nationales; documents quoted are from the Fine Arts files, catalogued under the number F21.

Angrand, P., 'L'Etat mécène: Période autoritaire du Second Empire (1851–1860)', *Gazette des beaux-arts*, June 1968

Angrand, P., 'Sur deux lettres inédites de Sisley', *Chronique des arts*, July–September 1971

Auvray, L., *Salon de 1861*, Paris, 1861

Auvray, L., 'Salon de 1864', *Revue artistique et littéraire*, vol. VII, 1864

Badin, A., 'Voyage d'un Parisien à la recherche de la nature', *L'Illustration*, 10 September 1864

Bailly-Herzberg, J. (ed.), *Correspondance de Camille Pissarro*, I, Paris, 1980; II, Valhermeil, 1986; III, Valhermeil, 1988; IV, Valhermeil, 1989; V, Valhermeil, 1991

Baroli, M., *Le Train dans la littérature française*, Paris, 1969

Barrell, J., *The Dark Side of the Landscape: The Rural Poor in English Painting 1730–1840*, Cambridge, 1980

Barron, L., *Les Environs de Paris*, Paris, 1886

Barron, L., *La Seine*, Paris, 1889

Barthes, R., *Mythologies*, London, 1972 (first published Paris, 1957)

Baudelaire, C., *Oeuvres complètes*, Paris, 1961

Baudelaire, C., 'Le Peintre de la vie moderne', Figaro, 26 and 28 November, 3 December 1863, in *The Painter of Modern Life and Other Essays*, translated by J. Mayne, London, 1964

Bazille, F., *Correspondance*, edited by D. Vatuone, Montpellier, 1992

Bender, B. (ed.), *Landscape: Politics and Perspectives*, Providence and Oxford, 1993

Berto, C., 'L'Invention de la Bretagne: Génèse sociale d'un stéréotype', *Actes de la recherche en sciences sociales*, November 1980

Beulé, C.-E., 'L'Ecole de Rome au dix-neuvième siècle', *Revue des deux mondes*, 15 December 1863

Bezucha, R., 'Being Realistic about Realism', in G. P. Weisberg (ed.), *The European Realist Tradition*, Bloomington, 1982

Bigot, C., 'Causerie artistique: l'exposition des "Impressionnistes"', *Revue politique et littéraire*, 28 April 1877

Bigot, C., 'Le Salon de 1883 (2e article)', *Gazette des beaux-arts*, 1 July 1883

Birnbaum, P., *"La France aux Français": Histoire des haines nationalistes*, Paris, 1993

Blanc, C., *Histoire des peintres de toutes les écoles*, 14 vols., Paris, 1861–76

Blanc, C., 'Salon de 1866 (1er article)' and 'Salon de 1866 (2e article)', *Gazette des beaux-arts*, 1 June, 1 July 1866

Blanc, C., *Grammaire des arts du dessin*, Paris, 1867

Blanc, C., 'Rapport au Ministre de l'Instruction publique et des beaux-arts, sur l'Exposition nationale de 1872', *Journal officiel*, 19 December 1871

Blanche, J.-E., *Dieppe*, Paris, 1927

Bodelsen, M., *Gauguin's Ceramics*, London, 1964

Bodelsen, M., 'Early Impressionist Sales 1874–94 in the light of some unpublished "procès-verbaux"', *Burlington Magazine*, June 1968

Boime, A., 'The Salon des Refusés and the Evolution of Modern Art', *Art Quarterly*, Winter 1969

Boime, A., 'Notes on Daubigny's Early Chronology', *Art Bulletin*, June 1970

Boime, A., *The Academy and French Painting in the Nineteenth Century*, London, 1971

Bomford, D. and others, *Art in the Making: Impressionism*, National Gallery, London, 1990

Bonnici, C.-J., *Paul Guigou 1834–1871*, Aix-en-Provence, 1989

Bouret, J., *The Barbizon School and 19th Century Landscape Painting*, London, 1973

Boutry, P., 'Le clocher', in P. Nora (ed.), *Les Lieux de Mémoire III. Les France*, vol. II, *Traditions*, Paris, 1992

Braudel, F., *The Identity of France*, vol. I, *History and Environment*, London, 1988

Brettell, R. R., *Pissarro and Pontoise: The Painter in a Landscape*, New Haven and London, 1990

Burty, P., preface to sale catalogue, *Tableaux et aquarelles par Claude Monet, Berthe Morisot, A. Renoir, A. Sisley*, Hôtel Drouot, Paris, 24 March 1875, reprinted in Riout 1989

Burty, P., preface to sale catalogue, *Tableaux et dessins par M. Amand Gautier*, Hôtel Drouot, Paris, 1 April 1875

Burty, P., 'Les Aquarellistes, les Indépendants', *La République française*, 8 March 1882

Bury, J. P. T., *Gambetta and the Making of the Third Republic*, London, 1973

Carlier, A., 'Elodie La Villette dans sa vieillesse', unpublished souvenirs, copy in Documentation du Musée d'Orsay

Castagnary, J., 'Le Salon, IV', *La Liberté*, 9 May 1866

Castagnary, J., *Salons (1857–1879)*, Paris, 1892

Cézanne, P., *Correspondance*,

edited by J. Rewald, Paris, 1978

Champa, K. S. and others, *The Rise of Landscape Painting in France: Corot to Monet*, Currier Gallery of Art, Manchester, New Hampshire, 1991

Champier, V., 'Variétés: Portraits de critiques d'art', *Moniteur universel*, 14 February 1878

Champier, V., *L'Année artistique, 1878*, Paris, 1879; *L'Année artistique, 1879*, Paris, 1880; *L'Année artistique, 1880–1*, Paris, 1881; *L'Année artistique, 1881–2*, Paris 1882

Chapus, E., *De Paris à Rouen et au Havre*, in series *Guides-Joanne*, Paris, 1855, 1862

Chassé, C., *Gauguin sans légendes*, Paris, 1965

Chennevières, P., 'Le Salon de 1880 (1er article)', 'Le Salon de 1880 (2e article)' and 'Le Salon de 1880 (3e et dernier article)', *Gazette des beaux-arts*, 1 May, 1 June, 1 July 1880

Chennevières, P., *Souvenirs d'un directeur des beaux-arts*, Paris, 1883–9 (reprinted Paris, 1979)

Cherbuliez, V., 'Le Salon de 1876, I: les impressionnistes, les tableaux de genre et les portraits', *Revue des deux mondes*, 1 June 1876

Chesneau, E., *L'Art et les artistes modernes en France et en Angleterre*, Paris, 1864

Chesneau, E., *Les Nations rivales dans l'art*, Paris, 1868

Chesneau, E., 'Au Salon: BATAILLE!!! Le Prix du Salon', *Paris-Journal*, 30 May 1874

Chevalier, F., 'Les Impressionnistes', *L'Artiste*, May 1877

Chicago Art Institute, *Museum Studies*, vol. 14, no. 2, 1989, special issue: 'The Grande Jatte at 100'

Cholvy, G., *La Religion en France de la fin du XVIIIe siècle à nos jours*, Paris, 1991

Cholvy, G. and Hilaire, Y.-M., *Histoire religieuse de la France contemporaine*, vol. I, Toulouse, 1985

Chu, P. T.-D., 'At Home and Abroad: Landscape Representation', in *The Art of the July Monarchy: France 1830 to 1848*, Museum of Art and Archaeology, University of Missouri-Columbia, 1990

Chu, P. T.-D. (ed.), *Letters of Gustave Courbet*, Chicago, 1992

Claretie, J., *Voyages d'un parisien*, Paris, 1865

Claretie, J., *Peintres et sculpteurs contemporains*, Paris, 1874

Claretie, J., *L'Art et les artistes français contemporains*, Paris, 1876

Clark, T. J., *The Absolute Bourgeois: Artists and Politics in France 1848–1851*, London, 1973

Clark, T. J., *The Painting of Modern Life: Paris in the Art of Manet and His Followers*, New York 1984/London 1985

Clément, C., 'Exposition de 1873: septième article', *Journal des débats*, 15 June 1873

Clément, C., 'Exposition de 1875: septième article', *Journal des débats*, 5 June 1875

Clément, C., 'Salon de 1878: septième article', *Journal des débats*, 11 July 1878

Clout, H., *The Land of France 1815–1914*, London, 1983

Cobban, A., *A History of Modern France, vol. III, France of the Republics, 1871–1962*, Harmondsworth, 1965

Corvol, A., 'La forêt', in P. Nora (ed.), *Les Lieux de Mémoire III. Les France, vol. I, Conflits et partages*, Paris, 1992

Cosgrove, D. and Daniels, S. (eds.), *The Iconography of Landscape*, Cambridge, 1988

Courthion, P. (ed.), *Courbet par lui-même et par ses amis*, Geneva, 1948, 1950

Couture, T., *Paysage: entretiens d'atelier*, Paris, 1869

Crapo, P., 'Courbet, La Rochenoire et les réformes du Salon en 1870', *Les Amis de Gustave Courbet: Bulletin*, 1990

Crouzet, M., *Un Méconnu du réalisme: Duranty (1833–1880)*, Paris, 1964

Culler, J., 'The Semiotics of Tourism', in *Framing the Sign: Criticism and its Institutions*, Oxford, 1988

Daniels, S., *Fields of Vision: Landscape Imagery and National Identity in England and the United States*, Princeton, 1993

Dayot, A., *Salon de 1884*, Paris, 1884

De Beauvoir, R., 'Le Touriste', in *Les Français peints par eux-mêmes*, III, Paris, 1841

Delaborde, H., 'Le Salon de 1861', *Revue des deux mondes*, 15 June 1861

Delaborde, H., *L'Académie des beaux-arts depuis la fondation de l'Institut de France*, Paris, 1891

De la Fizelière, A., *Memento du Salon de Paris, 1865*

De Lagenevais, F., 'Le Salon de 1875', *Revue des deux mondes*, 15 June 1875

De Laincel, L., *Le Salon de 1865*, Paris, 1865

Delouche, D., *Peintres de la Bretagne: Découverte d'une province*, Rennes, 1977

Delouche, D., *Les Peintres et le paysan breton*, Baillé, 1988

De Maupassant, G., 'La Vie d'un paysagiste', *Gil blas*, 28 September 1886, reprinted in *Oeuvres complètes de Guy de Maupassant: Oeuvres posthumes*, vol. II, Paris, 1930

De Montaiglon, A., 'Salon de 1875 (1er article)' and 'Salon de 1875 (2ème article)', *Gazette des beaux-arts*, 1 June, 1 July 1875

De Montifaud, M., 'Salon de 1868 – II', *L'Artiste*, 1 July 1868

De Navery, R., *Le Salon de 1868*, Paris, 1868

De Saint-Victor, P., 'Les Paysagistes au dernier Salon', *L'Artiste*, 1 November 1869

Desan, S., *Reclaiming the Sacred: Lay Religion and Popular Politics in Revolutionary France*, Ithaca and London, 1990

Devlin, J., *The Superstitious Mind: French Peasants and the Supernatural in the Nineteenth Century*, New Haven and London, 1987

Distel, A., *Impressionism: The First Collectors*, New York, 1990

Dole, Musée des Beaux-Arts, *Auguste Pointelin*, exhibition catalogue by A. Jacquinot and others, 1993

Dorbec, P., *L'Art du paysage en France: Essai sur son évolution de la fin du XVIIIe siècle à la fin du Second Empire*, Paris, 1925

Du Camp, M., *Le Salon de 1861*, Paris, 1861

Du Camp, M., 'Le Salon de 1864', *Revue des deux mondes*, 1 June 1864

Du Camp, M., *Les Beaux-Arts à l'Exposition Universelle et aux Salons de 1863, 1864, 1865, 1866 et 1867*, Paris, 1867

Du Pays, A.-J., 'Salon de 1863 (7e article)', *L'Illustration*, 11 July 1863

Du Pays, A.-J., 'Salon de 1864 (5e article)', *L'Illustration*, 16 July 1864

Durand-Ruel, *Recueil d'estampes*, with preface by A. Silvestre, Paris, 1873–5

Duranty, E., *La nouvelle peinture*, Paris, 1876, reprinted in Riout 1989 and San Francisco 1986

Duranty, E., 'Réflexions d'un Bourgeois au Salon de peinture (1er article)' and 'Réflexions d'un Bourgeois au Salon de peinture (2e article)', *Gazette des beaux-arts*, 1 June, 1 July 1877

Duranty, E., 'Variations dans la régime des Salons', *Chronique des arts et de la curiosité*, 14 July 1877

Duranty, E., 'La quatrième exposition faite par un groupe d'artistes indépendants, *Chronique des arts et de la curiosité*, 19 April 1879

Duret, T., *Critique d'avant-garde*, Paris, 1885

Duret, T. (ed.), 'Quelques lettres de Manet et de Sisley', *Revue blanche*, 15 March 1899

Duret, T., 'Paul Guigou: un grand peintre de la Provence', *L'Art et les artistes*, June 1912

Du Seigneur, M., *L'Art et les artistes au Salon de 1880*, Paris, 1880

Du Seigneur, M., *L'Art et les artistes au Salon de 1881*, Paris, 1881

Duval, L., 'Philippe de Chennevières-Pointel', *Revue normande et percheronne*, March–April 1899

Duvergier de Hauranne, E., 'Le Salon de 1872', *Revue des deux mondes*, 15 June 1872

Duvergier de Hauranne, E., 'Le Salon de 1873 – II', *Revue des deux mondes*, 15 June 1873

Edinburgh, National Gallery of Scotland, *Lighting up the Landscape: French Impressionism and its origins*, exhibition catalogue by M. Clarke, 1986

Edwards, S., *The Paris Commune, 1871*, New York, 1971

Eisenman, S., 'The Intransigent Artist, or How the Impressionists Got Their Name', in San Francisco 1986

Farr, D., 'Edouard Manet's *La Rue Mosnier aux drapeaux*', in J. Wilmerding (ed.), *In Honor of Paul Mellon*, National Gallery of Art, Washington, D. C., 1986

Fénéon, F., *Au-delà de l'impressionnisme*, edited by F. Cachin, Paris, 1966

Fiaux, L., *Portraits politiques contemporains, III: Charles Blanc*, Paris, 1882

Fidell-Beaufort, M. and Bailly-Herzberg, J., *Daubigny*, Paris, 1975

Fillonneau, E., 'Questions du jour: Prix du Salon', *Moniteur des arts*, 5 June 1874

Fillonneau, E., 'Questions du jour: Où va-t-on?', *Moniteur des arts*, 15 January 1875

Florisoone, M., 'Renoir et la famille Charpentier', *L'Amour de l'art*, February 1938

Ford, C., *Creating the Nation in Provincial France: Religion and Political Identity in Brittany*, Princeton, 1993

Frémont, A., 'La terre', in P. Nora (ed.), *Les Lieux de Mémoire III. Les France*, vol. II, *Traditions*, Paris 1992

Fromentin, E., *Maîtres d'autrefois*, Paris, 1875, reprinted in *Oeuvres complètes*, Paris, 1984

Fry, R., *Characteristics of French Art*, London, 1932

Gaillard, J., *Paris, la ville (1852–1870)*, Paris, 1977

Galassi, P., 'The Nineteenth Century: Valenciennes to Corot', in A. Wintermute (ed.), *Claude to Corot: The Development of Landscape Painting in France*, Colnaghi, New York, 1990

Garb, T., *Sisters of the brush: Women's Artistic Culture in Late Nineteenth-Century Paris*, New Haven and London, 1994

Gastineau, B., 'Le Voyage en chemin de fer (fantaisie)', *L'Illustration*, 9 June 1860

Gautier, T., 'Salon de 1857 – XV', *L'Artiste*, 20 September 1857

Gautier, T., 'La Rue Laffitte', *L'Artiste*, 3 January 1858

Gautier, T., *Abécédaire du Salon de 1861*, Paris, 1861

Gautier, T., 'Le Salon de 1866: IV' and 'Le Salon de 1866: VIII', *Moniteur universel*, 4 July, 26 July 1866

Gautier, T., *Tableaux à la plume*, Paris, 1880

Gellner, E., *Nations and Nationalism*, Oxford, 1983

Genet-Delacroix, M.-C., *Art et état sous la IIIᵉ République: le système des beaux-arts 1870–1940*, Paris, 1992

Gibson, R., *A Social History of French Catholicism 1789–1914*, London, 1989

Gildea, R., *The Past in French History*, New Haven and London, 1994

Gombrich, E. H., *Art and Illusion*, London, 1960

Goujon, J., *Salon de 1870: Propos en l'air*, Paris, 1870

Grad, B. L. and Riggs, T. A., *Visions of City and Country: Prints and Photographs of Nineteenth-Century France*, Worcester, Mass., 1982

Gravier, J.-F., *Régions et nation*, Paris, 1942

Green, N., 'Dealing in Temperaments: Economic transformation of the artistic field in France during the second half of the nineteenth century', *Art History*, March 1987

Green, N., '"All the Flowers of the Field": The State, Liberalism and Art in France under the early Third Republic', *Oxford Art Journal*, vol. 10, no. 1, 1987

Green, N., *The Spectacle of Nature: Landscape and Bourgeois Culture in Nineteenth-Century France*, Manchester, 1990

Grunchec, P., *The Grand Prix de Rome: Paintings from the Ecole des Beaux-Arts, Paris*, International Exhibitions Foundation, Washington, D. C., 1984

Guérin, M. (ed.), *Lettres de Degas*, Paris, 1945

Guillaumin, E., *La Vie d'un simple*, Paris, 1904

Guillemin, A., *Les Chemins de fer*, in *Bibliothèque des merveilles*, Paris, 1876

Guillemot, M., 'Claude Monet', *La Revue illustré*, 15 March 1898

Hamilton, V., *Boudin at Trouville*, Glasgow Museums and London, 1992

Halévy, D., *La Fin des notables*, Paris, 1930

Halévy, D., *La République des ducs*, Paris, 1937

Hébert, 'Salon de 1864: Le Paysage', *Les Beaux-Arts*, 15 May 1864

Henriet, F., 'Le Musée des rues, I: Le Marchand de tableaux', *L'Artiste*, 15 November and 1 December 1854

Henriet, F., *C. Daubigny et son oeuvre gravé*, Paris, 1875

Henriet, F., *Le Paysagiste aux champs*, Paris, 1876 (a revised version of an essay first published in 1867, with an added section titled 'Impressions et souvenirs')

Herbert, R. L., *Barbizon Revisited*, New York, 1962

Herbert, R. L., 'City vs. Country: The Rural Image in French Painting from Millet to Gauguin', *Artforum*, February 1970

Herbert, R. L., *Impressionism: Art, Leisure and Parisian Society*, New Haven and London, 1988

Herbert, R. L., *Monet on the Normandy Coast: Tourism and Painting, 1867–1886*, New Haven and London, 1994

House, J., *Monet: Nature into Art*, New Haven and London, 1986

House, J., 'Courbet and Salon Politics', *Art in America*, May 1989

House, J., 'Time's Cycles: Monet and the Solo Show', *Art in America*, October 1992

House, J. and others, *Impressionism for England: Samuel Courtauld as Patron and Collector*, New Haven and London, 1994

Houssaye, H., 'Le Salon de 1877', *Revue des deux mondes*, 15 June 1877

Houssaye, H., 'Les petits expositions de peinture', *Revue des deux mondes*, 1 March 1880

Houssaye, H., 'Le Salon de 1882 – II', *Revue des deux mondes*, 15 June 1882

Houssaye, H., 'Le Salon de 1883', *Revue des deux mondes*, 1 June 1883

Huet, R.-P., *Paul Huet (1803–1869)*, Paris, 1911

Hugo, A., *France pittoresque, ou Déscription pittoresque, topographique et statistique des départements et colonies de la France*, Paris, 1835

Hungerford, C. C., 'Meissonier and the Founding of the Société Nationale des Beaux-Arts', *Art Journal*, Spring 1989

Huston, L., 'Le Salon et les expositions d'art: réflexions à partir de l'expérience de Louis Martinet (1861–1865)', *Gazette des beaux-arts*, July–August 1990

Irvine, W. D., *The Boulanger Affair Reconsidered: Royalism, Boulangism and the Origins of the radical Right in France*, New York and Oxford, 1989

Isetan Museum of Art, *Masterpieces of French 19th Century Art from the Collections of Glasgow Museums*, exhibition catalogue by V. Hamilton, 1994

Jacobs, M., *The Good and Simple Life: Artist Colonies in Europe and America*, Oxford, 1985

Jean-Aubry, G., *Eugène Boudin: la vie et l'oeuvre*, Paris, 1922

Joanne, A., *Atlas historique et statistique des chemins de fer français*, Paris, 1859

Joanne, A., *Itinéraire général de la France: Normandie*, Paris, 1866

Joanne, A., *Itinéraire général de la France: La Loire et le centre*, Paris, 1868

Joanne, A., *La France*, Paris, 1868

Joanne, A., *Itinéraire général de la France: Le Nord*, Paris, 1878

Joanne, A., *Les Environs de Paris illustrés*, Paris, 1881

Joanne, A., *Itinéraire général de la France: Jura et Alpes Françaises*, Paris, 1882

Joanne, A., *Itinéraire général de la France: Normandie*, Paris, 1882

Joughin, J. T., *The Paris Commune in French Politics, 1871–1880: The History of the Amnesty of 1880*, Baltimore, 1955

Juillard, E. (ed.), *Histoire de la France rurale*, vol. III, Paris, 1976

Lafenestre, G., 'Salon de 1873', *Gazette des beaux-arts*, 1 July 1873

Lafenestre, G., *L'Art vivant: la peinture et la sculpture aux Salons de 1868 à 1877*, Paris, 1881

Lafenestre, G., 'Le Salon de 1886, I: La Peinture', *Revue des deux mondes*, 1 June 1886

Lafenestre, G., 'Le Salon de 1889', *Revue des deux mondes*, 1 June 1889

Lafenestre, G., 'Le Marquis de Chennevières', *Gazette des beaux-arts*, May 1899

Lagrange, L., 'Le Salon de 1864', *Gazette des beaux-arts*, 1 July 1864

Lagrange, L., 'Le Salon de 1865', *Le Correspondant*, May 1865

Langlois, C., *Le Catholicisme au féminin: les congrégations français à supérieure générale au XIXᵉ siècle*, Paris, 1984

Lehning, J. R., *The Peasants of Marlhes: Economic Development and Family Organisation in Nineteenth-Century France*, Chapel Hill, 1980

Lenoir, P., *Le Fayoum, le Sinai et Pétra*, Paris, 1872

Lindsay, S. G., 'Berthe Morisot: Nineteenth-Century Woman as Professional', in T. J. Edelstein (ed.), *Perspectives on Morisot*, New York, 1990

Loches, Musée Lansyer, *Hommage à Emmanuel Lansyer*, exhibition

catalogue, 1993

London, Hayward Gallery, *Pissarro*, exhibition catalogue, 1980–1

London, Hayward Gallery, *Renoir*, exhibition catalogue, 1985–6

London, National Gallery, *Manet: The Execution of Maximilian: Painting, Politics and Censorship*, exhibition catalogue by J. Wilson-Bareau with contributions by D. Johnson and J. House, 1992

London, Royal Academy of Arts, *Alfred Sisley*, exhibition catalogue, 1992–3

Los Angeles, County Museum of Art, *A Day in the Country: Impressionism and the French Landscape*, exhibition catalogue by R. R. Brettell and others, 1984

Mabilleau, L., 'Le Salon du Champ de Mars', *Gazette des beaux-arts*, 1 July 1890

McManners, J., *Church and State in France 1870–1914*, London, 1972

McMillan, J. F., *Napoleon III*, London, 1991

McMillan, J. F., 'Religion and Gender in Nineteenth-Century France', in F. Tallett and N. Atkin (eds.), *Religion and Society in France since 1789*, London, 1991

McMillan, J. F., 'Reclaiming a Martyr: French Catholics and the Cult of Joan of Arc, 1890–1920', in D. Wood (ed.), *Martyrs and Martyrologies, Studies in Church History*, vol. 30, London, 1993

McPhee, P., *A Social History of France 1780–1880*, London, 1992

Magraw, R., *France 1815–1914: The Bourgeois Century*, London, 1983

Mainardi, P., *Art and Politics of the Second Empire: The Universal Exhibitions of 1855 and 1867*, New Haven and London, 1987

Mainardi, P., *The End of the Salon: Art and the State in the Early Third Republic*, Cambridge, 1993

Mantz, P., 'Mouvement des arts et de la curiosité: Ecole des Beaux-Arts; les Envois des pensionnaires de Rome; Les Concours', *Gazette des beaux-arts*, November 1861

Mantz, P., 'Le Salon de 1863', *Gazette des beaux-arts*, 1 July 1863

Mantz, P., 'Salon de 1868 (7e article)', *L'Illustration*, 13 June 1868

Mantz, P., 'Le Salon de 1869', *Gazette des beaux-arts*, 1 June 1869

Mantz, P., 'Salon de 1872 (2ème article)', *Gazette des beaux-arts*, 1 July 1872

Mantz, P., 'Charles Blanc', *Le Temps*, 19 January 1882

Martel, P., 'La Félibrige', in P. Nora (ed.), *Les Lieux de Mémoire III. Les France*, vol. II, *Traditions*, Paris, 1992

Massarani, T., *Charles Blanc et son oeuvre*, Paris, 1885

Mayer, A., *The Persistence of the Old Régime: Europe to the Great War*, New York, 1981

Mayeur, J.-M., *Nouvelle histoire de la France contemporaine, 10: Les Débuts de la Troisième République, 1871–1898*, Paris, 1973

Ménard, R., 'Le Salon de 1870', *Gazette des beaux-arts*, 1 July 1870

Merlet, G., *Causeries sur les femmes et sur les livres*, Paris, 1862

Merlhès, V. (ed.), *Correspondance de Paul Gauguin*, I, Paris, 1984

Merriman, J. M. (ed.), *French Cities in the Nineteenth Century*, London, 1982

Michel, E., 'Le Salon de 1880: II', *Revue des deux mondes*, 15 June 1880

Michelet, J., *La Mer*, Paris, 1861

Michelet, J., *La Montagne*, Paris, 1868

Michelet, J., *Histoire de la révolution française*, 2nd edition, Paris, 1869

Michelet, J., *Histoire de France*, new edition, Paris, 1981

Michelez, *Salon de 1864: Tableaux commandés ou acquis par le Service des Beaux-Arts*, Paris, 1864, and annual volumes until 1886

Miller, M. B., *The Bon Marché: Bourgeois Culture and the Department Store, 1869–1920*, London, 1981

Mitchell, P., *Jean Baptiste Antoine Guillemet*, London, 1981

Mitchell, W. J. T., *Iconology: Image, Text, Ideology*, Chicago, 1986

Mitchell, W. J. T. (ed.), *Landscape and Power*, Chicago, 1994

Montpellier, Musée Fabre, *Frédéric Bazille et ses amis impressionnistes*, exhibition catalogue, 1992

Moreau-Nélaton, E., *Bonvin raconté par lui-même*, Paris, 1927

Murphy, A. R., *Jean-François Millet*, Museum of Fine Arts, Boston, 1984

Murray, J. (ed.), *A Handbook for Travellers in France*, Part 1, 14th edition, London, 1877

New York, Metropolitan Museum of Art, *Manet 1832–1883*, exhibition catalogue, 1983

New York, Metropolitan Museum of Art, *Origins of Impressionism*, exhibition catalogue, 1994–5

New York, William Beadleston Inc., *Paul Guigou, 1834–1871*, exhibition catalogue with essay by A. Sheon, 1987

Nieuwerkerke, A.-E., 'Rapport à Son Excellence le maréchal de France, ministre de la maison de l'Empereur et des Beaux-Arts', *Gazette des beaux-arts*, December 1863

Nochlin, L. (ed.), *Impressionism and Post-Impressionism, 1874–1904: Sources and Documents*, Englewood Cliffs, New Jersey, 1966

Nodier, C., Taylor, J. and de Cailleux, A., *Voyages pittoresques et romantiques dans l'ancienne France*, 20 vols., Paris, 1820–1878, including *Normandie I*, Paris, 1820; *Franche-Comté*, Paris, 1825; *Picardie III*, 1845

Nordman, D., 'Les Guides-Joanne: Ancêtres des Guides Bleus', in P. Nora (ed.), *Les Lieux de Mémoire II. La Nation*, vol. I, Paris, 1986

Noulens, J., *Artistes français et étrangers au Salon de 1885*, Paris, 1885

Olleris, H., *Memento du Salon de peinture, de gravure et de sculpture en 1880*, Paris, 1880

Orwicz, M., 'Criticism and Representations of Brittany in the Early Third Republic', *Art Journal*, Winter 1987

Orwicz, M. (ed.), *Art Criticism and its Institutions in Nineteenth-Century France*, Manchester, 1994

Paris, Galerie d'Art Braun, *Bulletin des expositions*, II, Sisley, 1933

Paris, Grand Palais, *Le Musée du Luxembourg en 1874*, exhibition catalogue by G. Lacambre, 1974

Paris, Grand Palais, *Centenaire de l'impressionnisme*, exhibition catalogue, 1974

Paris, Grand Palais, *Jean-François Millet*, exhibition catalogue by R. L. Herbert, 1975

Paris, Grand Palais, *Hommage à Claude Monet*, exhibition catalogue, 1980

Paris, Petit Palais, *Quand Paris dansait avec Marianne 1879–1889*, exhibition catalogue, 1989

Paris, Grand Palais, *Gustave Caillebotte 1848–1894*, exhibition catalogue, 1994

Parsons, C. and McWilliam, N., '"Le Paysan de Paris": Alfred Sensier and the Myth of Rural France', *Oxford Art Journal*, vol. 6, no. 2, 1983

Parsons, C. and Ward, M., *A Bibliography of Salon Criticism in Second Empire Paris*, Cambridge, 1986

Peirce, C. S., 'Logic as Semiotic: The Theory of Signs', in R. E. Innis (ed.), *Semiotics: An Introductory Anthology*, Bloomington, 1985

Philadelphia Museum of Art, *The Second Empire: Art in France under Napoleon III*, exhibition catalogue, 1978

Pissarro, L. R. and Venturi, L., *Camille Pissarro: sa vie, son oeuvre*, Paris, 1939

Plessis, A., *Nouvelle histoire de la France contemporaine, 9: De la fête impériale au mur des fédérés, 1852–1871*, Paris, 1979

Prendergast, C., *Paris and the Nineteenth Century*, Oxford, 1992

Proth, M., *Voyage aux pays des peintres: Salon de 1875*, Paris, 1875

Proth, M., *Voyage aux pays des peintres: Salon de 1876*, Paris, 1876

Proth, M., *Voyage aux pays des peintres: Salon de 1877*, Paris, 1877

Proth, M., *Voyage aux pays des peintres: Salon universel de 1878*, Paris, 1878

Proust, A., 'Le Salon de 1882', *Gazette des beaux-arts*, 1 July 1882

Pugh, S. (ed.), *Reading Landscape: Country-City-Capital*, Manchester, 1990

Redon, O., *Critiques d'art*, Périgueux, 1987

Renan, E., *Qu'est-ce qu'une nation? Conférence faite en Sorbonne, le 11 mars 1882*, Paris, 1882 (translated in H. Bhahba (ed.), *Nation and Narration*, London, 1990)

Rewald, J., *The History of Impressionism*, 4th edition, New York and London, 1973

Riout, D., (ed.), *Les Ecrivains devant l'impressionnisme*, Paris, 1989

Rishel, J. J., *Cézanne in Philadelphia Collections*, Philadelphia Museum of Art, 1983

Roos, J. M., 'Within the "Zone of Silence": Monet and Manet in 1878', *Art History*, September 1988

Roos, J. M., 'Aristocracy in the Arts: Philippe de Chennevières and the Salons of the mid-1870s', *Art Journal*, Spring 1989

Rosenthal, L., *Du romantisme au réalisme: Essai sur l'évolution de la peinture en France de 1830 à 1848*, Paris, 1914 (new edition, Paris, 1987)

Rouart, D., *The Correspondence of Berthe Morisot*, edited by K. Adler and T. Garb, London, 1986

Roujon, H., *Artistes et amis des arts*, Paris, 1912

San Francisco, Fine Arts Museums, *The New Painting: Impressionism 1874–1886*, exhibition catalogue by C. Moffett and others, 1986

Sand, G., *Tamaris*, Paris, 1862

Schapiro, M., 'Eugène Fromentin as Critic', in *Theory and Philosophy of Art: Style, Artist and Society*, New York, 1994

Schivelbusch, W., *The Railway Journey: Trains and Travel in the Nineteenth Century*, New York, 1979

Sellin, D., *Americans in Brittany and Normandy 1860–1910*, Phoenix Art Museum, 1982

Sensier, A., 'Le Paysage et le paysan', *Revue internationale de l'art et de la curiosité*, 15 May 1869

Sensier, A., 'Les Peintres de la nature', *Revue internationale de l'art et de la curiosité*, 15 May 1870

Sensier, A., *Souvenirs sur Th. Rousseau*, Paris, 1872

Sherman, D. J., *Worthy Monuments: Art Museums and the Politics of Culture in Nineteenth-Century France*, Cambridge, Mass., 1989

Shiff, R., *Cézanne and the End of Impressionism*, Chicago, 1984

Shikes, R. E. and Harper, P., *Pissarro: His Life and Work*, London, 1980

Silver, J., 'French Peasant Demands for popular Leadership in the Vendômois (Loir-et-Cher)', *Journal of Social History*, 14, 1980

Snyder, L. L., *The Dynamics of Nationalism: Readings in its Meaning and Development*, New York, 1964

Song, M., *Art Theories of Charles Blanc,*

1813–1882, Ann Arbor, 1984

Soucy, R., *Fascism in France: The Case of Maurice Barrès*, Berkeley and London, 1972

Soulié, F., 'Le Bourgeois campagnard', in *Les Français peints par eux-mêmes*, vol. III, Paris, 1841

Spencer, P., *Politics of Belief in Nineteenth-Century France*, London, 1954

Sternhell, Z., *Maurice Barrès et le nationalisme français*, Paris, 1972

Sternhell, Z., *La Droite révolutionnaire*, Paris, 1978

Stuckey, C. F. and Scott, W. P., *Berthe Morisot, Impressionist*, New York, 1987

Thomson, R., *Camille Pissarro: Impressionism, Landscape and Rural Labour*, London, 1990

Thomson, R., *Monet to Matisse: Landscape Painting in France 1874–1914*, National Gallery of Scotland, Edinburgh, 1994

Thoré, T., *Salons de W. Bürger, 1861 à 1868*, Paris, 1870

Toulon, Musée de, *La Peinture en Provence dans les collections du Musée de Toulon*, catalogue by J.-R. Soubiran and others, [1985]

Toulon, Musée de, *Le Musée à cent ans*, exhibition catalogue by J.-R. Soubiran and others, 1988–9

Toulon, Musée de, *Le Paysage provençal et l'école de Marseille avant l'impressionnisme, 1845–1874*, catalogue by J.-R. Soubiran, 1993

Tucker, P. H., *Monet at Argenteuil*, New Haven and London, 1982

Urry, J., *The Tourist Gaze: Leisure and Travel in Contemporary Societies*, London, 1990

Vaisse, P., *La Troisième République et les peintres: Recherches sur les rapports des pouvoirs publics et de la peinture en France de 1870 à 1914*, thesis for L'Université de Paris IV, 1980 (copy in library of Musée d'Orsay, Paris)

Vaisse, P., 'Salons, expositions et sociétés d'artistes en France 1871–1914', in Haskell, F. (ed.), *Saloni, Gallerie, Musei*, proceedings of CIHA Congress, Bologna [1982]

Valenciennes, P. H., *Elémens de perspective pratique à l'usage des artistes, suivis de réflexions et conseils à un élève sur la peinture et particulièrement sur le genre*

du paysage, Paris, [1800], reprinted Geneva, 1973

Véron, T., *De l'art et des artistes de mon temps: Salon de 1875*, Paris, 1875

Vollard, A., *En écoutant Cézanne, Degas, Renoir*, Paris, 1938

Vignon, C., 'Le Salon de 1863', *Le Correspondant*, June 1863

Wagner, A. M., 'Courbet's landscapes and their market', *Art History*, December 1981

Ward, M., 'Impressionist Installations and Private Exhibitions', *Art Bulletin*, December 1991

Warncke, M., *Political Landscape: The Art History of Nature*, London, 1994

Weber, E., *Peasants into Frenchmen: The Modernisation of Rural France, 1870–1914*, London, 1977

Weber, E., *My France*, London, 1991

Weisberg, G. P. (ed.), *The European Realist Tradition*, Bloomington, 1982

White, H. C. and White, C. A., *Canvases and Careers: Institutional Change in the French Painting World*, Chicago and London, 1965

Whiteley, L., 'Art et commerce d'art en France avant l'époque impressionniste', *Romantisme*, 40, 1983

Wildenstein, D., 'Le Salon des Refusés de 1863', *Gazette des beaux-arts*, September 1965

Wildenstein, D., *Monet: biographie et catalogue raisonné*, Lausanne and Paris, I, 1974; II and III, 1979, IV, 1985; V, 1991

Williams, R., *The Country and the City*, London, 1973

Wrigley, R., *The Origins of French Art Criticism: From the Ancien Régime to the Restoration*, Oxford, 1993

Zeldin, T., *France 1848–1945: Intellect and Pride*, Oxford, 1980

Zimmermann, M., 'Seurat, Charles Blanc and Naturalist Art Criticism', in Chicago 1989

Zola, E., *Mon Salon, Manet, Ecrits sur l'art*, ed. A. Ehrard, Paris, 1970

Photographic credits

Photographs reproduced in this catalogue have been provided by the lending museums and collectors. The South Bank Centre and the Museum of Fine Arts, Boston, express their gratitude and would like especially to thank the following photographers, agencies and museum photographic departments:

Michael Agee, Yale University Art Gallery; AKG, London; Jean Bernard, Aix-en-Provence; Bibliothèque Nationale, Paris; The Bridgeman Art Library, London; the Photographic Services Department of the Museum of Fine Arts, Boston; Ken Burris, Shelburne Museum, Vermont; Patrice Cartier, Carcassonne; Charles Choffet, Besançon; Yves Gallois; Glasgow Museums Photographic Service; Documentation Photographique des Collections du Musée de Grenoble; Tom Haartsen; J+M, Brest; Matti Janas, The Central Art Archives, Helsinki; Frédéric Jaulmes, Montpellier; J. Lathion, Nasjonalgalleriet, Oslo; M. de Lorenzo, Nice; Massi, Toulon; John Mitchell & Son, London; R. G. Ojeda, Paris; Service Photographique, Ecole Nationale Supérieure des Beaux-Arts, Paris; Photothèque des Musées de la Ville de Paris; Agence Photographique de la Réunion des Musées Nationaux, Paris; Jean-Marie Protte, Musées de Troyes; Roumagnac Photographe, Montauban; M. Seyve, Caen; Musée de la Ville de Strasbourg; Studio Basset, Lyon; C. Theriez; Richard Valencia, London; Thierry Daniel Vidal, Agen; and any other photographers we have failed to identify from the material provided.